GIVEN: 1°Art 2°Crime
Modernity, Murder and Mass Culture

JEAN-MICHEL RABATÉ

sussex
ACADEMIC
PRESS

BRIGHTON • PORTLAND

The right of Jean-Michel Rabaté to be identified as Author of this work has been asserted
in accordance with the Copyright, Designs and Patents Act 1988.

2 4 6 8 10 9 7 5 3

First published 2007 in Great Britain by
SUSSEX ACADEMIC PRESS
PO Box 139
Eastbourne BN24 9BP

and in the United States of America by
SUSSEX ACADEMIC PRESS
920 NE 58th Ave Suite 300
Portland, Oregon 97213-3786

British Library Cataloguing in Publication Data
A CIP catalogue record for this book is available from the British Library.

Library of Congress Cataloging-in-Publication Data
Rabaté, Jean-Michel, 1949–
 Given, 1° art 2° crime : modernity, murder and mass
 culture / by Jean-Michel Rabaté.
 p. cm. — (Critical inventions)
 Includes bibliographical references and index.
 ISBN 1-84519-111-0 (h/c : alk. paper) —
 ISBN 1-84519-112-9 (p/b : alk. paper)
 1. Murder in literature. 2. Detective and mystery
 stories—History and criticism. 3. Murder—
 Miscellanea. I. Title.

PN56.M85R33 2007
809'.933556—dc22

809.933
RAB
 2006020743

Typeset and designed by SAP, Brighton & Eastbourne
Printed by The Cromwell Press, Trowbridge, Wilts.
This book is printed on acid-free paper.

R53068

Critical Inventions

General Editor: John Schad
Lancaster University

PUBLISHED

Heidegger's Bicycle
Interfering with Victorian Texts
Roger Ebbatson

GIVEN: 1° Art 2° Crime
Modernity, Murder and Mass Culture
Jean-Michel Rabaté

FORTHCOMING

The English Question; or, Academic Freedoms
Thomas Docherty

The Prodigal Sign
Kevin Mills

Rapture: Literature, Secrecy, Addiction
David Punter

Someone Called Derrida
An Oxford Mystery
John Schad

John Schad is Professor of Modern Literature at Lancaster University. He is the author of *The Reader in Dickensian Mirrors*, *Victorians in Theory*, *Arthur Hugh Clough*, and *Queer Fish: Christian Unreason from Darwin to Joyce* – this last published by Sussex Academic Press. He is also the editor of *Dickens Refigured*, *Thomas Hardy's A Laodicean*, *Writing the Bodies of Christ* and co-editor of *life.after.theory*.

Contents

Illustrations

Series Editor's Preface

Jacques Derrida once wrote, "I was driving along with my mother and I leapt out of my car in a Paris street at the sight of Jean-Michel Rabaté." As you read the book that follows you too might just leap out of your seat at the sight of Jean-Michel Rabaté, at the sight of a student of art so engrossed by Thomas de Quincey's equation of art and murder that he himself begins to look like something of a murderer.

You are perhaps used to the idea of the critic as detective, as one who, in the name of the "hermeneutics of suspicion", labours at the scene of the crime that is art, particularly when the art-work in question is, say, a work of anti-art or depicts a murdered body. Cue (on both counts) Marcel Duchamp's installation *Given 1° The Waterfall, 2° The Illuminating Gas*, the eponymous focal point, or dead centre of Rabaté's book. Here, though, Rabaté-the-critic presents himself as not just a detective but also a suspect – for, in a way, his study of art-as-crime is itself criminal. This, you see, is a book that does not solve artistic crimes and riddles but seeks instead to add to them, as time and again the scene of avant-garde crime forces Rabaté into astonishingly learned evasions, detours and digressions. For instance, just when he seems about to mirror Patricia Cornwell's claim that Walter Sickert was really Jack Ripper by revealing that it was in fact Duchamp who committed the famous Black Dahlia murder of 1947, Rabaté suddenly launches into a long account of the Sadean excesses of Surrealism's criminal and (indeed) philosophical underworld.

With each new scholarly evasion, Rabaté looks more and more like the critic as riddler, or seducer who delights in luring us into the backstreets of anti-art, a maze in which all sorts of lurid and alarming chance encounters take place. Here Man Ray meets George Hodel the murderer, Pyrrho the Greek sceptic meets Max Stirner the anarchist, and Duchamp himself meets and marries a "very fat woman". And so it goes on, as we encounter everyone from Poe to Proust, Benjamin to Barthes, and Lautréamont to Laforgue. By the end, indeed, we want to echo James Joyce's famous cry "Here Comes Everybody." However, in Rabaté's paranoid interpretive world, everybody comes as a suspect – "this," says Rabaté, is "the basic law of the genre," the genre that is criticism.

So be warned, this book does not just educate us, it also suspects us; indeed, the bourgeois reader seated in his closeted domestic interior inhabits a space that Rabaté, following Benjamin, sees as ideally suited for murder. We cannot, it seems, escape the possibility of murder, not even in the study, not even when

merely philosophizing – "idealist metaphysics," warns the author, "is but a variation on the plot of the locked chamber." And, after Poe, we all know what happens in a locked chamber.

Or at least we think we know. Within Rabaté s locked chamber there are so many chambers that we may yet have to change our minds, if not our lives, or even deaths.

<div align="right">

JOHN SCHAD
Loughborough, June 2006

</div>

Acknowledgments

Parts of this book have appeared in a different forms or languages in various journals. Sections of chapter 2 were published as "Etant Donnés: 1° l'art, 2° le crime. Duchamp criminel de l'avant-garde", in *Interfaces*, Dijon, no. 14, June 1998, and as "Duchamp's Ego" in *Textual Practice*, vol. 18, no. 2, summer 2004. Sections of chapter 5 were published as "D'un Pan de Mur Jaune à l'autre: Proust avec Twombly", in *Interfaces*, no. 10, Dijon, February 1996. Sections of chapter 6 appeared in "Loving Freud Madly: Modernism between hysteria and paranoia", *Journal of Modern Literature*, "Special issue: Global Freud", 25, nos. 3-4, summer 2002. Sections of chapter 7 were published as "Clement Greenberg: Kantisme, Modernisme et Abstraction", in *Le Commentaire et l'art abstrait*, edited by Murielle Gagnebin and Chrstine Savinel, Paris, Presses de la Sorbonne Nouvelle, 1999. I thank the editors of these journals and book for permission to reuse this material. All my gratitude is for John Schad, who gave me the impetus and made this book possible.

Introduction
The Esthetics of Murder:
Of sirens, traces and auras

> "Every work of art is an uncommitted crime."
> W. T. Adorno, Minima Moralia[1]

The father and his son, both saddened by the recent death of their lovely wife and mother, have moved from London to an isolated cottage in South Devon. To occupy their long and gloomy winter evenings and complete the work of mourning, they read newspapers and they chat, they elaborate theories, they assess the pros and cons, they sift through evidence. For, in the depth of their despair, to find mutual comfort, they have found one single topic of conversation: true crime. Whenever they try other themes, they always come back to a question like: "What do you suppose they really did with the body?" Thus they discuss the cunning of Mrs Manning who had killed a man and buried him in quick-lime; they ponder the Carpet-bag mystery, with a bag found floating in the Thames full of gruesome human remains; they rehearse the famous Burke and Hare case.[2]

This curious family scene, an archetypal scene of the act of reading as bonding between the father and the son, is depicted in Edmund Gosse's famous autobiography.[3] It took place in the winter of 1857, when Thomas de Quincey was still alive. De Quincey had managed to make murder stories so fashionable that a devout Christian fundamentalist like Philip Henry Gosse would see nothing extraordinary in having lengthy discussions of murders with his eight-year old son. One century later, in 1959 to be precise, another orphan became similarly obsessed with unsolved murders. James Ellroy's mother had recently been strangled and her body dumped in an L.A. suburb. After this traumatic event, his father gave him a collection of real murder stories that included the notorious Black Dahlia case, which the young Ellroy became fixated with.[4] Let us tarry on this double image: facing murder, especially a young woman's murder – the most poetic theme

according to Poe – we all become orphans, widows or widowers. We don't really know what we are mourning, or if it is really mourning or an expiation of guilt that we are after. We are not sure what we have lost, hence we huddle together all the more closely and try to extract some warmth from the terror and pity that these stories inspire.

In the case of Edmund Gosse and his father, even if the topic of murders might not have been suitable for an impressionable young lad who "nearly turned to stone with horror" when he heard the tale of Burke and Hare, there was one law that was strictly adhered to, a commandment that the recently deceased Emily Gosse had laid for good: no fiction! The murder stories had to come from the newspapers and not from novels or romances. As he expresses it, calling up an even later period, "no work of romance, no fictitious story, had ever come my way. It is remarkable that among our books, which amounted to many hundred, I had never discovered a single work of fiction until my Father himself revealed the existence of Michael Scott's masterpiece."[5] The "masterpiece", *Tom Cringle's Log*, has not survived and does not figure in the canon of children's literature, nor have the cases of the Carpet-Bag mystery or Mrs Manning's murder. What has remained, next to the immortal Burke and Hare, is a certain attitude invented by the Victorians, the treatment of murder stories as a species of documentary drama that can be enjoyed for the thrills they offer without paying heed to any moral issue. In this bracketing off of ethics lies the root of "esthetics", and we cannot forget that the term of "esthetics" was introduced into English for the first time as a translation from the German of Kant and Schiller by Thomas de Quincey in his famous essay "Murder considered as one of the fine arts". We can conclude that without murder, there is no esthetic.

The first of the two essays that established de Quincey's name among British humorists and even gained for him a place in André Breton's *Anthology of Black Humor*, states that murder has two handles. It can be seized by the moral handle (which we can leave to priests and judges) or by the esthetic handle (used by everyone else). That esthetic handle turns murder into a spectacle and allows us to treat it purely "esthetically." The victim has been killed and cannot be resuscitated: let's just see whether this can make a good or a bad show. "A sad thing it was, no doubt, very sad; but *we* can't mend it. Therefore let us make the best of a bad matter; and, as it is impossible to hammer anything out of it for moral purposes, let us treat it aesthetically, and see if it will turn out to account in that way."[6] De Quincey's narrator famously considers at some length the murderer Williams, who had slaughtered two entire households, as a prime "artist" of murder – his crimes have to be assessed as works of art that set higher

and higher standards for forthcoming murderers and have been "signed" with his own personal stamp for posterity. Anticipating by one century Magritte's celebrated anti-caption of "This is not a pipe" handwritten under the realistic picture of a pipe, de Quincey tells us, via Kant, that murder both "is" *not* murder and "is" murder when it becomes art. The autonomy of esthetics means that the work of art simply turns into its own reality. The main point is less that it is ready to "kill" reality in order to assert its own laws, than that it becomes once and for all self-reflexive, its significance bounded by the deployment of its formal procedures, an active bracketing out of other worldly concerns that acknowledges the legislation of no human or divine tribunal.

While they cannot yet be identified with such a high modernist Credo, the creepy awe experienced by Gosse and Ellroy facing murders and horror stories goes beyond the male bonding, bringing together wifeless men and motherless boys. These individuals are not just trying out a sensationalist diversion from a terrible loss – the scandal of the mother's death at a young age – but are effectively caught up in a spiral that orients their mental powers and limns out their fates as aspiring writers. Perhaps I have generalized too glibly on the hankering for murder stories when suggesting that it is a universal condition of orphanhood. What is more revealing is that in the first case, the father, Philip Gosse, suffered as horribly, perhaps more horribly, from the general rejection of *Omphalos*, his opus magnum, published at the time of his wife's death, as from her demise. The general ridicule heaped on his well-meaning efforts to reconcile a creationist view and an evolutionist view, more than the loss of a dear wife, led him to "be angry with God".[7] And he was unlucky enough to publish it two years before Darwin's *Origin of Species*. I would argue that anger with the order of creation establishes the conditions to best enjoy "esthetically" the accounts of horrible crimes and murders. *Omphalos* had been written with the idea of making sense of the Bible at a time when the new teachings of Darwin and his colleagues the paleontologists and geologists were winning the day. For Gosse, Adam, although created from nothing, would have been given an *omphalos*, a navel, like everyone else, just as one would find everywhere fossils that confirmed that the world had not begun with Noah's flood. Thus the solution to the dilemma between science and faith was ingenious: it was not simply that God has planted a clever deception but more seriously that if one decides to "create", such creation cannot respect the time of organic growth to which it is diametrically opposed. Can one imagine Adam crawling like a baby and Eve asking for her mother's milk? Therefore, God created the world with an inbuilt past, as it were, and gave it to us full of fossils, layers, strata, all the illusionist signs that create a *trompe-l'oeil* palin-

genesis – and this in just six days of toil. Borges once praised the "monstrous elegance" of Gosse's solution and concluded that it proved by an involuntary *reductio ad absurdum* the validity of evolutionist theses.[8]

In a similar spirit, Stephen Jay Gould has praised and derided this book as good science gone awry.[9] He notes that the strength of the *Omphalos* is that it is irrefutable – but its weakness is that it becomes irrelevant as a consequence.[10] Indeed, if the world looks exactly the same whether is has a "prochronic" (i.e., illusionary) or a "diachronic" (i.e., historical) past, then there is no difference between reality (the world in its complex and very ancient evolution) and the illusion planted by God. Gosse takes it as a given that God would not create humans as babies but as grown men already endowed with marks, scars and hairs, and having ingested food already present in their intestines – he would create a world that would have already begun, a world full of ruins and half-destroyed vestiges . . . God is a Gothic architect or landscape designer who dots his creation with fake grottos, manmade mounds and spurious fossils. Gosse even speculates on the parallels between feces in intestines and fossilized excrements:

> The existence of Coprolites – the fossilized excrement of animals – has been considered a more than ordinarily triumphant proof of real pre-existence. Would it not be closely parallel with the presence of faeces in the intestines of an animal at the moment of creation? Yet this appears to me demonstrable . . . If the principle is true, that the created organism was exactly what it would have been had it reached that condition by the ordinary course of nature, then faecal residua must have been in the intestines as certainly as chyle in the lacteals, or blood in the capillaries.[11]

If the world is peopled from day one with beings who have already digested and are ready to excrete, the original turd displaces original sin.

However; there is one point of view that makes *Omphalos* less irrelevant – when one considers it from the point of view of murder. If one replaces "create" by "murder" much of the theological non-sense becomes coherent. On Gosse's view, creation and "decreation" become exact synonyms. Every day, murder victims are found whose bodies "speak" to forensic experts because, among other factors, of the food contained in their intestines. This, as well as all the other signs carried by their cells and DNA, reveals the exact moment when they were "de-created" or "unmade" by a criminal. Hence the "bog-men" found in Irish peat-bogs in the eighteenth century were found to be pre-historical victims of fertility rituals that had sacrificed them to a mother goddess, not recent murders – as those who found them almost intact when cutting peat first believed.[12] According to *Omphalos*, God's infinite kindness has extended to giving us the illusion of a much older past;

like excrement, murder produces signs that organize a whole simulacrum of archaic origins, and facing its riddles we are forced to become detectives. One might even say that God's creation is not far removed from the remains of a dead husband left smoldering in lime. The entire universe turns into a forest of symbols whose status hesitates between a distant past that recedes in an endless chain of causes, and the belief that somewhere there must be a demiurge, either the sadistic sacrificer who presides over blood rituals or a well-meaning plotter who plants clues to stimulate our intelligence.[13]

This is the starting point for Jean Baudrillard's meditation on God's "Perfect Crime":

> For Gosse, matters are simple: reality exists on God's authority. But what can we do if that same God is capable of simultaneously creating the true and the false? (This is not even a diabolical manipulation, since the germ of the illusion came from God himself.) In this case, what is there to guarantee that our world is not as false as the simulacrum of an earlier world? All of reality – present, past and future – suddenly comes into doubt. If God is capable of conjuring up a perfect illusion of the pre-Genesis era, then our current reality is eternally unverifiable.[14]

The "perfect crime", for Baudrillard, consists in the discovery that the world is a mere simulation. Baudrillard's book was written in the wake of the First Gulf War. Today, we have grown wary of simulation, and have learned the hard way during other campaigns in Afghanistan and again Iraq, that simulation tends to become all too real. Moreover, real crime, especially of the shocking type, mass-murder on a large scale with thousands of victims comes like a wake- up call – we are obliged to admit that there are limits to simulation. The less-than-perfect crime, which is the current form, gives birth to detective fiction and all its related sub-genres that talk to our "esthetic" taste.

This book will focus on a number of late nineteenth-century and twentieth-century artists who cross the bridges linking the history of the avant-garde and the esthetics of murder. Such a project runs the risk of coming across as bad taste, of being complacent to the kitsch of "true crime" aficionados, unsolved murder buffs, snuff film addicts and what not. The danger would be to restrict the scope of the investigation to the dubious interests of the "Society for the Encouragement of Crime" invented by de Quincey – a group of people who "profess to be curious in homicide, amateurs and dilettanti in the various modes of carnage; and, in short, Murder-Fanciers. Every fresh atrocity of that class which the police annals of Europe bring up, they meet and criticize as they would picture, a statue, or other work of art."[15] Besides, the idea of such a club, entertaining as it

is, misses what de Quincey himself strives after – namely to create sheer
terror in the minds of his readers. I will give examples of this strategy in a
later chapter but a basic point will suffice for now. De Quincey attempts to
found his articulation of ethics and esthetics on a distinction between action
and contemplation. His central argument is that as long as we can do some-
thing to prevent a murder or help a potential victim, we must act – this is
the realm of ethics; but if we come too late and the murder has been
committed, then we should be allowed to enjoy it as pure spectacle.
However, such a clear-cut distinction between a "before" and an "after"
moment simplifies the issue or misleads us. What makes murder stories
endlessly thrilling is that the repartition between the murderer, the victims
and the audience is often blurred. We are all potential victims, and perhaps
one of us will follow the model set by the famous criminal as artist and will
decide to act out the contents of the book, the suggestions of the work of
art. The frisson of such cheap thrills, all decidedly in "bad taste", derives
from such a structural lability.

The mention of "taste", whether good or bad, will lead me to reopen the
debate on the links between the avant-garde, modernism and popular
culture. I will try to do so by a different route, moving between psychoan-
alytic approaches and readings inspired by Walter Benjamin. Since I have
been arguing that any mention of "art and crime" forces one to look at the
creaky hinge between ethics and esthetics, it is important to note that these
categories have not always been separated. Thus in his seminar on the ethics
of psychoanalysis, Lacan attempted to make sense of the ethical conflicts in
Sophocles' *Antigone* by decreeing that the solution to age-old riddles lay in
the fact that the heroine had to bee seen as beautiful and that her beauty
would purify the spectator's "imaginary" – a new variation on Aristotelian
or Freudian catharsis.[16] All of this appears already contained in the debate
on ethics and esthetics that opposes Kant and Hegel. This is, for instance,
the point of view represented by David Ellison, one among a few critics who
try to connect ethics and esthetics. Ellison is perhaps the most comprehen-
sive of all, and his approach is both useful and symptomatic – which is why
I will outline his thesis below so as to state where I differ from it.

In *Ethics and Aesthetics in European Modernist Literature: From the Sublime
to the Uncanny*,[17] Ellison surveys the process by which European modernism
grew out of German Romanticism and took the form of a series of responses
to the challenge introduced by Kant's revolutionary ethics and esthetics.
Today's avant-garde has been constituted by successive discourses that pass
from Kant to Hegel and Kierkegaard, rebound via Nietzsche and Freud
before reaching other horizons with Levinas, Derrida, Lyotard and Blanchot
(all these authors being, as de Quincey noted with some glee when he

condensed his own history of philosophy, engaged in murdering one another). The poetologic evolution leading to high modernism and its debate with a contemporary avant-garde has been and still is determined by a conflicted interaction between ethics and aesthetics. Such an interaction, or at times pure contradiction, corresponds to a slow but definitive replacement of the concept of the Sublime by that of the "Uncanny", a term launched by Freud and which is now one of the critical keywords of our time. Indeed, the "Uncanny" would be Theory's "master trope", as Martin Jay excellently observed in his 1997 *Cultural Semantics*. The "Uncanny" stays half-way between psychoanalytical criticism and the latest evolution of deconstruction when it moves towards its "hauntological" mode, to follow the later Derrida in *Specters of Marx*. What this approach and recent Lacanian views have in common is the idea that the concept of the Sublime is unavailable. Hence, this book will deal less with the decay of the sublime as a genre, from Barnett Newman's monumental painterly abstraction promoting the artist to the exalted level of a "Vir Heroicus Sublimis" (as he did in a painting from 1950–1951),[18] to Jean-Luc Lyotard's recurrent use of the concept of the "presentation of the unpresentable" to talk about the Shoah in the 1980s, than with the obsolescence of the critical discourse associated with the Sublime.

This book's contention is that today's sublime can be best represented by Walter Benjamin's aura. "Aura" keeps all the religious connotations, the mystery of art, the ineffable –without the trappings of fear, overcoming fear, respect and the moral law. However, as we will see, the aura has enemies within – Benjamin calls them "traces" –– and most of these traces are traces of the Uncanny; or uncanny traces if you like. As so many half-erased clues, they reveal that a murder has taken place, already "committed" but not perfected or "perfect". Thus Baudrillard quotes Henri Michaux who wrote that the artist is he who resists with all his might the temptation not to leave traces.[19] True, the artist may leave as many traces as possible – they never add up to present the ancient auratic masterpiece. Similarly, Ellison sees in the uncanny the sublime of our age, and therefore his historiography of culture pursues the categories of the sublime and the uncanny across national borders.[20] He provides a theoretical genealogy that takes us from Kant to Freud's *Unheimlichkeit* via Romantic irony. Kant's concept of "aim" or "end" (*Zweck*) in the third *Critique* is here a foundational concept to which I will return in the context of Clement Greenberg's particular Kantianism. Let us not forget, Kant is not just the plodding writer of traditional discourse, since he was the first to negotiate boldly between ethical and aesthetical themes. At the moment when the imagination perceives its weakness in front of the magnitude of certain spectacles, the subject feels

the exhilaration of utter boundlessness; yet the linguistic form of the sublime adduced by Kant is the command prohibiting representations. The tensions contained in Kant's discussion of the Sublime lead to Hegelian dialectics of negativity, or alternatively to Kierkegaard's concept of irony. Irony leads us away from the sublime, although both concepts explore the same site, the point of an interaction between the finite and the infinite, in other words, between ethics and aesthetics.

In the conclusion to his book, following Blanchot, Ellison adds a third term to the two previous concepts: he believes that after the Sublime and the Uncanny, one should move to Blanchot's "neuter", the neutralizing synthesis between opposites. Accordingly, Blanchot would be the only writer capable of writing *after* Woolf and Kafka, the only one capable of blending theory and narrative in idiosyncratic tales, allegories or short stories. Indeed, both Kafka and Blanchot have meditated on music and silence, as evinced by Blanchot's well-known essay, "The Song of the Sirens". It is at this point, close to the end of the book, that something peculiar happens. Ellison distorts the very same passage on Ulysses and the Sirens in the *Odyssey* that had been quoted by Kakfa and Blanchot – while quoting the very lines of the *Odyssey* on the song of the Sirens in a note. Thus the really uncanny moment comes when Ellison writes: "The point of departure for Blanchot's theoretical meditation is the episode in *The Odyssey* in which Ulysses encounters the song of the Sirens, or rather, does not encounter it, since, making use of his habitual wiles, he stops his ears with wax and, by not hearing the enchanting singing, manages to survive the episode and move onward in his navigation."[21] Has Blanchot nodded, has Homer slept when Ulysses sailed on, or Ellison made an elision, or have all of these taken place at once?

Why has Ellison transformed what happens in Book Twelve of the *Odyssey*? We are told how Ulysses follows Circe's advice which is to block the ears of his sailors with pallets of wax and have them chain him to the mast so that he, at least, will enjoy the bewitching song of the Sirens without any risk. When he performs everything according to this plan, he can hear them boasting of the purity of the songs that flow "sweet as honey" from their lips. The Sirens try to lure him with the promise that they "know all that shall come to pass on the face of mother earth."[22] Ulysses hears them, longs to come nearer, but his men continue rowing. Blanchot even blames Ulysses for taking such a "cowardly, mediocre and tranquil pleasure", an enjoyment not worthy of a real hero, but fit only for a Greek of the decadence.[23] Indeed, Ulysses cunningly and basely exploits the resources of antique "techne" in destroying the enchantment of ancient myth. This is a far cry from Horkheimer's and Adorno's unequivocal praise of an enlight-

ened hero who fights against the darker power of myth, sacrifice and repetition: "Technically enlightened, Odysseus acknowledges the archaic supremacy of song by having himself bound. . .Despite the power of his desire, which reflects the power of demigoddesses themselves, he cannot go to them, just as his companions at the oars, their ears stopped with wax, are deaf not only to the demigoddesses but to the desperate cries of their commander."[24]

Not fully agreeing either with Adorno's praise or with Blanchot's strictures, Ellison chooses another angle, adding that the narrative situation is more complicated than Blanchot's evocation indicates. His entire strategy implies that his misquoting Homer's poem has been deliberate and calculated: "When Ulysses passes the Sirens, *what he does not hear* is the Sirens' own narrative summary of the Trojan War . . ."[25] Here, Ellison quotes the lines on the song of the Sirens as we find them in the *Odyssey*, while accusing Blanchot of not paying attention to the reflexivity of a poem (by the Sirens) within a poem (Homer's), and while all the time assuming that Ulysses has stopped his ears with wax! "There is, within the Sirens' episode in *The Odyssey,* a *mise en abyme* of narrative itself which Blanchot does not initially 'hear' before he passes on toward his own allegory of narrative."[26] Like this "allegory", deafness is contagious; it transmigrates from Kafka to Ellison, even if Ellison does not quote Kafka explicitly, since the first crucial misreading had been made by Kafka. Ellison, who uses Kafka a lot, does not quote the parable entitled "The Silence of the Sirens", a short text written in 1917 that triggered Blanchot's spirited response.

Kafka's main idea is based upon a paradox: the most powerful weapon of the Sirens was not their entrancing and seductive song but silence, a silence that made sailors want to go closer and then fall into their trap. It is a silence so intolerable that anyone will want to replace it with some kind of narrative. Thus, at the beginning of his short prose piece, he writes: "To protect himself form the Sirens Ulysses stopped his ears with wax and had himself bound to the mast of his ship."[27] He adds that even if there was a look of bliss on the hero's face, it was not because he enjoyed of the beauty of the Sirens' song, it was merely his pleasure at checking the paltry masochistic stratagem that he had devised: "And when Ulysses approached them the potent songstresses actually did not sing, whether because they thought that this enemy could be vanquished only by their silence, or because the look of bliss on the face of Ulysses, who was thinking of nothing but his wax and chains, made them forget their singing."[28] It is in answer to this text that Blanchot begins abruptly his own essay: "The Sirens: evidently, they really sang, but in a way that was not satisfying . . ."[29]

What this bewildering spiral of readings and misreadings contradicting

one another proves is that we have moved insensibly from the aura of the sublime moment, that asymptotic trajectory when the hero arrives in full view and hearing of the temptresses, to an endless and rather messy investigation that looks for hidden traces, clues, evasions, symptoms. A single text does not exist, just as a single corpse is rarely to be found in isolation: the murdered man or the misquoted passage always comes to us laden with misleading hints and distorting translations, yielding an array of contradictory circumstantial evidence that forces us to re-read once more and look for more omissions and distortions. As Borges wrote, developing Eliot's concept of an "ideal order" of culture, Kafka's genius made him "invent" several precursors,[30] and, next to Kierkegaard and Léon Bloy, these should include Homer's Sirens. Kafka's answer to the critical quandary in which we find ourselves was that the sirens did not sing at all, and their silence pierces through all other versions of the myth. It has certainly pieced Ellison's critical apparatus. Kafka had said that his stories had to do with "closing one's eyes", he could have added with stopping one's ears.

When Ellison rewrites the encounter between Ulysses and Sirens in a Kafkaian manner, his anti-Homeric rewrite makes sense in several ways. First, it demonstrates beyond any doubt that the "Uncanny" triumphs over the "neuter". We grasp that the "Uncanny" comes back unbeatable, unsuperable by any dialectical overcoming, and it returns in literary criticism as much as in fiction. Then it shows that one cannot bypass one intertextual network – by deciding not to look at the clues he would have found in Kakfa in order to attack Blanchot's own reading, or at least to question its agenda, Ellison leaves open the possibility for a return of the repressed. The repressed returns in the form of Kafka's distortion of the classical myth. The silence unleashed by Kafka in the name of an invented "wax in the ears" of Ulysses permeates Ellison's thesis. Conversely, by conflating the enchained Ulysses and the sailors whose ears are full of wax, Ellison solves one of the most intriguing conundrums faced by readers of Homer. If Ulysses can hear the enthralling song, the song that maddens whoever comes close enough, if he can listen and enjoy but at the cost of not moving a limb, tightly chained as he is, moreover caught in a "cowardly" ecstasy that makes him forfeit any heroism, if meanwhile his sailors keep on rowing on their own, deafened by a "technology" (this is the term used by Blanchot as well[31]), allegorized here by the invention of ear plugs, how or when can this process, this odyssey, end? Who will tell the rowers that they are far enough from the Sirens, if their ears hum darkly and if they see Ulysses still twitching in his chains, asking for more? In other words; does it help if their lovely song is undistinguishable from silence?

This is a question that we must leave unanswered for now. What is clear

to Adorno, Kafka and Ellison, is that after the triumphant "audition" of their song by Ulysses, the Sirens will die. They are condemned by the logic of "far enough or too close". These are terms that will ring a bell when we explore Walter Benjamin's definition of aura as a unique experience of distance, no matter how close the object may be. The aura, although on the wane, is still to be met here and there, and, for instance, it is the intrinsic property of indisputable masterpieces like Michelangelo's statue of Moses. We can gaze at it for hours and still wonder: How did he do this? We can also ask: Why? What did he mean, if indeed there is a meaning at all? Isn't there a mystery, a riddle, here? We will then attempts to reduce the riddle to a story, to a network of traces that will be biographical, cultural, biblical, architectural, anything that gives us a handle. This will also hopefully provide a good story, even, why not, the signs of a crime. Thus Baudrillard's "perfect crime" will be the equivalent of the perfect masterpiece – murder is a creation. It is so perfect that its creator, its very perpetrator, has forgotten that it was a crime in the first place. It will behoove to us to reawaken the lost sense of transgression, by accumulating more clues.

Technology always offers more clues – we do not need to reduce technology to the molding of wax; at least, wax is a good example since it connotes both endless plasticity and endless reproductibility. Thanks to this instrumental ruse, Ulysses was able to render all his companions deaf in no time – and a few readers as well. Similarly, when artists play with technology, finding in *techne* the common root of art and technique, they behave like Gosse's God: they plant simulacra that will be repeated endlessly, they produce fake genealogies, they simulate a "prochronic" present that mimics the diachrony of an authentic development. To find the end, or whether there is an end, we will need to turn into skilled detectives, sagacious interpreters, devoted hermeneutes; we will be looking for the hidden clues left in the body of evidence. We will have to become slightly paranoid – and along the way we will meet or invent crime. It is crime that forces us to conjecture while tempting us with a purely esthetic satisfaction. Is this a dilemma? This is one of the questions I will try to answer in this book – that murder makes artists and readers both more intelligent (as Freud will confirm it) and more guilty at the same time.

Thanks to our criminal or technological endeavours, we will end up hearing the song of the Sirens once more. Edgar Allan Poe was right to quote Sir Thomas Browne in the epigraph he chose for "The Murders in the Rue Morgue": "What song the Syrens sang, or what name Achilles assumed when he hid himself among women, although puzzling questions, are not beyond all conjecture."[32] We trust that Poe had a ready solution for all these riddles, the old ones as well as the new ones. At least, Dupin could recog-

nize the traces of the ape, realize that the culprit must have been a partially tamed ape whose gibberish was interpreted as all the languages of Babel by the clueless witnesses of the savage double murder. To meditate further, we need to go back to Sir Thomas Browne's *Hydriotaphia*, to let him continue addressing us in his own learned and mocking voice:

> What Song the Syrens sang, or what name Achilles assumed when he hid himself among women, though puzzling Questions are not beyond all conjecture. What time the persons of these Ossuaries entred the famous Nations of the dead, and slept with Princes and Counsellours, might admit a wide solution. But who were the proprietaries of these bones, or what bodies these ashes made up, were a question above Antiquarism; Not to be resolved by man, nor easily perhaps by spirits, except we consult the Provinciall Guardians, or tutelary Observators. Had they made as good provision for their names, as they have done for their Reliques, they had not so grossly erred in the art of perpetuation. But to subsist in bones, and be but Pyramidally extant, is a fallacy in duration.[33]

It is nevertheless here that we must dig – and even if we never identify the right owners of these bones, we will soon learn how to read the traces of their murderous cultures: once more, interpretation will send us back to crime.

Freud's Da Vinci Code

Interpretation as crime

In spite of the divergences we have seen between Adorno, Blanchot and Ellison, there is an academic consensus that a new hermeneutic paradigm has emerged within modernity, a paradigm in which criticism occupies a crucial position at least since Kant and the German Romantics. To this widely accepted view I would like to add a qualification: being a critic entails being ready to become a criminal, or at least to engage actively with crime. Criticism and crime would derive from a common root, since to criticize refers ultimately to "judgment" and "distinction", whereas "crime" calls up the cry at the origin of all accusations – the scream in the street. These roots highlight, in their common anaphoric beginnings, a similar outcry, a shared outrage. Such an apparently paradoxical thesis derives in part from Freudian criticism and in part from a revised historiography of modernism. First comes Freud, who states unambiguously the thesis of a criminal desire, a desire in which he recognizes the mettle of a true critic. This is to be found in a letter from June 1910 to his friend Oskar Pfister. Pastor Pfister was a deeply religious man; also an admirer of Freud and a staunch promoter of psychoanalysis for educational ends. When discussing psychoanalysis with him, Freud regularly insists that one has to be explicit and leave behind all traces of prudish Victorianism, this is imperative if one is to understand the sexual roots of neuroses. This attitude is recurrent in Freud; one recalls his insistence facing the young hysteric whom he called Dora that one has to "call a spade a spade",[1] or that, in matters of sexual knowledge, one cannot make an omelette without breaking eggs. This bold attitude led him to compare his own work as an analyst to that of a romantic artist about to burn the family's furniture to create a masterpiece (just as Bernard de Palissy had to do when he was discovering his famous china glazes). Pfister had recently published *Analysis of Hate and Reconciliation* (1910), a book which, as Freud wittily remarked in the same letter, "suffers from the hereditary vice of – virtue."

Pushing further, Freud developed his insight: "discretion is incompatible with a satisfactory description of an analysis; to provide the latter one would have to be unscrupulous, give away, betray, behave like an artist who

buys paint with his wife's housekeeping money or uses the furniture as fire-wood to warm the studio for his model."[2] As if these fiery words were not enough to shock the demure Swiss pastor, Freud added: "Without a little of this criminal disposition (*Verbrechertum*), nothing can be accomplished. [3] Must a thinker who wishes to share conclusions derived from case studies always be pushed to such dire extremities? In fact, the main reason invoked here is rhetorical: well-meaning discretion allows one to gloss over the vivid asperities of cases, and in consequence the crucial or telling details will not come alive for the audience. "the true picture is not conveyed to the reader who cannot identify himself with his unconscious and is therefore in no position to exercise his critical faculties (*nitcht ordentlich kritisieren*)"[4] as Freud tells us. One might be surprised by the way in which an appeal to the reader's unconscious is combined with a rationalist call for the deploy-ment of critical faculties. Freud implies that one's critical faculty can be brought to bear on a case best when it is aligned with the deepest wishes of one's unconscious. We shall later see how Freud himself, when he attempts to analyze his relation to a powerful, almost overwhelming work of art, strives to unite the most acute feeling of awe with exacting intellectual discernment.

In the context of these letters, Freud regularly extols the bawdy or sexual side of the body and chides Pfister for being too timid in front of Groddeck's bold sexualization of the Id: "I energetically defend Groddeck against your respectability. What would you have said if you had been a contemporary of Rabelais?"[5] In another letter, however, Freud admits frankly that he is not as nice a person as the Pastor is and that he lacks the real sensibility of an artist – but only to debunk these artists as quacks and fakers: "so far as these "artists" are concerned, I am actually one of those whom you brand at the outset as philistines and barbarians."[6] Freud refuses to lower his guard, as he implies Pfister did in his book on Expressionism, by making room for complicity with radical avant-garde artists and poets like André Breton, who hailed Freud as a guide when he had no idea of what these artistic exper-iments meant! I will return to Freud's and Breton's missed encounter, sticking here with Freud so as to give a sense of what he means by trans-gressive interpretation.

The essay that Freud published in 1914, "The Moses of Michelangelo", was the product of intense meditations on a statue that he discovered in 1901, and visited repeatedly over the years. In 1912, he goes to the church daily and takes many notes. In September 1913, staying for three weeks in Rome, he visits the Moses statue every day, studies it, measures it, compares it with other Moses effigies.[7] Finally, once Freud felt that he had cracked the code of the stone monument, he wrote this essay, published anony-

mously at first. He begins by describing his need to interpret; that is, to explain for himself the effect exerted by such major artworks – without this interpretive moment, he cannot fully enjoy the masterpieces. This fits well with Freud's self-depiction as an avowed non-artistic character – in the arts, he know that he is only a "layman", and precisely because he lacks the intimate empathy, the intuitive appreciation that mark off a seasoned connoisseur, he must compensate with hard-won knowledge. This insistence on epistemophilia, almost akin to a *resistance* to art, contradicts the genuine familiarity leading to the sensual hedonism of a real art lover: "Some rationalistic, or perhaps analytic, turn of mind in me rebels against being moved by a thing without knowing why I am thus affected and what it is that affects me."[8]

Let us pause slightly at the outset to observe a striking parallelism – Freud the layman "rebels" against the tyranny of powerful works of art, just as he feels a kinship with the rebellious crowd of unbelievers whose idolatry triggers the scorn of the prophet's angry stare:

> How often have I mounted the steep steps from the unlovely Corso Cavour to the lonely piazza where the deserted church stands, and have essayed to support the angry scorn of the hero's glance! Sometimes I have crept cautiously out of the half-gloom of the interior as though I myself belonged to the mob upon which his eye is turned – the mob which can hold fast no conviction, which has neither faith nor patience, and which rejoices when it has regained its illusory idols.[9]

In his autobiographical narrative, aimed at countering the overwhelming effect of the famous statue, Freud dramatizes a double movement: on the one hand, he needs more intellectual control, but on the other hand he identifies with the rebellious and, as we know, ultimately murderous rabble. It is, of course, because Freud has already elaborated the theory of the "murder of the father", a murder which did not spare Moses, as Freud's later "historical novel" on Moses will make plain (the key to the success of Moses' Egyptian-based monotheism is that he, an Egyptian priest of Aton, had been murdered by the Jews who later repented and then venerated him as a founder of the group and a symbolical father), that Freud feels all the more mesmerized by Moses' stony glare. In this case, interpretation should both lead to a freedom from the enslavement of fascination and a dangerous flirtation with the unholy idols that the mob takes a counter-model.

Freud begins his exploration of the statue's riddle by listing most the previous interpretations, and concludes that they are inherently contradictory and conflicting. Nobody agrees on the meaning of Moses' attitude: some critics see him as a model of calm and majesty, others see him as

animated by a violent passion. In order to go beyond the conflict of read-
ings, Freud make use of a method devised by a Russian art-critic, Ivan
Lermolieff, who could identify forgeries by focusing on details such as
finger-nails, ear-lobes, halos, and generally unseen "trifles"[10] – the tell-tale
clues of a Conan Doyle. Accordingly, Freud narrows down his gaze to a
close-up of Moses' right hand, a hand whose fingers pass through the dense
volutes of the beard while also holding from above the heavy tables of the
Law. He gazes with more attention and perceives that the thumb of the right
hand is concealed while the index finger presses into the beard. Indeed, it
pushes so hard against the billowing hair that it flows away from it, cascades
out beyond above and below. Moses' three lower fingers seem propped
against his chest and are slightly bent, allowing the right-side lock of his
beard to fall gently past them. These lower fingers do not push the beard
really, which leads Freud to surmise that they have withdrawn themselves
from the beard. He concludes this close-up analysis of a detail with the
following statement: "the index finger is laid over a part of the beard and
makes a deep trough in it",[11] which suggests a bizarre gesture that one
cannot easily understand.

Freud's loving description of the beard is a dynamic rendering of how
the strands and coils appear finally churned, chastised and chided by the
"despotic finger", Moses' right index. What is more, it appears that it is in
fact the left side of the beard that is controlled by the right finger, a precious
hint since the loop of the beard gives an indication on the path previously
taken by the hand. This is what allows Freud to reconstruct the movement
of the hand an instant before it has been turned into stone. Moses was resting
on his throne with the tables of the law until he was startled by the screams
of the crowd carrying the Golden Calf. Seized by wrath and indignation, he
first wants to punish and annihilate the wrongdoers, but then clutches the
left side of his beard with his right hand, checking his fury. Finally, he
decides not to destroy the fickle Jews or the divine tables.

Freud needs no less than four drawings to show the trajectory of the hand
and finger, thus recreating a chronoscope similar to those invented by
Marrey and Muybridge to document movements at the end of the nine-
teenth century. He has to suppose that the moment depicted by
Michelangelo deliberately collapses two different scenes in the Bible: the
first goes back to the destruction of the original tables written by God, and
the second presents Moses bringing the new set of tables written by himself
under God's dictation. Freud attributes such a willful distortion to
Michelangelo's complex relationship with Pope Julius II, whose tomb the
very statue was to adorn. The artist, whose temperament was fiery and
violent like the Pope, carved his Moses "as a warning to himself, thus rising

in self-criticism superior to his own nature."[12] What is interesting to note in the four drawings, made at Freud's request by an artist, is that they have reduced the chaos of Moses' beard to a simpler sketch. In the last two sketches, one can recognize a schematized animal with four legs. Could this be Moses' despised Golden Calf imposing itself here, as if marking the return of the repressed?

This is the interpretation that the French critic Alain Roger has dared to explore further. His spirited reading takes its cue from an insight offered by Oskar Pfister when in 1913 he added to Freud's reading of Leonardo's *Saint Anne with two others* (we will return to this painting very soon) his own startling discovery: he saw the distinct shape of a vulture hidden in the dress of Mary. Roger, in his turn, decides to hallucinate a Golden Calf in Moses' abundant beard. Roger's paranoid-critical reading of Freud's essay on Michelangelo's Moses insists upon the descriptive passages devoted to the prophet's beard.[13] He shows that Freud sexualizes the beard by picturing it as a soft feminine mass into which the "despotic finger" plunges with libidinal abandon. The Golden Calf thus marks the return of the repressed in the garlands of a beard which offers little resistance to the convulsive palpation of the fingers. As he was writing his Moses essay, Freud had just completed a preface to the German translation of J. G. Bourke's *Scatological Rites of all Nations* (1913). In this preface, Freud appeared very tolerant and pointed out numerous examples of infantile connections between scatology and sexuality. It is likely that his interpretation of Michelangelo's statue was colored by the undeniable suggestion (at least visually speaking) of an anal penetration of the Golden Calf by Moses' finger. In this sublimated sodomy, the despotic finger enacts a mimetic revenge (the orgiastic heretics get just what they deserve) while regaining self-mastery. But it also reconnects with a very archaic moment in the sexual development of the child.

Freud's book *Three Essays on the Theory of Sexuality* evokes discreetly a digital stage which would be contemporary with the oral stage and prior to the other stages. The second essay devoted to infantile sexuality begins with an examination of the phenomenon of thumb-sucking, or more precisely "sensual sucking" (*Wonnesaugen*, literally "ecstatic sucking"). What defines this early activity is that it cannot be reduced to a basic need such as nourishment, since it derives its function from the fact that instincts are not outward-bound but look for satisfaction from within the baby's own body. It starts, no doubt, as a simulation of the pleasurable breast-feeding, but in this case, the drive soon becomes independent, and finds a finger, an ear – any body part that can play the role of a substitute for the mother's nipple. The delight later experienced in an erotic kiss owes some poignancy to this primitive auto-eroticism through which we all turn into little Narcissuses

("'It is a pity I can't kiss myself', the [baby] seems to be saying"[14]). Freud reconstructs infantile sexuality from a close analysis of thumb-sucking: it attaches to a vital somatic function but becomes independent from it; it has no sexual object yet but its sexual aim is dominated by an erotogenic zone. This sketches the structure of desire itself, a desire free of any need and any object, underpinned by an auto-erotic repetition. It is only later, with the onset of the sadistic-anal stage, that a bifurcation appears between activity and passivity. In the third stage, which is the phallic moment, the whole weight of sexual differentiation is brought to bear on the subject's psychic constitution.

In 1938, Freud developed an historical and primaroly political thesis on *Moses and Monotheism*, but he did not forget the early libidinal investments. The political element is simple to measure: by making Moses an Egyptian, Freud hopes to deflect the Aryan rage that expresses itself as organized anti-Semitism. Moses founded his new law upon the Egyptian idea of a transcendent and invisible God, whose teaching excludes and represses both animality and anality – condensed by the Golden Calf, the portable allegory of all pagan or regressive rituals. The dark humour of a brutal zoophiliac sodomic rape inscribed in a stone that cannot be moved, but nevertheless moves its audience to extremities of perplexity, would explain the curious rhetorical progression of Freud's text. He has to find a lever, even if infinitesimal, so as to make the statue move and then account for its cryptic history. In that sense, Freud is indeed the logical predecessor of Dan Brown, to whom I will shortly return.

If Alain Roger's reading has any validity, beyond its value as shock-therapy, it comes from the notion that we, as readers, must necessarily find it impossible to stop the interpretive process at some "normal" level, and thus we will be forced by the overarching logic of Freud's argument to assume that Moses' despotic index is engaged in a contorted anal penetration of the Calf. The anal rape by something that we might call the "digital stage" would allegorize the crucial moment when one has to opt for or against passivity in an almost unspeakable decision henceforth underpinning any other critical decision. Moses's pointing *Zeigefinger*, in this interpretation, would be the harsh reminder of an ancient *deixis*, a term which, in linguistics, corresponds to the gesture of pointing to an object, in a pure reference without signification. This pointing gesture is enacted by the Law whenever it confronts its "others", but on the other hand, this Law can only be reached by a transgressive interpretation.

This is probably why Freud felt the need to resort to English in his essay, as if to disguise his hubristic transgression, first when talking about "refuse" when he alluded to Lermolieff's insight that an observer should pay atten-

tion to the discarded details left behind,[15] and then when quoting a book on Moses by Watkiss Lloyd. In this case, unlike with his others references, Freud does not translate. According to Lloyd, if one followed a reconstruction similar to that offered by Freud, one would have to conclude that Moses' movements reveal "a gesture so awkward, that to imagine it is profanation" (in English in the text).[16] It is because Lloyd's insight has paved the way for Freud's thesis, as he recognizes himself, that he can all the more strongly denounce the English writer's pusillanimity. Just like Oskar Pfister, who does not dare go into the unpalatable details, Lloyd almost sees the truth but then shrinks from it at the last moment, and thus he misses the revealing connection between the finger's gesture and the fate of the tables.

This is clearly why Freud had to leave this last interpretation at the very conclusion of his own essay. Lloyd had intelligently reconstructed the path of the hand, or what he called the "wake" of Moses' beard, in a sequence of gestures performed by the prophet, but failed to see that these "awkward" gestures betrayed the prophet's sudden revision by which he regained possession of his will to give the tables of the law intact to his people. Freud proves once more that, if one wishes to analyze to the end, one must be close to the spirit of a malefactor, a delinquent acquainted with crime and murder (*Verbrechertum*, in the letter to Pfister), or turn into a tomb raider ready to profane a holy sepulture. His real model is simply Michelangelo, who cannot be held responsible for the obscurity that surrounds his masterpiece since it is structural, and who has gone "to the utmost limit of what is expressible in art."[17] If Moses' rude finger accusatorily *points* to the locus of an anal-logical sin without naming it fully, then the legislator nevertheless leaves us the task of questioning the interpretive manipulations of images. My contention is that the equivalent of such a legislator in contemporary art, someone who could play a role similar to that of Michelangelo at the Renaissance, was none other than Marcel Duchamp.

Less for his urinal that functions as an ironic *deixis* of what is and is not art, than for his wish not to remain at a purely retinal stage in art, Duchamp, who famously refused to be "stupid like a painter", puts forward calculation, reflection, and intellectual games. He bridges the gap between the two antithetical Freudian paradigms of the artist, Michelangelo and Leonardo. Freud had shown that the problem evinced by Leonardo was that he sublimated too much and often lost his artistic impulse. His libido being left in the lurch, he would often fail to complete frescoes or portraits and frittered his time away in countless pseudo-scientific reveries. These fantasies of absolute knowledge; according to Freud, masked a *libido sciendi* rooted in unaccomplished sexual knowledge.

Michelangelo, on the other hand, managed to sublimate truly when he transformed an interpretive effort into the sculpture's main spring, thus uniting *libido sciendi* and artistic creativity. Nevertheless, he leaves us with the difficult task of understanding the archaic roots of his sublime creation His sublime is thus a *para*-sublime, closer to a parody of the great tradition than to the long lineage that goes from Longinus to Kant, and from Kant to Lyotard.[18] Roger's calculated critical profanation reminds us of the need to connect the libidinal, the material and the base with the lofty or sublime. Ergo, if we imagine Moses' finger sodomizing a golden calf hidden in the prophet's beard, it follows that this parody of scientific deciphering radicalizes Freud's mixture of rationalistic reconstruction and heretic profanation. This links Freud to Giambattista Vico, who had been the first to connect interpretation and transgression historically and philologically.

In his *Scienza Nuova*, Vico imagines the first men begotten from Noah's sons as giants scattered in primeval forests. Left alone without any guidance, they return to an animal state, engage in wild sex and chaotic activities – as "wild things" or giants, they lose all connection with culture. Parents sleep with their offspring; no law is respected except the law of the jungle. One day, a huge thunderstorm erupts, the primitive giants believe that they hear the voice of a paternal God, whom they call Zeus, Jupiter or Jove, and who is recriminating against them. In their terror, they hide in caves, and there found human institutions like the family, followed by the whole edifice of society, jurisprudence, cities, governments, states.[19] Language keeps the traces of the ancient metaphors used by these ungainly but poetic creatures and shows etymological interbranchings that, once correctly deciphered, allow a cultural historian to make sense of fables and myths. One of these is the link between "interpretation" and "perpetration". For Vico, the giants first tried to imitate the sound of the thunder, then called it "pa!" or "pape!":[20] The first gods, all identified with powerful fathers, were the only ones who could be "doing" or creating, in Vico's Latin, *patrare* (to make, to create). The first Roman augurs then interpreted the sign language of the gods and translated it for the people. "To this first jurisprudence therefore belonged the first and proper interpreting, called *interpretari* for *interpatrari; that is 'to enter into the fathers,'* as the gods were at first called."[21] Today, we project the greatest distance possible between a "perpetrator" and an artist or creator, forgetting that the two verbs were indeed originally linked. We have seen how one can make fun of the notion of penetrating the false god symbolized by the Golden Calf. A perpetrator is someone who trespasses, commits a crime, and who, if the product of the activity is a work of art, will indeed be called a bad artist.

The following pages will be devoted to a few of these perpetrators, but

I would like to suggest a deeper complicity between the critic and the artist, a complicity that often brands them as criminals. To understand this better, I will now turn to Walter Benjamin, who also believes, like Vico, that words keep the traces of past deeds, whether criminal or heroic. For Benjamin, it is more explicitly the work of art itself that embodies a dialectic interaction of traces and auras. A short and pithy remark in his *Arcades Project* makes this opposition clear: "Trace and aura. The trace is an appearance of nearness, however far removed the thing that left it behind may be. The aura is appearance of a distance, however close the thing that calls it forth. In the trace, we gain possession of the thing; in the aura, it takes possession of us."[22]

A discussion of Benjamin's remarks on photography, especially on Atget's photographs, in the well-known essay on "The Work of Art in the Age of Mechanical Reproduction" will follow in a later chapter. I will also explore the concept of "aura", with its many shadings and tensions. The concept is valid for the perception of artistic objects, but also of natural objects, which is why the first definition of the aura given in the "Work of Art" essay is taken from nature and *not* from art: "We define the aura of (natural objects) as the unique phenomenon of distance, however close it may be. If while resting on summer afternoon, you follow with your eyes a mountain range on the horizon or a branch which casts its shadow over you, you experience the aura of those mountains, of that branch."[23] In the course of Benjamin's essay, aura, which stands for the air of authenticity and uniqueness of a masterpiece, soon becomes equated with the fetishization of art objects by their owners or viewers. The tendency that I will analyze in these pages is the wish to reduce or translate the aura of a work of art by the forceful deciphering of traces, more often than not imaginary traces. When the work of art is devoid of obvious traces, one can always hallucinate them as a systematic use of paranoia-criticism demonstrates. A similarly typical strategy is employed by Dan Brown, who uses Leonardo da Vinci's masterpieces, especially the Mona Lisa in the Louvre, as a point of departure for the weaving of a complex, if rather absurd, conspiracy theory. A good thriller is usually produced at the intersection between the aura of the work of art and traces read in his works. This is surprisingly close to what Freud did with Michelangelo or with Leonardo himself.

In his essay on Leonardo's childhood memory, Freud presents at some length the figure of the artist who is slowly limited in the realization of artistic endeavors despite obvious gifts, because of an overwhelming desire to know.[24] On his account, Leonardo's problem is an excess of *Wissensdrang*, his unquenchable thirst for knowledge, which ends up cutting him off from ordinary human contacts and from the pleasure taken in finishing a work

of art. Freud's thesis had been formulated as early as 1909; he told Jung that the key to the riddle of Leonardo's character had been given to him when he had understood how Leonardo had converted his sexuality into scientific investigation, which led him to be unable to finish any project. This diagnosis might apply to many other artists, among whom, no doubt, Marcel Duchamp, who will play an important role in these pages, but Freud may have been thinking of his own "criminal" wish to know at any cost, of a *libido sciendi* that should not heed any preconceived notion of propriety and normalcy. Malcolm Bowie has shown the importance of images of conquest, highlighting Freud's recurrent identification with rebels like Hannibal in the war against the Roman Empire.[25] Moreover, Freud's hermeneutic method when confronting artworks is similar to Leonardo's general attitude since, as we have seen, the artistic and literary masterpieces of the past contain unsolved riddles that test the limits of his interpretative skills. In Leonardo's case, the craving for knowledge derives from different sources, but the result is almost identical: "What interested him in a picture was above all a problem; and behind the first one he saw countless other problems arising, just as he used to in his endless and inexhaustible investigation of nature" (LV, p. 77).

Freud tends to see a deep continuity in Leonardo's life while stressing the unfinished nature of most of his paintings and the painstaking slowness in his productions. The source of such hesitations or technical failures (such as the destruction of the *Last Supper* on which he had worked for three years) must be found in Leonardo's attitude towards sexuality. He is indifferent to moral or to sexual issues while being very fastidious in all his other tastes. He repudiates sexuality, which is surprising to find in an artist who likes portraying feminine beauty. This frigidity led him to avoid the question of eroticism. The key to Leonardo's inhibitions was not that he lacked creativity or passion, but that artistic creativity had been converted into a craving solely for knowledge. Leonardo's fascination for all sorts of machines, from weapons to artificial wings, is the consequence of his inability to understand the "natural" feelings of men and women. In order to reach the root of this inhibition, Freud analyzes the earliest memory Leonardo has consigned to paper when he explains that his obsession with flying birds goes back to one of the earliest recollections of his infancy: "when I was in the cradle . . . a kite (*nibbio*) came and opened my mouth with its tail, and struck me within upon the lips with its tail many time."[26]

A symptomatic misreading due to the German translation he was using, led Freud to believe that the *nibbio* (literally "kite") mentioned by Leonardo was a vulture. This slip was prepared by a string of mythological associations brought to bear on the passage. Freud sees the tail as carrying the trace

of an exclusive link to the mother, betraying an archaic wish to suck the penis of a phallic mother. This passive homosexual fantasy is strengthened when the vulture calls up androgyny and bisexuality, which is why Freud needs Egyptian myths. They allow him to see the vulture as a female father, Leonardo himself becomes a "vulture child" (LV, p. 91). Leonardo's desire to know derives from his anxiety about the place where babies come from – an anxiety heightened the difficult position of an illegitimate child brought into his father's family at the age of five. As he knew that his mother was single, she became a Virgin Mary of some sort. We can interpret Mona Lisa's blissful smile as an echo of the loving and luminous smile of a mother who lavishes all her love on the son for want of a husband, thus causing premature sexual longings in the precocious boy. But there is also a father and a stepmother. In the angelic smiles of the Madonna and of Saint Anne in the Louvre painting called *Saint Anne with Two Others* or *Santa Anna Metterza*, the dedoubling of Leonardo's mother finds a direct expression. The painting depicts Christ with his mother and grandmother and, for Freud, this "picture contains the synthesis of the history of his childhood. . . . Leonardo has given the boy two mothers . . . both are endowed with the blissful smile of the joy of motherhood" (LV, pp. 112–13). Saint Anne appears as radiant and beautiful as the mother; nothing in her face betrays the passage of time.

Many critics supposed that Leonardo had used a self-portrait to paint Saint Anne, which might account for the playful narcissism displayed by the face of the Virgin's mother. The same has been claimed of Mona Lisa's face, which was apparently confirmed after it had been superimposed on a recognized self-portrait. Even if this insight had not then been confirmed by X-rays and scientific methods, Marcel Duchamp probably heard that the famous portrait was painted on top of a self-portrait of the artist with a beard. This led him to add a moustache and a goatee to a banal reproduction of Mona Lisa, in the notorious Dadaist joke entitled *L. H. O. O. Q.* (She's hot in the ass) from 1919. But even before the Dada movement had started, it was inevitable that a faithful disciple would literally hallucinate and discover the non-existent vulture somewhere. It fell to the same Oskar Pfister, obviously emboldened with time, and duly admonished to be criminally creative by Freud himself, to make the cryptographic discovery in 1913, when he saw the vulture hidden in the draperies of the Virgin's dress. The discovery is mentioned with a certain reserve by Freud ("a remarkable discovery has been made in the Louvre picture . . . even if one may not feel inclined to accept it without reserve." [LV, p. 115, added in 1919]), as it seems to prove his theory too neatly. The vulture is seen in the piece of "blue cloth" as a "light grey field against the darker ground of the rest of the

drapery"; this belongs to the category of "picture-puzzles" and would provide the key to the allegorical meaning of the painting, since the bird thrusts its tail toward Jesus, as the *nibbio* did to infant Leonardo in his fantasy. Even if Pfister's solution to the visual riddle with ring the two mothers is crude and not entirely convincing, nevertheless, once one has *seen* the vulture, one cannot forget its ghostly presence. The *nibbio* keeps on hovering above the painting, it haunts us like an indelible after-image, a perceptual lure called for by Leonardo's family romance. This forced reading of a famous painting announces what Dalí later called "paranoia criticism", a paranoia that it enacts concretely by showing how one can organize a patch of nondescript color into a visual riddle that generates other shapes.

Whoever gazes at the Louvre painting with sustained attention will be struck by disquieting details. Those very same folds of the Virgin's dress that could hide a bird shape are dotted with irregular spots, the coloration is uncertain, hesitating between blue and green. The impression of degraded pigments is reinforced as soon as one compares this surface with the red velvet of Mary's right shoulder or with the olive green of Anne's left arm. It looks as if the paint has not aged well, has turned into a grayish curtain awaiting restoration, a veil hastily thrown in so as to hide a secret or perhaps enhance the beauty of the faces. The painting is constructed on an opposition between the complementary colours red and green: the ground is reddish-brown, the flesh nacreous and pink, while the background presents a mass of darker shapes just separated from the blue-green sky by a thin opalescent halo. The Virgin's dress functions more as a blurred backdrop than as a foreground, even if it is the first plane that we see. This surface occupies almost one-fifth of the canvas and has been described either as green or blue. Photographs reproducing the picture show an alternation between green and blue according to filters and background hues, thus confirming Leonardo's principle that a mixed colour partakes of all other colors.

Did Leonardo plan to achieve the effect of an indescribable color or was this the consequence of a technical failure? The shifting blue-green veil separates as much as it unites the three entangled figures of the child and his two mothers. The two mothers seem to have one body in common, and the lamb held by Jesus blends with his own body. The grayish blue-green hue of the folds calls up a crucified flesh more than the draperies that fascinated Leonardo. If the greenish foreground looks more like a background, does this mean that the rocky substance has devoured the mother's dress so as to conjure up the Golgotha of a passion still to come? Or is the blue-gray surface a holy shroud waiting for the inscription of a bleeding face? Its shape, an oblique pyramid, mirrors the construction of the whole group,

while unbalancing it and tilting it to the side. The Virgin's knees form jutting angles (they provide the "bird" with a skeleton) which force one to imagine some rock or earth bank by which she would be supported in order to account for the strange angle formed by the right leg, covered by an almost transparent fabric, and the left knee, smothered in folds with an elbow draped in the same color. It would be tempting to apply Freud's method when reconstructing Moses' gestures prior to the statue to this triad: here, who is catching whom before they all fall?

A famous essay by Meyer Schapiro on the flawed readings produced by psychoanalysis has called attention to a cultural context often forgotten by Freud. On his critical account, the indefinable quality of the colour and the strange grouping of the three figures with the lamb should have been interpreted in the light of the then emerging tradition that aimed at rehabilitating Saint Anne, and also Mary as a saint.[27] The cult of Saint Anne culminated around 1485–1510, just when Leonardo was painting the Virgin and her mother in numerous pictures and sketches. This slowly-growing cult led to the official dogma of Immaculate Conception finally adopted by the Roman Catholic Church in 1854. At that time of the Renaissance, there was a divergence between one view which tended to stress seniority and authority, and would thus depict Anne as older and higher than Mary, and another, more prevalent in Northern European countries, which tended to see them as equals. Leonardo wished to resolve the contrasts – he wanted to render the conflicts of the individuals while retaining family harmony, which is why, for Schapiro, the painting's quality suffers from so many unresolved tensions: "There remains an aspect of the rigid and artificial in the group, most evident in the abrupt pairing of Anne and Mary, with the sharp contrast of their profile and frontal forms. It may be explained, perhaps, by Leonardo's commitment to the traditional mediaeval type of *Anna Metterza*, in conflict with his own tendency towards variation, distinctness and movement."[28] Commentators have seen in this trinity of two mothers and one child the theme of the Passion, since the painting could be understood as a foreboding of the death of Christ: the lamb with which Jesus plays presages the sacrificial host. Mary hesitates between a desire to reclaim her child and let him go to his destiny, the redemption of humanity.

The fascinating quality of the painting comes from the fact that it is an attempt at embodying a theological mystery, which can be variously glossed as the mystery of the Immaculate Conception, hinting that Mary's own mother had been conceived without the blemish usually associated with human sexuality, or the mystery of the Incarnation, the link between humanity and divinity condensed in "carnation", that is the evanescent and

indefinable color of flesh. Looking again at the painting, we now see that
the Virgin, almost in profile, has just moved to catch Jesus. Only three feet
can be seen for three human figures, and the lamb is only showing three feet
too. Three hands, likewise, are visible, as if to stress the enigma of a purely
feminine and sinless trinity underpinning conception and birth. The trian-
gular shape of the blue-green dress thus hides and reveals the riddle of
generation in so far as it attempts to bypass male agency, be it divine or
human. By a strange metonymy leading from dress to body to symbol, the
mystery of a "Maculated Carnation" is spreading and thus absorbs the color
and the shape of the dress. In its unnamable hue, the entire burden of a
world of pain has been suggested. Hesitating between tears and laughter,
in the indecision of a frozen smile, Anne and Mary simultaneously clutch
and repel the beautiful son; He is moreover endowed with the appropriate
transitional object – a lamb allegorizing his coming fate. Spectators cannot
but be captivated by the enigma of such a moiré blue-green drapery, a
prophecy as well as the impossibility of prophecy, a visual riddle hiding a
theological Mystery.

Can we congratulate Freud for having tried to solve the riddle? Not
necessarily, since he had to pay for his sacrilegious boldness, as so often was
the case, by committing a severe misreading, almost a slip of the pen. For
Meyer Schapiro, Freud's essay on Leonardo is a mere *jeu d'esprit* and should
not be taken as a test of his general psychoanalytical theory, here faultily
applied.[29] Indeed, Freud dismisses details that would contradict his biog-
raphical reconstruction such as the notes on kites made by Leonardo, notes
which do not associate these birds with loving mothers. But, as Eissler's
forceful defense of Freud's reading against Schapiro's historicism has shown,
one should not be misled by the repeated invocation of a whole "tradition"
that end up being as spectral as the bird seen by Pfister on the famous
painting.[30] More damagingly, Eissler shows that Schapiro occasionally
distorts the evidence in order to prove Freud wrong: while he postulates an
entire series of images in which Mary and Anne appear to be equally young,
tall and beautiful, the only painting that he refers to is by Luca di Tommè
and that one presents a Saint Anne who is much bigger than her daughter.[31]

Eissler asserts that Freud would have maintained his theory even if he
had been confronted with Schapiro's objections. His psychoanalytic
construction operates in a domain for which the Unconscious is the deter-
mining factor. A Freudian axiom is the idea of a productive link between
childhood fantasies and the creation of masterpieces; on this domain, cultur-
alist and historicist approaches miss the critical issue, because they
presuppose a positivistic answer to the riddle. What if the riddle was meant
to *remain* a riddle? Here is another riddle that may remain without a defin-

itive answer: "Why does the eye see a thing more clearly in dreams than the imagination when awake?"[32] Perhaps Leonardo himself provided a solution to his own riddle by stressing dreamed links between men and birds: "Feathers shall raise men towards heaven even as they do birds, – That is by letters written with their quills."[33] Quite often with Leonardo's riddles, the solution is purely verbal. He also recycles old saws, as in the following riddle: "They will be many hunters of animals who the more they catch the fewer they will have; and so conversely they will have more in proportion as they catch less."[34] The answer is given by the title: "Of catching lice." Actually, Leonardo is here quoting Heraclitus' fragment that describes the death of Homer: the poet, as an old man, died because he could not solve this riddle recited to him by children. It seems that when it comes to riddles, we all lapse back into childhood.

Dan Brown is also a specialist in riddles – and as the author of one of the most celebrated recent international bestsellers, a theological thriller at that, since the *Da Vinci Code* has sold more than ten million copies throughout the globe, and more than six books or collections of essays have been devoted to heated discussions of his "revelations" – he has found a way of tapping into the infantile pleasure we take in solving riddles, even childish riddles like those gathered by Leonardo under the heading of "Prophecies". His recipe is simple but the result has proved its long-term appeal. First, one needs an endearing and unlikely couple of heroes made up of a cryptologist and a "symbologist", professions that specialize in solving riddles and analyzing hidden symbols. No matter if the male hero, Robert Langdon, who has an uncanny physical resemblance to Harrison Ford and is a professor at Harvard in a specialty that does not exist, has come to Paris to give a lecture at the American University of Paris which does exist! His accomplice will be a dashing young woman who cracks cryptographs, ciphers and codes, Sophie Neveu. In one of the most bizarre twists of an utterly unbelievable plot, she will be shown to have a very close relation to the hero – as well as being the distant great-great-granddaughter of Jesus and Mary Magdalene.

Let us begin at the beginning, and for those who may have escaped from the worldwide craze by shunning the bulky page-turner, we must start with a building that does exist, the Louvre museum. It all begins with the shocking discovery of the body of Jacques Saunière, chief curator of the museum, shot dead but lying naked, spread-eagled on the floor of the grand gallery. As he has had a few minutes' respite before dying, he has posed his stark naked body as the Man of Vitruvius by Leonardo da Vinci, and has scribbled with his blood a few letters and numbers so as to leave a complex but tantalizing rebus. Some of the clues he has scattered are written in invis-

ible ink on the side of a Leonardo masterpiece. These coded messages are in fact reserved for the initiates, among whom are to be found evidently Sophie, who happens to be Saunière's estranged granddaughter, trained from birth by him to become a perfect riddle decoder, and Robert, who beyond his good looks and American energy, is the author of books such as *The Symbology of Secret Sects* and *The Lost Language of Ideograms*.

We soon discover that Saunière was the head of a secret organization called the Priory of Sion, and that all its grand masters have just been murdered on the same day by a masochist albino monk who doubles as a serial killer who works for the conservative Catholic Opus Dei organization. Pursued by a slightly unhinged police chief and the albino killer, Sophie and Robert flee whilst solving one after the other the puzzles left behind by Saunière. What Saunière and the other Priory of Sion members (a distinguished cohort that includes Leonardo, Botticelli, Newton, Victor Hugo and Jean Cocteau) keep from the Church is a dangerous secret. If they were to reveal it to the world, it would have shattering consequences for all Christian churches and especially the Church of Rome. The sacred object that underpins the quest is the Holy Grail, the vessel thought to have contained Christ's blood while on the cross. In fact, the sacred relic yields access to a different version of the gospels, one in which Jesus had been married to the arch sinner Mary Magdalene and had had a daughter with her. What has been repressed over centuries by the brutal phallocratic rule led by the Opus Dei is a fundamentally feminist spin that Jesus had meant to give to his teachings.

This is of course just a novel, and one should never restrict artistic freedom to literary creators, however *The Da Vinci Code* is preceded by one page listing as "facts" not only the recent construction of an Opus Dei headquarters in New York for $ 47 million but also the "European Secret Society founded in 1099" as the Priory of Sion, whose existence is attested by documents found in the Paris Bibliothèque Nationale in 1975. These two more or less occult societies are presented as waging an apocalyptic struggle, a war to the death (with real murders) over matters of faith and doctrine. And we read this: "All descriptions of artwork, architecture, documents, and secret rituals in this novel are accurate."[35] "Accurate" is a nice adjective here. For if the discovery of documents pertaining to the Priory of Sion in the Bibliothèque Nationale in 1975 is indeed an "accurate" fact, it was nevertheless based on a deliberate falsification mounted by a certain Pierre Plantard.

Born in 1920, Plantard was active in the thirties in a variety of anti-Semitic and anti-Masonic movements. He was jailed twice, once just after the second World War and once in 1953 for starting these organizations

illegally. Later, he heard of the curious story of a certain Abbé Saunière (one recognizes a similar name), who pretended that he had found a treasure coming from the Templars (in fact, he was trafficking in masses and soon suspended). With a few friends, Plantard founded the Priory of Sion in 1956 in Saint-Julien-en Genevois near Annemasse, a site of some note in the novel. Sion is a place near Geneva, not Jerusalem. To render his invention more credible, Pierre Plantard became the author with his friend Philippe de Chérissey of a mass of documents that were forged in the early 1960s. These were hidden, or rather planted, in the French National Library to be purposely discovered. They pretended to be the "Secret files" of a certain Lobineau, also a fictional character, and were an amazing rag-bag of religious and historical fantasies: one found there genealogies of the Merovingian kings connecting them with Plantard, legal documents relating the foundation of the priory of Sion in 1099, the idea that the Priory of Sion was the occult center of command of the Templar Knights, and a list of the Priory's grand masters since the twelfth century which included Leonardo da Vinci, Isaac Newton, Victor Hugo, Claude Debussy and Jean Cocteau. It is possible that Plantard had heard of a hoax perpetrated by Jean Cocteau in the 1930s, since Cocteau was in the habit of indulging his fantasies by extemporizing prestigious lineages with his friends, once inventing a secret society on similar lines. This provides a link with Surrealism, a movement in which Philippe de Chérissey had been interested.

Surprisingly, given such wild claims, the deception worked, but this entailed several relays. First, a certain Gérard de Sède published in 1967 a book entitled *L'Or de Rennes* purporting to detail the documents. He had been helped by Plantard, who made Nicolas Poussin a key painter. Poussin, because of his connection with the secret organization, would have hidden allegories in his famous pastoral scenes. In 1967, de Chérisey admitted that the documents had been forgeries. However in 1982, the publication of *The Holy Blood & Holy Grail*, written by three British journalists, Henry Lincoln, Michael Baigent and Richard Leigh, became a bestseller. The book accepted most of Plantard's inventions as true, adding to the Priory of Sion legend its own twist: Jesus had been married with Mary Magdalene and had fathered a child born after his death. The publicity given to the fable threw too much light on the accomplices: In 1984, Plantard was denounced by his friends and forced to resign from the Priory of Sion. He changed his strategy and in 1989 gave a new list of the former grand masters of the Priory, including Roger-Patrice Pélat, a friend of President François Mitterand. Unhappily for Plantard, Pélat, who died soon after, was investigated for embezzlement in what became a huge financial scandal. After

Pélat's death, the police searched Plantard's apartment, found the spurious documents and made him confess to the mystification. Already it was too late – twelve different Priories of Sion had sprung, and the myth had gained a footing in the public unconscious, which made it absolutely ineradicable. It had become the hot stuff from which novelists derive their inspiration.

It is worth comparing *The Da Vinci Code* with a contemporary thriller on a similar topic, art and murder: *Spiral*, by Joseph Geary.[36] *Spiral* is a more literary novel and evinces first-hand knowledge of the world of art and of contemporary art collectors. The hero is a British scholar, Nicholas Greer, the author of a biography of Frank Spira, a famous artist in whom one will immediately recognize the persona of Francis Bacon. Spira, whose life was sulfurous and full of drugs, gay sex, multiple sales of the same painting, friendships with thugs, and all sort of perverse and debasing provocations, has died some time ago. Just as he is revising the proofs for his book *Life*, Nicholas is called from New York by a former friend of Spira who tells him that one of Spira's former lovers has been seen in a shelter for the homeless. Apparently in a state of panic, he flees from everyone. Just after Nicholas interviews him, he is horribly murdered, his lips removed and the skin of his body more or less flayed. It turns out that other people who were close to Spira in the fifties are being chased, murdered and mutilated. The object of the quest is a painting that could have been destroyed by the artist or never completed, called *The Incarnation.* But its secret is a sort of ghastly joke: *The incarnation* was drawn, printed or tattooed on a living person. Nicholas will discover that the criminal is none other than a rich collector who is ready to do anything to retrieve the paintings that he had somehow bought in advance, which proves rather difficult as they have been tattooed directly on the skin of various lovers by the artist. Spira would also "sign" the living bodies of the consenting – but drugged – friends with the monogram "S", which the monomaniac killer has subsequently to cut off from inside their mouths.

The idea of biographer-critic turned into a private detective who can alone patch up a complex intrigue and a gory story because he knows all the details of his artist's life, works perfectly. It is also the concept that underpins the classy thrillers written by painter-novelist Jonathan Santlofer (I will deal with him later). However, in spite of all the subtlety of the style and the suspense that rebounds at every moment of the plot, *Spiral* fails precisely where *The Da Vinci Code* succeeds. For even if the disguise is transparent and we can recognize Francis Bacon's works (there are long descriptions of the "Scream" series"), Spira is an invented character and the famous *Incarnation* remains a fictional painting, even if it has been painted on human skin. The astutely rendered verbiage of art critics who are first

ecstatic about the daring decision to paint on "vellum", then protest against "sick" and degenerate art is convincing, but the very evocation of *The Incarnation* falls under the category of ekphrasis (which I'll discuss at some length in chapter four). Ekphrasis is here simply understood as the description of an imaginary work of art. As a consequence, no "code" is offered, there is no grand promise of a revelation that takes its point of departure in an artist's work and then includes Christian religion in a universal conspiracy. The world of rich art buffs and perverted esthetes provides an excellent and fresh setting, but it fails to be universal, thus its appeal remain limited. We will see with Walter Sickert and Jack the Ripper that in order to produce a bestseller, as Patricia Cornwell has done, one needs to ground ekphrasis in history with real artists and a totalizing myth.

The situation is quite different with Dan Brown, who took just what he needed from the plot spun by the authors of *The Holy Blood & Holy Grail*, and turned this material, pragmatically, into clichés calculated for a thriller that could have a broad appeal. He did not have to show familiarity with a milieu or a historical problematic, and all the bogus religious history derives from this one source. Nevertheless, he promises a universal key for an invented code, a key that allegedly throws light on a well-known artist. Indeed, Brown acknowledges the derivative nature of his borrowings with a grain of salt when he calls the villain of the plot Teabing, an obvious anagram of Baigent, and gives his male hero the first name of Plantard's painterly model. His personal contribution to the French saga was the decision to make Leonardo the key to the riddle. Plantard had based his personal mythology on Nicolas Poussin's *Bergers d'Arcadie*, another famous painting that fitted more precisely his French taste – it was supposed to indicate the place where the Templars had buried their vast treasures. Thus a relatively banal thriller, admittedly a page-turner, replete with clichés, stereotyped characters, absurd coincidences and mechanical reversals, could became almost overnight a universal bestseller.

One may wonder about the causes of such success. Is it just the fact of parading the archetype of all quests with the Grail? Is it the promise of an even wider and more fundamental revelation? Is it the way in which a conspiracy theory opposing two sects, the orthodox one (the Opus Dei and evil Church prelates) and the heretic (the Priory of Sion allied with the Templars) are made to reenact recent political battles between the ideology of the American Right opposed to abortion and the left-wing defenders of women's rights in a still combative post-Clintonian feminism? Probably all of this is to be taken into account at once and gets blended, fusing current myths about secret societies and their evil conspiracies, the marriage of Jesus and its numerous offspring, the Gnostic lore tucked away in early heresies,

occult things that were hidden since the beginning of the world, all of which contributed to the success of the novel.

To this farrago is added the playful dimension of a society game easy enough to master, its hermeneutics of suspicion gone wild, launching a frantic goose chase that transforms canonical art – art institutionalized and sanctified by today's main museums – into intellectual puzzles for us to solve. The hidden truth about the foundation of Christianity turns into a series of coded riddles, Fibonacci numbers in a scrambled order, society's puzzles ripped from a specific culture and turned into trivialized pursuits that can be leisurely cracked one after the other. The model of the narrative is that of an interactive videogame with puzzles, multiple choices, some guesswork leading to a misleading solution until the next test comes. If we succeed in all these trials and ordeals, can we prove that we, too, are made of a divine mettle? After all, who hasn't dreamed of descending directly from Jesus? Besides, as Auden once quipped, we need to believe in the virginity of Mary, the Mother of us all, because we are reluctant to imagine our parents having sex – such an idea forces us to plunge back a little uncomfortably to our criminal roots in the Oedipus complex. Thus, we may have less difficulty in imagining them as criminals themselves. This is why we love the idea that a cryptic code is hidden in Leonardo's religious paintings, and in the secular Mona Lisa. We gaze at them so as to verify whether they are accurate mirrors. And we are not surprised when they send back reflections of the artist as a criminal perpetrator.

chapter 2

Duchamp's fait-divers
Murder as a "ready-made"

By general admission, Marcel Duchamp's last work of art, the posthumously unveiled *Given 1° The Waterfall, 2° The Illuminating Gas*, which one can admire in the Philadelphia Museum of Art's invaluable and almost exhaustive Duchamp collection, contains a riddle, if it is not a riddle itself. One way of finding a key to the riddle may lie in a visual parallel between the first installation ever to be presented as a permanent work of art in a museum and a few tabloid photographs from Los Angeles showing a woman's body cut in two, the ghastly and sensational pictures of the Black Dahlia murder. The key would reside in the link between the two[1]. Let me begin with the most obvious picture. The Duchamp piece is well-known. After having admired the beautiful "Large Glass" that seems to float in the air in front of a wide window, the visitor has to proceed to a small room, so dark that many actually turn upon their heels, believing that there is nothing to see after a glimpse of what they take for a condemned entrance. They face a wide double door, hermetically closed, an old barn door framed in bricks. Only on further inspection does one realize that the door is part of the artwork, that one has to come closer and peer through two tiny pinholes that allow one to discern what is behind.

A friend of mine[2] who lived in Philadelphia in 1969 recalls with a nostalgic thrill the long line of watchers queuing up for the opening, eager to see what Duchamp had reserved for them. He reminisced with a shiver how he politely let an older female cousin of his pass in front of him. As she was very tiny, he had to hold her up so that her eyes faced the keyholes. At first, he did not understand why she was wriggling so violently, desperately struggling to be free, then tore away angrily and left on her own, until he gazed at the scene and discovered what looked like a deliberately shocking sight. In a glaring light, contrasting all the more with the gloom of the antechamber, the gaping vulva of a naked woman was exposed frontally in the jagged opening th*rough the bricks. Her sex is devoid of any pubic hair but her face is almost entirely covered in a mass of blond hair. Her legs are slightly folded under her, one cannot see the right arm, the left hand holds steadily a little metal lamp in which gas seems to be burning eternally. The

realistic skin of the body with its legs open for the world to see also exposes one naked breast. The rendering of the vulva, however, is not hyperrealistic, since one does not see labia of any kind. The contrast between the twinkling light and the vivid glow of what looks like a summer afternoon is striking. In the background, an artificial waterfall keeps flowing thanks to a mechanical revolving device, and one can make out wooden hills, a little lake, and some clouds. The total immobility of the woman's body contrasts starkly with the regular movements of the water and the flame. It looks as if Courbet's notorious *The Origin of the world* displaying a woman's legs and genitals had been reframed in a hallucinatory Victorian diorama while adding a macabre touch. Is this the scene of a crime? But everything there is real, hyper-realistic even, and also totally unreal. What was Duchamp's point?

Since the piece is made up of two elements, the flat barn door and the three-dimensional diorama, it stages its own rapport to the viewer's gaze and perspective. Duchamp forces spectators to come to terms with a calculated sense of voyeurism: in fact, we all become peeping toms whose gazes inevitably fall first onto the woman's half-open vulva and shaven pubis. Is this a way of suggesting that there lies the secret of the "Bride laid bare by her bachelors, even"? Has the bride's elusive auto-eroticism been reinterpreted in a new "light", a light provided here by the gas, and perhaps any electricity that might be produced by the famous waterfall? The exhibitionism displayed here often triggers uneasiness if not downright rejection, not so much because of the sexual explicitness of the "show" (we have grown to be accustomed to more daring and explicit spectacles) but because of the forced naturalism of the *trompe-l'oeil* effects, the visual excess that points to its artificial status. The bricks and twigs are surprisingly real, one can see that the backdrop is simply a colour photograph with hand-painted additions. Today the pigskin used for the body itself shows cracks and signs of aging. One only guesses at the effect of a little electric engine that forces a light to rotate, thus creating the illusion, of a steadily flowing waterfall.

We now know that Duchamp chose his mixed media and found objects with great care, putting together a photograph from Switzerland and a door discovered in a Catalan village next to Cadaques, then shipped back to New York where it was hidden for a few years in the studio (Duchamp was extremely secretive about this project, going to the point of dividing his studio into two rooms so that unexpected visitors would never surprise him while he was working on it) before being assembled in Philadelphia according to strict instructions accompanied by photographs, diagrams and numbered montage procedures in a booklet carefully designed by the artist,

who left no room for improvisation.[3] To be sure, the absolute secrecy of the work's preparation aimed at creating an event that would be posthumous in nature: a visual testament based upon the distance between two alle-gories, the definitively unfinished large glass founded upon a male/female dichotomy and the single female body left to our contemplation. The obvious allegorization is reinforced by the gesture of the woman whose lifted hand with a gas-lamp calls up the Statue of Liberty, that famous token of a Franco-American exchange that, by extension, involved Marcel Duchamp himself. In this case, however, these are not tidings of freedom that are conveyed by Woman; rather, a faintly menacing pun, a still life calling up French idioms like the old oxymoron coupling *"nature morte"* (still life) and *"tableau vivant"* (waxworks representing famous people); this will inevitably echo with other works by Duchamp such as *Sculpture Morte* (1959) and *Torture Morte* (1959), two contemporary pieces. In all these works, death returns to inhabit Arcadia. Here, it is a shaven vulva that speaks, an "indis-creet jewel" (to quote Diderot) that silently voices the classical motto: "Et in Arcadia ego!"

The vision of the sex is compensated by the invisibility of the face. Noted Duchamp scholar and curator Jean Clair writes in *Medusa*: "The face of the young woman is not visible, as if she had been decapitated. The body, made of pigskin stretched upon a plastic mold, is endowed with an astonishing mimetic power. Fascinated, the gaze of the spectator lingers on the vision of a rather lugubrious game."[4] The absence of hair below is compensated by the excess of hair covering the face. We know how often Duchamp would play with hair and moustaches, not only by shaving his own hair figure a startling starfish shape (as seen in a famous photograph taken by Man Ray), but also by releasing his delightfully impertinent *L. H. O. O. Q.* in which Mona Lisa is given a moustache and goatee. And, of course, when he later reprinted the "original copy" of Mona Lisa, it would be just a "shaven" version! With *Etant donnés*, our startled gaze upon the shockingly-shaved sex has to paid by the body's deliberate decapitation, as Clair puts it: *Aut vultus, aut vulva*. Clair meditates on the function of the gaze in modern art, a gaze that mortifies nature in so far as nature may be said to contain femi-ninity. Is the finality of this posthumous installation to negate death, or rather to stage it in such a way that we accommodate it in our lives?

Anne D'Harnoncourt, the director of the Philadelphia Museum of Art, Octavio Paz, Joseph Mashek, Dalia Judovitz and many other critics have described the way in which this installation seems to have been calculated by Duchamp both as a summary and a negation of the rest of the works gathered and enshrined in the adjacent rooms. This time, it looks as if the category of the retinal had triumphed over the purely conceptual, and as if

the interplay between the viewer's perspective and the shocking content was what mattered most. But what is really presented or represented in such a naturalist fashion? What if the naked body of the woman who holds a lamp was just what it appears to be on first inspection – a dead body? The first visitors who discovered the installation in June 1969 had all the same impression: it looked like a woman's corpse. The front page of the *Philadelphia Inquirer* of July 8[t], 1969, titled its review of Duchamp's instal-lation: "Resembles Cadaver." The journalist interviewed visitors who were all equally in shock: "'It's awful looking, said Philadelphian Gini Stephens. That's the best way for me to explain it. I liked his (Duchamp's) early period. But then he gets worse and worse.'" Another witness, Miss Stephens' companion, a German visitor, Philipp Frings, felt that the reclining nude "looked like a cadaver on which they would perform autopsies in a medical school." This impression was confirmed by a city resident named Arthur Zbinded who thought that the piece "bordered on pornography".[5] The newspapers wanted to start a "public debate" on the question: "Is it art?" and gives a subtitle to the last part of the review: "Last Duchamp Work Is A Real Peepshow." The thesis that *Etant donnés* exploited or denounced the sensationalism of tabloids by criticizing the popular "pornography" of crime scenes, was defended more or less persuasively by several critics. The first was Arturo Schwarz, who had to incorporate the analysis of the late installation to his edition of Duchamp's *Collected Works* in 1969, and who alluded to a tortured Virgin trapped in a Nurenberg coffin. Dalia Judovitz, in an important article from 1987, "Rendez-vous with Marcel Duchamp: *Given*",[6] reprinted in *Unpacking Duchamp*, compares the woman with a corpse and suggests that Duchamp had taken his inspiration from a Magritte painting, *L'Assassin menacé*, dating from 1926.

When, in 1947 Duchamp revisited his own archive, he was not only cele-brating his love-affair with the beautiful Brazilian artist Maria Martins, but also starting in a new direction. It was early in that year that Duchamp began working on a series of sketches for "Etant donnés." The first drawing, a preparatory sketch, shows the body of a naked woman's torso without a head and right arm, and whose left arm is only half-outlined. "*Etant Donnés: Maria, la chute d'eau et le gaz*" is dated December 1947 and was owned by Maria Martins.[7] Maria also owned a wax model that prefigures the final project completed by the end of 1947. It is thus tempting to connect Duchamp's project with the time of the Black Dahlia scandal, even if he is grafting on it his own erotic passion for the Maria Martins. Had Duchamp been struck by the sensationalist pictures "given" on the front pages in the press as visual ready-mades? If he was to appear as a character in one of James Ellroy's novels, the issue would be to decide which: *Black Dahlia* or *My Dark*

Places. At the date of the Elizabeth Short's murder, that is January 15, 1947, Duchamp was sailing back to New York (he left on January 13th and arrived on January 22nd). Meanwhile an old friend of his, Man Ray, was living in Hollywood, and he was also a regular guest at the house of one of the prime suspects, as we will see. At the time of Geneva Ellroy's murder (June, 22, 1958), Duchamp was traveling between Paris and Normandy as he was taking his wife Teeny to a tour of the places of his childhood – but Steve Hodel, upon whose investigations I will draw extensively, has a solution for that murder's riddle as well.[8]

Duchamp's fascination for women's bodies in strange contexts was recurrent, as exemplified by the scandal caused with the window he designed for André Breton when the latter was launching *Arcane 17* at the New York Gotham Book Mart in 1945. Duchamp exhibited a female dummy dressed with an apron, a water tap jutting from her right thigh. At that time, Duchamp was aware of the peculiar qualities of Southern Californian culture, as he would visit his old friends from New York, Walter and Louise Arensberg, who had settled in Hollywood and were trying to donate their Duchamp collection to the UCLA museum. The fifty or so pieces that are now in Philadelphia were meant to be the centrepiece of a new modern art museum. *Newsweek* magazine's headline declared: "Arensberg Wills the Nude"! Because the scandal caused in 1913 by the controversial painting had not been forgotten, the donation was canceled in October 1947. Duchamp had come to California for the first time in 1936. He went again to Los Angeles when he participated in a legendary symposium – "the Western Round Table on Modern Art – and disagreed about everything with Frank Lloyd Wright. The LA *Daily News* announced another visit in April 1949, which gave Duchamp the opportunity of catching up with old friends such as Dalí, Max Ernst, Beatrice Wood and Man Ray. Duchamp flew once more to LA in April 1950 to visit the Arensbergs for the last time. Meanwhile the Philadelphia museum acquired the collection in 1950. Both Arensbergs died in 1953.

The unsolved murder of Jean Ellroy, who had been strangled with her own stockings (she was 42 and was found in a run-down LA suburb on June 22, 1958) attracted much less attention than Short's, but Steve Hodel, who has successfully solved the mystery of Black Dahlia's death, links this murder with one of the accomplices of the first murder, Fred Sexton[9]. One year later, Duchamp exhibited the disquieting *Torture-Morte* ("Dead Torture") that I have already mentioned; it looks as if a foot-sole had been burnt with cigarettes, with flies glued to it. When the Duchamp retrospective was organized by the Pasadena Art Museum in November 1963, Duchamp chose to modify an old 1923 poster showing his own face

with the caption: "WANTED, $2,000 Reward!" If the artist is a criminal, he sure knows how to denounce himself so as to get the reward before anyone else.

I would like to suggest as a source for *Étant Donnés*, the macabre photographs published in January 1947 and after throughout the United States, which seemed to top all the photographed horrors of the Second World War. They documented the discovery of a woman's body in Los Angeles and started the controversy about what was soon called the case of Black Dahlia's murder. The most precise description is given by James Ellroy in the eponymous novel devoted to the spectacular murder. At 7:30 a.m., a little girl who was being walked to school in SouthEast Los Angeles discovered a sight that seemed to come from a horror movie. At the intersection of South Norton Avenue and 39th Street, she saw lying in a field the parts of a young woman whose body had been cut in two. The body has been "posed" to look even more arresting. She had been drained of her blood, washed thoroughly and a hysterectomy had been performed, perhaps as a conscious homage to Jack the Ripper. Ellroy masterfully evokes the terrifying vision in *The Black Dahlia*:

> It was the nude, mutilated body of a young woman, cut in half at the waist. The bottom half lay in the weeds a few feet away from the top, legs wide open. A large triangle had been gouged out from the left thigh, and there was a long wide cut running from the bisection point down to the top of the pubic hair. The flaps of skin beside the gash were pulled back; there were no organs inside. The top half was worse: the breasts were dotted with cigarette burns, the right one hanging loose, attached to the torso only by shreds of skin; the left one slashed around the nipple. The cuts went all the way down to the bone, but the worst of the worst was the girl's face. It was one huge purpled bruise, the nose crushed deep into the facial cavity, the mouth cut ear to ear into a smile that leered up at you, somehow mocking the rest of the brutality inflicted. I knew I would carry that smile with me to my grave.[10]

The victim was Elizabeth Short, a beautiful 22-year old woman who had tried to become a movie star, had failed and then lived off the help of various suitors. She would dye her brown hair black, thus earning her nickname of "Black Dahlia". The sadistic torturer, or torturers, who had played with her for two or three days had perhaps dyed her hair with henna. Short's grisly demise became a notorious unsolved case for the LAPD. And although a number of men accused themselves spontaneously of the deed, no one was convicted.

Among the macabre details that may provide a clue, Ellroy mentions the

change of hair colour, noting that, "Her jet-black hair was free of matted blood, like the killer had given her a shampoo before he dumped her." (BD, p. 79). Short, as we know, was in the habit of dying her hair black with henna, whereas her real hair colour was reddish. The riddle of such a savage murder haunted the young Ellroy, echoing how his own mother had been murdered in similarly unexplained circumstances when he was just ten. When Ellroy comments on his mother's unsolved murder in his autobiography, *My Dark Places*, he always calls her "the Redhead". One year after his mother's murder, when he was eleven, his father gave him as a thoughtful present a copy of *The Badge*, a collection of murder stories followed by realistic police investigations. He was soon engrossed in the Black Dahlia case which he read "a hundred times": Betty Short became his obsession.[11] He explains his morbid and erotic fascination for Black Dahlia by the guilt he felt for not having been more distraught when his mother had been killed. His inability to mourn her had led him to superpose the *real* redhead, his mother, with the disfigured victim, Elizabeth Short. "Betty and my mother were body-dump victims. . . . My daytime tales of death by saw and scalpel gave me terrible nightmares. They were devoid of narrative lines – all I saw was Betty being cut, slashed, poked, probed and dissected."[12]

Hodel's Solution to the Riddle

Steve Hodel pays homage to Ellroy's novel in the memoir he has written – a memoir that shows with undeniable evidence that the main killer was his own father, the "genius" George Hodel. When he published in 2003 *Black Dahlia Avenger* it looked likely that he had finally solved the riddle, had provided *"The True Story"*. This story is first of all a character study, that of his own father, a remarkable man by all accounts. George Hodel was born in 1907 in Los Angeles. His father had come from Ukraine and fled to Paris where he met his wife, Esther Leov, a Russian dentist. They then married and emigrated to the United States. The French-speaking family went on to enjoy a prosperous life in America. Their son George Hodel was a young prodigy with an IQ of 186 (one point above Einstein), and he was sent to Paris when he was just five to be schooled at the Montessori school. After two years in Paris, he returned to LA and became a musical virtuoso who played his own musical compositions in public. He was even befriended by Rachmaninoff, who attended a concert given by the young boy when he was nine. From early on, therefore, he was treated as a special child, and all of his whims were attended to. He graduated from high school at the age of 14, and at 15 he became a student at the California Institute of Technology,

in 1923. However, he was expelled soon from school because of a sexual scandal. This fact is only revealed by Steve Hodel at the end of his book, and stands out as a primal trauma. George had an affair with a much older married woman who became pregnant, divorced and fled East. George discovered where she was hiding and followed her with the idea of marrying her, only to be rejected because of his age. He was never allowed to see her again, nor "Folly", the daughter he had fathered.[13] Back in LA, he was proud to have been selected in a group of highly gifted children, who were regularly tested for their scholarly performances. Having dropped out of school, in 1924, when only 16, George worked as a crime reporter and discovered the teeming underworld generated by Prohibition laws. In parallel, he launched a literary magazine named *Fantasia* in which he revealed a morbid, decadent and *fin-de-siècle* sensibility. When the venture folded in 1925, he became a night-time cab driver in order to see the world, while writing stories for the newspapers, taking professional photographs, working in advertising, and using his fine voice as a radio announcer – all this before he was twenty. Around that time, he befriended John Huston, the actor and film director, and had a son with a woman named Dorothy, who also dated Huston. Finally, he found his true vocation – medical school. In 1932, he graduated from Berkeley pre-med school, while having a daughter with another Dorothy, Dorothy Anthony. This daughter, Tamar, would play a crucial role in his life. He graduated in 1936, specializing first as a surgeon and he took a variety of medical posts, one in an Indian reservation in New Mexico, several others in California.

In 1938, Hodel returned to LA to specialize in venereal diseases, becoming the head of the County Health Department and control officer in 1939. He opened his own clinic at the same time and his business was thriving. He caught up with Dorothy Anthony, who had just divorced John Huston. Hodel had three sons with her, including the author of the book, Steve Hodel. They married (although rumors persisted that the first of these sons was actually Huston's). Because of a recurrent heart condition, Hodel failed to enlist during the Second World War and remained in LA. After four years of marriage, Goerge and Dorothy divorced and the mother of three started drinking heavily. Just after the war, George bought an architectural wonder, a mansion built by Frank Lloyd Wright's son called Sowden House, which was a replica of a Maya temple and an urban fortress with secret passages and rooms ensuring total privacy. Soon after, he asked to be sent to China as an officer of the United Nations Relief and Rehabilitation Administration. His wish was granted in 1946. He had the rank of three-star general there and worked with Communists and Nationalists, saving many lives, but had to resign unexpectedly, probably

because of a sudden heart attack. In 1946, back in LA, he befriended Man Ray, who took many photographs of him, often dressed as an officer. He used the officer persona when seducing women after the war. His extraordinary mansion was soon filled with all sorts of Asian artworks bought when he was in China. Upon his return, George entertained a lavish lifestyle, organizing regular sexual parties during which drugs and alcohol were freely distributed. He had also invited his ex-wife to stay in the house with their three sons, and she often participated in these orgies. In fact, Sowden House had been turned into a recreation of Château Silling, Sade's utopia of a self-contained world where entire licence was given to a group of libertines. George was virtually untouchable as he kept files about the venereal diseases (ergo, the private lives) of the most important local actors, politicians, businessmen and, of course, policemen of the LAPD.

When Elizabeth Short was murdered in 1947, George Hodel was one of the prime suspects, but this was based on evidence (probably a photograph he sent her from China) that was later destroyed. One detective who had found incriminating material was dismissed from the case. Nevertheless, scandal caught up with him in October 1949 because of young Tamar, who had come back to live with her father and three half-brothers. She was barely fourteen but already promiscuous and looking like a younger version of Marylin Monroe. One day, she ran away and was caught by the police, whereupon she denounced her father and his friends, described orgies in which she made love to her father, disclosed that she had just had an abortion as a consequence, spoke of the nude photographs of her taken by Man Ray, of the frequent consumption of cocaine, and of the wild, drunken and often violent orgies regularly organized by her father for his friends. What was more, she accused her father of being Black Dahlia's murderer, as well as having killed at least another young woman. Despite his connections, George Hodel could not avoid a trial. When he was arrested he began confessing that the situation seemed to him like a hypnotic dream. Finally, to the surprise of the DA, whose team believed that they had gathered enough evidence to get him executed, he was acquitted by the jury. Helped by the best lawyers in LA (he had to sell all his Chinese antiquities to pay their fees) he discredited his daughter's evidence and made her pass as a pathological liar. The very enormity of what she was disclosing was obviously too much for a jury to believe; they preferred to settle for a more conventional truth. Hodel was freed in February 1950. Immediately after his release he sold the mansion and left for Hawaii. The sons lived with their mother, surviving in dire poverty while she would regularly binge on alcohol.

George Hodel then seemed to start several lives in succession. In Hawaii,

he changed his medical specialty and became a psychiatrist. He then moved to the Philippines with a new wife, Hortensia, whom he had met in LA. He had four children with Hortensia, who came from a rich family, and they lived in luxury, but separately. He founded a big market research company in Manila and was more often seen with Diana, a beautiful young Chinese secretary. Steve visited him there as he himself was stationed in the Philippines while serving in the US Army. When he was discharged, Steve returned to LA and it was through the Hollywood connections of his mother that he met his first wife, Kiyo. Kiyo was a very seductive and domineering Eurasian. She had been a singer, a dancer, an actress and made a living by teaching astrology and drawing charts for film stars; she pretended to be 30, but Steve later discovered that she was 45. They quickly married, and she insisted that he should keep their union a secret from everybody, which he did. She also urged him to become a police officer in the LAPD, in spite of the mysterious reluctance of several older officers to his enlistment. Then the moment of revenge arrived. Steve's father was visiting from Manila with Diana, and the four of them were to have dinner, as Steve wanted to introduce his wife to his father; when they met, he turned ghostly pale and cancelled the dinner under an improvised pretext. Steve realized that Kiyo had known his father at a time when she was going to be rounded up as Japanese suspect during Internment. Hodel had saved her by inviting her to live in his house during the war. She became his lover, participated in the orgies for a while and then fled. It seems (this is not what the author writes but can be easily deduced) that she was secretly hoping that Steve Hodel would discover the truth about his father and indict him – which happened, but only after his death. It took the revengeful calculations of this woman, who believed in horoscopes, to mastermind a whole Oedipian plot.

Having been told the shocking truth about Kiyo, Steve went home early one afternoon only to discover her having sex with an actor. He divorced her and never heard of her again. Meanwhile, he made progress in the police department and became a top detective, while keeping up with his father, who had by then created a sort of financial empire in Asia. He had again remarried, this time with a much younger Japanese woman, June. They lived royally in Manila, Tokyo, and Hong Kong and had offices throughout Asia. In 1991, George Hodel finally returned to the US after 40 years. A mellowed man, he settled in San Francisco, where he died in May 1991. He had no personal friends except his many children and his widow. Even though he had instructed June to destroy all his personal belongings and requested his ashes to be thrown out to the sea, she still let Steve take possession of some precious objects.

Thus George's death gave Steve access to an album of family photo-

graphs, in which he saw, first, two photographs of Kiyo, and then two photographs showing the lovely face of a young woman with downcast eyes, caught in the house with the Chinese antiquities whom he recognized (because of his LAPD training) as Elisabeth Short. This proved that his father had known Black Dahlia, and that she belonged to the gallery of portraits of those he particularly loved. This triggered his private investigation, an investigation that took him three years, during which he read all the evidence, especially in the local newspapers, as many police files had been tampered with. He also interviewed surviving witnesses and family members like Tamar and examined other unsolved sexual murders of the times, which allowed him to find a pattern and reconstruct the awful truth. His father, accompanied by his old school friend Fred Sexton, had wantonly indulged in serial murders of women, some who were well-known actresses or well-dressed "teases" like Black Dahlia, others totally obscure prostitutes, between 1947 and 1949. Sexton continued on his own a murder spree that included Jean Ellroy. Hodel and Sexton would help one another with hide-outs and tips, send the police on the wrong track with carefully contrived messages, and above all exploit the numerous connections they both had with the underworld of gangsters and the networks of policeman and politicians whom they were blackmailing. Other photographs taken by his father and exhibited in the 1920s showed the faces of famous gangsters, including one well-known drug-lord who controlled the LAPD in the thirties and forties, Kent Kane Parrot. Steve Hodel, who had been told that he was named Steve in homage to James Joyce's hero, then realized that he owed his middle name, Kent, to this criminal.

From the portrait of George Hodel that emerges, one recognizes less a serial killer than a perverted esthete who wished to test an almost limitless power on his entourage – a psychic power that was enormous, as all those who approached him testify, but also reveals and underlying frustration that he could never become the artist he aspired to be. His prodigious intelligence and total recall of facts and numbers would come handy in his later career, but seemed to deprive him of any genuine creativity. My personal impression is that the real compulsive killer was Sexton, and that George Hodel fancied being accompanied by a devoted and murderous accomplice, perhaps enjoying the fact that his last name was a pun conflating "sex" and religious duties. So why did he kill Black Dahlia? From all the information gathered by Steve Hodel, his father had probably offered to marry her (he had again divorced by then) while she was reluctant to commit herself, especially when she understood what marriage meant in this case. In the frantic last days of her life, she looked terrified and on the run, barely escaping twice from two men and a woman, in whom one recognizes Sexton and an

accomplice, sent to prowl and bring her back to Hodel's house for his "revenge". A policeman to whom she ran in despair at one point only brought her back to the bar where she was finally picked up. The elaborate torture that lasted three days has many features in common with Sade's catalogue of tortures in his *One Hundred and Twenty Days of Sodom* – a book that Man Ray and George Hodel knew very well. Man Ray had photographed the manuscript (actually a large roll of hygienic paper used by Sade to pen his darkest thoughts) in the 1920s.[14] It is likely that Hodel and Man Ray met for the first time in New York in 1928,[15] but as soon as Man Ray settled in Hollywood in October 1940, aged 50, he made two crucial acquaintances: the first was Juliet Browner, then 28, who first became his model and soon after his lover and then wife; the second was the rich, glamorous, educated, and libertine George Hodel.

Man Ray obviously liked George Hodel. He took many photographs of him and his house, where he was a regular guest, in 1944, even before Hodel bought Wright's Mayan mansion. "From 1945 until the Fall of 1949, both Man Ray and Juliet were regular partygoers at the Franklin House, where dad's guests could relax and indulge themselves in cocktails, a courtesan, or plenty of cocaine."[16] In 1946 Man Ray gave a self-portrait as a gift to the Hodels, with a warm dedication that ends on "I celebrate you", a photograph which later was used as the cover for his 1963 autobiography, *Self Portrait*. Steve Hodel notes that Man Ray left for France quickly after the murder, that is in the Spring of 1947, then returned and stayed until the end of 1950. He left the US for good exactly at the same time as George Hodel and there is no doubt that the sexual scandal was one determining factor. Man Ray was more directly implicated in the Tamar scandal than in the previous murders, since Tamar had named him as the photographer who had taken compromising pictures of her naked and having sex with young men – photographs that were later discovered in a hiding place and then curiously "lost". Sexton's own daughter told Steve Hodel that Man Ray had managed to get his doctor to write a letter stating that he was impotent and therefore could not be charged for direct sexual involvement with a minor![17] Man Ray, who "had a lot of clout" (as the daughter said), barely avoided being arrested along with Hodel's friends and accomplices.

The more damaging details put together by Steve Hodel concern the particular way in which Black Dahlia's body was left "posed" on the ground. He compares the position of the arms, slightly lifted, with Man Ray's famous "Minotaur" photograph (1936), in which one sees the top part of a naked and decapitated woman's body whose extended arms call up a bull's horns. Indeed, the excised breasts in Short's body look very much like the deep shadows left on the woman's truncated torso.[18] The hideous smile of

Black Dahlia, the lips having been enlarged in a grin extending from ear to ear, also evokes Man Ray's famous 1932–1934 painting, entitled either *A L'Heure de l'observatoire – Les Amoureux*, or *The Lovers, or The Lips*, a painting that he worked on after Lee Miller had left him – all the accounts of Man Ray's life testify to his utter depression and suicidal thoughts at the time, including his roaming around in Paris with a loaded gun looking to kill Miller.[19] Happily, Man Ray managed to sublimate his rage. A first work of art was the famous *Object of Destruction*, in which one sees Miller's eye attached to a metronome, with the indication that one should smash the thing with a hammer – it was later actually destroyed in an exhibition. George Hodel lacked the artistic impulse to sublimate and he reveled in the sensation of power provided by actually getting his revenge in the flesh. As Freud wrote about doctors and surgeons in particular, their early sadism needs to find the proper type of channel. At least a similar welter of passion is at work behind *A L'Heure de l'observatoire – Les Amoureux*, a painting that Man Ray kept for a very long time in his private collection, and the sadistic work of art compose by Short's mutilated body.

It is also quite likely that Hodel had read accounts of Jack the Ripper's stories. He not only cut out the uterus from the victim's body but he played with the police in a similarly taunting way, sending messages composed with letters cut out from the papers. In his book, Steve Hodel insists on his father's lasting veneration for the Marquis de Sade's writings. The elaborate torture sessions to which Short was submitted were literally Sadian, re-enacted applications of the last sections of *One Hundred and Twenty days of Sodom*: her pubic hairs were cut and tucked into her sex, as were small bits of flesh cut from her breasts and belly, she was forced to eat excrement, her own and that of her torturers, her mouth was cut to display a wide grin, and she was finally beaten all over her body so as to stamp out any trace of her former beauty. It was therefore a crime of outrage, followed by an act of esthetic transformation and recreation. By bisecting the body, unsexing it, posing it as a Minotaur deprived of a uterus, the mad surgeon was trying to hurt Nature, a Nature he found all the more unbearable as it had given birth to beauty effortlessly. Thus the last art piece made by Man Ray which keeps some connection with this torture is his homage to Lautréamont: a 1929 photograph called *The Riddle, or the Enigma of Isidore Ducasse*, in which one discerns either a body wrapped in burlap and tied with a rope, or the famous meeting of an umbrella, a sewing machine and a dissecting table.[20] Since the dissecting table was available to Doctor Hodel, he used it to transform the beauty of a young woman who had made the mistake of refusing him into his own funerary art piece.

Sade never forgot his point of departure, rage and conflict with a mother

Nature whose most fundamental law, as he tried to argue and demonstrate, is murder – since murder condenses in one word the endless clash between the weak and the strong. Thus, quite often, the object of the transgressive crimes is parenthood, in sofar as it would be "natural". Roland Barthes often quoted Sade's sentence which for him expressed the core of the Sadian fantasy and endowed it with a specific grammar: "To bring together incest, adultery, sodomy, and sacrilege, he buggers his married daughter with a host."[21] Indeed, Sade aims at subverting the foundational notion of the family as the site of an older morality prior to human laws, as one can see in *Antigone*. As Adorno and Horkheimer have shown in *The Dialectic of Enlightenment*,[22] a book jointly written in California by the two exiles, whose neighbour was in fact George Hodel, Kant's "pure reason" creates its exact opposite and counterpart – the calculating rationality of power organizing a totalitarian order. The systematic mechanization of transgressive pleasures in Sade's perverse utopias is the reverse of the autonomy and self-determination of the moral subject. After Kant, the philosophy of Enlightenment meets global capitalism with a vengeance: human concerns are ruled out, what matters is the conformity of Reason with its own laws. All "human" emotions and affects are pushed further away from an independent and powerful Reason. Sade's Juliette is more logical than Kant when she draws the conclusions that Kant denies: the bourgeois order of society justifies crime, provided crime be regulated by a rationality that controls all activities and pleasures.

Sade militates for the supremacy of the truly libidinal individual but this thesis is founded upon a paradox. As Maurice Blanchot puts it, "He is the man of all passions, and he is without feeling. First he destroyed himself as man, then as God, and then as nature, thus did he become the Unique being. Now he is all-powerful, for the negation in him has vanquished everything. To describe his formation Sade resorts to an extremely curious concept to which he gives the classical name: *apathy*.[23] I will soon develop the Stirnerian connotation of this apt formulation. Sadean "apathy" functions like an equivalent of Kant's disinterestedness, as both are underpinned by the brutal efficiency of the bourgeois conquest of the world. George Hodel's successful career as a "robber baron" in Asia would be typical of this evolution. The right to enjoyment, even by inflicting pain to chosen victims, entails a systematic extension of its field; it becomes my "right" to request the bodies of others of those I want to torture and kill. The counterpart of this excessive rationality is the mechanization of perverse pleasures evinced by the Sadian orgy. Its aim is to reduce sex to a perfectly oiled mechanism in which everyone has a part to play since nobody can be left idle.[24] Marcel Duchamp's "bachelor machines" metaphorize the social production of

desire. From Sade's orgies to the *Bride laid bare by her bachelors, even*, a single continuum limns an ideology of erotico-technological relationships and posits as a utopian good the new *perpetuum mobile* of desire. From the Sadian orgy organized as a montage chain in an automated plant to the eternal masturbators of the nine "malic moulds" gazing at the vaporous bride beckoning from above in Duchamp's Glass, the machine materializes a certain type of mechanical reproductibility.

In his seminar on Anxiety, Jacques Lacan quotes as emblematic Sade's enthusiastic evocation of the acme reached by a Libertine. In the novel *Juliette*, he tortures a woman until he roars: "I had her by the skin of the cunt!"[25] This climactic ejaculation expresses the fantasy of a total evisceration, similar to the atrocious hysterectomy performed on Elizabeth Short. The torturer wants to imagine himself as close as possible to the *jouissance* of God, but of a perverse God who is unsurpassable in evil. This is the absolute rival whom the Sadian Libertine tries to emulate through the medium of these exhausting rounds of tortures and orgies. Infantile rage facing a mother's body that must be penetrated violently should then be turned into the bland serenity of pseudo-rationality soaring above weak human feelings like pity and sympathy. The ultimate aim of the Sadian subject is therefore ataraxy, a "rest" combining a courtly ideal of impassability in the most extreme enjoyments and a post-Kantian autonomy by which a depraved Reason regulates itself. There is an endless quest involving countless new victims who are all interchangeable. As Beckett asks in *Watt*, the central question would be: "But what was this pursuit of meaning in this indifference to meaning?"[26]

The Philosophical Roots of Marcel Duchamp's (In)difference

If Man Ray was involved in the Sadian orgies and scandals surrounding George Hodel, it is not impossible that he would have confided in his oldest friend, Marcel Duchamp. By the time of the Black Dahlia case in the late forties, they would often broach the issue of death in their conversations and correspondence. After Duchamp had hurried back to Paris to see Mary Reynolds die of cancer in December 1950, he wrote in a letter to Man Ray from the ship bound for New York: "Nothing like [the] death of *one single person t*o bring home to you the senselessness of all the rest of the bloody human race."[27] They almost certainly discussed the scandal, the suspicion of murder and similar "hot" scenes that Man Ray had known during his stay in Hollywood, when they were reunited on board the *De Grasse*, as Man Ray

was returning to France for good with Juliet in March 1951. Man Ray knew that he was leaving the Hollywood scene behind; it was on that day that Duchamp gave Man Ray his cast of female genitals, *Feuille de vigne femmelle*, a cast made from the headless nude torso fashioned by Duchamp in 1947, just at the time of Short's murder.[28] He thus gave Man Ray an idea of the work in progress that became the posthumous *Etant donnés*. Man Ray could not ignore the fact that he had been taken as an artistic model by George Hodel, whose criminal actions had duplicated or incarnated his own works of art. Man Ray had always tried to imitate Duchamp, which gives a curious series linking George Hodel to Man Ray and to Duchamp. If George Hodel was the criminal, while Man Ray was his esthetic source of inspiration, then the artistic sadism of the avant-garde had found a lurid and all too Hollwyoodian application. Better take refuge in the old world of Paris!

After these historical "facts", it may be necessary to return to the philosophical background shared by Man Ray and Duchamp. We know more about Duchamp's formation – Man Ray seemed to absorb everything very quickly, but often as second hand knowledge. Like Picasso, who was influeced early enough by Catalan anarchism, Duchamp's early years were steeped in the widespread anarchist culture of the Montmartre bohemians, still dominant at the beginning of the twentieth century. I will rapidly sketch the philosophical traditions indicated by Duchamp himself, philosophical anarchism on the one hand and early skepticism on the other, two schools whose crisscrossing lends a particular style to Duchamp's thinking, and whose impact on Man Ray was undeniable. Duchamp quoted just two names when he wished to describe his philosophical position, whereas we know much more about the importance of Mallarmé or Raymond Roussel for him. There were only two philosophers whom he read with passion in 1913 when he was an assistant librarian at the Bibliothèque Sainte Geneviève: Pyrrho and Max Stirner.

Pyrrho is today known as the founder of skepticism, but in the era Duchamp read him, he was totally obscure, academically overshadowed by Sextus Empiricus, who quotes and distorts him systematically. He enjoyed a revival in French academic circles in the twenties, when Léon Robin gave philosophical dignity to his work, going as far as to call him the unknown "hero" of philosophy.[29] It is quite likely that Duchamp read Victor Brochard's *Les Sceptiques grecs*, published in Paris in 1887, and perhaps Waddington's *Pyrrhon et le Pyrrhonisme*, which had been translated into French in 1877. What we know of Pyrrho (roughly 365–275 BC) is limited, but there is one detail that may have triggered Duchamp's interest: Pyrrho is the only classical philosopher known to have begun his career as a painter. Born into a poor family in the city of Elis, he started as a poet

and a painter (one painting at least has been described in Elis – it represented a procession or "theory" of torch-bearers). Some 20 years younger than Aristotle, Pyrrho became a disciple of Anaxarchus and then followed Alexander during his conquest of Asia, thus witnessing the creation of a new political world based on new values. Alexander himself, earlier taught by Aristotle, was under the influence of Anaxarchus during his conquests, and in keeping with the type of magnificent gesture he was known for, gave Pyrrho 10,000 gold coins the first time he met him, after Pyrrho had recited a poem celebrating his glory.

Having visited India and debated with its wise men, Pyrrho returned to his native city in Peloponesus, where he founded a very successful philosophical school. He reached the estimable age of 70. He had been easily impressed in his young age, but he later mastered the art of impassability; if a prospective disciple came to see him and was unconvinced by his explanations and turned away, Pyrrho would continue his speech imperturbably after the other had left. He would often leave and travel without warning his close friends or disciples, and would be seen in strange places talking to himself. He was nevertheless highly appreciated by his fellow citizens, since he was asked to become a high priest in Elis, where his statue could be found a century later.

Pyrrho preached and practiced "indifference", a term that calls up "humility" and "neutrality". He elected to pay no attention to the world around him, and would refuse, for instance, to go out of his way to avoid a dangerous dog or a precipice. This became a sort of well-rehearsed joke in his school: somebody would pretend to be about to fall into a hole, just to be saved by the others at the last minute. Conversely, Pyrrho would never attempt to influence any one around him, leaving others free to do what they wanted. The keyword in his teaching was "ataraxia", which is not so original, except that it leads from practical wisdom to considerations of an epistemology that may be summed up in the phrase: "No more this than that." A favorite example of this was provided by the little pigs he pointed out to his disciples when they were once on a ship during a violent storm: the pigs continued eating without being afraid or bothered, and according to Pyrrho they were right. Indifference, both as being "adiaphoros" and "astorgos" (without affect) leads to a radical "apathy" which also involves some form of "aphasia". Aphasia does not designate a speech defect, but a state of "non-assertion" that leads to a final annulment of differences: "Pyrrho said there was no difference between being alive and being dead," a rather paradoxical idea to which I will return.

The basis of Pyrrho's teachings was that the nature of things was "in-different" (*a-diaphora*), "im-ponderable" (*a-stathmèta*) and undecidable (*an-*

epicrita). One cannot judge, therefore one cannot assert or negate anything, and the best is to let oneself drift in the unceasing flux of things. This quietist doubt aims at divesting man of any certainty. The suspension of doubt denudes man, divests him of all the false trappings of the world. This is the main rule to follow if one wants to live happily in the world. This attitude is complex, and found at least with Montaigne an adequate literary expression. Philosophically, one may say with Marcel Conche that Pyrrho is the first philosopher who stressed the ontological dignity of appearance. In *Pyrrhon ou l'Apparence*,[30] Conche shows how Sextus Empiricus had distorted Pyrrho's teachings; whereas Sextus points to the misleading character of mere appearances, in order to assert a deeper reality, Pyrrho radically abolished any distinction between Being and Appearing – a distinction that had underpinned all philosophies so far (with the possible exception of Heraclitus). On Conche's account, Pyrrho's notion of appearance is not appearance *of* (a being) or appearance *for* (a subject), but an absolute appearing: "But, one will say, in order to appear, one needs to 'be'. Surely, but what does 'to be' mean? And if 'being' only meant 'appearing' and nothing more? If everything only shimmers for a moment, what can we say? That nothing *is*, for there is, all in all, only a present that collapses without leaving anything, just traces which, one day, inexorably, will also be erased."[31]

A lot has been written on Duchamp's studied or natural indifference, on a curious listlessness that seemed at times to border on the pathological. I would like to add just a few remarks on the links between the ready-mades and this pervasive principle of indifference. Against all those who would try to see esthetic values in his ready-mades, pointing out for instance how the famous urinal could be seen as a perfect oval suggesting the stylization of male and female shapes, Duchamp would always assert that these objects had not been chosen for their esthetic qualities but had to be seen as "indifferent", extolling precisely the "liberty of indifference" that abolishes boundaries between art and life. The only ready-made that seems to escape from this lack of esthetic qualities is the first object transformed by Duchamp, the bicycle wheel. Talking about it, he would say that the object had a beautiful simplicity and was in fact pleasant to see, relaxing even, once it had been fixed on to a stool. This is Tomkins's view, and this is why he sees a contradiction in Duchamp's attitude. My perception is different; if we accept that the Ur-ready made (the word had not yet been invented) was a first-time application of Pyrrhonian principles – the wheel was made in 1913, the year Duchamp started reading Pyrrho – it becomes plausible that the soothing effect is less esthetic than a conceptual paradox linking kinetic to static properties. This is the paradox of a wheel that has

been "arrested", taken out of its usual function, used just to turn in the air but not on the ground. What is then seen is how the spokes graciously blend into a whirl and then pure nothingness, until speed decreases and they can be individualized again. Besides its being the quintessentially Jarryan object, the bicycle is reduced to an abstract principle, the wheel. In French, the phrase: *"Il n'a pas inventé la roue"* is commonly used to suggest that someone is not too bright. Let us note, however, that the Incas and Aztecs managed to build all their pyramids without having discovered the wheel. The wheel on a stool is thus the Pyrrhonian object par excellence: as a bachelor machine, it uses speed for and in itself, not so as to progress in the world but in order to create a sweet and gentle blur, suggesting a hypnotic state of annulment, a double abolition of the vehicle it both allegorizes and cancels.

Philosophy's time usually progresses cyclically, and in his attempt to master that field, Duchamp needed a second wheel. The second philosopher in whom Duchamp found an alter ego was Max Stirner. Stirner belongs to the very different context of the Berlin Left Hegelians, the group of "free men" associated with the *Rheinische Gazette*. Stirner was at first close to Friedrich Engels who admired him until Marx took over. Stirner's main theses were published for the first time in several articles written for the Gazette in 1842, especially in a text on "Art and Religion."[32] There, Stirner declares that religion is man's main enemy as soon as it plays the part of Romantic or "idealizing" art; religion makes "creatures" of us, thus compelling us to forget that we are fundamentally "creators" of forms and values. Stirner's life is even more obscure than Pyrrho's, while not being devoid of parallels with that of Duchamp. He, too, had poor origins, never relinquished his radical opinions and was hounded by poverty. Destitution was only briefly interrupted when he married his second wife (the first having died young), the flamboyant Marie Dähnhard, one of the most visible members of the Berlin *Freien*. She had a small fortune of 30,000 thalers which Stirner soon squandered. The story of their hilarious marriage (they had no ring; on the morning of the ceremony, everybody was drunk and playing cards; the bride arrived late) calls up the decision made by Duchamp in 1927 when he married a woman whom he described simply as a "very fat woman". I will return in the next section to the marriage that took place in June 1927, was filmed by Man Ray, and may have been motivated by Duchamp's belief that the bride was going to inherit a fortune.

Like Duchamp, Stirner was known for one pervasive concept, in his case "egoism", a term that was deployed at some length in his only book, *Der Einzige und sein Eigentum*, published in 1844 and later translated into

English as *The Ego and His Own*. One of the figures behind the London-based *Egoist* magazine, Benjamin Tucker had made Stirner his god; his motto of "Egoism in Philosophy, Anarchism in Politics, Iconoclasm in Art", sums up the general ideology of many American avant-gardists and would, of course, not have been denied by Duchamp. Egoism soon became the doctrine of the British writers and artists who were gathered by Dora Marsden in the *New Freewoman*, subsequently renamed *The Egoist*. Stirner enjoyed something of a revival in the first decades of the twentieth century, and was often seen as a rival to Nietzsche's influence. *The Ego and His Own* essentially reduces the system of Hegelian idealism down to a threadbare pattern which distinguishes two main periods, that of the "Ancients", or classical wisdom, and the modern age, identified with Christianity. As moderns we are haunted by Christian theology, a myth founded upon a doctrine of transcendent Love that attacks the egoism of those who are unwilling to sacrifice their personal interest to a cause.

Stirner presents the teachings of the "Romantics" in terms that will curiously reappear in the first lines of Marx's and Engels's *Manifesto of the Communist Party*: "Yes, the whole world is haunted! Only is haunted? Nay, it itself 'walks', it is uncanny through and through, it is the wandering seeming-body of a spirit, it is a spook. . . . to you the whole world is spiritualized, and has become an enigmatic ghost; therefore do not wonder if you likewise find in yourself nothing but a spook."[33] Facing what he sees as a spectral modernity, Stirner's point of resistance is the "Ego": transcendental egoism is posited as the absolute weapon against the domination of abstract ideas and causes. The Ego is the modern tool that corresponds to what ancient wisdom had tried to erect as a dam against the encroachments of the world: "The break with the world is completely carried through by the *Sceptics*. . . . According to Pyrrho's doctrine the world is neither good nor bad, neither beautiful not ugly, but these are predicates which I give it. . . . To face the world only *ataraxia* (unmovedness) and *aphasia* (speechlessness – or , in other words, isolated inwardness) are left. There is 'no longer any truth to be recognised in the world', things contradict themselves; thoughts about things are without distinction . . . "[34] However, Stirner does believe in truth, even if it as paradoxical as the world depicted by skepticism – and it is a truth founded on the Ego. His book elaborates on the fundamental principle that the Ego owns itself and should never be owned by anything exterior to itself, a theme repeated with various rhapsodical variations.

The key issue of love should pose a problem for such a staunchly programmatic egoism. Needless to say, Christianity is relentlessly denounced as an ethics of love as reciprocity and altruism. Love is,

however, a concern for Stirner, and often couched in terms that are curiously ambivalent, if not outrightly bisexual. "I love men too, not merely individuals, but every one. But I love them with the consciousness of egoism; I love them because love makes *me* happy. I love because loving is natural to me, because it pleases me. I know no 'commandment of love'".[35] Fair enough – but then this statement leads to: "I can kill them (other men), not torture them",[36] before launching into a disquisition on Eugène Sue's *Mysteries of Paris* and the wickedly sadistic Prince Rudolph. Stirner finds accents that evoke Lautréamont's *Chants de Maldoror*: "because I cannot bear the troubled crease on the beloved forehead, for that reason, and therefore for my sake, I kiss it away. If I did not love this person, he might go right on making creases, they would not trouble me; I am only driving away *my* trouble."[37] Love cannot be exercised in the name of an external value: the egoist will love because his love exalts him and provides a higher form of satisfaction. This leads to the paradoxical notion of a "community of egoists" – and to the almost Sadian idea that the others are not my "equals" but can become my property: "No one is *my equal*, but I regard him, equally with all other beings, as my property. . . . For me no one is a person to be respected, not even the fellow-man, but solely, like other beings, an *object* in which I take an interest or else do not, an interesting or uninteresting object, a usable or unusable person."[38] Is Stirner presenting an atheistic parody of Bentham's utilitarianism?

All this would have been forgotten as a philosophical oddity, a bizarre minor Hegelian comparable to minor French anarchists like Proudhon, Fourier and other "utopian socialists", had Stirner not been the butt of Marx and Engels's ferocious humor in *The German Ideology*, a text that monumentalizes him by making him the main adversary, the individualistic petty bourgeois opposed to the Cause of Communism. Stirner becomes the whipping boy of historical materialism, and in order to criticize him, Marx and Engels feign a tactical incomprehension of the parodic tone so crucial in *The Ego and His Own* in that they deliberately remain deaf to the ironies that are rife in Stirner's evocation of a "phantasmagoria". It is true that Stirner does not explain the history of Christianity through the "empirical conditions" and "industrial relations and relations of exchange" connected to a given form of society. For Marx and Engels, Stirner remains a prisoner of the Spirit he denounces: by dint of crying "ghost", he has effectively transformed himself and his conceptual world into a spectral phantasmagoria. The dialectic of enunciation invented by Stirner heralds later insights such as Nietzsche's critique of the substantial self (there is at least one allusion to Stirner's "Unique" in *Thus Spake Zarathustra*), Adorno's negative dialectics, or Blanchot's concept of the *Neuter*, a neutral-

ity more passive than passivity. The "I" only calls itself "Ego" to transcend itself and vanish once again in its own enunciative process. This is why Stirner's affirmation of the ego meets Pyrrho's withholding of any asser-tion. Both positions yield an abyssal foundation upon almost nothing, or the simple "subject of the enunciation", as Lacan would say; that is, a subject that is a mere cut or hole in a chain, a speaking or writing "ego" that manages to invert the All into Nothing and vice versa. The final para-graph of *The Ego and His Own* confirms this view:

> I am *owner* of my might, and I am so when I know myself as *unique*. In the *unique one*, the owner himself returns into his creative nothing, of which he is born. Every higher essence above me, be it God, be it man, weakens the feeling of my uniqueness, and pales only before the sun of this conscious-ness. // If I concern only for myself (*Stell' Ich auf Mich meine Sache*), the unique one, then my concern rests on its transitory, mortal creator, who consumes himself, and I may say: // All things are nothing to me." [39]

A literal translation would be: "I have founded my cause on nothing (*Ich hab' Mein' Sach' auf Nichts gestellt*)." Stirner not only invented anarchism, he also posed the question of the paradoxical nature of subjective enunciation. This generates the self-cancelling rhetoric of the book's conclusion. "The conceptual question, 'What is man?' – has then changed into the personal question, 'Who is man?' With 'what' the concept was sought for, in order to realize it; with 'who' it is no longer any question at all, but the answer is personally there present at once in the asker: the question answers itself."[40] Stirner extols the pleasure of life perceived as the Ego's auto-delec-tation and self-erasure. Being All and Nothing at once, the Ego introduces a non-totalizable negativity into the world. This position, more Fichtean than Hegelian, is unassailable; it can only be refuted if you show to the Ego that he is just another ghost, which is what Marx and Engels do in *The German Ideology*.

However, the ghost, or its "old mole", to quote Marx quoting *Hamlet*, re-surfaced again half a century later. The historical context of Duchamp's discovery of Stirner places him alongside Pyrrho in the context of a broad definition of anarchism. Stirner is not a purely rhetorical anarchist who betrays a fundamental political quietism or merely reactionary leanings. Martin Buber, for one, described Stirner as a "pathetic Nominalist", *ein pathetischer Nominalist*. It is true that his philosophy leads to a "pathetic apathy" in the name of a wholesale critique of all causes and dogmas written in the first person. The main effect of his book, however, repetitive as it is, is to produce an identification of the reader with *der Einzige* – the Unique One who owns himself and therefore owns nothing. A particular grammar

of affirmation and negation is thus posited, which curiously is not dissimilar to Pyrrho's complex dialectics of non-affirmation.

How can this network allow us to make sense of Duchamp's work and evolution? Even if this dedoubled philosophical tradition cannot explain everything in Duchamp's *oeuvre*, it can at least throw some light on what remains one of the main paradoxes in his career; which I would situate as an apparent discrepancy between the logic underpinning his two major works: the Large Glass or *The Bride Laid Bare by Her Bachelors, Even* and *Etant Donnés*. The clash is often presented as a betrayal of the avant-garde project, of a purely conceptual work attempting to evoke for the mind all the tensions implied by sexuality and its dead-ends (the upper and lower halves of the glass suggest the impossibility of direct sexual relationships, and the unfinished emanations that move up from bottom to top recall a sublimation process closer to a masturbatory model of activity), by the interaction between human desire and the machine, and more momentously by the riddle of the fourth dimension, evoked obliquely through the mental calculus of several "time-images" (as Deleuze said, following Bergson) – hence the function of the Green Box as the necessary conceptual part of the visual apparatus presented in the museum.

I have sketched a few aspects of *La Mariée mise à nu par ses célibataires, même* so as to call up the often baffled reaction to *Etant Donnés*. As Tomkins's biography infers, the main link would seem to be the autobiographical aspect of both works, since one moves from a cryptic signature – *Mariée* and *Célibataires* yielding "Marcel" (but how do we know it is not a meditation on Marcel Proust?) to a tableau vivant that both commemorates and embalms for eternity Duchamp's erotic relationship with Maria Martins. Although I do not want to dismiss the autobiographical relevance of these themes, I would like to suggest a way of understanding how the "definitively unfinished" project of *La Mariée* – a radically Pyrrhonian examination of life crystallizing its most important aspects – could lead to the strangely frustrating trompe-l'oeil of *Etant Donnés*, a work in which the so-called "return" to classical perspective can be read either parodically or seriously. It becomes obvious then that *Etant Donnés* should appear as a Stirnerian work: the Ego has merely to be transformed into an eye/ I by an obvious pun; it shows that the gaze of the I discovers its field of vision as "its own" object, namely Nature seized in its broadest determinations, the flux of a Heraclitean time and the "gas" concealing both "chaos" (Beckett reminds us of this curious proximity in *Murphy*) and the source of light without which we could not see anything. The apparatus of classical perspective is requested to universalize the I/ ego/ eye: it is only thanks to a classical perspective that one can reach the conclusion that "egoism" can be shared

by all. We share it when we recognize simultaneously how deluded we all are by the fetish of sexuality (the gaping cunt *Etant Donnés'* woman) and the conventional nature of representation, and how easy it is to just go on living in the world of pure appearances and aesthetics.

The convergence between Pyrrho and Stirner thus allows Duchamp to solve the last remaining paradox concerning his apparent compliance with the classical "rules" that he had apparently always wished to subvert. It is crucial here to distinguish between repetition and reproduction. While Duchamp wished to avoid repeating himself or previous artists at any cost, he was never opposed to the idea of playing the game of artistic or industrial reproduction (he never distinguished between the two anyway). He was notoriously ambivalent facing the market of symbolic goods, since he would criticize the commodification of artistic egoism – he once asked: "Why should artists' egos be allowed to overflow and poison the atmosphere?"[41] – while, on the other hand, he knew how to play on this market by manufacturing or supervising the reproduction of limited series of copies of copies of his own works.

We can therefore understand what Duchamp meant when he said to Katharine Kuh in 1962 that he never felt he had been trapped in a prison of artistic narcissism: "I was never interested in looking at myself in an esthetic mirror. My intention was always to get away from myself, though. I know perfectly well that I was using myself. Call it a little game between `I' and 'me'".[42] This did not prevent him from asserting that "art is the only form of activity in which man shows himself to be a true individual." All this, of course, with the touch of sardonic humor that became Duchamp's signature. It is nowhere more apparent than in the epitaph he had chosen for himself. *"D'ailleurs, c'est toujours les autres qui meurent."* The off-hand motto inscribed on his tombstone (meaning "Besides, it is always the others who die!") was yet another quote from his miscelleanous writings, this time from his collection of puns.[43] As he had confided, he believed that one never "knew" one's death. When his old friend and lover Mary Reynolds was dying of cancer, he wrote: "The main thing is to die without knowing anything about it, which is in any case what always happens."[44] This irrefutable insight has been expressed in a more syllogistic manner by Nabokov. Confirming Duchamp's effort to deny death, his motto functions like an enthymeme, that is a creative paralogism. Its memorable formulation sums up John Shade's intimations of immortality in Nabokov's *Pale Fire*:

> A syllogism: *other men die; but I*
> *Am not another; therefore I'll not die.*[45]

One might want to examine more closely the syntax of Duchamp's epitaph. In formal French, one would expect *"D'ailleurs, ce sont toujours les autres qui meurent"* (Besides, these are . . .). The choice of a spoken style (*c'est*) contradicts the solemnity of the occasion – marked off by the capitals in the second text. One might see something else looming out of Duchamp's engraved dying words. He might be echoing in this *"c'est toujours . . . "* the famous signature of *Rrose Sélavy*, a rose blossoming as *Rose, c'est la vie*, a phrase one often says in English, generally when someone dies: *C'est la vie!* Deleting the accent of the last name, thus cutting the rose's thorn, Man Ray would distort the phrase into "Rose, cela vit!" ("Rose, IT lives!" or, better, "Rose, the Id lives!") By cunningly superimposing life and death in these last words, Duchamp exemplifies Pyrrho's principle of the equivalence between life and death. Indifferent to the end, he shows that Death is a productive grammatical mistake, a misprint that can transform a *Pyrrhic* victory into *Pyrrhonian* transcendence.

The Seducer's Diary:
Duchamp and the Bride, even

The best example of the original way in which Duchamp managed to synthesize the teachings of Pyrrho and Stirner can be seen in his short-lived marriage to Lydie Sarazin-Levassor. One can gauge as well the ineluctable limits met by his willed transcendence, or freedom, in front of crucial limitations set by the state of his finances, the encroachments of the social world, and basic bodily needs such as food and sexuality. Duchamp had lost both his parents in 1925, they had left him a substantial inheritance that he planned to use so as to achieve a change of career as he had decided that he was to abandon art and become a professional chess player. He assumed that he could make a living from chess-playing as a "grand master" but alas, the title always eluded him – as well the revenues he had anticipated. In fact, he had to resort to becoming an unofficial art-dealer engaged in commercial ventures like buying and selling contemporary art so as to find an intermittent source of funds. This is why in 1926, Duchamp bought eighty paintings and drawing by Picabia and sold them at some profit at the Hôtel Drouot, a sale that worked very well, and then repeated the operation when he acquired some thirty sculptures by Brancusi previously owned by John Quinn, the New York patron, which depleted his inheritance. As is well-known, he was partly stymied in his efforts by the American customs, who decided to treat these sculptures as industrial material and not as art, taxing them to a maximum. This was the dire financial state he found himself after

he had returned to Paris in February 1927, when he decided that the key to his problems might be to marry a rich heiress.

In fact, the plan had been concocted by his friend Picabia, who also knew the ideal candidate, for he was a close friend of the girl's father, with whom he often spent summer vacations on the French Riviera. The father was a rich industrialist who was going to divorce his wife in order to marry his mistress, the famous singer Jeanne Montjovet, but only if he could marry off his single daughter first. This was the condition put by Henri Sarazin-Levassor 's wife: she would divorce him but only after their daughter, Lydie, got married. Picabia immediately thought of Duchamp: he would marry Lydie and live comfortably off her parents' generous dowry, which would solve Henri's problem. Lydie was an unlikely candidate for Marcel, though, as she was quite immature, on top of that "very fat", not a beauty at all, closer to the type of high-society scion deliberately kept in ignorance of the world after having been educated in religious schools. Besides, she knew nothing about contemporary arts, even if her grand-father had been a successful society painter. However, she was fretting in her constrained education, had already refused a few suitors and was incurably romantic. Duchamp nevertheless slipped with glee into the shoes of the professional seducer. There was something of Freud's Dora case in the quadrille in which Lydie found herself, as she was caught up between a distraught mother who would reproach her for her role as an accomplice in her father's designs, and the rather sordid plans elaborated by the two artists who did not hide that their main interest was to have access to her dowry. A slightly more sinister turn would have been to imagine Duchamp as a sort of Landru, ready to assassinate and burn in an oven the corpses of his serial wives. This was not to happen, first of all because Lydie's father had wisely limited the dowry he was giving to her to a bare minimum.

What makes this episode so interesting, as it was both documented on film by Man Ray, and described at length by Lydie herself, is that we see a curious reversal: she appears at first at the "white goose" (*oie blanche*) in awe of a seasoned and charming seducer, but she ends up growing up, maturing, accepting all of Duchamp's terms, reaching a new degree of awareness, while unable to move from the status of "bride" – that is unable to move from that position to that of a "lover" or "friend". Her recently-published memoir bears a title whose irony is calculated: *Un échec matrimonial*[46] ("A matrimonial failure") evokes the enduring obsession of Marcel for chess (*échecs*) while describing a "failure" (*échec*) in their marriage. As such, it has much in common with the marvelous piece by Sophie Calle entitled *Douleur Exquise*, a mixed media installation for two rooms in which Calle painstakingly depicted how she lost the man she was in love with.[47] Similarly, Lydie

bitterly complained about the many hours of the night that she had to wait nervously until Man Ray and Marcel had finished their games, postponing the time when she and her husband would have to share a tiny bed in Duchamp's walk-up studio in rue Larrey.

Lydie's memoir analyzes without sentimentality her willful delusion, her refusal to consider the sordid side of the affair. Each time she was brought back to reality, that is when money became an issue, she was shocked by Marcel's coldness and deliberation, only to forgive him the next day if he happened to be in a better mood. It was only at the end that she was able to reconstruct the whole scheme: Jeanne Monjovet, shown as a gold-digger without scruples (Duchamp, for one, who should have been on her side, did not trust her, and saw through her jealousy facing Henri's adored daughter) must have told Picabia: Henri would give anything to get his daughter married. If you help him, he'll be generous. However, Henri, whose huge fortune had just dramatically diminished following a monetary devaluation, proved to be rather stingy with Lydie, so as to counter the insinuation that he was selling out his daughter to be free, and he also forgot to "thank" Picabia financially. "To recognize that he had rendered a service would have been to confess, to acknowledge that he had bought his freedom at the price of an infamous deal, the sacrifice of his daughter to his mistress. Impossible" (EM, p. 172). This is why Lydie sensed that it was Picabia's changed attitude towards her that first brought about Marcel's coldness. Later on, Picabia's indelicate transaction with her father's Riviera house indicated some ill-will on his side (EM, p. 185). The abject barter nevertheless took place, with the added consequence that she was shunned by a large part of her family; while Marcel tried to introduce her into an artistic milieu in which she felt lost. Ironically, the newly-weds had to share Marcel's minimalist studio rather than living in the luxury which they had both expected.

Lydie's sprightly memoir documents with great accuracy and an unerring critical eye the complexity of Marcel's position at a time when he seemed bored with New York and with the world of art, and decided to stake everything on chess-playing. One might say that she lost Marcel not to another woman (even if there soon would be another), but to his passion for chess. It was during a chess competition in Nice which occurring after the relaxed atmosphere and pleasant parties of Mougins that she discovered that Marcel was not interested in her any more. He was playing two games a day in Nice and explained that chess-playing necessitated total concentration, hence chastity! She confides this to a friend: after the game, he is too exhausted, but the presence of Lydie (or any other woman) tempts him, he forgets his vow of continence and "burns the candle at both ends" (EM , p. 141).

Lydie's naive but spontaneous remarks, her lack of bourgeois prejudices,

and her earthly and astute common sense won, for a while, Marcel's affections, until it became obvious that his systematic training to be a chess champion, the hangover from his past artistic program and his free-wheeling lifestyle left no place for her. Indeed, Marcel Duchamp could be charming when he wanted; for instance, he managed to seduce Lydie's own mother, even thought she knew that he was sent by Picabia and her husband for sordid calculations, and was therefore the enemy. At this occasion, she told her daughter: "My poor child, I'm not sure whether I should congratulate you. The man is truly remarkably intelligent, possibly too intelligent for you, my good old fat girl" (EM, p. 35). Marcel could also turn ice-cold, cruel and distant when he was upset or suddenly frustrated. When Lydie invaded Duchamp's small artist's studio with all her silly rococo furniture, he could not disguise his annoyance, his handsome face turned white, closed up and looked hard as steel (EM, p. 43). A similar spread of pallor marked the day when he heard from his future father-in-law that Lydie's dowry would be a severely limited annuity (EM, p. 49). And when finally he found for Lydie another apartment into which he moved all her belongings, she returned for one more night to his studio and discovered with dismay that everything was back in place, each object exactly as it was before she had moved in. Duchamp soon tired of the Pygmalion role that he had imposed on himself. However, what he taught Lydie, more than a finer appreciation of the distinctions between Surrealism and Cubism, was, bizarrely, love. "I believed in his word. It was HE the strong man who had taken me away from the milieu in which I was stifled. It was he who had taught me to love," she writes in a typical lyrical outburst (EM, p. 179). And by love, Lydie also meant love-making, that is having sex.

Un échec matrimonial is instructive in what it reveals about Marcel's libidinal body. Lydie describes how he would slightly blush whenever he would talk of himself, for instance when he mentioned his artistic fame and his previous success in New York (EM, 87). On the whole, Marcel appears not at all ascetic but an Epicure; the only sense he did not properly enjoy was the ear, as he was impervious to the charms of music (EM, 65). What he shared with Lydie, at first, was above all a taste for food and sex. Marcel had a great appetite, especially at night, after chess or late discussions, and a great relish for the sensual body of his plump wife. Their honeymoon was spent in Paris, and was nothing but a gastronomical tour of as many restaurants as they could find in different neighborhoods.

Their regular travels in her small 5 CV car (she was the only one driving) were always punctuated by epic lunches and dinners that she describes with unabashed gusto and greed (e.g., EM, 147). No wonder that the only summer that she spent with Marcel made her gain a few unwelcome extra

kilos! When they drove South a month or so after the wedding, they arrived in the crowded city of Orange, in which a theatrical show was to take place at night in the well-known local Roman amphitheatre. Finding at last a room in a barn, they refused to share it with others, Lydie stating that Marcel understood that she would not want other people witnessing their wild lovemaking and that she was not ready to be deprived of it, even for one night (EM, p. 102). However, there were other realities to be taken into account. For one, Marcel did not want children, as he repeated it to Lydie, and beside which, he believed that he was sterile. He had given Lydie a cautionary tale, explaining that he had repeatedly slept with the wife of a friend who had been rendered impotent by the war, and she never became pregnant – but then she liked this so much that she could not stop seeing Marcel (EM, p. 144). In fact, what stands out with terribly clarity is that Lydie had fallen head over heels in love with her husband, while Marcel never even pretended to be in love. For instance, he never uttered the words "I love you" (EM, p. 97). Lydie and Marcel did not even say "tu" to one another: they would use the formal *vous* (EM, p. 135). Marcel's fondness for plump women was accompanied by a equally virulent disgust for body hairs – his above all – and in consequence, he convinced Lydie to get rid of all superfluous hairs, which she did without too much difficulty (EM, p. 69). This exemplified a rigorous application of his dictum of bareness and a philosophy of "*dépouillement*", a word that he liked since it combined the meanings of "stripping", of laying bare, and of refusing any kind of ornamentation. This later extended to the anonymous vulva of *Etant donnés*. Marcel's lifestyle was similarly bare; he had no personal belongings except for a big trunk in which he kept his scraps of papers and a few photographs.

Marcel tried very hard to teach Lydie his home-made philosophy of life, a philosophy in which freedom was a key concept. One sees him deploying all the resources of his Stirnerism (misread once by Lydie as fashionable Nietzscheism, see EM, p. 160) and Pyrrhonism to assert the need for spiritual autarky, the total autonomy of the creator. This entailed refusing any responsibility, which was how he justified his refusal to have children. He insisted on his need to be free to create, his wish to travel light and without impediments. No decoration, no science, no culture: Duchamp portrayed himself as born Dadaist who always lived fully in the present. "He had decided to make a clean slate of his past, the mere mention of it bored him. He wanted to live in the present" (EM, p. 73). Of course, this discourse, although consistent, was tendentious, especially when Duchamp would allude to Stirner's individualism to justify his need to separate from his "bride": "he exposed to me the advantages of living separated; insisting upon the fact that the individual is one and has to master

his fate alone" (EM, p. 159). Or again: "To evolve, an individual has to be free or any responsibility." (EM, p. 160). In a less guarded moment, Marcel confides that he has reduced life to two main motivations: either maintenance or creation (EM, p. 71). Since he extols creativity over any other virtue, the issue is to reduce the maintenance function to a strict minimum, or better even, to leave it to others altogether. At least, the preoccupations concerning "maintenance" should not clutter one's mind. Marcel's true success, it might be said, came when he finally managed to push Lydie to a similar attitude of "indifference" concerning love entanglements (EM, p. 183).

On the whole, Duchamp aimed at reconciling his need for an unconditional or absolute freedom with a revolutionary attitude transcending petty bourgeois individualism, and it comes as no great surprise to hear that he took Trotsky's "permanent revolution" as a working model (EM, p. 47). His catechism was not the Surrealist credo – nor did Marcel share André Breton's respect for psychoanalysis. In an unexpected diatribe against Freud, and also against spiritualism, Marcel parodies his own belief in the preponderance of sexuality: "Freud . . . the Viennese guy who cures the mad by interpreting their dreams and gives sex as a mobile to all their actions . . . One wonders who is crazier. He is a vicious pervert, and psychoanalysis nothing but a maniac's joke" (EM, p. 119). This attack confirms an ingrained rationalism which confines to petit-bourgeois cynicism. For Duchamp, however, science and the imagination should work *together*. Lydie points to the influence of his god-mother Julia Bertrand (*née* Julia Pillore, barely mentioned in Tomkins's biography) as a key synthesizer of avant-garde ideas and a promoter of an original philosophy of freedom. Julia marked with her wit and culture (she had been the secretary of an academician, in fact his ghostwriter) the whole Duchamp family (EM, pp. 129–31). Her homemade philosophy emphasized personal freedom, a freedom to be gained by shedding previous personalities by way of *dépouillement*, by strenuously leaving behind the "old man" and discarding previous selves (EM, p. 131).

In a conversation during which Lydie, for once, asked questions about Marcel's childhood and his studies as a schoolboy, he replied that he possessed absolutely no culture and that he found academic knowledge useless for life. She replied that some knowledge could "furnish" one's mind – at which Marcel scoffed, making fun of her need to have a "furnished mind" as one rents a furnished room. The point, for him, was to have an "empty mind" so that one might "fill it with what was interesting", and "not clutter it with useless residue" (EM, p. 78). This is only one instance of Duchamp's desire for emptiness, an almost Zen-like wish

for a clean slate, so that creativity would be allowed to flow unhindered. Whereas Lydie always admired this resolution, there was one feature in her husband that she did not like: his fondness for silly puns, spoonerisms, and word ladder games. For instance, the section that narrates how they were married is titled *"En chaire et en noces"* – a pun on *"en chair et en os"* (in the flesh) and *"chaire / noces* calling up a pulpit and nuptials)*, and Lydie notes that this pun had already been made by Marcel in 1919, when he had also played on *"en cher, en hausse"* (expensive, prices rising) (EM, 56). The multiple ironies are that these words seem to sum up the complex knot of financial speculations, marriage ceremony and loaded flesh appeal in which both of them were caught for a while.

On the whole, Lydie has a point when she finds this punning "heavy" or "simplistic" – just as he and Man Ray find her too "heavy". During their first car trip to the south of France to while away the hours, they would compose little poems entirely made up of *double entendres* (EM, p. 103). In a later, sadder trip, Marcel's gloom was only dispelled when they reached the city of Oyonnax: then Marcel started composing ditties and spoonerisms on the funny name and his spirits returned (EM, p. 147). Lydie observes sharply that these puns were a weapon wielded by Marcel, a distancing tool next to the pervasive function of chess-playing, both being a way of postponing more serious discussions, leaving to a mixture of chance and strategy the resolution of personal or political dilemmas. This is how, according to Lydie, Marcel had managed to avoid taking sides in the dispute opposing the Dadaists and the Surrealists, not an inconsiderable feat. This non-committal attitude was also successfully imitated by Man Ray.[48]

Lydie's memoir reveals a Duchamp who was less of an avant-gardist than most people tend to believe. He had a strong sense of family ties, loved the way their regular Sunday family gathering strengthened the tribe's sense of identity, of warmth in the unleashing of wry Normandy humor. Marcel was only interested in art and everyday matters if they could make him laugh. What distinguished him above all was an obsessive concern for privacy and freedom that bordered on the neurotic. The same logic presided for his "work" and the simplest choices in his everyday life. I subscribe entirely to Marc Décimo's balanced assessment in his Introduction to the memoir: "His passion for individualism had something rabid about it, and exerted itself without any concern for the others, this deliberately pared down lifestyle, this phobia of functionalism that prevented him from entering into any social role, whatever it was, his disgust facing Art reduced to pure decoration, his use of money, the charm and intelligence of the man are the many features that characterize Duchamp" (EM, p. 16). Duchamp was originally

not averse to entering into a new role, that of the bridegroom, the *marié* who, ideally, was the counterpart of the bride left in an unconsummated union in the large *Glass*. This is why he chose a woman who could play the part of the "bride" fully. She had to be fat and sensual, as Lydie was; her personality was to be as "natural" as possible. For instance, Lydie had no problem with posing in the nude for Jean Crotti, to Marcel's amused amazement, and courageously faced the outrage of her conservative family when the painting was exhibited and turned out to be all too recognizable (EM, p. 121). Better plump and naive than slim and sophisticated, as most of his American friends were, with the exception of Katherine Dreier. But this new role could not be sustained for long – it clashed too much with the opposite side in the spectrum, his "egoistic" celibacy. When he pleaded with her to accept the idea of a divorce, he argued that he was "egoistically celibate", a bachelor who needed his freedom to create – the very idea of marriage was too heavy a burden to carry (EM, p. 162).

Having been notified of the divorce judgment, Lydie drove down to the Riviera in order to meet Marcel, who was preparing for a chess tournament in Hyères. As he had repeated that "nothing would change" things between them, she tried to kiss him upon arriving at his hotel. He rebuffed her sharply with: "Again! Haven't you understood yet!" (EM, p. 180). At that moment, Lydie realized that there was nothing that she could do to regain Marcel's affection (he hadn't told her that he was back with Mary Reynolds by then). It would be wrong to conclude, as Tomkins does in his biography, that Lydie "never understood any of it"[49]. Actually, she understood all too well the truth, but it took her the time to write the said memoir. In her view, if Marcel wasn't cut to become a chess champion, he was a champion when it came to calculating moves with people after he had turned them into pawns. His game was a gamble with his and other people's failures (*échecs*). Marcel was adept at eliciting success from failure and he knew, as Beckett said, "how to fail better". Thus while always remaining very polite, he did not hesitate to "operate" or sweep the place clean whenever he needed his freedom back. He was ready to kill if threatened in his autonomy, and life becomes an Aunt Sally game, a true "*jeu de massacre*". Here is how Lydie puts it:

> His need to act is intense and when he believes that it is necessary to act, he has no fear of leaving some waste behind. In literary or artistic matters, even better if all the shots kill. It is an Aunt Sally game, the more they fall, the more one laughs. In life, it's different, wastage is more like peelings, rotten parts that had to fall anyhow. Amputation was inevitable, why not precipitate it. Not even a surgeon's business, a simple sweeping away, a game = Dada. (EM, p. 169)

Structure and Function of the "fait-divers"

A similarly Mallarmean (if not Caesarean) operation was at work in Duchamp's final work. When the notes for the *Bride Laid Bare by her Bachelors, Even* were published in *Le Surréalisme au Service de la Révolution* as the first feature of the double issue (5 and 6) edited by Breton in May 1933, the text was preceded by a short epigraph linking the scientific ambitions of the work and its attempt to deduce the general laws of natural dynamics with an esthetic program defining the two cognate ideas of the "ready made" (*tout fait*) and of the "found object" (*objet trouvé*) with which the Surrealists had been toying in the 1930s:"*pour écarter le **tout fait en série**, du **tout trouvé**. L'écart est une opération.*"[50] (Literally: "So as to differentiate the *serial ready made* from the *ready found*. This difference is an operation.") This epigraph is not found in Duchamp's published *Notes*. I will quote here the fragments edited by Breton in the double issue 5–6 of *Le Surréalisme au Service de la révolution* for several reasons: it is the first time these notes were made public in a review while being surpervised by their author; they offer a rapid and condensed montage of texts that, in their later versions, multiply and proliferate unaccountably; the context of the review itself is interesting, since we see in the same issue an article by Maurice Heine extolling Sade's influence that concludes with a line by Baudelaire ("The charms of horror make drunk only the strong)"; and finally, a correspondence between Freud and Breton about the *Interpretation of Dreams*, to which I will return in chapter five.

Starting from the text that condenses two versions usually called "Preface" and the "Foreword", I will focus on a mistranslation, or to be more precise a literal translation that has had important consequences for what has turned into a "Duchamp industry". Most of his riddles are contained in a Pandora's box, the box or suitcase in which he put all the notes written between 1912 and 1915. These jottings vary enormously in size, style and format, but those that were collected in the "Green Box" are preparatory notes for "The Bride Stripped Bare by her Bachelors, Even" also known as the "Large Glass" (1913–1923). What cannot be forgotten, of course, is that the title of Duchamp's last work, "Given 1° the waterfall, 2° the illuminating gas" comes directly from the Preface, or Foreword or Warning. This is a text that insists on an active difference (one would be tempted to write it with an − a, i.e. "differ*a*nce", as Derrida famously did) between "ready made" and "ready found" objects. What matters for Duchamp is to define the conditions of *poesis*, understood as "making", creating and also tinkering. Let us just remember that Lydie accused her short-term husband

of being less an artist than a "bricoleur"[51] (tinkerer), an idle dilettante who loved nothing more than building a shed for her father's garage, or meticulously unpinning strips of blotting paper meant to hide a dirty wall in her apartment. I translate the text as reproduced in the Surrealist review under the general title of "The Bride Stripped by her Very Bachelors:[52]

> Given 1° the waterfall
>
> 2° the illuminating gas,

> we shall determine the conditions for the instantaneous state of Rest (or allegorical appearance) of a succession [of a group] of *fait-divers* seeming to necessitate each other under certain laws, *in order to isolate the sign of the accordance between*, on the one hand, this state of Rest (capable of all eccentricities) and, on the other, a *choice of Possibilities* legitimized by these laws and also causing them.

> Or:

> We shall determine the conditions of the best exposition of extra-rapid Rest [of extra-rapid positioning] (= allegorical appearance) of a group . . . etc.

> Or:

> Given in the dark 1° the waterfall
>
> 2° the illuminating gas,

> we will determine (consider) the conditions of an extra-rapid exposition (allegorical appearance / allegorical reproduction) of several collisions [attacks] apparently succeeding one another rigorously – following the laws – to isolate the *sign of the concordance* between this extra-rapid exposition (capable of all eccentricities) *one the one hand* and the choice of possibilities legitimated by these laws *on the other hand*.[53]

Breton was right to highlight the "documentary" nature of these notes for the large glass and does not attempt to streamline the style; on the contrary countless footnotes describe the interlinear additions, the coloured insertions, the superscriptions and words crossed out. We never forget that we are deciphering with some difficulty a written text, a heap of jottings and "ancient calculations" to quote Mallarmé, a file that is layered like an archive, closer to a scientific document of a research in progress than to an esthetic manifesto.

What is clear to anyone who knows French is that the original text alludes less to "various facts" (Duchamp would have written "*divers faits*"),

which is what all available English translations have, than it aims at showing how *faits divers*, or rather *"faits-divers"* with a hyphen (this is how the phrase is printed in the Surrealist review), a phrase that is much closer to "news in brief", "trivial events" or "short news items", can fit in a pattern and follow universal laws. The initial "givens" here emblematized by the waterfall and the illuminating gas, hence to the realms of nature and culture, belong to a scientific determination governing the transformation of "faits divers" into an "allegorical appearance". In the paradoxical or oxymoric logic that prevails here, "Rest" seems identical with "extra-speed", as if the greatest speed led to absolute rest. These scientific or pseudo-scientific laws operate on data or givens; they turn into occasions for the calculation of the general laws. Between the years 1915 and1918, Duchamp was particularly fond of physics and its attendant problems as he seemed to follow in the steps of Alfred Jarry's "pataphysics", a literary game presenting itself as scientific discourse giving "imaginary solutions" to real problems. Jarry's *Gestes et opinions du docteur Faustroll, pataphysicien*, has a final section entitled "Of God's surface" in which he endeavors to calculate it. After three pages of the most bizarre or frankly absurd equations, Jarry concludes:

> Therefore, definitively:
>
> GOD IS THE TANGENTIAL POINT OF ZERO AND INFINITY
>
> Pataphysics is the science . . . [54]

This sends us back to the beginning of the book and forces us to reread the definition of pataphysics: "Definition: *Pataphysics is the science of imaginary solutions that grants symbolically to lineaments objects described by their properties.*"[55]

If Duchamp's notes can be understood as his own version of pataphysics, thus testifying to Jarry's pervasive influence on his work, these calculations also belong to a different cultural moment, especially when they are published by André Breton in the thirties and thus appear marked by discussions between Dadaists and Surrealists on the role of chance encounters, epiphanies, radiant objects, the esthetics of surprise, the validity of the Freudian unconscious, and so on. Even if Duchamp's schemes owe their style to school exercise books in physics and algebra ("Given . . . " was the usual beginning of problem), what matters for him is to find a rigorous language addressing the issue of "data" coming from the world and the laws under which they can be regulated, interpreted and finally understood. Among these data, next to light, energy and speed, one should also include the man-made or at least historically constructed *"faits divers."*

What is then a *fait divers?* One might turn to Roland Barthes for some help; in 1962 he devoted a whole essay to an elucidation of the "Structure of the *Fait Divers*". Richard Howard, the translator, explains why he decided not to translate the phrase. noting that *fab divers* it commission i translated an "filler" (one might say "local news" as well), he acknowledges that he could not find an exact equivalent. He needed to retain the French expression in order to stick to the specific phenomenon. Here is how Barthes begins: "A murder is committed: if political, it is news, otherwise we French call it a *fait-divers*."[56] What is the difference? Is it simply a matter of journalistic heading? Not only. A *fait divers* is by definition unclassified, it is a "fact" taken from everyday life; it has been brought to the attention of the public without reaching the abstract categories of official taxonomies. Here is how Barthes glosses the distinction – tellingly returning to the example of a murder:

> This difference appears as soon as we compare our two murders; in the first, (the assassination), the event (the murder) necessarily refers to an extensive situation outside itself, previous to and around it: "politics"; such news cannot be understood immediately, it can be defined only in relation to a knowledge external to the event, which is political knowledge, however confused; in short, a murder escapes the *fait-divers* whenever it is exogenous, proceeding from an already known world; we might then say that it has no sufficient structure of its own, for it is never anything but the manifest term of an implicit structure which pre-exist it: there is no political news without duration, for politics is a transtemporal category; this is true, moreover, of all news proceeding from a named horizon, from an anterior time: it can never constitute *faits-divers*; in terms of literature, such items are fragments of novels, insofar as every novel is itself an extensive knowledge of which any event occurring within it is nothing but a simple variable.[57]

By contrast with a political murder, say, a *fait-divers* is pure news and contains nothing extraneous to itself. This includes disasters, murders, rapes, accidents, incidents, catastrophes, falls, thefts, fires – here is the stuff of which our human world is made, the virtually endless variety of local and not-so-local news proliferating beneath the concept. As soon as the event is deemed important enough to become the object of a narrative, it turns into a self-contained whole in which its causes and circumstances are given. As Barthes sums this up: "It is immanence which defines the *fait-divers*."[58] Of course, one can describe its logic and its structure, at least for journalism, and Barthes singles out two main features: the prevalence of causality of an uncommon or twisted type (which allows for stereotypes like "mystery" or "riddle"); and the domination of coincidence as a way of dealing with the

repetition of stereotypes, a coincidence that often lets the figure of fate loom behind a single silly event.

> We have seen that the explicit causality of the *fait-divers* was in fact a faked causality, or at least one under suspicion, dubious, absurd, since in some sense the effect frustrates the cause; we might say that the causality of the *fait-divers* is constantly subject to the temptation of coincidence and, inversely, that coincidence here is constantly fascinated by the order of causality. Aleatory causality, organized coincidence – it is at the junction of these two movements that the *fait-divers* is constituted: both ultimately refer to an ambiguous zone where the event is experienced as a sign whose content is nonetheless uncertain. We are thus in a world not of meaning but of signification, which is probably the status of literature, a formal order in which meaning is both posited and frustrated: and it is true that the *fait-divers* is literature, even if this literature is reputed to be bad.[59]

As Barthes writes in his conclusion, it is the *fait-divers* that introduces us to "mass art" and to a structural uncertainty facing the true function of signification. We want to have signs, but at the same time we need them to remain uncertain as to their content, which thereby frees us from responsibility. Duchamp would agree with Barthes' analysis, which seems to offer the best possible gloss on the Large Glass notes. These notes open onto a textual archive capable of incorporating any *fait-divers* because they deal with the absolute singularity of so many anecdotes or events that cannot be generalized.

Barthes was thinking of the "literature" provided by newspapers when he pointed out that all was merely "bad literature". It was Apollinaire's poem *Zone* that ushered in a modernity in which the press defines the only literature:

> You read the handbills the catalogues the singing posters
> So much for poetry this morning and the prose is in the papers
> Special editions full of crimes
> Celebrities and other attractions for 25 centimes.[60]

For Duchamp, next to Apollinaire, there was another model, that constant example of the poet he loved most (as he told Lydie, see EM, p. 103) – Mallarmé. As a precursor in many domains, it belonged to Mallarmé to systematize the literary use of *faits-divers*. In the late prose essays collected under the title of "Divagations", a section is devoted to "*Grands Faits Divers*". "Divagations" opens by stating that: "No one, finally, escapes from journalism."[61] In these exquisite, decadent and convoluted prose arabesques, often previously published in French or English newspapers,

Mallarmé meditates on topics provided by recent scandals (the Panama crash), political unrest (the anarchists and their bombs in Paris), literary feuds (the accusations against Huysmans launched by two Rosicrucians) or the uneasy confrontation between an idle bourgeois (himself) and a cantankerous proletarian worker. In these short essays replete with dizzying purple patches, he invents the genre of the "critical poem" – a prose poem, of course. The prose poem "Accusation" replies to the accusation that Mallarmé had anarchist leanings and was a friend of the anarchist Vaillant who had thrown a bomb in parliament in 1893. Mallarmé defends himself by stressing that he does not condone these bombs (at least not when studded with nails and bullets) although he would like to be able to keep a critical distance without "offending the *fait divers*."[62] Carving out a place for literature in spite of the domination of the press leads to the recognition of a literary "exception", in other words, extolling the poet's sublimated anarchism.

For Mallarmé, another type of *grand fait-divers* was provided by the demise of literary figures he admired, especially the trinity he had chosen to illustrate: Poe, Baudelaire and Verlaine. Multiple echoes of these *"tombeaux"* in Duchamp's writings and works have often been noticed, but it took a very good expert of Duchamp, someone who had met him when he was still a struggling artist, Arakawa, to see that *Etant Donnés* can be understood as a visual literalization of the second stanza in Mallarmé's sonnet monumentalizing Baudelaire. Here are the first two stanzas:

> The Tomb of Charles Baudelaire
>
> The buried temple reveals by the sewer's dark
> sepulchral mouth slavering mud and rubies
> abominably some idol of Anubis
> all the muzzle flaming like a ferocious bark
>
> or if the recent gas twists a squinting wick
> that puts up with who knows what dubious
> disgrace it haggardly lights an immortal pubis
> whose flight depends on the streetlamp to stay awake.[63]

Since the second stanza is quite opaque – it is in the original as well – I will quote a more recent version by Henry Weinfield:

> Or if the recent gas the wick befouls
> That bears so many insults, it illumines
> In haggard outlines an immortal pubis
> Flying along the streetlamps on its prowls.[64]

As Weinfield comments, this poems announces Walter Benjamin's thesis

on "Paris, capital of the nineteenth century"[65] when it limns a modernity summed up by prostitution, the sewers and the invention of the gas lamp: Paris has turned into a *ville lumière*, but at the cost of having banished its Romantic shadows. Thanks to numerous streetlamps, a garish gaslight throws an equal light on everything, cities has lost their "evenings", night is like day, and one can buy sexual wares everywhere. The strolling prostitute does not come from an Egyptian temple any more, now that the god of death, Anubis, presides over sexuality. The shocking anatomical precision of an exhibited "pubis" that is visible to all shows that the sexual truth is now exposed. Nevertheless, Baudelaire's hope was to find rubies in the mud, and even the prosaic lightning gas would evoke a flickering Hegelian Spirit. Hence, Mallarmé's "Tombeau pour Baudelaire" couples the themes of prostitution with that of the city's modernity in a dense and complex allegory.

The poem calls up a passage from Poe's "The Man of the Crowd" admired by both Mallarmé and Benjamin, which evokes the streets of the metropolis when "the rays of the gas-laps, feeble at first in their struggle with the dying day, had now at length gained ascendancy, and threw over every thing a fitful and garish luster. All was dark and yet splendid – as that ebony to which has been likened the style of Tertullian."[66] Duchamp's diorama is bathed in a less troubled light, and one could not imagine a sewer defiling the pure alpine landscape. Yet the city is not absent from it, at least if we think of the bricks gathered by Duchamp from construction sites in Manhattan. One tends to forget the interference of this intermediary diaphragm, which suggests another type of sexual hole, a jagged oval distancing once more the female body once the viewer peers through the peepholes. It is powerful enough to evoke by itself the "scene of the crime", the pocket of urban blight, the parenthetical wasteland in which a murdered body will be discovered.

Like de Quincey, Mallarmé believed that murder belonged entirely to literature, or at least could be reclaimed wholly by it. One of Mallarmé's last prose texts was a posthumously-published essay that he was devoting to Shakespeare, and which turned into an extended commentary of de Quincey's famous essay "On the Knocking at the Gate in Macbeth." As Mallarmé part condenses and part translates this essay, I will rapidly sum it up. De Quincey begins with a digression, explaining that one should always trust one's intuition and not one's mind. This is exemplified when he returns to the moment in *Macbeth* which perplexed him – the knock at the gate following the murder of Duncan. For a long time, de Quincey could not understand why the knock produced such an effect on him, a little like Freud facing the Moses statue, until he decided to bracket out his rational

faculty. The solution came to him as he read about the Williams murders in 1812. Williams, who murdered a whole family and who was disturbed by a knock while still in the house, was such a master, such an "artist" in the art of murder that every other murder paled in comparison. The super imposition of the two incidents allowed de Quincey to grasp that this "knock" was truly crucial in both cases: thanks to the knock, the spectator first ceases identifying with the poor victims (a feeling that derives only from a base sense of self-preservation) and acquires some understanding of the criminal's mind. The murder-artist Williams sheds some light on the tortured darkness of Macbeth's motivations. In the theatre, the viewer enters the private hell of the murderer, and as long as this empathy with the unholy wishes, fears and impulses dominates, everything is suspended, until a call from the "real world" reestablishes its usual proportions:

> In order that a new world may step in, this world must for a time disappear. The murderers, and the murder, must be insulated – cut off by an immeas-urable gulph from the ordinary tide and succession of human affairs – locked up and sequestered in some deep recess: we must be made sensible that the world of ordinary life is suddenly arrested – laid asleep – tranced – racked into a dread armistice: time must be annihilated, relation of things without abolished; and all must pass self-withdrawn into a deep syncope and suspen-sion of earthly passion? Hence it is that when the deed is done – when the work of darkness is perfect, then the world of darkness passes away like a pageantry in the clouds: the knocking at the gate is heard; and it makes known audibly that the reaction has commenced: the human has made its reflux upon the fiendish: the pulses of life are beginning to beat again: and the re-establishment of the goings-on of the world in which we live, first makes us profoundly sensible of the awful parenthesis that has suspended them.[67]

The spectator should undergo a double movement: first, total empathy with the troubled mind of the murderer, who behaves exactly like a drugged opium-eater living in a world of his own invention; second, a return to the "normal" feelings of sympathy with the victims – but only once the deed has been committed. This suggests a new rationale for Duchamp's double screening of the awful scene. Perhaps one ought to knock at the old Spanish gate before peering into the ominous peepholes. Perhaps those who stop there and decide that there is "nothing to see" behind the door are right. Or if they do not knock, they just rub their faces on the rough wooden surface of the gate. This is where one can follow year after year the progres-sion of the strange butterfly trace left by the thousands of greasy faces that have been pressed against the wood as Denys Rioult has shown. Here truly would be the meeting place of the trace and the aura.

When Mallarmé, who does not hide his admiration for de Quincey's prose, translates the last sentences from the essay I have quoted here, the equivalent that he finds for "goings on of the world in which we live" is "*des faits communs . . .*"[68] The loud and untimely knock reintroduces the diversity of the *fait divers*, and should be understood as the necessary intrusion of the real world. Mallarmé starts his parallel piece from a similar moment of wonder, but it is triggered by a different surprise; he focuses on another "perplexity" produced by *Macbeth*, its opening itself. Is the irruption of the three witches a first scene or just a prologue? How do they appear, why do they suddenly vanish? Has the play really begun, or is it a guided hallucination? The fantastic is no sooner conjured up than it is blown away in a gust of wind. Is it not unlike a scene in a vaudeville, when a technician or prompter is seen hurrying along as the curtain goes up. In *Macbeth*, the curtain goes up too soon – should one laugh? No, answers Mallarmé, since the witches possess, like all "bat-like beings", an uncanny "ability to dissolve silently as the gas lamps are switched off".[69] The curtain that separates us from the mystery has been raised too early, forcing us to peep through a darkness that was not meant for us. A profanation has taken place, a premature disclosure that is excessive and hard to fathom; it is a violation presented as random which "multiplies anxiety" and renders visible, too soon, that which had to remain hidden. In this flash, "each of us scrutinizes and disrupts, among flashes of lightning, the kitchen of crime, without the caldron whose future ingredients are much worse than recommendations and an abrupt goodbye."[70] Mallarmé goes even further than de Quincey when he questions the very act of looking or hearing, both are staged and exceeded by the stage – but then quickly everything closes up, and the play can now begin.

In a similar manner, Duchamp questions our very act of gazing at nature, and he does so, as Thierry de Duve eloquently argued, with a "negative Kantism".[71] More than Kant, perhaps, it is de Quincey (also a great admirer of Kant) who can show us the way here. De Quincey's essay "On Murder considered as one of the Fine Arts" points out an essential link between the art of murder and philosophy. It begins by stating that most philosophers were murdered or nearly murdered. Kant himself barely escaped being assassinated, but his murderer preferred killing a five-year-old girl to an old and wrinkled academic.[72] Here, by adapting the German term of "esthetics" and using it in the context of raw murder, de Quincey lays out the lineaments of an esthetics of modernity.[73] One of his basic principles is that everything can be "aestheticized"; and that includes all the "given" facts of everyday life, even the most horrible. For de Quincey, as long as the murder can be prevented, one should do something; but

after the deed has been done, the best is to treat it from an aesthetic point of view.

> A sad thing it was, no doubt, very sad; but we can't mend it. Therefore let us make the best of a bad matter; and as it is impossible to hammer anything out of it for moral purposes, let us treat it aesthetically, and see if it will turn to account in that way. . . . We dry up our tears, and have the satisfaction, perhaps, to discover that a transaction which, morally considered, was shocking, and without a leg to stand upon, when tried by principles of Taste, turns out to be a very meritorious performance. (MFA, 16)

This is why a murderer such as Williams, who terrified the whole of England after the cold-blooded massacre of two families in 1812, takes on the proportions of a criminal genius. He is not only a genius but a true artist. De Quincey's fastidious recreation of Williams's murder in the long 1854 "Post-Script" (MFA, pp. 70–124) is a climax of narrative art which anticipates techniques later developed by Truman Capote in *In Cold Blood* and by James Ellroy in a documentary thriller like *Black Dahlia*.

For de Quincey, even a moralistic personality like S. T. Coleridge should be able to enjoy a fire in London without seeing himself as an incendiary or a monster. One can legitimately become an arsonist of the Imagination. A city fire becomes a "luxury" that one should applaud or, in some cases, "hiss" as any performance that has "raised expectations in the public mind which afterwards it disappointed" (MFA, 14). Anything, even the vilest show can turn into a legitimate spectacle, which means that one is forced to re-examine the whole Kantian notion of disinterestedness, to question further the complex links connecting the analysis of the sublime and the discovery of moral laws via the limitations of the imagination.

Duchamp's imagination was fired by Mallarmé, Jarry, Lautréamont, Laforgue and Roussel; these are the only poets whose direct influence has been acknowledged by Duchamp, who did not enjoy Romanticism except in its later forms, since he had read Baudelaire closely as we have seen. Could one add Sade to the list of key writers, a Sade who insisted that crime is an irreducible "given" of human behaviour? Here is what Sade writes in *Philosophy in the Bedroom*:

> Let us deign for a moment to illumine our spirit by philosophy's sacred flame; what other than Nature's voice suggests to us personal hatreds, revenges, wars, in a word, all those causes of perpetual murder? Now, if she incites us to murderous acts, she has need of them; that once grasped, how may we suppose ourselves guilty in her regard when we do nothing more than obey her intentions? But that is more than what is needed to convince any enlightened reader, that for murder ever to be an outrage to nature is impossible.[74]

Duchamp is as Sadean as he is Mallarmean: in his art of "abolition", he never ceases in his outraging the public so as to follow the workings of an enigmatic and cruel Nature. As Derrida has suggested in *Given Time*,[75] the only "gift" that might remain outside the recuperation of "economies" would be the gift of time – a gift that borders perilously close to the gift of death. In a similar way, Duchamp's *oeuvre*, taken as a whole, engages with the fundamental conceptual issue of *data*. Are the "various facts" provided by everyday news sufficient data? Duchamp had practically stopped painting 1923, leaving his Large Glass in a state of final incompletion. If the Notes for "Given" look like Mallarmé's unfinished great Book, perhaps it is that both artists link abstract thinking with concrete realizations which look baffling in their enigmatic simplicity. Both have confronted the world of "low culture" and the trivia of daily newspapers when they saw found in press cuttings the presentation of "*fait divers*" that stimulated jaded imagination, forcing us to rethink the links between art, ethics and history.

Hegel had already announced that the word was "the murder of the thing", and that philosophy should "murder" art, or replace it by giving it a deeper meaning, a meaning of which it was unaware. Duchamp, following Mallarmé and de Quincey, also postulates that art can encompass everything. He is a logical Dadaist who needs the repeated murder of art in order for artists to stay alive. This is why, for him, as for Walter Benjamin against Adorno, there is no progress in the arts, no modernity that would be any more advanced than previous periods. On this point, Tzara, Picabia, Man Ray and Duchamp all agree. They have never stopped claiming, at least since 1920, that "Dada is not modern", contrarily to André Breton, who believed that a "modern spirit" could find its determinations and rhythms in history. This would force us to reexamine Duchamp's fundamental Dadaism, a Dadaism that he shared with Man Ray, an uneasy mixture of anti-art insofar as art is being practiced, and of perverse estheticism whenever everyday life came into play. Which is why Man Ray could debunk photography and consider it not to really be an art form, whereas painting was a true art. Similarly, Duchamp kept a critical attitude when facing photography, as his famous letter to Stieglitz from 17 May 1922 eloquently proves:

> You know exactly what I think about photography
> I would like to see it make people despise painting until something else will make photography unbearable –
> There we are.[76]

In that context, it is worth noting that the famous urinal shown briefly in 1917 at the New York Society of Independent Artists survived only thanks

to an "artistic" photograph made by Stieglitz, then published in a little magazine called *Blind Man* (an excellent title chosen by Duchamp as a way of fighting against what he saw as the domination of the "retinal" in art). Duchamp's subsequent experimentation with foto reliefs and kinetic art hint at what he had in mind as to the "something else" that in its turn would render photography obsolete and make the whole of "art" history. What makes art "unbearable" is not just photography in itself but what it can reveal and destroy at the same time (this might include murder), along with the development of technology, which implies computerized and digitalized reproduction. Duchamp's wish to use photography tactically, in order to destroy the esthetic mystification of retinal painting, is not far from Man Ray's strictures facing the medium in which he had illustrated himself fist and foremost. This double attitude is underpinned by a belief in truth, an unaccommodating truth leading to a rather monstrous Lacanian *Real* that one can only approach via horror and transgression.

We will return later to Duchamp's approval of pop-art, of Rauschenberg, Cage, and Andy Warhol in the sixties, in contrast to how he loathed the high modernist art and abstract expressionism. Duchamp's concern for the conditions of possibility of art, his insistence on a priori "givens" to the detriment of the purely "retinal" factor will be addressed via the influential writings of a critic whom he hated above all others, Clement Greenberg. What opposed Greenberg's modernism and Duchamp's modernity is Duchamp's idea that everything can become the object of art, even the most debased voyeuristic spectacle. Therefore, it is not sufficient to speak of the "death of art" – as a sort of historical ending – but one should go further, and want to murder art again and again. Duchamp's main weapon in that endeavour, the idea of the "ready-made", had already effectively collapsed any distinction between art and industrial production. He did not wish to identify a ready-made by intrinsic esthetic properties, as a formalist reading of the famous urinal seen as a pure beautiful oval design might still suggest to some critics. The fundamental concept of the ready-made is to reach "total anesthesia" and to produce the "freedom given by indifference" (DDS, 191). Thus, to the "aided ready-mades" and the "reciprocal ready-mades" that Duchamp contemplated producing in the twenties, one should add a new category: the "tabloid ready-mades". This category would include "Given" insofar as it uses a tabloid photograph to get rid of personal and emotional overtones, like having to say farewell to Maria Martins, who left Duchamp when she returned to Brazil. It exploits and denounces at the same time the spectator's voyeurism while questioning the basic apparatus of the classical perspective upon which it is founded.

Without the theatricality of binocular vision and the urge to return to

a mother nature emblematized by a woman's open vulva, there would not be the tinge of perversity in artists and spectators alike. Duchamp kept repeating that it was the watcher who made the picture. No spectator can be sure that he or she is not just playing with the body of the mother, as a Kleinian child is wont to do; that is with scissors and needles rather than by caressing it. Talking of novelists – but one could apply the insight to any artist – Barthes writes that their main concern is to "play with the mother's body . . . in order to glorify it, to embellish it, or in order to dismember it, to take it to the limit of what can be known about the body. I would go so far as to take bliss in a *disfiguration* of the language, and opinion will strenuously object, since it opposes 'disfiguring nature'."[77] This disfigured nature still gives, to be sure, but it is the given-ness of an Arcadia in mourning, haunted by Death and transgression. Since "giving" hesitates between "giving the world" and "giving death", all these gifts will have to be enjoyed via disguises and transvestitism. This is why one can see Duchamp photographed posing as a woman named "Rrose Sélavy". *Eros, c'est la vie*, no doubt; although life is not always that *rose* (pink), it nevertheless feeds dialectical flowers in spiraling dialectical images. It is our task to make sense of them.

chapter 3

Scene of the Crime

Nothing to see!

Interiors: The serendipity of the closed room

In *One-Way Street*, one of Walter Benjamin's most literary texts, a decidedly modernist collection of dreams, epiphanies and city panoramas, one section evokes the bourgeois furniture typical of the end of the nineteenth century. The title borrows ironically from real-estate advertisement language ("Manorially Furnished Ten-Room Apartment") before unleashing a sequence of subjective images that could be compared with Aragon's dream-like associations in *Paris Peasant*. Benjamin's fancy takes him from the machinery of fin-de-siècle furnishings, the world of stuffy boudoirs, gaslit corridors, sturdy marble tops, drooping candelabras, squat ormolu clocks under glass, musty bedrooms locked from within, the decor that Mallarmé would stage so well in his dense allegorical sonnets, to the world of popular fiction rife with tales of murder and detection:

> The furniture style of the second half of the nineteenth century has received its only adequate description and analysis in a certain type of detective novel at the dynamic center of which stands the horror of apartments. The arrange-ment of the furniture is at the same time the site of deadly traps, and the suite of rooms describes the path of the fleeing victim. That this kind of detective novel begins with Poe — at a time when such accommodations hardly yet existed — is no counterargument. For without exception the great writers perform their combinations in a world that comes after them . . . The bourgeois interior of the 1860s to the 1890s — with its gigantic sideboards distended with carvings, the sunless corners where potted palms sit, the balcony embattled behind its balustrade, and the long corridors with their singing gas flames — fittingly houses only the corpse. 'On this soda the aunt cannot but be murdered.' 'The soulless luxury of the furnishings becomes true comfort only in the presence of the dead body.' Far more interesting than the oriental landscapes in detective novels is that rank Orient inhab-iting their interiors. . . . This character of the bourgeois apartment, tremulously awaiting the nameless murderer like a lascivious lady her gallant, has been penetrated by a number of authors who, as writers of 'detec-tive stories' — and perhaps also because in their works part of the bourgeois

pandemonium is exhibited – have been denied the reputation they deserve. The quality in question has been captured in isolated writings by Conan Doyle and in a major work by A. K. Green. And with *The Phantom of the Opera*, one of the great novels about the nineteenth century, Gaston Leroux has brought the genre to its apotheosis.[1]

Benjamin is thinking here of Anna Katherine Green's famous thriller, which followed in the steps of Poe, Collins and Gaboriau, her first major novel, *The Leavenworth Case* (1878). In what remains Green's best-known novel, the unexplained murder of a rich old man who has been shot in the library of his New York mansion offers an original variation on the theme of the locked house. Here, the murderer is hidden among the retinue of family members and secretaries; the first discovery of the corpse triggers a curious de-doubling of personality for the young clerk who narrates the tale and ends up playing the part of involuntary detective when, right at the outset, he realizes that the splendor of the décor merely hides another reality in which intrigue, passions and secrets give the lie to bourgeois respectability:

> I found myself experiencing something of the same sensation of double personality which years before had followed an enforced use of ether. As at that time, I appeared to be living two lives at once: in two distinct places, with two separate sets of incidents going on; so now I seemed to be divided between two irreconcilable trains of thought; the gorgeous house, its elaborate furnishings; the little glimpses of yesterday's life, as seen in the open piano . . . occupying my attention as fully as much as the aspect of the throng of incongruous and impatient people huddled about me.[2]

It will take some four hundred pages before we discover that the disinherited niece all clues point to as the culprit, was innocent, whereas the real villain is none other than Trueman Harwell, an apparently perfect secretary. Out of the extremity of an unrequited love for Leavenworth's beautiful niece, Harwell wanted her to inherit the fortune that she had been unfairly denied, acting upon her silent rage at being left without any means. Close to the *dénouement*, and in order to save her from the detectives who pretend that they are going to arrest her, he blurts out that he killed the stingy uncle. In the confession that sends him to the gallows, he clearly states that any forthcoming fortune will stink of murder, thus literally damning money and riches: "every dollar that chinks from your purse shall talk of me. Every gew-gaw which flashes on that haughty head, too haughty to bend to me, shall shriek my name into your ears. Fashion, pomp, luxury – you will have them all; but till gold loses its glitter and ease its attraction you will never forget the hand that gave them to you!"[3] Thus we witness a de-doubling:

the gilded bourgeois décor betrays the welter of unholy passions that leads to crime, and the "happy ending" of the story nevertheless keeps on indicting money, or more specifically, capital as inherently tainted by bloody extortion and ruthless exploitation.

The rich uncle incarnates the Freudian father, the totemic god or the dominant male of the horde whom *everybody* has a motivation to kill. Everyone has to be suspected; this is the basic law of the genre. The intellectual parlour game consists of narrowing our gaze to the character who looks most innocent – no doubt, he will turn out to be the murderer. On the other hand, there is no tear wasted on the corpse – on the contrary, the dead body legitimizes the scandalous accumulation of wealth that he represents, only because he lost it. Benjamin's assertion that, "The soulless luxury of the furnishings becomes true comfort only in the presence of the dead body," provides indeed a good summary of Green's masterpiece. The accumulation of signs that forces us to re-read an entire family history is also a material accumulation of power that calls for obliteration. However, this obliteration is announced or betrayed by countless objects, lost or hidden keys with a missing corner, creaking cabinets, musical chairs or yawning doors opening and closing at night, drawers with a loaded gun next to a bed, half-empty glasses of sherry next to a dead body, and so on. This is why an authentic detective will convey to transfixed readers the floating sensation of being under ether similar to the dominant mood of "Hashish in Marseilles", the wonderfully autobiographical piece which Benjamin concludes with a flourish and an appeal to generosity – "that squandering of our existence that we know in love".[4] The *Leavenworth Case* offers us "ether in New York", the freely floating dream of being a sleuth who tracks a murderer, which leads us to view our surroundings in a new light. In that context, the revisionist view on all appearances, endowed with a new shine, bathed in a sharper aureatic glow, is only be brought about by crime. The novel agency brought about by murder generates a particular elation that approaches closely the surrealist state of double vision, daydreaming and hallucinating mystical signs in an everyday setting. Such an elation comes from the superimposition of humdrum tokens of bourgeois accumulation and the knowledge that all this can be swept away in one gesture, that its staid solidity is more fragile than its seems, that it is always at the mercy of the ineluctable murderer hidden in the shadows.

Murder is productive violence in so far as it appears inseparable from a certain set-up, a staging of details that add up to create a whole scene. This is why in many novels by A. K. Green (among others), we are given a diagram or map of the houses or rooms. This is the case in *The Leavenworth Case*, in which a map of the rooms[5] makes it clear that the number of

suspects is limited and illustrates, too, why no-one could have left the house after the murder. In *The Woman in the Alcove* (1906), Green goes one step further, providing a particularly complicated diagram to show how a woman sitting at a dinner party table can have seen in a revolving window facing her the reflection of a mirror that reflected in a flash the instant a murder was committed![6] As Benjamin has noted, the real precursor in these matters is Edgar Allan Poe, who single-handedly invented the genre of the "detective novel" that became so popular at the end of the nineteenth century.

It comes as no surprise to see Benjamin alluding regularly to Régis Messac's compendium, *Le "Detective Novel" et l'influence de la pensée scientifique*[7] in his *Arcades Project*. Messac had already authored a book on Poe and French literature, and he insists upon Poe's centrality for the whole century. Benjamin refers to this bulky survey, spanning the whole period from Biblical and Arabic storytellers to the inception of modernity, at least seven times in his *Arcades Project*, while many other entries owe insights or quotes to it; it is clear that the genealogy of the genre provided by Messac develops earlier glimpses, like the excerpt from *One-Way Street*. Messac studies the genre of the "detective novel" defined as rigorously as possible by the process of "detection" at the expense of all other features. What matters for him is not the fact that a detective often intervenes after a murder, but that he should take up the ancient art of examining traces left by high deeds or crimes, inducing from them a true "reconstitution". The temporal sequence is reversed by an intellection which follows the gesture from its genesis (the intention) to its consequences (the crime, the murder or attempted murder). Whenever some abnormality has taken place, however startling or baroque it may be, it can be reduced to a number of revealing signs which will have to be interpreted in the right order, without missing any steps. Then the only remaining "x", the identity of the culprit, will be revealed.

Messac's paradigm is the tale narrated in chapter three of Voltaire's *Zadig*, in which the hero is thrown into jail because he has described the king's horse and the queen's dog without having seen them. Voltaire has used an ancient anecdote that has many variants among which is a version given by *A Thousand and One Nights*. In all these, the three princes of Serendip are similarly jailed for their apparent knowledge of the lost camels. The tale's origins are uncertain, they could be Arabic, Jewish, Greek, or even Persian, but all its versions rehearse common features: three brothers are generally able to induce from traces left by camels or horses (the way the grass has been eaten, the depth of their holes left by their feet, the broken branches on one side, the little pools of urine or other liquids left behind,

etc.) who the ladies carried on the camels were, what their ages and appearances were. Messac opts for an Arabic source, given the prevalence of princes, camels, and details of a Bedouin-inflected desert culture, and he connects this science of divination from exact observation to the term of "*Firasah*" – in other terms, physiognomy.[8] The three princes of Serendip are best known for finding exactly what they need without looking for it – an emblematic gift also bestowed on most detectives: before they even look for clues, they multiply around them, they just need to bend down and read. Serendipity is the boon of the sleuth for it blends happy accidents and trained sagacity.

The art of observing traces in the sand, in grass or in streets, and then of reconstructing what has taken place, is germane to the art of looking at animals when they run or eat in order to assess their qualities or defects. This double field of expertise has led to the age-old equation between the shapes of people's faces and animals they resemble, a pseudo-science already present at the time of Aristotle and which knew its heyday with Lavater. Messac thus sees in the progress of "detection" a burgeoning scientific spirit that came to maturity with the Age of Enlightenment. He observes rightly that since the emergence of Dupin and Sherlock Holmes, everyone speaks of "deductions" in order to describe the ratiocinative process aimed at reconstructing the criminal's actions, whereas this ought to be called more properly "inductions".[9] It is true that in 1913 the distinction between induction and deduction was more crucial and operative than today. The lament over the blurring of these concepts turns into a leitmotif in the book; indeed, a confirmation of the widespread malapropism, if one needed it, could be given by the title of chapter Three of *The Leavenworth Case*, typically entitled "Facts and Deductions".[10] Could it be blamed on the facile anaphora linking "de-tective" and "de-deduction"? To "detect" means literally to "uncover" by taking away the roof – it is as if the fantasy of transparent glasshouse (which Breton nurtured as the model of ethical life for a true Surrealist) would underpin the voyeuristic motivation of the typical sleuth.

Whatever the reason, Messac insists that the rise of the "detective novel" is contemporary with the flowering of the scientific spirit in the nineteenth century, to the point that Poe often compares his detection games to "pure" sciences like mathematics. Poe's Dupin, the ancestor of all famous detectives, marks the triumph of the thinker detective who remains in a room, smokes and thinks, trying to identify with the criminal. Messac has no difficulty in pointing out that Dupin is much more cerebral than Sherlock Holmes; the latter seems indifferent to other sciences that those he can use and will resort to more traditional ways of catching his preys, like having

someone tailing a suspect or using guess work based on other cases he has seen. It was Poe who famously praised Godwin for having written *Caleb Williams* in reverse in his "Philosophy of Composition," who also guessed the correct *dénouement* of *Barnaby Rudge* as Dickens was still serializing it, and who concluded from an examination of Maelzel's mechanical chess-player that it could not be an automaton that played chess: there must have been a dwarf hidden in a complicated machine, placed in such an uncomfortable position that he was forced to play with his left hand. The "solution" given to the ancient historical riddle will not be lost on Benjamin – Poe's text underpins the simile with which he opens the "Theses on the Philosophy of History": "The puppet called 'historical materialism' is to win all the time. It can easily be a match for anyone if it enlists the services of theology, which today, as we know, is wizened and has to keep out of sight."[11] Similarly, the art of the detective is a modern adaptation of earlier religious divination or ancient haruspicy.

Messac discusses the Dupin trilogy, "Murders in the Rue Morgue", "The Purloined Letter" and "The Mystery of Mary Roget", as these three short stories established the genre of the detective novel. He points out that the name "Dupin" was borrowed by Poe from Vidocq's spurious but famous *Memoirs*, translated into English almost as soon as they were published in French from 1828. There, Vidocq alludes to "that great prognosticator M. Charles Dupin."[12] Indeed, Poe's Dupin is seen engaged in endless calculations when not solving chess problems. Messac does not take these too seriously: "*The Purloined Letter* is algebra if one wants, but then it is really elementary algebra."[13] Poe flaunts his scientific knowledge which entails mathematical computations, whereas most of the time the only science he uses is simple psychology – this is why Dupin's supputations on schoolboys who play a game of odd and even (they have to guess whether the number of marbles in one fist is odd or even) are based on a classical psychology. The calculated expectancy of the next move is systematic guesswork founded on the adversary's sophistication, or lack of, on his or her level of cunning. As the narrator concludes, "It is merely an identification of the reasoner's intellect with that of his opponent."[14] The same guided guesswork applies to Dupin and his friend at the beginning of "The Murders in the Rue Morgue." Dupin reconstitutes the entire chain of thoughts of his friend because he has observed his face, his expressions, and the posters he has glanced at in passing. A similar psychology of imitation sends us back to physiognomies: if I can imitate the expression your face makes, I will reconstruct your chains of thoughts.

Moreover, the psychological acumen needed by Poe's French sleuth seems once more derivative from Vidocq's *Memoirs*, which at any rate acted

as a trigger for Poe, the devoted solver of riddles. The fundamental thesis of *The Purloined letter* is that one hides best by not hiding at all. Dupin guesses this truth when he hears that the police, despite a remarkably systematic scrutiny of the house, have been unable to find the letter hidden by the scheming minister. By pure "deduction" in this case, Dupin surmises that the letter will be all too obviously visible, if only he reads well – and indeed, when he manages to pay a visit to the said Minister under a trifling pretext, he finds the letter upside down, the paper folded back and merely scribbled over with another address. He is thus able to steal it and replace it with a similar-looking letter. In fact, Poe owes probably the central insight to Vidocq's *Memoirs* – although, it is true, in a style that makes it sound trite: "If you are forced to leave your home for some time, find a place to hide your most precious possessions; the most conspicuous place is quite often the place that no-one will want to search."[15] If, for Poe, the terms of "induction" and "deduction" are at times interchangeable, it is because his "science" owes little to calculus and algebra, but relies more heavily on Humean and Lockean laws of association of ideas. Mathematics is replaced by pseudo-sciences like physiognomy, but the sleuth's sagacity needs as a protective disguise the parading of scientific jargon. However, Dupin does not resort to mere guesswork. In fact, guessing would be to deduce abstractly from general truths, whereas he starts from reports about traces (or their absence). When he interprets these correctly, his inductive process falls in conformity with ancient logic. Sherlock Holmes understood the lesson given to him by Dupin (although he often criticizes him snidely) when he states: "I never guess. It is a shocking habit destructive to the logical faculty."[16] What remains moot is that Dupin needs to remain in a room and think, reconstructing the various laws that govern the appearance of *faits divers* (one will have recognized echoes of another sleuth, Duchamp, whose name ominously echoes that of Dupin). It is this double knowledge that leads him to the solution of riddles and mysteries like that of the purloined letter. Dupin is the archetype of the *détective en chambre* who plays chess with himself, a type that surfaces again with Sherlock Holmes and Hercule Poirot, both never too far from the character invented by Paul Valéry to summon up the passion of pure ratiocination, Monsieur Teste.

God said: "Abe, Kill me a son!"[17]

Adorno could be telling Benjamin: "One should never guess. It is a shocking habit destructive to the logical faculty." In fact, this is more or less what he says to Benjamin in his 1933 book on Kierkegaard when he

grapples with expressions like "baroque thinking", "allegory" and "dialectical image." These concepts are turned against themselves as Adorno tackles post-Hegelian philosophy. Through this, Adorno reveals himself as a master sleuth and philosophical detective. The obvious suspect is Kierkegaard. It is not that Adorno wants to catch him confessing to a new crime after his own staged and masterminded throughout "seduction" and desertion of a bride. But he finds it important to understand why *The Diary of a Seducer* is a necessary preliminary stage before the religious turn. The main suspect, the brain hidden behind all these obfuscations and sleights of hand, is elsewhere. Adorno begins by stating that Kierkegaard, who keeps attacking Hegel, is much more Hegelian than he thinks; for instance, he betrays his Hegelianism when he tries to constitute the domain of esthetics as a separate field – thus expanding Hegel's dialectics in the direction of concrete immediacy. As Ellison's book shows,[18] Kierkegaard completes the system where it is lacking and points out its fault-lines. He teaches Hegel how *not* to think abstractly. However, it soon transpires that behind Kierkegaard, Walter Benjamin is hiding; it is the Benjamin who has been taken to task by Adorno and his friends of the school of Critical Theory for his non-dialectical materialism, for his reliance on imagery, and for his direct investigation of raw historical facts.

In that context, Kierkegaard's concept of interiority is shown to have been generated by a dialogue of the philosopher with himself: the inner self is produced by a thinker whose defect is to spend too much time talking to his mirrored image in a bourgeois salon. The *intérieur* is a mental space as well as a physical one. Kierkegaard is a paradoxical *flâneur* who does not roam the streets but stays *en chambre*, just pacing up and down in his study, which tends to confirm that idealist metaphysics is but a variation on the plot of the locked chamber. Adorno quotes a biographer: "How his fantasy developed, aided by the arts of disguise and imagery, during promenades in the parlor, how it ran wild! – in the parlor! Everywhere one looks in Kierkegaard, one finds something undeniably shut-in; and out of his prodigious oeuvre there comes to us the small of the hothouse."[19] As a young man, when the philosopher asked to be allowed to go out, his father would simply walk with him up and down the hall, and conjure up an entire urban landscape, complete with cars passing by noisily, friends greeting them, cakes in the windows of bakeries. Adorno comments: "Thus the *flâneur* promenades in his room; the world only appears to him reflected by pure inwardness."[20] Inwardness is generated by the bourgeois *intérieur.*

A passage of *The Diary of a Seducer* is taken as emblematic of the whole *oeuvre*: Kierkegaard describes Cordelia as symbiotically identified with her *intérieurs*, her drawing room, her house, her bedroom, the lampshades,

carpet, decorated trinkets of her house. Adorno's comments would be valid for most "detective novels" in which the agency of crime is enough to transform the flotsam of every day kitsch into some form of organized totality and beauty: "The lamp shaded like a flower'; the dream orient, fit together out of a cut paper lampshade hung over its crown and a rug made of osier; the room an officer's cabin, full of precious decorations greedily collected across the seas – the complete *fata morgana* of decadent ornaments receives its meaning not from the material of which they are made, but from the *intérieur* that unifies the imposture of things in the form of a still life."[21] Evidently, this page had to find its way in Benjamin's notes for the *Passagenwerk*[22]. Pascal had already said that all the ills of humanity come from the fact that men are unable to sit quietly in a room. Here, humble and mute things in the room once again speak – but only under threat of death. Then they can tell stories other than those spun by the logics of capitalistic reification and commodification. Similarly, murder precipitates the semblance of a pseudo-nature into a process that will have to be re-historicized. The threat of death made palpable by the presence of the serial murderer lurking in the shadows of the room or corridor is thus a figure of a more fundamental metaphysical threat by which we are reminded of our fated demise. And Kierkegaard breaks up abruptly with his intended fiancée, thereby committing a "crime" against bourgeois decency, so as to ward off the irresistible temptation to murder her in her closed boudoir.

In the same way, Benjamin had discovered in Kafka the lineaments of a "theology in the detective novel" – as he writes, quoting a book by Willy Haas.[23] After all, Kafka's *Trial* is the ultimate metaphysical variation on the detective novel: we know that the hero is guilty, he will pay for this with his life, and the only unknown factor is the exact nature of the crime that he has committed. Kierkegaard, too, treats the Bible as an awe-inspiring serial detective story. His main meditation on ethics and religion in *Fear and Trembling* starts with Abraham's swift agreement to do what God orders him; when he hears God's command to sacrifice Isaac, he does not even think about it, he simply obeys in silence. This silence, echoed in the pseudonym taken by the author, Johannes de Silencio, is the true mark of faith: "There is also another reason why Abraham cannot speak, for in silence he is continually making the movement of faith; this (if he were to speak) they could understand even less, since he would thereby contradict himself."[24] The frightful pathos of this moment is the source of an abyss – a treacherous and yet exhilarating passage through absolute singularity. Silence means inwardness – but it could also be the psychotic resolve of Wieland,[25] who has heard a voice telling him to kill all his family in Charles Brockden Brown's famous gothic novel of the same name. Wieland acts upon this

voice, and after having savagely slaughtered his two children and his wife, attempts to do the same with his sister, Clara. The plot discloses that the voice he heard had nothing divine but issued from the ventriloquist whisper of an evil character called Carwin. American newspapers from the nineteenth century are full of stories of sudden killing frenzies seizing all too religious men or women who all of sudden heard God's command to kill such and such a family member.

Kierkegaard does not seem to have read *Wieland*, but he echoes the novel when he elaborates on his philosophy of immanent interiority; he discovers that the silent instant of decision, the threshold before the act when murder is possible, just before the moment of God's intervention, is a suspension that literally abolishes the opposition between the subject and the object (hence the telepathic voice). Such a brief moment of "indifference" requires either a myth or simple faith, a belief in something eternal like God or Nature, in order to be anchored with a minimum of stability. In that sense, Kierkegaard's religious existentialism announces Benjamin's knotted articulation of myth and imagery – an articulation in which, according to Adorno, dialectics come to a standstill, which petrifies history by returning to elementary archaisms. "Dialectic comes to a stop in the image and cites the mythical in the historically most recent as the distant past: nature as proto-history."[26] Adorno sees the image as bringing dialectic and myth to a point of indifferenciation, thus giving birth to "antediluvian fossils". As Philip Gosse had suggested, the real question is: can these images become truly dialectical or historical again? No – the answer must be, because they are "allegories" and blend the dialectics of history with a mythical nature. Adorno concludes that these allegories present us the *"facies hippocratica* of history, a petrified primordial landscape."[27]

This passage from Adorno's book on Kierkegaard quoting Benjamin is then literally quoted again in *The Arcades Project*, without any commentary, although one is announced.[28] It was to be inserted in a section devoted to the "Refuse of History" (*Abfall der Geschichte*).[29] Such "refuse" or "trash" will be read – that is Benjamin's ray of hope, against Adorno's neo-Hegelian upbraiding – by the sleuth who acts in a Freudian manner when he pays attention to what is commonly omitted: nail clippings, torn envelopes, wrapping papers, scratches on a wall. Is thus Benjamin's flâneur a detective? A New Historian? Or both? In this case, the precise answer to the gap opened by Adorno is given one page later in the same N section, in a passage that enlists Ernst Bloch to counteract Adorno's strictures: "A remark by Ernst Bloch apropos of *The Arcades Project*: 'History displays its Scotland Yard badge.' It was in the context of a conversation in which I was describing this work – comparable, in method, to the process of splitting

the atom – liberates the enormous energies of history that are bound up in the 'once upon a time' of classical historiography. The history that showed things 'as they really were' was the strongest narcotic of the century."[30] The revolutionary impact of such a materialist and allegorical history is compared with the invention of the atomic bomb; by abandoning any illusion of historical objectivity and by refusing to bend facts to accommodate the dialectical becoming of Spirit, the detective re-reads history patiently and productively as a field of half-erased or discarded traces, thereby reconstructing a plot while letting the details radiate. Petrified ruins explode, their atoms whirl in the light of a new sun, a new mode of "detective" intellection is created.

Exteriors

Benjamin's solution to these quandaries was to look for a dialectical image that would be powerful and encompassing enough, and the main one he has found is that of the Paris arcade – a *passage* whose main characteristic is that the interior and the exterior are impossible to distinguish as they literally bleed into one another. The arcades, these precursors of today's malls, are both streets and houses, one can use these shortcuts between major thoroughfares to avoid the rain and gawk at shop windows and allow oneself to be tempted by a cake, a drink or a prostitute (as Aragon does when he narrates quite innocently his rapid visit to an arcade brothel in *Paris Peasant*). The arcades become almost a fetish for Benjamin, who notes that their apex was in the middle of the century and that the introduction of a new type of lighting killed much of their charm, leading to their relatively rapid disaffection.

The original aura of the arcades was partly due to their old-fashioned gas lighting. As Benjamin had discovered, the first gas-lamps of Paris were installed in the arcades. "The appearance of the street as an *intérieur* in which the phantasmagoria of the *flâneur* is concentrated is hard to separate from the gaslight."[31] What was a token of modernity in the middle of the nineteenth century soon became obsolete with the arrival of electricity. Benjamin blames the "white fairy" for the rapid decadence of the Paris arcade:

> So long as the gas lamps, even the old oil lamps were burning in them, the arcades were fairy places. But if we want to think of them at the height of their magic, we must call to mind the Passage des Panoramas around 1870: on one side, there was gaslight; on the other, oil lamps flickered. The decline sets in with electric lighting. . . . The inner radiance of the arcades faded

with the blaze of electric lights and withdrew into their names. But their name was now like a filter which let through only the most intimate, the bitter essence of what had been.[32]

Already by the turn of the century, the arcades were synonymous with urban nostalgia, had become "Louis-Philippe", their small stores a far cry from the new bazaars and huge department stores that Zola would illustrate so flamboyantly in *Au Bonheur des Dames*. This nostalgia for an already decayed urban kitsch also runs through Aragon's *Paris Peasant*.[33] As we have already observed in the context of Duchamp's *Etant Donnés*, there is a typically Surrealist yearning for the dioramas of the nineteenth century. It is because, above all, they seem to truly embody our dreams? "Arcades: houses, passages, having no outside. Like the dream."[34] Whose dream is this, then? Could it be Napoléon's posthumous dream? Or the unknown soldier's restless flame? "When Napoleon was interred in the church of Les Invalides, the scene lacked nothing: in addition to velvet, silk, gold and silver, and wreaths of the immortals, there was an eternal lamp of gas over the resting place."[35]

Given the low and flickering light, crime was, of course, rampant in the arcades, since the attention of strollers was often diverted by shows, exhibitions and encounters of all kinds. Most of them closed down at night. Prostitution was rife. Thus, when Aragon and Breton attempt to revisit the old arcades and make them fashionable once more in the 1920s, the former dwells upon the hints of criminality and lets his imagination roam towards America. *Paris Peasant* evokes the advantages of Café Biard, one of Aragon's favorite hang-outs next to the café Certa in the Passage de l'Opéra. Café Biard is praised for the fact that it is open on three sides, one leading to the passage that Aragon baptizes "Passage du Thermomètre", the other to the Boulevard des Italiens, and that it is entirely decorated with mirrors: "with your pillars and your mirrors you constitute a beautiful palace of reflections that calls up a whole image, for us European dreamers, of distant America and its bloody epics. You are the backdrop for murder in hiding, projected attacks, hot pursuits and deadly traps."[36] The trope of murder renders a place exciting, even if, like the Berlin rooms called up by Benjamin, murder remains totally hypothetical, a potential threat that is immediately recaptured by the clichés of Western stories.

Here Aragon hits by chance – and again, one sees an effect of serendipity – upon the main thesis developed by Messac's book on detective fiction, published three years after *Paris Peasant*: the murder story, the detective fiction, the penny newspaper's gory depiction of crime scenes, are all transpositions to an urban setting of a frontier world of adventure

and "tracking" invented by James Fennimore Cooper with Indians as main protagonists. The immense resources of observation and sagacity deployed by Cooper's Mohicans in their forests when they had to interpret the signs left by the enemy party, are used in an urban setting by the new figure of the detective. This had been systematized in the Alexandre Dumas novel *Paris Mohicans* (1854) and with Gaboriau, who writes in *L'Affaire Lerouge* (1866): "Having read the memoirs of famous policemen, I grew enthusiastic for these men whose sense of smell was more subtle than silk, who were lithe like steel, shrewd and cunning, full of unexpected inventions, who followed crime with their codes in their hands through the underbrush of legality just as Cooper's natives pursued their enemies in the midst of American forests."[37] Paul Féval had transcribed more or less literally the adventures of Natty Bumppo and Leatherstockings in *Les Couteaux d'Or*. We meet among the Parisian streets a tattooed dog called Mohican; in the suburbs there is a duel of hunters in the best Wild West tradition; and a real redskin named Towah even kills and scalps four enemies in a moving hansom so deftly that the driver never sees anything. The big city, evoked in all its details by Balzac, becomes a field as full of signs as the American forest, and new variations on the hunters, preys, sheriffs and outlaws emerge, decked in urban clothes.[38] Féval's novel, *Les Habits Noirs* (1863) systematizes the comparison, and it recurs under the pen of Victor Hugo in *Les Misérables* (1862). All these policemen and private detectives are "pathfinders" whose amazing "woodcraft" is borrowed from Chingachgook and his Mohican friends. The old antagonism of Javert and Jean Valjean in *Les Misérables* proves that a true policeman, like a good bloodhound following its track (the etymology of the "sleuth" is connected to the famous dog) never abandons his prey. And old wrapping paper around a candle will be sufficient to retrace the whereabouts of the storeowner who sold it and thus get a faithful description of a gang of thieves who will all be arrested.

Gustave Aimard completes the process when he depicts a real Comanche walking on the streets of Paris in *Les Peaux Rouges de Paris* (1888). Nevertheless, the Comanche Tahera will take lessons in detection from Zumeta, who gives as an example not the Indians of the West but the gauchos of the South, in the pampas of Argentina, and the *rastreadores* (those who discover traces) who apply to the tangled streets of Buenos Aires the tricks they have learned in the open.[39] All this no doubt accounts for the emergence of the designation of Parisian "apache" for the tough guys of the popular quarters, all ready to fight with a knife, at the turn of the century. Messac notes as well that the influence of Cooper passed from Balzac and Baudelaire and to the prolific *feuilletonnistes* of the last two decades of the

nineteenth century, whereas there is no direct link between Poe and Conan Doyle. On the whole, Cooper and Poe have had a much more important impact in France than in England, protected by its insularity and resolutely sticking to its own tradition shaped by *Caleb Williams* and Dickens and later refined by Wilkie Collins.[40]

Finally, it is the combination of the two American writers who are rigorously contemporaneous, since in 1841 Cooper published *The Deerslayer* and Poe the "Murders in the Rue Morgue," that gives to the Baudelairian flâneur an air of the idling "private" detective. This we can see in Poe's "The Man of the crowd." Benjamin's reading is at first glance surprising, since he stresses the element of detection that is not immediately clear to first time readers. "Poe's famous tale 'The Man of the Crowd' is something like the X-ray picture of a detective story. In it, the drapery represented by crime has disappeared. The mere armature has remained: the pursuer, the crowd, and an unknown man who arranges his walk through London in such a way that he always remains in the middle of the crowd."[41] The story is well-known: a convalescent man simply enjoying his regained health ("Merely to breathe was enjoyment"[42]) observes the crowd from a safe vantage point in a London café conveniently located on a busy thoroughfare. At first, he seems simply eager to engage in a variation on Balzac's "physiognomies" as he observes the "tides" and groundswells of the crowd and narrow his attention to specific details. Balzac's 1833 *Theory of the Walk* could have served as model for Poe. Balzac's narrator insisted that his *"Théorie de la demarche"*[43] provided a new science, blending sociological observation and metaphysical deductions. In order to classify the many "codes of walking" which yield a new understanding of the workings of social life, one simply needs to analyze bodies in movement, their attitudes and dresses. To implement this program, he spends one day on a boulevard observing and describing Parisians who pass in front of him. Of course, the French word *démarche* is richly amphibologic in nature: it suggests both "gait, way of walking" and "steps, method, progression".

Here, in a London setting, the exercise in Balzacian physiology or physiognomy appears to be a training course for a would-be detective capable of making sense of the most minute of details. In his radiography of social classes, he starts with categories of clerks, briefly glimpses at nobility and then goes down to the lowest levels of prostitutes and drunks. He focuses, at one point, on gamblers and lists their characteristics: "There were two other traits, moreover, by which I could always detect them: a guarded lowness of tone in conversation, and a more than ordinary extension of the thumb in a direction at right angles with the fingers" (CTP, 477). Here is physiognomy once more masquerading as sociology. Finally, his gaze is

attracted by an older man whose countenance is completely different from any of the previous types he has seen; he seems to embody absolute "idiosyncrasy", pure singularity: "Any thing even remotely resembling that expression I had never seen before" (CTP, 478). The features he lists are all contradictory, shifting from "mental power" to "blood-thirstiness", from "coolness" to "terror" and "despair". Unable to seize him up or pigeonhole him, the narrator decides to follow him. What he discovers is that the old man simply drifts about with the crowds, always choosing the streets where there are most people. He is not looking for something or someone in particular in his frantic wanderings; he simply craves the anonymous company of the mass, to the point that he finds shelter in the red-light district of the East End, with its streetwalkers and gin palaces, until he is forced by daybreak to return to the centre of the city. Mortally exhausted, the narrator finally tries to stare directly at the old man but he does not even stop, hurries along in his quest of the throng. The narrator is forced to conclude: "'This old man,' I said at length; 'is the type and the genius of deep crime. He refuses to be alone. *He is the man of the crowd.* It will be in vain to follow; for I shall learn no more of him, nor of his deeds. The worst heart of the world is a grosser book than the 'Hortulus Animae', and perhaps it is but one of the great mercies of God that '*er lasst sich nicht lessen*'" (CTP, 481). The tale closes as it had opened, with the German quote, which translates as "he does not let himself be read". In fact, the tale is a story of failed detection as we will never learn the man's secret; Poe suggests that it is as well, since our "little garden of the soul" contains far worse nightmares than the teeming horrors of the world around us.

As a story of detection, "Man of the Crowd" repeats the pattern of the "Purloined Letter," in which we merely study a trajectory, a circuit devoid of content, the circular displacement from legitimate addressee to the intervening minister who steals the object, until Dupin steals it again, and gives it back while leaving a duplicate with a different text in the same place. We will never be privy to the contents of the letter, much as the few elements we learn about the "man of the crowd" are too sketchy to create a consistent portrayal – does he even really carry a diamond and a dagger? What remains of the usual trappings of the gothic genre is muted; what counts is to produce a pure blueprint, a scheme, a simple pattern – crime is defined in a metaphysical perspective as the consequence of the horror at being alone. If La Bruyère's epigraph states it already ('*Ce grand malheur, de ne pouvoir être seul*', CTP, 475), it is not immediately clear why such existential despair should push someone to crime, unless Poe wishes to suggest that the old man will do anything so as to be put in jail and stop his endless wanderings. True, English jails were rather crowded then, unlike the model

penitentiaries as panopticons that were built in Philadelphia and elsewhere and relied on the total isolation of the prisoners.

However, an overarching urban environment is crucial to the Dupin stories: the closed drawing room in which one meditates finds an extension of itself in the streets. The two friends are shut off from the street noise during the day, but at night they wander: "The we sallied forth into the streets, arm in arm, continuing the topics of the day, or roaming far and wide until a late hour, seeking, amid the wild lights and shadows of the populous city, that infinity of mental excitement which quiet observation can afford."[44] Is the old man who cannot live alone and needs the bustle of the crowd as a sort of oxygen, in fact a flâneur, as Baudelaire thinks, or something else? Benjamin disagrees with Baudelaire, since for him the "man of the crowd" cannot be a true *flâneur*, as he is too sick or addicted, too hurried or in desperate need of company to fit in with the pattern of leisurely walks along arcades. On the other hand, the "convalescent" author of the tale, he who lets his gaze float on the crowd and finds an interesting character to meditate on, and perhaps to pursue until the end, is a *flâneur*. During the pursuit, the narrator's fever flares up as rain starts falling: it becomes clear that the old man's anxiety has started contaminating him. Finally, he understands that the old man embodies the spirit of the crowd insofar as a crowd is also a reflexive entity, which often becomes a spectacle to itself.

The term *flânerie* supposes both leisure and a vague quest, even if it is a mere pretext to distraction. Here, the process has split into two agents, a paroxysm of hyperbolic transformations of the initial motivation, a quest for nothing but human proximity, a quest in which crime lurks, and a quest for the criminal, even before any crime is committed, just to sustain the "convalescent's renewed interest" in the simple fact of being alive. By this double exaggeration, Poe manages to make the crowd come alive both as a machine and as a Nature: the crowd is a "tumultuous sea of human heads", it turns into a sea, an ocean, it has its own laws of attraction, its regular ebbs and flows. But its rhythm is measured by a special clock, and this is when urban space becomes also a machine. Above all, it is ultimately inscrutable: like the old man, "*er lasst sich nicht lesen*", the crowd is a text that does not let itself be read. This renewed opacity entails the need for new and better instruments to pierce the darkness. Even if photography was not yet able to provide "snapshots", this is the future technology that the narrator wishes he had when he comments on his prodigious observation skills: "although the rapidity with which the world of light flitted before the window prevented me from casting more than a glance upon each visage, still it seemed that, in my then peculiar mental state, I could frequently read, even in that brief interval of a glance, the history of long years" (CTP, 478).

Photography and the Scene of the Crime

If keen attention to all sorts of traces defines the specific competence of the sleuth, he must pay attention to infinitesimal details like faint traces of paint, drops of blood on clothes, dust left by moved furniture and so forth. Thus Gaboriau's thriller *Le Petit Vieux des Batignolles* (1876) portrays a detective who compares himself to a camera: "My eye played the role of a photographic lens, the theater of the murder had been fixed in my mind as on a prepared plaque, with such a precision that no circumstance was lacking, with such solidity that even today, I could draw the flat of the little old man form the Batignolles without forgetting anything . . . "[45] The trope of photography used to describe the detective's total recall when a recent murder triggers an investigation, generates a more daring simile. A recurrent idea used by authors of popular detective fiction in the last decades of the nineteenth century is that the retinas of the victims keep a photographic image of the murderer imprinted upon them. The panic of the last throes following a violent assault transforms the eye into a dark chamber that freezes the last vision. To find the criminal's portrait, one has then simply to photograph again the eye's photography! Ponson du Terrail uses the conceit in *Les Tribulations de Shocking*, in which Rocambole convinces a judge that a person who dies fixes a last image as within a dark chamber. He photographs the pupils of the dead man, and they then represent not only the face of the murderer, but also the setting of the crime. Unhappily, Ponson du Terrail gets carried away: he describes both men, the victim and the killer, caught together in the same retinal photograph![46] The "camera eye", located in the transcendent point of view of the author, has been surreptitiously foisted on the dilated pupils of the startled victim. This same trope recurs some twenty years later in Jules Clarette's *L'Accusateur* (1897), a novel in which the posthumous photographic image taken from the retina, which accuses the killer, provides the hinge of the whole plot.

In his book on Charles Baudelaire, Walter Benjamin notes that the development of photography throughout the nineteenth century has been crucial for the emerging science of criminology, and he compares its influence to the invention of print. The detective story has been rendered possible by the fact that people can, from that moment, leave permanent traces behind them, evidence of their presence:

> Technical measures had to come to the aid of the administrative control process. In the early days of the process of identification, whose present standard derives from the Bertillon method, the identity of a person was

established through his signature. The invention of photography was a turning point in the history of this process. It is no less significant for criminology than the invention of the printing press is for literature. Photography made it possible for the first time to preserve permanent and unmistakable traces of a human being. The detective story came into being when this most decisive of all conquests of a person's incognito had been accomplished.[47]

Indeed, the use of photography for the identification of suspects caught during the Paris Commune of 1871 has been amply documented. This allows us to understand better Benjamin's imagery when he calls "The Man of the Crowd" an "X-ray picture of a detective story". In this story, no crime is committed: we have just the bare skeleton of criminality and the blueprint of detection, as it were. A good example of such an "allegorical" identification can be found in August Sander's photographs of the 1920s. Benjamin praises in fact Sander in his "Little History of Photography" (1931) for having "compiled a gallery of faces that is in no way inferior to the tremendous physiognomic gallery mounted by an Eisenstein or a Pudovkin, and he has done it from a scientific viewpoint."[48] His documentary project was to illustrate all the strata of German society, providing in effect the visual equivalent of what Poe wanted to achieve by simple observation: a list of all the trades, a series of faces with a date, nothing more. *The Face of Our Time* (1929) was to cover all levels of society and run to five hundred illustrations. The scientific view was precisely a combination of individual photographs, so many portraits of singular persons, caught up in an allegorical process of classification, and offering in the end an X-Ray of Germany in 1929. No wonder that the Nazis suppressed Sander's series when Hitler seized control of the country in 1933.

What is remarkable when one reads the "Little History of Photography" is how much material it contains that went directly into the "Work of Art in the Age of its Technical Reproduction" five years later, to the point that it seems as if whole paragraphs had been lifted from the former and left unrevised in the latter. This proves at least one thing – that the main form of art deemed relevant for the analysis of a revolutionary change in the production and perception of artworks in the second essay is photography. At the same time, the numerous parallels between the two essays throws some light on the notorious conundrum relative to the function of the aura: is Benjamin nostalgic for the aura that he seems to be looking for in a number of essays (as in the piece on Surrealism for instance) or is he just happy to see it wither and disappear in the vast historical process by which the multiplication of reproductions destroys any fetishism attached to

uniqueness and private ownership? I tend to agree with the general drift of
a recent essay by Diarmuid Costello, who opts for a nuanced picture and
sees Benjamin's hesitations less marked by ideological conflict and personal
ambivalence, than by calculated strategic modulations.[49] The passing of the
aura in the modern period is a phenomenon that is globally positive for
Benjamin, since it should generate a new subjectivity capable of endorsing
a socialist or communist revolution, without the usual resistance associated
with the old bourgeois interiority; but it is also fraught with dangers, as
one can see with the star system in Hollywood. Also, the concept of the aura
is used to describe what Benjamin loves in old photographs by Hill, Nadar
and others – in which case the term is, obviously, not so negative. His evoca-
tion of the famous portrait of Kafka as a child staring at us with immensely
sad eyes and in a totally absurd disguise, keeps its aura entire for us.[50]

The aura of ancient photographs is partly due to different technical
conditions with the long poses, the props to rest the bodies or heads, all of
which forced the "subject to grow into the picture" and allegorize a whole
life in an instant, but it is also something intrinsic to the art invented by a
few gifted artists. By the end of the nineteenth century, however, most
photographers attempted, lamely, to recreate a fake aura, adding halos and
retouches. Then comes Atget, the crucial artist for Benjamin, since he is the
"Busoni of photography". Atget not only announces the experimental art
of the Surrealists who actually discovered him, but above all he "cleanses"
the atmosphere and effectively "kills" the aura. "He was the first to disin-
fect the stifling atmosphere generated by conventional portrait
photography in the age of decline. He cleanses this atmosphere – indeed,
he dispels it altogether: he initiates the emancipation of object from aura,
which is the most signal achievement of the latest school of photography."[51]
It is true that Atget rarely does portraits and prefers street scenes, build-
ings, or details of architectural ornament. Like Sander but before him, his
aim is primarily scientific: he wants to capture a city that is changing
constantly so that it could be reconstructed as such, with all its varied idio-
syncrasies. He has an eye for the old trades, the fast disappearing rag-pickers
and street-vendors, but there is no search for the picturesque.
Documentation is the motivation, but, as Benjamin notes, Atget never
forgot that his first vocation was to be an actor (apparently he was not very
good at it!), and therefore he likes staging his compositions, multiplying
dramatic effects that are almost always masterful.

His prolific production, spanning four decades of Parisian street-life has
left a lasting legacy that Benjamin identifies in the period's avant-garde
magazines; curiously, he isolates the new taste for almost abstract details:

> When avant-garde periodicals like *Bifur* or *Variété* publish pictures that are captioned 'Westminster', 'Lille', 'Antwerp' or 'Breslau' but that show only details, here a piece of balustrade, there a treetop whose bare branches criss-cross a gas lamp, or a gable wall, or a lamppost with a life buoy bearing the name of the town – this is nothing but a literary refinement of motifs that Atget discovered. He looked for what was unremarked, forgotten cast adrift. And thus such pictures, too, work against the exotic, romantically sonorous names of the cities; they suck the aura out of reality like water from a sinking ship.[52]

I have quoted this passage at length because it condenses two motifs that seem to clash: one the one hand, the object is purified from its romantic associations and brought into conformity with pure patterns or shapes, like the formalist dream of high modernism that we will later analyze with Clement Greenberg, and on the other hand, the object works against the aura because the photographer selects the "refuse of history" and makes a point of immortalizing the most unremarkable objects or details. In both cases, however, according to Benjamin, the uniqueness of each object disappears, swallowed by the possibility or the reality of reproduction.

This salutary cleansing role again reappears when Benjamin talks about Atget's street scenes. He lists a few of these, mentioning the brothel with the number 5 (he sees the number repeated four times when it is in fact repeated only three times, although one finds another picture of a prostitute in Versailles waiting under a number 5[53]) in which we see two women, one leering from a window, the other in the door entrance. The fact that most pictures are devoid of people (Atget liked taking his photographs at dawn, so as not to be disturbed, which is why so many streets and buildings appear ominously empty) is not a defect for Benjamin, on the contrary, since "the city in these pictures looks cleared out, like a lodging that has not yet found a tenant. . . . It gives free play to the politically educated eye, under whose gaze all intimacies are sacrificed to the illumination of detail."[54] The detail is purified, clarified and finally illuminated (*Erhellung*). We are veering into the same territory as Poe, who concluded his "Mystery of Marie Roget" with a critique of the illusion that one can calculate odds when playing dice – each time the throw will be entirely determined by chance: "It may be sufficient here to say that it forms one of an infinite series of mistakes which arise in the path of Reason through her propensity for seeking truth *in detail*" (CTP, 207).

Which is why Benjamin occasionally makes little mistakes in his readings, and also why the gothic undertone is always present in is analysis. As is well-known, Atget is praised for having reconstituted the "scene of the crime" in his deserted urban landscapes. Whereas the analogy is given early

enough in the "Work of Art" essay, it provides a fitting conclusion for the whole of the "Little History of Photography": "It is no accident that Atget's photographs have been likened to those of a crime scene *(eines Tatorts)*. But isn't every square inch of our cities a crime scene? Every passer-by a culprit *(ein Täter)*? Isn't the task of the photographer – descendant of the augurs and haruspices – to reveal guilt and to point out the guilty in his pictures?"[55] It should be clear from this that "crime" is a general metaphysical condition, and that Atget's own postlapsarian "crime" is productive in that it fulfills an important ethical function. The essay concludes nostalgically on the enduring charm of the first photographs from the nineteenth century: "It is in the illumination of these sparks that the first photographs emerge, beautiful and unapproachable, from the darkness of our grandfather's day". We know now that this is only to stress the parricidal nature of the necessary "crime" performed by Atget.

This explains why the often quoted expression of the "scene of the crime" cannot be applied to art, either literally or metaphorically. If it is a literal application, the confusion is about the object: it would be futile to illustrate this with a dead body sprawled in the middle of a room. But a purely metaphorical illustration would lose the force of Benjamin's dialectics of details and auras, of unsurpassable distance and flat proximity inhering in endless reproduction. This has been verified by a 1997 exhibition in LA entitled "Scene of the Crime". The show's lesson is that one cannot curate an exhibit with either explicitly good or bad intentions. There is a sharp contrast between the poverty and banality of the artworks exhibited at "Scene of the Crime" and the sophistication of the superb essays authored by Ralph Rugoff, Peter Wollen and Anthony Wilder. Even a groundbreaking piece like Barry Le Va's remarkable *Shatterscatter (Within the Series of Layered/Pattern Acts)* from 1968–1971 looks tame and *passé* in the context of the catalogue.[56] The only images that survive in such programmed thematic entropy are real-life documents and photographs, like the stunning snapshots of murders and crime scenes taken by Weegee, and then Atget's *Rue Pigalle à 6 heures du matin en avril 1925*, an empty street scene that stands out in its mute grandeur and empty sepulcrality. All the rest looks fake, staged, jocular, never even frightening or awe-inspiring, like well-meaning tokens handed to us by artists playing at being "fun-loving criminals". It is hard to exhibit art that lives up to the level of intensity and disappointment immediately created by real "scenes of the crime". Without falling into waggish simulations or stale jokes endlessly rehearsed (like Chris Burden looking sorry for himself after having been shot in the arm by a friend), the best is to conclude that there is, in all cases, nothing to see.

Did Benjamin also see this "nothing", whether guilty or salutary, when

he gave Atget such a prominent role in the history of photography? Another perspective on Atget can be adduced as a counterpoint – this is Atget seen from the point of view of someone we have already met several times, namely Man Ray. Man Ray had met Atget almost by chance – they lived close to one another on rue Campagne-Première. In 1926, he bought a number of prints and kept them in a beautiful album. He showed these prints to his assistants, especially to Bernice Abbott, who loved them and got in touch with the seventy-five-year old Atget, despite Man Ray's warning that he was a "primitive".[57] By this, he meant that the French artist refused to upgrade his machines, and was still using a heavy and cumbersome camera with a tripod and plaques. Man Ray tried to have him use a fast Rolleiflex; Atget was nonplussed and refused to work with a "fast" medium that would make him take snapshots. He needed the time a slow-burning camera dictates to let the scene become a scene. Later, Bernice Abbott became the first serious specialist of Atget and the author of an excellent monograph on his work,[58] as well as being a very distinguished photographer herself. Man Ray also showed the Atget prints to his friends the Surrealists, who printed three of these (all owned by Man Ray) in *La Révolution Surréaliste* n°7, June 1926. These pictures do not all exemplify the qualities praised by Benjamin: the first one is on the review's cover. Instead of its title ("*L'éclipse, Avril 1912, Boulevard de Strasbourg*), one just reads "The last conversions" in block capitals. It is a group scene, with roughly twenty people massed together looking transfixed at the sky in which, one supposes, an eclipse is to be seen. Only one little girl is not in profile; instead, she waves back directly at Atget's camera. We also see the prostitute under number 5 and a shop window full of corsets. Number 20 of *La Révolution Surréaliste* (December 1926) reproduces a more abstract photograph showing a detail from a metal ramp in a staircase. These Atget photographs fit the characteristics listed by Benjamin in connection with other avant-garde magazines like *Bifur*, but do not in the least call up the "scene of the crime". On the other hand, let us note that was Man Ray who was instrumental in making Atget into a proto-surrealist. He collected him at a time when Atget was seen as a half-crazy original, an old-fashioned documenter using an antiquated technology and not an artist. Thanks to Man Ray's initial discernment, Atget gained a reputation as a fellow-traveler of the Surrealists, a forerunner of their visual experiments – although, as always quite cautious, it was he who had asked Man Ray not to name him when his photos were printed in *La Révolution Surréaliste*.[59]

If Atget was obstinately resistant to the technological or artistic innovations represented by Man Ray, Benjamin is nevertheless right when he says that his sensibility fitted that of the Surrealists. Atget was at the cusp

between an older technique with the long pauses and the new hand-held camera that could be used effectively and fast. In Benjamin's terms, one might say that he aimed at keeping the aura intact – yet he is shown to "kill" the aura, to suck it from the objects he photographs. Is there a contradiction, then? In fact, no. Even when Atget focuses his lens on genre scenes like streets full of prostitutes, or creates visual jokes as in the picture that shows a bread-vendor chatting up a charming *grisette* with a long apron under a huge sign reading "DEGUSTATION" while an older woman seems to evaluate their chances, the scenes are witty and full of life.[60] Benjamin had clearly not gauged the immensity of Atget's endeavour, an attempt at documenting all the aspects of a city that he loved; in fact, with more than 8,000 prints of Paris, he could hope to rival the only artist who was as comprehensive and diverse, Balzac. The often inhabited buildings and empty streets of Paris seen by Atget compose a broad human comedy – but if man or women are absent, the houses and the streets assume human faces. They stare at us, waiting for us to reconstruct the inexplicable murder mystery.

Thus, in spite of Man Ray's avant-gardist sophistication, it is quite likely that it was Atget who taught *him* a few things about the staging of the "crime". One can verify this idea in the very album owned by Man Ray. Right in the middle of the album, two stunning photographs face one another. On the left side, we see a nude, which is not so common for Atget. "Femme, 1925–26" presents just the back of a naked woman resting on a sofa; her shoulders and head are obliterated by shadows. The gaze's focus is the sinuous line made by the thighs and buttocks, the dark crease in the middle suggesting a dimple or a smile. The overall construction of the cropped nude (one barely sees the back of the knees and the beginning of the legs) transforms her into a pure oval shape split in the middle by a black line. This pattern is exactly the composition of Man Ray's 1932 "Lips" painting (*A l'heure de l'Observatoire*), in which, as we have seen, the two lips can also be read as bodies embracing or legs pressing against one another. On the right hand side of the album, we encounter a vision of desolation; what is titled blandly "Rue du Cimetière Saint-Benoît, 1925" shows, in fact, a demolition site, with ruins in the middle ground and the blind wall of a building in the background. This wall is like a text, it has kept traces of old chimneys, of their fires and of vanished partitions. In the foreground, at the right, a huge wooden gate commonly used to keep curious passersby away is left open – like a sombre premonition of Duchamp's Cadaquès gate used for *Etant Donnés*. The obvious pun linking the two photographs would be the "back": the back of a woman half-disclosing her sex while obstinately facing a wall, and the back of a building left after wrecking down a house.

It would be tempting to superpose the two images so as to create an Ur-Version of *Etant Donnés*: the naked woman's body would just need to face us, her head still hidden, she would have to be lifted up by magic and deposited in the middle of the debris-filled hole, providing an erotic and tantalizing corpse for what is aptly named the "street of the Saint-Benoît graveyard".

We are back to the scene of a crime in a most literal sense, and to do this we have had to move significantly from Benjamin's dialectical images that conjure up a complex problematic of aura and reproduction, and into the realm of Man Ray's own Sadean Surrealism. I have discussed at some length Man Ray's identification with Sade's programmatic praise of crime, a Sade who also left no traces after his death, except his writings, and whose famous will insisted upon total obliteration. Man Ray's cult for Marquis de Sade found a fascinating expression when he tried to give a face to Sade in a series of portraits that all became immediate allegories. As if Crime needed to have a human face, he drew and painted several "imaginary portraits of Sade". The first attempt was a double portrait done for *Les Mains Libres* in which Man Ray's illustrations dialogued rather freely with poems written by Paul Eluard. A whole section is devoted to Sade whose name is printed in block capitals and clashes with the naked women shown before. It shows the face of the Marquis turned into stone while in the background the Bastille castle is first looming menacingly then is attacked and burns.[61] This image then turned into a painting in 1938. A caption says: "No-one knows for sure any portrait of the Marquis de Sade, a fantastic and revolutionary writer."[62] This belongs to what Man Ray considered his real work, that is either drawings or paintings since for him, photography was an inferior art, or not an art at all, and he was always wounded when critics called him a fashion photographer foremost. It was perhaps because of his Sadism, the last avatar of an innate gothic Romanticism, that he was unable to see the grandeur of photography – a grandeur whose essence lies in crime, a crime against all auratic propriety, decency and authenticity.

Poe with Lautréamont: from Marie Roget to Maldoror

Benjamin remarked somewhat cryptically that "Baudelaire was too good a reader of the Marquis de Sade to be able to compete with Poe."[63] For a good reader of Sade, it is a waste of time lookimg for clues, since murder is everywhere. The point is to add more murders, not solve ancient crimes. On this

view, Poe is clearly not a Sadist, he is a sentimentalist who loves nothing more than melodrama. At times, he appears to err on the side of poetic masochism, as when he empathizes with the pain of a bereft lover suffering the Raven's repetition of a mechanical "Nevermore". Again and again, Poe acts out the famous programme outlined in "The Philosophy of Composition," in a categorical statement: "The death of a beautiful woman is, unquestionably, the most poetical topic in the world." And he can recognize a good one when he sees one in the newspapers, as a tantalizing *fait divers* – such as the story of Mary Rogers. Just after the remark on Baudelaire and Sade, Benjamin develops his insight with a brief outline of "The Mystery of Marie Roget":

> The original social content of the detective story was the obliteration of the individual's traces in the big-city crowd. Poe concerns himself with this motif in detail in 'The Mystery of Marie Roget,' the most voluminous of his detective stories. At the same time this story is the prototype of the utilization of journalistic information in the solution of crimes. Poe's detective, the Chevalier Dupin, here works not with personal observation but with reports from the daily press. The critical analysis of these reports constitutes the rumour in the story.[64]

Poe appears, once more, as a reader of local newspapers along with mystery stories in almanacs, sensational pamphlets and the penny press. The detective becomes a peruser and decipherer of tangled documents, hence the length and repetitiveness of this tale, which comes closest to a real police inquiry while forfeiting the neat allegorized pattern of the other stories. Here, with surprising modernism, Dupin's strategy will be to find a way through a printed maze made up of countless conflicting accounts of a then highly-visible murder story, a paper trail that he will try to superimpose on the map of the city. Needless to say, he is not successful – and this second failure, after the impossible identification of the criminal nature of the "Man of the Crowd," is what renders this tale most interesting.

Messac's book alerts us to one level of difficulty brought about by Poe's deliberate transposition of the *fait divers* from New York to Paris; the Paris inhabited by Dupin is not "local" but an invention or a simple translation of New York. Poe has Parisians cross the Seine in a ferry-boat, and the children who find the young woman's clothes gather sassafras bark.[65] Baudelaire himself had to excuse these blunders and note that Poe could not pretend to have ever been in Paris – he merely relocates a New York murder to the French capital. Mary Rogers, the "beautiful cigar girl" whose body was found drowned in the Hudson river after having been apparently sexually molested in the summer of 1841, becomes Marie, a *grisette*, and even

the newspapers have transcribed names; in the final version, footnotes give us the key to real street names in New York. Did Poe deliberately obfuscate an already muddled case just to protect John Anderson, the owner of the cigar store in which Mary had worked for a while, and a friend of his who had been suspected of the murder? Two direct suspects were in fact rapidly identified – one, Daniel Payne, who was to marry her, committed suicide out of grief in October 1841; the other, John Morse, one of Mary's beaux, was apprehended but successfully cleared himself by explaining that he was on Staten Island, not in Hoboken, where Mary's body was found.[66] In fact, under the pretence of rational calculations of probabilities, heady reflections on coincidence and chance, the opening pages of "The Mystery of Marie Roget" make one bold and unfounded assumption: that this was definitively a murder. "The atrocity of this murder (for it was at once evident that murder had been committed), the youth and beauty of the victim, and, above all, her previous notoriety, conspired to produce intense excitement in the minds of the sensitive Parisians" (CTP, p. 171).

When Poe started being "excited" by the case, he published a serialized version of his detective work in three issues of the *Ladies' Companion* in 1842 and 1843. His thesis was in conformity with his previous attempts; that is, one should look for a single murderer, with whom Mary would have had a date, and who might have been killed subsequently by a gang of thieves. This allowed him to fuse together the two main hypotheses developed so far by the penny press: either a jilted lover, or a collective rape by one of the notorious gangs of New York. Poe, in fact, was not sure that his conclusions were right, so he delayed the publication of the third instalment (the second section of his mystery tale was published in December 1842 and the third in February 1843). He then revised extensively the text for his collected *Tales*, published in 1845. The main revisions made room for what seemed to be another hypothesis, namely that Mary had not been gang-raped or murdered by a jealous suitor, but died in consequence of a botched abortion. The publication of his *Tales* in 1845 is contemporary with the new abortion law, and well-know abortionists like Madame Restell had been named in connection with the death of Mary. In November 1842, a certain Mrs Loss, who owned a roadside inn in the vicinity of the discovery of the corpse, made a deathbed confession that linked Mary's death to a botched abortion. She appears under the name of Mrs Deluc in Poe's story. And this might not have been Mary's first abortion, since we have heard of a previous suspicious disappearance. One year earlier, Mary's many admirers had been "thrown into confusion" by her absence from the cigar shop. Indeed, the police were in the process of starting an official investigation when she mysteriously reappeared "in good health, but with a somewhat saddened

air"(CTP, p. 171) or with "a slight paleness" (CTP, p. 192). She resumed her work at the counter without giving any explanation and soon after, left her job to help her mother manage their boarding house. The place did not have a great reputation and Mary seems to have behaved just like Polly, the loose and pretty daughter of Mrs Mooney in Joyce's story "The Boarding House". As in the *Dubliners* tale, she was hoping to entice men of some means and had got at least one promise of marriage as a result.

Poe's "mystery" starts with one unverified assumption (since it is not an accident and not a suicide, it must be a murder) and continues with the development of the original programme – any mystery will find a solution. As Poe writes, there is "nothing *outré*" in this murder (CTP, p. 180) – meaning that it does not equal the rabid savagery and gruesome violence of the two women's deaths, their throats slashed by razors, one body stuffed in a chimney, of "Murders in the Rue Morgue." In consequence, it should be easier to solve, but this turns out not to be the case: "for this reason, the mystery has been considered easy, when, for this reason, it should have been considered difficult, of solution" (CTP, p. 180). What if this was not even a "mystery" but just a sad and trite *fait divers*? Would Dupin's once serendipitous "inductions" (CTP, p. 170) still work? In fact, the reading and deciphering of a mass of documents highlights an ineradicable and unsurmountable illegibility. In short, one might say of Mary that *sie lasst sich nicht lessen*. Here and there, Poe inserts a few qualifications, writing "if murder was committed on her body" (CTP p. 181), or adding "There might have been a wrong *here*, or more possibly; an accident at Madame Deluc's" (CTP, p. 200) and later assuming equal probability between "either a fatal accident under the roof or Madame Deluc or a murder perpetrated in the thicket of the Barrière du Roule" (CTP, pp. 203–4), but, on the whole, these later modifications do not prevent him from looking for clues of murder as he still seems intent on finding one or several guilty parties, of "tracing to its *dénouement* the mystery which enshrouds her" (CTP, p. 206).

Such programmatic delusion sends us back to a crucial point in all the reports. The police had spoken of "brutal violence", hinting at evidence of sexual torture visible on her body, but was not more explicit because crucial details of a very intimate nature could not be disclosed. Like all the newspapers accounts, Poe's analysis is both very precise and purposefully vague: "In the outer garment, a slip, about a foot wide, had been torn upward from the bottom hem to the waist; but not torn off. It was wound three times around the waist, and secured by a sort of hitch in the back. The dress immediately beneath the frock was of fine muslin; and from this a slip of eighteen inches wide had been torn entirely out – torn very evenly and with great care. It was found around her neck, fitting loosely, and secured with a hard

knot" (CTP, p. 174). Since the "slip" was not used to strangle her to death, it is clear that the clean cut in the inner garments is not compatible with a savage rape performed by a gang of inebriated men nor with the sudden murderous act of a single man. It is curious to see Poe's usual sagacity be at fault – one reason that has been adduced was that it might bring renewed suspicions to the plausible father of the first aborted fetus, his friend John Anderson. Besides, all the evidence pointing to screams of terror, the presence of a threatening gang of mischief-makers came either from "Madame Deluc" or friends of hers, that is all those who have an interest in diverting suspicions from what may have taken place in their house.

True, in one passage, Poe adds several ominous diacritics after Madame Deluc's testimony: "But the evidence, you will say, of Madame Deluc (!) points especially to the presence of a *gang* in the vicinity . . . " (CTP, p. 202) and "that it is abundantly clear that the gang quitted the Barrière du Roule *prior* to the scream overheard (?) by Madame Deluc" (CTP, p. 203). Is Poe thereby annotating his own text and merely adding a note of interrogation and exclamation to what were his previous hypotheses? Curiously, in the last pages of his tale, Poe only develops one hypothesis that still orients to a singular or collective murder and never pursues the second one. This is also why he concludes on the idea of "coincidences" and "important miscalculations" (CTP, p. 207). This derives, as we have seen, from his wish to use reason and calculus without leaving anything to chance. Chance is here connected with "details" – reason is easily mistaken when it tries to "seek truth *in detail*" – as we have seen, these are the last words of the text (CPT, p. 207). This conclusion is completely at odds with a previous statement that insists upon the importance of details.

> It is the malpractice of the courts to confine evidence and discussion to the bounds of apparent relevancy. Yet experience has shown, and a true philosophy will always show, that a vast, perhaps the larger, portion of truth arises from the seemingly irrelevant. (. . .) The history of human knowledge has so interruptedly shown that to collateral, or incidental, or accidental events we are indebted for the most numerous and most valuable discoveries . . . *Accident* is admitted as a portion of the substructure. We make chance a matter of absolute calculation. We subject the unlooked for and unimagined to the mathematical formulae of the schools. (CTP, p. 191)

This contradiction should make us think. If it is true, as Amy Gilman Srebnick writes that with "Marie Roget" Poe invents a new literary form, "nonfiction fiction", it is however more difficult to believe that this new genre is in total conformity with his esthetics. Srebnick adds one page later:

> in Poe's works, murder and mystery moved from the street to a conscious

aesthetic from that was consonant with the deeper psychological themes created by the tensions of a new urban culture. (. . .) over the familiar 19th century literary preoccupation with love and death are superimposed the battle between the irrational emotional life and the logic of intellect and, not the least, the chaos of daily life in conflict with the imposition of social order. And, more important, in these tales, and especially in "Rue Morgue" and "Marie Roget," Poe introduced the art of ratiocination or detecting: an act of intellectual finesse carried out by a male observer – the brilliant, if quirky, detective.[67]

While I agree with the general concepts and approve the description of Poe's new "nonfiction fiction", I hope to have shown that he is more at odds with himself, to the point that he does not hesitate to reveal a duped Dupin in the tale, merely in order to save the programmatic balance of the narrative. Far from solving the mystery he presupposes, he actually adds to the commentary a further layer that is as symptomatic and full of holes as the rest. The theoretical contradiction between his praise of the sleuth's usual method of looking for clues and his own rationalist induction reaches a climax here. Just like us, the detective is simply a reader of *faits divers*, and it seems that the more he speculates, the less he understands. In this case, the detective is far from being brilliant – he is literally blinded by evidence. It will take the whole of a purely speculative "Purloined Letter" to cure him of his myopia. Both stories mark the intellectual limits of detective serendipity and the emotional limits of the esthetic transformation of a sad but common *fait divers* into a "tragedy" or a "mystery".

The facts provided by the real case of Mary's death were, from the start, tainted by melodrama – all the elements were there: a beautiful and promiscuous young woman, whose corpse is washed ashore, the disappearance of an icon whose entourage counted at least three or four persons who might have an incentive to kill her. The popular press did not wait for Poe to invent the "mystery" of Mary Rogers's death. It was couched in the stuff of popular epics, dated gothicism and urban melodrama from the start. Melodrama is not just a variation on vague sentimentalism, but occurs more often as the reverse or underbelly of dry rationalism. Poe's reasserted faith in the powers of ratiocination facing riddles and mysteries is but the counterpart of his staunch belief that the most poetic topic in the world is the death of a young and beautiful woman. Similarly, Dupin's rationalism is just the other side of the clichés and bad taste of 'The Raven." To go back to Srebnick's terms, Poe's romantic exchange between "love and death" was grafted onto the popular coupling of madness and genius, the productive interaction between feminine irrationalism and male intellect, all of which intertwined in a conflict between subjective chaos and an artificially imposed social order.

This is the point at which Poe needs to be succeeded by Lautréamont. Poe's involuntary kitsch needed a more coherent esthetic programme, one that could successfully integrate all these tensions by heightening them. Isidore Ducasse chose popular melodrama as the literary site which he had to occupy (as an army does with an enemy's land, that is with massive amounts of destruction and by inflicting as much pain as possible) which he set out to warp and pervert – by blending the positivism of the rationalist tradition with excessive gothic streaks. By doing this, he radicalizes the link between melodrama, crime and *fait divers*. Poe is, of course, one his models, although he more regularly returns to Ponson du Terrail's endless *feuilletons*. His decision to copy and invert popular crime stories in the *Songs of Maldoror* is parallel to what he did in his *"Poésies,"* a sequence of quotes from the main moralists from Pascal to Vauvenargues, and whose meaning was sytematicaly inverted. For Maurice Blanchot, Sade and Lautréamont were the two central figures of excess that not only underpinned the beginnings of Surrealism but aimed at a concerted *outrage* against both morality and esthetics.

Ducasse specializes in the *outré* style, as seen when he rewrites the sad story of Mary Rogers, and this time it reaches a climax of sadism and gratuitous horror. He will make totally explicit what remained veiled by innuendoes in Poe's tale about a botched abortion; and he will subject the "unimagined" (which he chooses to understand as the "unimaginable") to the "mathematical *formulae* of the schools" with a vengeance. This takes place in the third book of the *Songs of Maldoror*, a section which had shocked even Walter Benjamin.[68] We first meet a crazy old crone who dances along the road. A stranger enquires about her, and she pulls out a roll of paper on which she has consigned the sad story of her life. She reads to him the account of her daughter's murder. The stranger reads the text. It describes how the lovely and innocent little girl is violently raped by Maldoror. Having finished, Maldoror then commands his dog to bite her to death. Not obeying the order, the bulldog imitates his master and rapes the girl once more. To Maldoror's surprise, she is still alive. Thereupon Maldoror unleashes his devastating furor. I quote the gruesome passage in full because of its obvious relevance to Black Dahlia's murder.

> He approaches the sacrificial altar and sees the behaviour of his bulldog, gratifying his base instincts, rising above the young girl, as a shipwrecked man raises his head above the waves. He kicks him and cuts out one of his eyes. The maddened bulldog flees across the countryside, dragging after him along a stretch of the road, which, though it is short, is still too long, the body of the young girl which is hanging from him and which only comes free as a result of the jerky movements of the fleeing dog; but he is afraid of

attacking his master, who will never set eyes on him again. He takes an
American penknife from his pocket, consisting of twelve blades which can
be put to different uses. He opens the angular claws of this steel hydra; and
armed with a scalpel of the same kind, seeing that the green of grass had not
yet disappeared beneath all the blood which had been shed, he prepares,
without blenching, to dig his knife courageously into the unfortunate child's
vagina. From the widened hole he pulls out, one after one, the inner organs;
the guts, the lungs, the liver and at last the heart itself are torn from their
foundations and dragged through the hideous hole into the light of day. The
sacrificer notices that the young girl, a gutted chicken, has long been dead.
He stops his ravages, which had gone on until then with increasing eager-
ness, and lets the corps sleep, again, in the shade of the plane-tree.[69]

The old woman concludes that even now she thinks that the rapist was
insane, and that because of that, she forgives him. The stranger almost
faints, then comes to and burns the manuscript – he is none other than
Maldoror himself! Maldoror had returned to the same spot because he had
forgotten this crime of his early youth (as Ducasse adds sarcastically, "how
habit dulls the memory!"). The paroxystic passage ends almost quietly and
with a parodic quiver sending up the mock pastoral tone of the beginning:
"He will not buy a bulldog! . . . He will not converse with shepherds! . . .
He will not sleep in the shade of plane-trees! . . . Children chase after her
and throw stones at her, as if she were a blackbird."[70] The tone is almost
Yeatsian in its elegiac suggestion of deepening shades that veil the grue-
some transgression.

It was inevitable that this gory scene should attract the attention of
thriller writers. This has happened with Hervé Le Corre's novel, *The Man
with Sapphire Lips*, in which Isidore Ducasse is a character. He is suspected
of being a serial murderer, whereas the true criminal, Henri Pujols, reads
him avidly and then enacts in real life the scenes that the poem describes.
Thus he reads these pages to a little girl whom he will later torture and
murder. Before, he stages the scene on which Song VI closes: a man is left
bleeding and eviscerated on top of the dome of the Panthéon like Mervyn,
who has been hurled there to his death by Maldoror.[71]

The last of the *Songs of Maldoror* similarly revisits popular genres like the
feuilleton narrating the exploits of invincible criminals, and adds a touch of
surreal gore in the tradition of the *grand-guignol* plays, which attracted the
crowds along the inner "grands boulevards" of Paris (the meticulously doc-
umented site of the adventures of Maldoror) in which torrents of fake blood
would spout at the least provocation. The mixture of melodramatic charac-
terization and inflated rhetoric that undermines itself produces a poetry of
pulp carnivalization, a verbal pop art *avant la lettre* that bridged the gap

between an older, debased mass culture and a new sensibility attuned to linguistic excess, jarring metaphors and the parody of conventional morality. When Maldoror revisits the English gothic tales and the French *romans noirs*, he does so with sublime and grotesque twists (in his unique style, the two modes are always hard to distinguish) that verbally mimic convulsive hysteria. At the same time, he makes fun of the Romantic aspiration to "recollection in tranquility" by means of a peaceful immersion in bountiful Nature. Like Rimbaud, he has read Baudelaire – even if critically – and has therefore absorbed the distilled spirit of Sade. Accordingly, Benjamin writes, commenting on Baudelaire's sadism, "Nature knows only one luxury, crime." Here is the full entry: "Nature, according to Baudelaire, knows this one luxury: crime. Thus the significance of the artificial. Perhaps we may draw on this thought for the interpretation of the idea that children stand nearest to original sin. Is it because, exuberant by nature, they cannot get out of harm's way? At bottom, Baudelaire is thinking of parricide."[72]

Without even entering into parricide, Ducasse was often ironical when facing his great predecessor, Baudelaire. In his *Poésies*, he called for the criminal, the *"dadas de bagne"*[73] or the guillotined Troppmann and Charlotte Corday to sweep the table clean. He thus created a poetic language that opened new doors of perception for André Breton and the Surrealists, all the while addressing a general reader (he boasts that his poetry should be read by fourteen-year-old schoolgirls) and in such a manner that the reader becomes part of the poem. The most direct forms of address accompany the most bizarre images clamping together incompatible levels of style. This is also why in the *Songs*, murder often replaces sexuality, or is strongly sexualized: Ducasse sets in motion the desiring process that underpins our loitering unconscious, our base temptations and silly leers at sordid *faits divers*. Finally, the poetry of Lautréamont is the exact equivalent of the Parisian "passages" so eloquently sung by Aragon and so systematically memorialized by Benjamin: they are outmoded, sooner or later "condemned"[74] and already ruined from within, they are remnants of another age, but they also contain the seeds of the future, announcing new forms of change and exchange. Benjamin noted cryptically: "The arcades as milieu of Lautréamont."[75] Perhaps he knew that at the end of his brief life, Isidore Ducasse, who had first lived near the Passage Vivienne, wrote and died in a small room at 7, rue du Faubourg Montmartre. "Go and see for yourself, if you do not believe me."[76] You will discern the discreet plaque that has been fixed on the wall of an inner courtyard, a short "passage" giving access to the recommendably cheap and cavernously Balzacian restaurant *Chez Chartier*. And if you still have some appetite . . .

What is radically new in Ducasse's writing is that he explicitly quotes

these popular genres and reclaims them for serious poetry while making a show of pithy condensation: "in a tale of this sort . . . there is no occasion for diluting in a godet the shellac of four hundred banal pages. What can be said in half-a-dozen pages must be said, and then, silence."[77] As Messac shrewdly noted,[78] Lautréamont's poem condenses the substance of count-less interminable dime novels and serialized adventures of Rocambole. By transforming the substance of pulp fiction such as was daily produced by Ponson du Terrail and colleagues, and later Souvestre and Allain, who wrote 12, 000 pages of Fantomâs adventures in three years,[79] Ducasse accom-plished what Duchamp and a few others understood well after him – how to reconcile high modernism and popular culture. However by doing so, he had also generated monsters – and it took just a few more years for a serial killer like Jack to Ripper to enact the grandiose and sadistic fantasies of Maldoror.

Chapter 4

Scalpel and Brush, Pen and Poison

The ekphrasis of murder

Jack the Ripper was the first of the famous serial killers, the original psychopathic murderer who transformed his crimes into paradoxical mementos of popular culture, monuments to an inflated egocentrism, doubtful shrines to a widespread fascination for male outrage on women. By allowing themselves absolute mastery over the lives of others, serial killers radicalize the artist's well-known narcissism – *fiat opus, pereat mundus*! If Poe invented detection fiction while shrinking from the exploitation of real murders, as we have seen, the inventor of this genre was his contemporary Thomas de Quincey, who does not care for the intellectual process by which the murderer is discovered, but specializes in the creepy horror generated by mass murder, especially when this is not a fiction. I will return to one of his tales later to study his technique. For de Quincey, it is the artist who is a murderer; he merely transcribes the deeds in an exalted style which I will compare to classical *ekphrasis*. For Poe, the artist is the detective, who outdoes the failed artist hidden in the murderer by identifying esthetically with him. Poe died in 1849, De Quincey died in 1859. Within one decade they had set the stage for the next generation, the generation of Jack the Ripper. Jack the Ripper was unique in that he multiplied taunts and false clues, leaving sarcastic messages in a medley of assumed voices to the London police in order to "sign" his crimes as an artist signs a work of art. He (for we may reasonably assume that he was a male killer, although a few bold writers have suggested a female Ripper) was clearly someone who wanted to be remembered – and he succeeded: he was never found out, his murder spree stopped as mysteriously as it had started, spawning in its wake all sorts of unverifiable rumours and a bizarre industry of horror uniting the "Ripperologists" of all countries, the countless amateur detectives who have all tried to reopen the case and solve it, and, so far, have all failed.

Several websites throughout the world are devoted to Jack the Ripper and they contain impressive electronic archives, discussion groups, fanzines publishing the latest findings, among which stand out the historically

minded *Ripper Notes* and *Ripperlogist*.[1] The success of the film *From Hell* (2001), starring Johnny Depp and Heather Graham, gave a new lease of life to the thesis that Jack the Ripper was actually the Queen's surgeon, disguising under a series of apparently random murders a carefully plotted elimination of a group of Whitechapel prostitutes. They had all serviced the Duke of Clarence, like Mary Kelly, and were blackmailing the weak-witted Duke or "Eddy". If freemasons and, why not, Satanic subgroups devoted to ritual murders, could be added to such heady concoction, so much the better! Here again, we encounter a recurrent temptation: for want of an identifiable culprit, rather than resign oneself to randomness, one resorts to conspiracy theories in the hope of introducing a semblance of order.

Jack the Sickert

I would like to single out one author and analyze the success of an historical thriller written by Patricia Cornwell, the well-known author of bestselling crime novels mostly based on realistic forensic investigations like *Postmortem, Body of Evidence, Cause of Death*, and *The Last Precinct*, all of which would all fall under the general heading of "detective stories". They add a scientific twist to the usual cocktail of gore and violence, but they usually "induce" logically the solution of the murder cases described. This is what she did in 2002 with the real-life mystery of Jack the Ripper. Like many others, but perhaps more arrogantly, she pretends to have "closed the case" by identifying Jack the Ripper. He would be none other than Walter Sickert, the distinguished British painter of German, Irish and Danish descent. In her examination of Jack the Ripper's case, *Portrait of a Killer*,[2] Cornwell argues with brio and total conviction that Jack the Ripper must have been the painter Sickert. The evidence that she has put together after several years of research is at first glance impressive; so let us rehearse her arguments.

Her starting point is the constitution of a damning psychological portrait of Walter Sickert. Cornwell demonstrates that he had reasons to hate women, especially prostitutes, and wanted to kill them. Sickert displays a group of features usually associated with a psychopath: a very high intellect coupled with a borderline or asocial personality to which one can add a marked disdain for women (in fact we have the old equation of artistic genius with mania, obsession, misogyny and, to boot, a total lack of moral sense or remorse). Born with a fistula in his penis, Sickert endured three painful operations on this sensitive organ before he was five years old; as a

result, Patricia Cornwell surmises, he felt mutilated and was impotent.[3] Nevertheless, all his life, he was an avid frequenter of the *louche* milieus of popular beer-halls, workers' pubs, vaudeville shows, and music halls, where he lapped up the energy of low-life and popular entertainment. Many of his paintings detail and magnify the tawdry pleasures of music halls and brothels. He was known to be sexually promiscuous (he once said that one could not be in love with more than three of four women at a time) and to befriend prostitutes. He enjoyed portraying prostitutes from various cities and countries, and some of his best pictures focus on the various aspects of music hall performances.

In his quest for cheap places to haunt, Sickert would often prowl all night through the red light districts of London, Paris or Venice, thus looking very much like the "man of the crowd", who, let us not forget, embodies, according to Poe the essence of crime. In order to avoid being recognized, he would often disguise himself, pretending to be various types of foreigners, which was easy as he spoke perfectly several languages (English, French, German, Italian and some Danish). Besides, although constantly impoverished, he was in the habit of keeping two or three studios at the same time, and most of these were out-of-the-way dilapidated rooms left in a sorry state of disrepair, paints and newspapers littering the floor, tables loaded with tottering piles of books. Most of these were close to the East End, the area in which the London prostitutes were found murdered, or later to Camden Town, a district made famous by a few violent murders when he lived there.

At the time of the first "ripper" murder, in August 1888, Sickert was twenty-eight years old and his marriage to a woman twelve years older and more mature was fast unraveling. The distance between Sickert and his wife was quickly becoming a chasm. When he did not forget about her existence, he was cruel to her and his deliberate slights were aimed at inflicting psychological pain on her. He loved the theatre, having begun his career as an actor, and had turned to painting shortly after, under the influence of the American painter James Whistler. In London, during the summer of 1888, the new sensation was the play *Doctor Jekyll and Mister Hyde*, and Sickert might have wanted to enact in real life the savage crimes that mark the Doctor's fatidic change of personality. That same summer, Whistler, his former mentor and guide, but now estranged from him, was marrying Beatrice Godwin, a beautiful woman who was the widow of Edward Godwin, who had lived with the actress Ellen Terry, a flamboyant figure that had struck Sickert's fancy when he was an adolescent. He could be ripe for some acting out, as a psychoanalyst might say.

Then there is circumstantial evidence to be adduced. All his life, Sickert

was a compulsive letter-writer to all sorts of newspapers, and Patricia Cornwell concludes that there are important similarities between his handwriting, his mannerisms, his doodles even, and the contents of some of the 250 Jack the Ripper letters sent to the press and kept in London archives. It was the effect of these taunting and malicious letters that literally created the character of "Jack the Ripper", since he signed them this way. Jack often boasts of his murders and announces more to come. Most of them are considered hoaxes but some look genuine enough, like the famous "Dear Boss" letter from September 25, 1888, in which Jack the Ripper (who craves for celebrity and acquires it under his self-chosen nickname, used here for the first time) announces that he will strike again and this time cut out a woman's ears. Three days later, this was to happen with Stride and Eddowes, whose ear fell off when she was moved to the Morgue. In this inaugural or baptismal letter, the serial murderer dwells on the special red ink he uses, explaining that he could not use the blood of his victims. Cornwell focuses on the fact that the special ink used by Jack the Ripper to simulate blood in his letters to the police was, in fact, a rare artist's ink, something that painters could have easy access to. Finally, Cornwell also paid huge sums to have DNA collected form letters and paintings by Sickert. The results were inconclusive, showing merely that whoever composed these letters had a DNA that was generally not incompatible with Sickert's.

It is quite possible that Sickert wrote one or several letters to the press during the heat of the Ripper-craze; in fact, it would be more surprising if he had not. Cornwell has found that one letter signed "Nemo" (a pseudonym often used by Sickert, also by Jules Verne's hero, the captain of the Nautilus) has the same watermark as Sickert's usual letterhead paper. This constitutes no real indictment however, for an inspection of the contents shows that the letter offers a theory about the killer's origin and psychological make-up, while warning that "Unless caught red-handed, such a man in ordinary life would be harmless enough polite, not to say obsequious, in his manners, and about the last a British policeman would suspect" (PK, p. 178). This does not seem to prove that the author of the letter was the murderer. Moreover, if he was, and if he slyly alluded to himself, Sickert would hardly fit the description – he then led a life of debauchery and eccentricity that had little to do with the obsequiousness supposed to the killer. True, the fact that once Sickert amused himself by shouting in the street "Jack the Ripper!" as a group of young women was approaching, causing panic (PK, p. 209) evinces a curious sense of humour, but such behaviour smacks of the equivalent of a "sick joke" in Victorian England, rather than a giveaway sign of the killer's identity. In a similar manner, Cornwell supposes that the "haha!" or "hahaha!" laughs that recur in the Ripper's letter derive from

Whistler's habit of rudely and loudly laughing at people with a strong American accent, a mannerism later imitated by Sickert – and then reproduced symptomatically in his killer letters.

The strongest argument advanced by Cornwell is of a visual nature and hinges around the little drawings often found in the Ripper letters, which very much resemble the doodles or vignettes that decorate many of Sickert's signed letters. They do seem to come from the same hand. But again – are these letters in themselves enough of a proof of guilt? Can we take his paintings as full of clues? "Sickert's works of art may contain 'clues', but they are about himself and what he felt and did" (PK, p. 113). Cornwell insists that some violent paintings by Sickert show women who are either disfigured or whose throat has been cut. She speculates that they closely imitate the appearance of the victims of the Ripper, and that therefore Sickert, who could not have seen the photographs, reproduced from memory what he had remembered after his killing sprees. This would be true of a number of disquieting paintings all executed in 1905–6, when Sickert was back in London having spent a few years in France. This sounds like a damaging accusation, but Wolf Vanderlinden has shown in 2002[4] that the photos that would have been used by Sickert for these paintings are only those of Mary Kelly and Catherine Eddowes. Now, these two victims had been mentioned by Doctor Lacassagne, in a book about the French Ripper, Vacher l'éventreur, entitled *Vacher l'éventreur et les crimes sadiques* and published in 1899. Given his fascination for the case and his good knowledge of French, it is quite likely that Sickert had seen this book, especially as he had settled in France a year earlier. He would have seen these two women's mutilated bodies photographed in the book and would then have used them later for his pictures. What seems to prove Vanderlinden's point is that Sickert never used any other photograph of a dead woman for his representations of murder scenes. If he had been the Ripper and had worked from memory, why would he have restricted himself to the only photographic evidence that was currently available?

This shows that Cornwell focuses on the "hard" forensic evidence that she can gather, to the exclusion of the abundant literature of "docufiction" that has proliferated over the century since the Ripper mystery. For instance, she alludes in passing and rather dismissively to the theory that was "advanced in the 1970s" (PK, p. 111) of the involvement of Eddy, the Duke of Clarence, blackmailed by Mary Kelly and her network of prostitutes. She sums up the theory in two pages (PK, pp. 111–13) and then goes back to Walter Sickert in her apparently obsessive quest. What is curious is that her very comprehensive bibliography omits the few books that originally launched the hypothesis that connected Sickert with the Ripper case. These

are, first, Stephen Knight, who published *Jack the Ripper: The Final Solution* in 1976, and second Jean Overton Fuller, who published in 1990 *Sickert and the Ripper Crimes*, followed by, third, Melvyn Fairclough's *The Ripper and the Royals* (1991). It is not, I trust, that Patricia Cornwell refuses to acknowledge the priority of other authors – it is more pointedly that she knows that these books, the first especially, are based upon a story told by Joseph Sickert, Sickert's alleged "son", who pretended that he had heard the story in his family, in which it was a well-kept secret. He later recanted and admitted that he had invented the whole story.

The story goes like this: Walter Sickert had been asked by Queen Victoria to give painting lessons to her son Eddy, the Duke of Clarence. At the time, Clarence had been secretly married with a prostitute. They had a daughter, Alice Margaret, who was subsequently educated by Sickert. Hearing of a possible scandal, the royal family intervened to nip the rumours in the bud, and they arranged to have the entire group of women murdered. To hide this, they had had recourse to a group of Freemasons who helped them in their effort to disguise the targeted eliminations, making them pass as random murders committed by a madman. Eddy was later forced to try out other wives, but he never found one who accepted him and he died in 1892 of a bad cold, aged only 28 years old. Later, Sickert fell in love with Alice Margaret and as a result they had an illegitimate son, Joseph Sickert, born in 1926. He lived in London and was a painter like his father. Shortly before dying, the old artist (he died in 1942), told Joseph the whole secret. Here was a good story with all the ingredients needed to make headlines, even if it was a total fiction. The hoax extended to the parentage linking Walter to Joseph Sickert, and both to the royal family. In 1973, the BBC gave some credibility to the story when it aired Joseph's Sickert's version. However, Joseph Sickert felt that he had not gained enough from his disclosures to Stephen Knight, whose *Jack the Ripper: The Final Solution* had made him rich and famous. Finally, on June 18, 1978, Joseph decided to call the bluff, and in an interview to the London *Sunday Times*, he declared: "It was a hoax; I made it all up." In 1988, Melvyn Fairclough finally met Joseph Sickert and had to admit that his distant informer had relied on distorted gossip and faked diaries.[5]

Neither Fairclough, Knight, Fuller or Joseph Sickert are quoted by Cornwell; when she attempts to draw the line, start a clean slate and reject the dense network of myth and legends, she betrays a rather naïve or positivistic belief in the powers of American scientific criminology, DNA testing and comparative graphology to pin the murders on Walter Sickert. The famous painter is suddenly promoted from a privileged witness to the royal cover-up to the position of major culprit. Cornwell believes that by

simply dismissing the tangle of old and new lies, she can cut through the Gordian knot that links the murders to Sickert, forgetting that this knot had been partly tied by Sickert himself. Her sleuth's serendipity (for, since she works with a dogged conviction, she is bound to find something, and find a few clues she did, as we would have expected) is fundamentally flawed, since she needs to treat Sickert's gleeful games with the Ripper case as so many proofs of his culpability. She is the embodiment of the detective Sickert would have wished for himself – a modern forensic writer armed with patience, energy and aided by a lot of money, who is devoted to seeing him fit his best role, that of Jack the Ripper. From beyond the grave, we may hear once more the idiosyncratic American guffaw, a "<u>ha ha</u>!" that Jack the Ripper would have borrowed from Whistler via his wayward disciple Sickert.

There is no denying that Sickert was fascinated by the Ripper case; but this fascination expressed itself after the fact, at least twelve years after the murders. This appears in a number of paintings dating from 1905, after his return to England, like the notorious "Le Journal" (1906) or "Jack the Ripper's Bedroom" (1908). In 1907, Sickert had moved to Mornington Crescent in what is still today Camden Town, and he rented the two top floors of a house in which, so his landlady had told him, Jack the Ripper had also lived. It was in this studio that he painted the series of popular scenes known as "The Camden Town Murder" series; they typically depict a naked female either dead or about to be murdered, and a huge man brooding next to her or overpowering her. Of course, Patricia Cornwell takes this a further admission of guilt – and if in this case the killer had contented himself with slashing the throat of the victim without "ripping" her, the reason adduced by Cornwell is that Sickert knew that his intended victim was a syphilitic prostitute and thus wished to avoid the risk of contagion though blood splatter. Why didn't he strangle her, then, as we see in one sketch, "*Camden Town Murder: la belle Gâtée*" of 1908 (PK, p. 309)? She never accounts for the fact that the series of sketches and paintings (some of which seem to illustrate another *fait divers*) never represent the murder of Emily Dimmock as it really happened. The evidence gathered by the inquest shows that Dimmock was murdered in her sleep by someone who cut her throat, then left the room at night without being seen and without "ripping" her body. In all the Camden Town Murder scenes, we see either a man strangling a woman, or a man gazing at her while she looks back, or a man apparently praying next to a dead and naked woman who has been strangled and is lying face up. If the series contains any clue, they are strikingly at odds with what-ever details of the case we have. In fact, it is likely that Sickert was in Dieppe at the time, and only heard of the case through newspapers.[6]

Many similar "clues" gathered by Cornwell testify simply to the fact that Sickert had been highly excited – as millions of his contemporaries were – by all the aspects of these murder cases. For instance, the French painter Dunoyer de Segonzac wrote to Denys Sutton (when he was writing the biography of Walter Sickert that I have already quoted), that around 1930 Sickert had told him that he had lived in the house that Jack the Ripper had inhabited (also quoted in PK, p. 60). De Segonzac mentioned Whitechapel as an area because he was thinking of the original case's location, while it is clear that Sickert was boasting of his distant connection with Jack the Ripper from the Camden Town period. Anyway, such a confidence is hardly thinkable if we believe, first, that he was the Ripper, and then that he had managed to elude all suspicions so far. Even more curiously, Cornwell refuses to believe that during the same Camden Town period, when, according to her, Sickert had dug up again his by then rusty war hatchet or scalpel against syphilitic prostitutes, he had helped, as he writes in a letter to Nan Hudson, a woman who lived below him and who once came screaming for help around midnight because her hair had caught fire (PK, p. 302). This is simply dismissed by Cornwell as implausible: she believes that Sickert was looking for an alibi while he was killing prostitutes like Emily Dimmock. However, such an event is easily verifiable, and if Sickert had totally invented that neighbour who, as a result of a lurid accident, turned bald, either she existed and could corroborate the facts, or she did not, in which case this is a fact that the police could easily check, even after some considerable time had elapsed. Cornwell's systematic suspicion amounts to interpretive paranoia – a practice that is commendable provided one knows one is paranoid. Unhesitant, she writes: "It wouldn't be hard to locate a bald downstairs neighbor or find out that she had a full head of hair and no recollection of a horrific encounter with a fiery comb. The alibi may have been for the benefit of Nan Hudson" (PK, p. 302). Via paranoia, we have suddenly stumbled into an Ionesco play like the *Bald Singer*, in which nobody ever mentions a bald singer until the end, when one character suddenly asks whether the bald singer is still endowed with her gorgeous blonde hair.

We have seen that this same methodological suspicion applies to Sickert's son or sons. There is one main reason why Patricia Cornwell cannot mention a son, any son: much of her argument is based on the idea that Sickert was impotent and sterile. Lamenting the fact that she cannot find any Sickert DNA, she writes bluntly: "Sickert had no children" (PK, p. 175). In fact, even if Joseph Sickert was a proved fabulator, Sickert had at least one son, born out of wedlock, the son he had had with "Titine" or Madame Villain, another stunning stranger with flaming red hair, the tall

Marcel Duchamp: *Étant Donnés: 1° La Chute D'eau 2° Le Gaz D'éclairage (Given: 1. The Waterfall 2. The Illuminating Gas)*, 1946–1966. Courtesy of the Philadelphia Museum of Art: Gift of the Cassandra Foundation, 1969. Copyright © Succession Marcel Duchamp/ADAGP, Paris and DACS, London 2006.

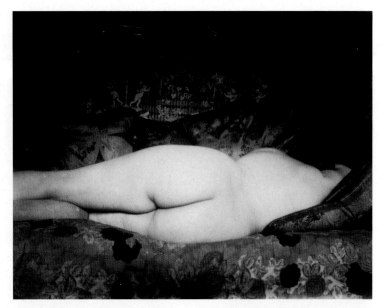

Eugène Atget, *Woman*, 1925–26. Courtesy George Eastman House.

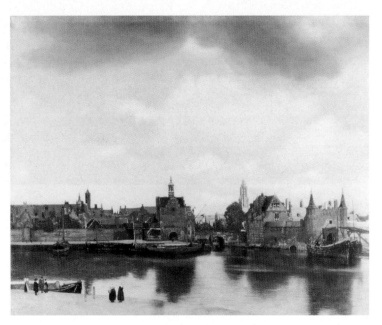

Vermeer, *View of Delft*, c. 1660–61. Courtesy of Bridgeman Art Library.

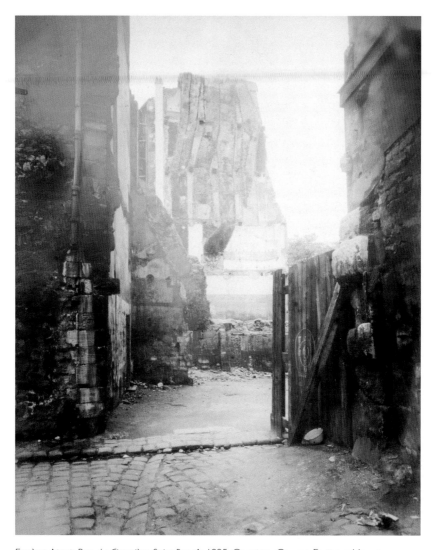

Eugène Atget, *Rue du Cimetière Saint-Benoît*, 1925. Courtesy George Eastman House.

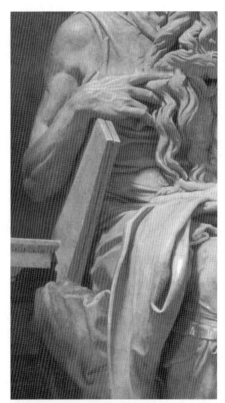

Detail from Michelangelo's statue of Moses, San Pietro in Vincoli, Rome, 1545. Courtesy of Bridgeman Art Library.

The Black Dahlia Murder

One of the most fiendish mutilation murders in local police records was discovered here when the nude severed body of a young woman of 22 was found in a vacant lot near a busy inter-section on the southwest section of Los Angeles. The victim had apparently been strangled to death and had been tied up and cut with at least three different instruments. Police theorized that the body had been cut in half at the waist elsewhere, and had been dumped in the lot from a passing car. A bundle of clothes believed to have been those of the victim was found some miles away. Courtesy Corbis/Bettmann.

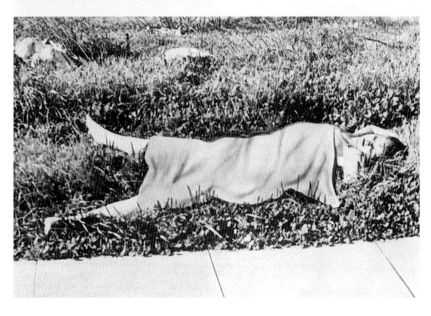

and beautiful fishmonger from Nieuville near Dieppe. It was in many ways normal that Sickert would look for a real-life partner in that particular village – it was the place in which his own mother had lived before marrying Sickert's father. Walter Sickert started living in Titine's house from 1898, at which point he was not yet divorced. He was never ashamed of his companion's lowly status, and his letters are full of jokes about his new business of pushing the sales in the fish trade. At that time, he would regularly dress like a simple fisherman to the amazement of his distinguished friends, who saw in this act further proof of his increasing eccentricity. His close, French friend the painter Blanche, sent to Gide a revealing letter that shows an intensely promiscuous Sickert, who was moving constantly from London where he had several mistresses to Dieppe where he had fathered many children.[7] Even if this may contain an exaggeration and allude to Madame Villain's other children, all the witnesses agree: "At least one of her brood – a boy – was Sickert's."[8] There is some evidence that Sickert felt responsible for his son Maurice, who was born in either 1898 or 1899. As Maurice did not speak much English, he had once needed help when he was eleven and had come to see his father in London; Sickert, at a loss, left him with McEvoy and his wife for a few months until he could take care of him. There is at least one known and inventoried painting of this sad-looking young boy, who has the same wistful, morose and depressed air as his father has in many of his photographic portraits. The affair with Titine ended in the summer of 1902, and Sickert eventually came back to London in 1905. He could not possibly have been so horrible to his wife as Cornwell insinuates since, even after the divorce was granted in July 1899, a divorce for which adultery with an unknown woman in London and Paris was cited, she continued helping him financially until she died of cancer, often buying his paintings secretly so to spare him the humiliation.

It is true that at some point (and it hard to decide exactly when, either in 1888 or 1905), Sickert had become obsessed with Jack the Ripper, as he did with the Camden Town murder. There were periods when he would pretend to be Jack the Ripper, would dress like Jack the Ripper and behave strangely. His tastes ran to the sensational, like most Victorians; he loved newspapers headlines, read them avidly in several languages, and cut out the most startling titles. He enjoyed mingling with low-life culture and loved moving quickly from the high to the low. His humour was that of the popular music hall, and his friend Osbert Sitwell said that he would write as he spoke, in an effortless improvisation, a rambling and hilarious monologue full of the "jokes, the quips, the seriousness, the fun, the acting, the singing, the snatches of old music-hall songs and even of hymn-tunes."[9] The description could apply to most of Sikert's articles on art and painters.

They are full of verve, alive with quotes in various languages, made suddenly popular by snatches of low slang or popular song, and they testify eloquently to Sickert's impressive range and variety of tones.

Sickert shared with Baudelaire a stubborn admiration for Poe's world and especially his poetics. One of his first esthetic statements, which went some way towards defining his artistic credo, quotes Poe's "Poetic Principle." When he wrote the Preface to the collective show of the "London Impressionists" exhibited at the Goupil Gallery in December 1889, Sickert asserts that the main feature that unites them is that they all reject realism, and then adapts Poe's dictum that "the sole legitimate province of the poem" is "beauty". He also stresses the urban setting as a condition of their modern beauty: "for those who live in the most wonderful and complex city in the world, the most fruitful course of study lies in a persistent effort to render the magic and the poetry which they daily see around them."[10] In this context, it becomes even more obvious that Cornwell's reading of all his paintings as carrying clues or betraying guilt and remorse forces her to misrepresent Sickert's artistic program. In other words, if one applied her methods, Poe, Baudelaire, Ducasse and Degas should all have been incriminated for whatever sadistic crimes and pedophiliac outrages are left unsolved from these times. Any avid reader of the newspapers of the second half of the nineteenth century should find material for thrillers there.

What is worse is the impression that Cornwell systematically disregards or misunderstands Sickert's esthetic program. Throughout his long and varied career, one perceives a dense network of personal obsessions and recurrent concerns. His first step in the direction of esthetic autonomy was to reject Whistler's neo-symbolist pose, an estheticism stressing artistic refinement, deliberate and sustained sublimation allied with a posture of ironical distance. In opposition to his master's dandiacal attitude, Sickert adopted a distinctive and original approach that always mixed the high and the low, the homely and the theatrical, while sticking to his objective of telling a story in images. His insistence on draftsmanship as the supreme key to a painter's training, and his rejection of both Picasso and Lewis in his cubist phase as being too easy, stem from the same programme, which is confirmed by his praise of Degas as a model in all aspects of his craft.[11] All of this converges on one motto: good art will tell a story. This is a pet theme, and he repeats it quite often. "It is just a quarter of a century ago since I ranged myself, to my own satisfaction, definitively against the Whistlerian anti-literary theory of drawing. All the greater draughtsmen tell a story . . . A painter may tell his story like Balzac, or like Mr Hitchens. He may tell it with relentless impartiality, he may pack it tight, until it is dense with suggestion and refreshment, or his dilute stream may trickle to

its appointed crisis of adultery, sown thick with deprecating and extenu-
ating generalizations about 'sweet women.'"[12]

This was written in 1912, and Sickert never changed his point of view
on this topic. In a lecture given in November 1934, he insists with renewed
vigour that "Painting is a branch of literature", and then develops the
insight with a flourish: "You have got to be interested in everything. There
are always opportunities of seeing the finest literature ever written placed
before you on the stage by first-rate actors and actresses. Then of course there
is the literature we listen to at church, which is some of the finest there is.
And of course there are all sorts of books which have been written which
are really good literature. You should be saturated with them."[13] What
follows almost logically from this foregrounding of literature, any litera-
ture, be it provided by daily newspapers, church sermons, songs in a music
hall, or snatches of Shakespeare on the stage, is that literature is a vast cate-
gory comprising, among other things, murder stories. In another lecture
given two weeks before, Sickert playfully and chattily alludes to his life-
long fascination for murder. "They call you too a 'literary artist' and they
consider this a term of blame. Why is a man a 'literary artist' if he draws
Noah coming out of the Ark? He is called a 'literary artist' because he paints
a subject which is in literature, but if you don't paint such subjects which
occur in literature, there is nothing left that you can paint. Even very illit-
erate people are interested in the illustrations of literature. It is said that we
are a great literary nation but we really don't care about literature, we like
films and we like a good murder. If there is not a murder about every day
they put one in. They have put in every murder which has occurred during
the past ten years again, even the Camden Town murder, not that I am
against that because I once painted a whole series about the Camden Town
murder and after all murder is a good a subject as any other."[14] Surely
Cornwell would see in this a confession of guilt. In fact, Sickert consciously
extols that space of freedom within us, in which we can entertain any kind
of fantasy we want, a space more and more threatened by the police and
morality, since he claims for art the right to remain an unpunished "vice".
Here is how Sickert replies with bitter irony to his censors: "We all under-
stand – and nobody more than I – that we cannot have liberty in our private
lives, can we? We are not asking for anything so preposterous. But – that
is why we want these little flights. Drawing is a vice – it is one of these
pretty vices that the police do not pursue."[15]

In one of her rare essays entirely devoted to a painter, Virginia Woolf,
who had met Sickert a few times and greatly admired him, confirms this
view. She begins her examination of Sickert's painting by describing what
she calls "the violent rapture of colour" which strikes her as soon as she

enters the gallery.[16] At the end of her superb essay, Woolf develops the idea about a Venice series when she praises the materiality of Sickert's art: "His paint has a tangible quality; it is made not of air and star-dust but of oil and earth. We long to lay hands on his clouds and his pinnacles; to feel his columns round and his pillars hard beneath our touch. One can almost hear his gold and red dripping with a little splash into the waters from the canal."[17] It is nevertheless because of this density of colour and texture that we are made to perceive the beauty of the world: he makes us "aware of beauty".[18] Then there is a second factor that strikes her: it is the constant presence of humanity, even in landscapes or architectural city scenes – in fact, none is deprived of human quality. This is the "complexity and intrigue of character" that strikes her, by which she insinuates that Sickert is above all a "biographer" – no mean praise for someone whose father had compiled the *Dictionary of British Biography*. In producing visual "biographies" of exactly observed characters, the painter proves to be far superior to any novelist: "Not in our time will anyone write a life as Sickert paints it. Words are an impure medium; better far to have been born into the silent kingdom of paint."[19] She adds that he is by nature an anti-puritan (which does not mean a libertine), someone who extols the pleasures of the flesh and who loves the simple pleasures of the poor. She even notices that he could attract censorship: "He could not draw breath in a starved, a stunted or a puritanical universe; His people are always well fed in body and mind; they excel in mother wit and shrewd knowledge of the world. Some of their sayings are really a little broad; I have always wondered that the censor let them pass."[20] It is an amusing paradox that while Victorian England let these daring "sayings" (by which I understand her to refer to the actual meaning of the pictures) pass, it became the mission of an American forensic expert to combine scientific detection with hostile and partisan Puritanism.

After some reflection, Woolf qualifies her praise: Sickert should be seen more directly as a novelist than as a biographer. Indeed, each of his picture tells a story – despite the silence and immobility, the whole apparatus made up by the suggestive titles, the well-observed individualities, the ever-present social context, creates a little drama. Once one has admired Sickert the colourist, and appreciated his skill as a physiognomist, one cannot help but narrate to oneself a plot, which is akin to the outline of a chapter in a novel. "The figures are motionless, of course, but each has been seized in a moment of crisis; it is difficult to look at them and not invent a plot, to hear what they are saying."[21] Woolf exemplifies this principle by taking one example, which is perhaps the most famous painting by Sickert, the celebrated 1913 *Ennui*. It depicts a middle-aged man sitting and puffing on a cigar with a big glass half empty in front of him, staring in the void, while

behind him a younger woman faces the wall, her eyes half-closed, her slouching body leaning on a chest of drawers. The fact that their bodies occupy the center of the painting in a single oblique line as they gaze in diametrically opposite directions suggests more than boredom – it is the whole nightmare of a stuffy interior, of a man and a woman who have nothing to say to one another.[22] Woolf's imagination was fired by the scene and she imagined a whole story – here is how she narrates it:

> You remember the picture of the old publican, with his glass on the table before him and a cigar gone cold at his lips, looking out of his shrewd little pig's eyes at the intolerable wastes of desolation in front of him? A fat woman lounges, her arm on a cheap yellow chest of drawers, behind him. It is all over with them, one feels. The accumulated weariness of innumerable days has discharged its burden on them. They are buried under an avalanche of rubbish. In the street beneath, the trams are squeaking, children are shriek-ing. Even now someone is tapping his glass impatiently on the bar counter. She will have to bestir herself; to pull her heavy, indolent body together and go and serve him. The grimness of the situation lies in the fact that there is no crisis; dull minutes are mounting, old matches are accumulating and dirty glasses and dead cigars; still on they must go, up they must get.[23]

It is a poignant reverie on the dreariness of life, but it is based on the assumption that the couple owns a pub and has retired upstairs in the private part of the house. Why call the man a "publican", why assume that the woman is his wife who has taken a break upstairs next to him before returning to serve the customers? Did this come directly from Sickert's mouth?

What we know from the other paintings of the Camden Town period is that the older man who is sitting down (Woolf's "publican") is based upon Hubby, a reformed alcoholic. It looks as if the huge glass on the table was filled with just water, which might explain his taedium vitae. Hubby had been hired by the Sickerts, and they had also hired his wife Marie in the hope of luring him away from pubs. Another painting representing both of them is titled *Off to the Pub* (1912) and shows a man about to leave his house, his hand on the door-handle, while a woman is tensely glowering, obviously displeased by his departure. They just had an argument, her stiff body posture indicates that she disapproves of his going. It may be important to note in the context that Hubby served as the male model for all the Camden Town murder drawings and paintings. Could Hubby be contemplating the murder of Marie in *Ennui*? Is he waiting for his cigar to be completely finished, before suddenly jumping on her? Behind an air of calm, his left hand is clenched, betraying pent up anger. Besides, the painting was owned

by Queen Elizabeth, the Queen mother: might this not be a further proof of the old conspiracy theory?

Happily, Virginia Woolf never stoops to such drivel. Nevertheless, her inspired recreation of a plot, her adlib recreation of individualized charac-ters suggest that there is a self-consciously subjective element in her construction. She mentions in the next paragraph that the presence of a stuffed bird in a glass case makes the situation even more stifling, while suggesting at the same time the persistence, despite so much tawdriness, of some order and beauty. In the version described by Woolf, one sees painting on the wall, it represents a beautiful woman whose shoulders are uncovered and looks seductively straight to the spectator. Is this a portrait of the woman of *Ennui*, to show how decrepit she has become, or is it a classical portrait that clashes with the humdrum grind of their everyday world? At that time, Sickert was interested in exploring "anecdotes of everyday domes-ticity".[24] At last Jack the Ripper has been tamed; he is now a bored husband, unsure whether his previous exertions were worth all the trouble.

Woolf demonstrates the obvious dangers and well-known pleasures of *ekphrasis*. She is followed by Cornwell, and that entire literary lineage shows that when a painter chooses narrative figuration with a hidden plot, he is sure to attract all sorts of artistic sleuths – and the most obstinate will, in the end, succeed in pinning a crime on him. The reason for such a curious twist might be that if murder conditions the very possibility of the esthetic as such, as we have seen with Thomas de Quincey, it is because murder inhabits the fundamental genre of ekphrasis. Murder repeatedly whispers: *Et in Arcadia ego.* We know that ekphrasis originally referred to vivid and intense descriptions of a person or thing; it was a ritual exercise in Greek schools as students were commonly asked to render a person "from head to toe". However, the canonical example of the trope was Homer's detailed evocation of the new shield made by Hephaistos for Achilles as he prepares to fight the Trojans in order to avenge Patroclus. Thus the term took on a second meaning – now much more common – of "painting in words", that is the rendering via language of imaginary paintings, sculptures, and by extension, of any artwork. But if we look at Homer's purple patch in book XVIII of the *Iliad*, we can note that the theme of murder is already inscribed in decorative silver. The first rim depicts two cities, one that allegorizes war, since two armies are fighting for its control; the other stands for peace. However, even in such a peaceful town, a dispute has arisen about a murder, and the issue is how to solve it without further bloodshed. It is in fact a dramatization of the difficulties of right judgment: "Two men disputed over the blood-price of a man who had been killed: one said he had offered all; and told his tale before the people, the other refused to accept anything; but

both were willing to appeal to an umpire for the decision. The crowd cheered one or other as they took sides, and the heralds kept them in order. The elders sat in the Sacred Circle on the polished stones, and each took the herald's staff as they rose in turn to give judgment. Before them lay two nuggets of gold; for the one who should give the fairest judgment."[25] The animated description looks more like a filmed sequence than like a frozen frieze graven in metal. Everybody moves, we see elders taking turns to speak *after* the two men have stated their cases; what remains suspended in an eternal future is the outcome of the judgment: will blood-money be accepted and the crime settled by legal means, or will the injured kinsman require death or a harsh punishment for the murder? Will this then lead to civil war? By leaving the decision open and having the following scene describe a skirmish during a battle between besiegers and defenders, with an advantage to those who successfully mount an ambush, the poet implies that a peaceful solution is always better.

Ekphrasis with a Vengeance

If moral judgment is the ethical counterpart of a purely esthetic contemplation, we will need to look at those who refrain from moralizing ekphrasis. The one writer who has been the most vocal in defending the point of view that art was immune to moral issues was Oscar Wilde. He famously stated in the Preface to *The Picture of Dorian Gray*: "There is no such thing as a moral or an immoral book. Books are well written, or badly written. That is all."[26] In order to avoid multiplying similar quotes, I will focus on Wilde's atypical reaction to the Jack the Ripper case. Wilde knew Sickert very well, as he had put him up in Paris when Walter Sickert, a then very young man , and quite dashing, went to deliver a Whistler painting to the 1883 Salon. Wilde was on intimate terms with Sickert's mother as well (see PK, p. 299). Curiously, Wilde never expressed himself publicly on the case (which does not mean that he was Jack the Ripper!). However, soon after the intense initial popular excitement around the case subsided in the autumn of 1888, he wrote a study entitled "Pen, Pencil and Poison," published in January 1889 in the *Fortnightly Review.* The essay was later republished in the collection of *Intentions* (May 1891), and most critics agree that the other three essays in that volume are better written and have a thematic unity that is partly broken by this more journalistic piece. Why did Wilde decide to devote a longish biographical essay to the notorious murderer and forger Wainewright, a man who had the added distinction of being a dandy and an artist of some talent? Ellmann's biography usefully

orients us in the direction of the Parisian literary scene that was at the time saturated with stories of perversity and decadence. Already in 1882, Wilde had been impressed by Rollinat's "Soliloque de Troppmann," a poem dramatizing the deliberation of a noted murderer, who like Williams had not hesitated to dispatch coolly a whole family.[27] Similarly, Wainewright is presented as a decadent esthete turned professional murderer. In fact, as Wilde dispassionately states, his crimes had a salutary effect on his art both as a painter and as a writer: "His crimes seem to have had an important effect upon his art. They gave a strong personality to his style, a quality that his earlier work certainly lacked."[28] A good example of the "stronger" quality he acquired can be observed in one of Wainewright's most memorable *bon mots*. When a friend visited him in jail and reproached him for having poisoned his sister-in-law Helen Abercrombie, a very beautiful woman who was barely twenty when she died, Wainewright coolly replied: "Yes; it was a dreadful thing to do, but she had very thick ankles."[29]

As Wilde's biographical account explains, Thomas Wainewright had become a master in the use of the pen, as he was a good art critic; the pencil, since he would draw with elegance; and poison – he always had some rare and undetectable brew hidden in the stone of his rings, and would at times use this indiscriminately, often just for the fun of it. When his sinister reputation started spreading, none of his acquaintances, including Thomas de Quincey, Charles Lamb, Walter Scott and many other distinguished artists, would agree to have tea with him! He was recognized by the police while he was hiding in London, jailed, tried, condemned and sent to Tasmania in Australia for his murders in 1837. An expert in exotic poisons that left no trace, he was difficult to accuse and most of his crimes remain unpunished. Accusing him of embezzlement, the police discovered that he had murdered at least six persons, among whom his rich uncle who, very kindly, had taken him up as he had lost both parents. Most of the time he would kill by interest, to inherit a house or draw money from a victim's insurance policy, but at times by pure pleasure, or simply to take a revenge on insurance companies that refused to pay him. Like Wilde, Wainewright considered that his own life had to be as interesting as a work of art. Often, when one reads Wilde's essay, one wonders whether Wilde is considering that he might follow a similar fate, as when he pities his fate after his deportation, in a curious anticipation of his own fall from grace after his trial: "The sentence now passed on him was to a man of culture a form of death."[30]

This essay embodies a plea for the autonomy of art that has to be defended against the encroachments of Victorian morality: "The fact of a man being a poisoner is nothing against his prose. The domestic virtues are not the true basis of art, though they serve as an excellent advertisement for

second-rate artists . . . There is no essential incongruity between crime and culture."[31] Yet, Wilde refers constantly to the "art" of poisoning cultivated to a high degree by Wainewright as a "strange sin".[32] When he analyzes the murder of the young Helen Abercrombie, he adds that he hopes that such a deed was committed by Wainewright alone, without any help from his wife: "Sin should be solitary and have no accomplices."[33] This is crucial in view of Wilde's nascent socialism – he holds the view that the perverted artist chooses his "sin" and is therefore not on the same level of responsibility as the majority of criminals whose crimes are in many ways "forced" on them; out of need for money or to silencer someone, etc. "Crime in England is rarely the result of sin. It is nearly always the result of starvation".[34] Thus Wainewright was a true aristocrat, a dandy who decided to become a serial killer because of his perverted estheticism. This is also why he always remained a gentleman, even in prison and subsequent exile. Wainewright therefore sets a model, a paradigm for all the other "crimes" Wilde will want to be accused of —-homosexuality being, of course, the dominant one.

The subtitle of "Pen, Pencil and Poison" is "A study in Green," which sends us back to one passage in which Wilde seems to identify even more with the poisoner: "He had that curious love of green which, in individuals, is always the sign of a subtle artistic temperament, and in nations is said to denote a laxity, if not a decadence of morals. Like Baudelaire, he was extremely fond of cats, and with Gautier, he was fascinated by that 'sweet marble monster' of both sexes that we can still see at Florence and in the Louvre."[35] Notwithstanding what this reveals of Wilde's assessment of Ireland and of the Irish national colour, we know how systematically the French had associated green with same-sex choice by a pun on *vert* and *inverti*. The oblique allusion to a marble hermaphrodite mentioned in Théophile Gautier's "Contralto" and *Mademoiselle de Maupin*,[36] still visible in the Louvre, cannot leave any doubt. Yet, there is another level of allusion. By subtitling his study "in green", Wilde was alluding to a text by Conan Doyle, the first story in which Sherlock Holmes appeared: "A Study in scarlet."

Wilde was an avid reader of Conan Doyle's stories, whose "strength" he admired – much as he admired Wainewright's newly-gained strength of style. It was at a dinner given by the American J. M. Stoddart in the summer of 1889 that both Wilde and Doyle were given important commissions: Wilde for the installments of *The Portrait of Dorian Gray*, and Doyle for the second Sherlock Holmes tale, "The Sign of the Four." Both obliged Stoddart and subsequently published their texts in *Lippincott's Magazine* in the coming months. Ellmann narrates how their conversation at dinner hinged

around the relationships of art, literature and murder.[37] In a sense, *The Portrait of Dorian Gray* is a crime story, even though there is no "detection", as are told early on the nature of the special trade-off between Gray and the devil. The fact remains that the idea of a portrait that embodies evil may be called an example of ekphrasis with a vengeance. Indeed, the originally beautiful portrait retains all the traces of sin and depravation brought about by Dorian Gray's disreputable life, while his own face remains without a blemish. Here again, we might be tempted to find Walter Benjamin's dialectic of traces and aura – Gray's perfectly auratic face looks like a magazine image that has been aided by some sort of supernatural botox, while the painting registers all the traces and deep changes that a life of transgression brings to a countenance. It is the painting that speaks, whereas the face remains a blank space – a simple surface upon which one's fantasy can project something – otherwise known as beauty. Wilde denounces in advance the American dream of dumb eternal youth at the hand of plastic surgeons. In the process, ekphrasis has been literalized: the painting is animated with a life of its own, and the "vengeance" it harbours may have to wait, but it will come in the end.

A similarly esthetic theme is sounded in "Pen, Pencil, and Poison." The art that Wainewright originally specialized in was a variation on the trope of ekphrasis. He would try to convey the impression that works of art were provided to him via words, straining "to give, as it were, the literary equivalent for the imaginative and mental effect."[38] If Wainewright often practiced ekphrasis, he was not particularly successful at it. Wilde quotes at length two passages, one a reading of Rembrandt's *Crucifixion*, and the other an evocation of Giulio Romano's *Cephalus and Procris*. Noting that both passages characterize the style of the times (implying, therefore, that they have considerably aged), flush as they are with mythological parallels and laboured verbal padding, he has to conclude that they are lacking in overall power. Wilde indicates that these would have to be rewritten, managing at the same time to turn his discreet strictures into a plea for his own brand of estheticism: "Were this description carefully rewritten, it would be quite admirable. The conception of making a prose-poem out of paint is excellent. Much of the best modern literature springs from the same aim. In a very ugly and sensible age, the arts borrow, not from life, but from each other."[39] Wilde often lamented the fact that he had put his genius into his life and not his works. Just as Wilde would deplore his inability to do what Conan Doyle did so well, with his direct style, his mixture of meditative moments and action, the narrative strength that *The Portrait of Dorian Gray* lacks – he blamed this shortcoming on the fact that the novel progresses by going directly from conversation to conversation. He felt that

he did not know how to make a plot advance economically and dynamically. Wilde was slow in reaching the conclusion that had been exemplified by Wainewright's example. Both believed in the end that ekphrasis had to be reinforced by strenuous practical criminal exercises, and the best of these was the art of murder. Wilde was worried about the radical consequences of this maxim and chose both a tamer and more ambitious role: he courted disaster and became the ideal victim when he defied conventions and the whole British establishment. Like Wainewright, he would have to suffer ignominy, dispossesion and exile, in order to learn the hard way that the arts should borrow only from one another and never from life. Even when ekphrasis is literalized, what is literalized is a figure of rhetoric, nothing more, a mere trope, like "decadence" or "inversion".

Murderous Life, or Murderous Fiction?

It seems that de Quincey is the other literary model chosen by Wilde when he narrates the curious trajectory of Wainewright's career. De Quincey himself had been thrilled to have sat at a dinner with a "real" murderer – as he was able to find out later, happily for him! Wilde is ready to believe that de Quincey subsequently exaggerated the limited merits of Wainewright's critical prose about paintings.[40] De Quincey is Wilde's true predecessor here because with him, one finds no pretence of intellection or "detective" ratiocination as with Conan Doyle. What matters for him is pure excitement, the intense enjoyment provided by an air of murder. For him, as we have seen, the murderer is the artist, and the reader should both identify with him and also with the victim, in a deliciously wicked consent to fictional sado-masochism. I will give one example of his skill at rendering horror – one finds many in the accounts of the Williams murders. I will focus on later story entitled "The Avenger" (1838), especially because it might have inspired George Hodel's decision to call himself the "Black Dahlia Avenger" and to exact a similarly bloody revenge from various victims.

The scene takes place in a small northeastern German town, the year is 1816, just after the Napoleonic wars. The narrator is a professor of Greek at the local university (this character echoing Kant, de Quincey's old friend and butt of numerous jokes) who befriends a young man who has distinguished himself during the war. This Maximilian Wyndham, who has just turned twenty-three, is half-English and an orphan; his mother was rumoured to have been a beautiful gypsy, for he has a rather Moorish complexion; he is the heir to a great fortune and has served valiantly at

Waterloo and in other battles. His distinctive feature is melancholy, "a sadness that might have become a Jewish prophet, when laden with inspiration of woe."[41] He had expressed a desire to study Greek with the professor, and this is how he met the beautiful Margaret Liebenheim, it has been love at first sight. Meanwhile, his rival for her heart, a Catholic nobleman of the city, Ferdinand von Harrelstein, vents his jealous anger and resentment by disappearing into the woods for days on end. It is clear that he is the obvious suspect in the case of the sixth murder, that of the town jailer, who disappears mysteriously. Harrelstein seems to know instinctively that the body will be found in the woods when the leaves fall. Soon after, the dead jailer is indeed found, crucified on a tree with an inscription that says: "T. H., jailor at —— ; *Crucified, July* 1, 1816" (TA, p. 264).

As soon as the serial murders begin, ten in all, we know already that several families are going to be slaughtered. There is no obvious motivation, no sign left – each time, nothing is stolen; the aim seems to be the pure obliteration (de Quincey writes, "extermination") of human life. There is an escalation in the gruesome details and rare escapes of few witnesses. The city lives in terror, it is like a waking nightmare. Here is a passage from the fifth murder that will dispatch two old ladies. As they are in charge of a boarding-house, two younger girls are made attentive to suspicious noises one night, and one keeps watch – for nothing. The next night is that of the attack:

> The next day, wearied with this unusual watching, she proposed to her sister that they should go to bed earlier than usual. This they did; and, on their way upstairs, Louisa happened to think suddenly of a heavy cloak, which would improve the coverings of her bed against the severity of the night. The cloak was hanging up in a closet within a closet, both leading off from a large room used as the young ladies' dancing school. These closets she had examined on the previous day, and therefore she felt no particular alarm at this moment. The cloak was the first article which met her sight; it was suspended from a hook in the wall, and close to the door. She took it down, but, in doing so, exposed part of the wall and of the floor, which its folds had previously concealed. Turning away hastily, the chances were that she had gone without making any discovery. In the act of turning, however, her light fell brightly on a man's foot and leg. Matchless was her presence of mind; having previously been humming an air, she continued to do so. But now came the trial; her sister was bending her steps to the same closet. If she suffered her to do so, Lottchen would stumble on the same discovery, and expire of fright. On the other hand, if she gave her a hint, Lottchen would either fail to understand her, or, gaining but a glimpse of her meaning, would shriek aloud, or by some equally decisive expression convey the fatal news to the assassin that he had been discovered. In this torturing

dilemma fear prompted an expedient, which to Lottchen appeared madness, and to Louisa herself the act of a sibyl instinct with blind inspiration. 'Here,' said she, 'is our dancing room. When shall we all meet and dance again together?' Saying which, she commenced a wild dance, whirling her candle round her head until the motion extinguished it; then, eddying round her sister in narrowing circles, she seized Lottchen's candle also, blew it out, and then interrupted her own singing to attempt a laugh. But the laugh was hysterical. The darkness, however, favored her; and, seizing her sister's arm, she forced her along, whispering, 'Come, come, come!' Lottchen could not be so dull as entirely to misunderstand her. She suffered herself to be led up the first flight of stairs, at the head of which was a room looking into the street. In this they would have gained an asylum, for the door had a strong bolt. But, as they were on the last steps of the landing, they could hear the hard breathing and long strides of the murderer ascending behind them. He had watched them through a crevice, and had been satisfied by the hysterical laugh of Louisa that she had seen him. In the darkness he could not follow fast, from ignorance of the localities, until he found himself upon the stairs. Louisa, dragging her sister along, felt strong as with the strength of lunacy, but Lottchen hung like a weight of lead upon her. She rushed into the room, but at the very entrance Lottchen fell. At that moment the assassin exchanged his stealthy pace for a loud clattering ascent. Already he was on the topmost stair; already he was throwing himself at a bound against the door, when Louisa, having dragged her sister into the room, closed the door and sent the bolt home in the very instant that the murderer's hand came into contact with the handle. Then, from the violence of her emotions, she fell down in a fit, with her arm around the sister whom she had saved. (TA, pp. 258–9)

Needless to say, the two girls have been unable to save the older ladies. This passage brilliantly shows how skillfully de Quincey empathizes with the potential victims, while leaving the murderer's designs completely opaque. The point is to create an atmosphere of terror which in its turn generates a specific "hysteria" – a term to which I will return in a later chapter.

The last murders occur in the house of the Liebenheims – where the news of Margaret's pregnancy had reached her father. We are told that she had earlier secretly married Maximilian. This time, the only person to be spared is Margaret, but she is found unconscious, her dress soaked in blood, delirious. After a few weeks of uncertain respite, she dies in the arms of a distraught Maximilian. He, too, dies soon after and leaves a written confession for his old teacher. He had been the murderer and wanted to avenge the horrible treatment inflicted upon his family at the hand of the townspeople. The father had been arrested and when the rest of the family arrived, the mere mention of their Jewish blood heaped indignities on them. The

father was tortured and died from his wounds, the mother humiliated followed soon after, so did the two sisters of the young man. They had moreover been forced to live in a "Jewish quarter", a ghetto in the suburbs, where they were constantly harassed. Then Maximilian handpicked eight Jewish soldiers left from Napoléon's army and led them into a private war against all those who had made them suffer. Each victim was told the retribution meted out came "from the Jewess" whom they had dishonoured. But Margaret, who was to be absent, saw the scene of her father's murder in the hands of the man she loved and had married. The letter ends with Maximilian's reiterated claims as a avenger, his need to "bring a shock to society, in order to carry my lesson into the councils of princes" (TA, p. 285).

What is extraordinary in this tale, however, is that it is replete with portents of the events that marked "modernity" from the end of the nineteenth century to the present moment. Not only does de Quincey invent a sort of frenzied gothic cinema, but he also announces stories of racial hatred, of impossible assimilation, of wholesale slaughter, and of religious wars. This time the murderer is not an artist, failed or otherwise; he is an avenger sent by God, someone who has a divine mission to fulfill and is ready to die for it. He is the ancestor of all the suicide bombers and of those who want to wake up a whole community by the means of mass murder. What is so disquieting is that we feel that Maximilian was somehow right, and that, once we finish reading the story, if we reopen it, we side wholeheartedly with him. De Quincey had anticipated the next wave – not the weak and slightly mouldy seductions of gratuitous murder accomplished to satisfy a jaded esthete's decadent sensibility *à la Gide*, but the killer as a remorseless religious fanatic intent upon redressing real wrongs committed not just against him, but against his family, his race or his creed.

We have wandered away from the confines of ekphrasis as a trope. The only iconography that would be admissible in this cased would be taken from the Bible, with a Maximilian playing the role of a Jewish prophet thundering from a high mountain, like Moses ready to sacrifice half the idolatrous and treacherous tribe that has accompanied him in the desert. This distinguishes him from Wainewright, the esthete turned real serial killer. It is clear that Wilde almost fell in love with him first because he was a handsome young man with a taste for art and also because he reminded him of his his favorite fictional hero, Lucien de Rubempré. He writes: "There was something in him of Balzac's Lucien de Rubempré,"[42] and this quasi identification colors his reaction. Proust has repeatedly analyzed the role of famous paintings or heroes to bring about the specific crystallization of love – Swann can only fall in love with Odette when he realizes that she looks like a Botticelli. It was also Proust who had mercilessly attacked

Wilde's predilection for Lucien de Rubempré, adding that Wilde ended up resembling his weak and doomed hero. Wilde had stated that his life's worst grief had been caused by Lucien's death in Balzac's *Splendeurs et Misères de Courtisanes*. Proust chides his Irish predecessor for this excessive literary sentimentalism, remarking pitilessly that "life, alas, was soon to teach him that there are more poignant sorrows than those that are caused by literature."[43] As we will see in the next chapter, Proust did not hesitate to murder people – all fictional, of course, and one of them is the novelist Bergotte. Here, when he skewers Wilde, he serves a useful warning: do not take ekphrasis for real life, or you will make a true mess of it. In fact, as the painter Felix Vallotton tells us in his strange semi-autobiographical novel, *The Murderous Life*,[44] it is often life that kills, much more than art. This novel, written in 1907 under the title of *Un Meurtre*, was published posthumously in 1927. The hero, in whom one recognizes a young Vallotton, is caught up in an incredible series of mishaps; by mistake, he kills or maims horribly all those whom he befriends, from a painter who wounds himself fatally as the boy comes screaming to surprise him, to a married woman with whom he has an affair and whom he contaminates with a fatal venereal disease, not excluding a nude model whose breast is horribly burned by him. Although he has achieved fame as a recognized art critic, he commits suicide in the end so as to settle his accounts with a "murderous life". With this novel, Vallotton destroys once and for all the decadent cliché of the "murderous esthete".

Chapter 5

Who Killed Bergotte?

The patch and the corpse

The success of Patricia Cornwell's fanciful recreation of Walter Sickert as Jack the Ripper can be paralleled with the success of another novel which was duly followed by a film adaptation, *Girl with a Pearl Earring*. Both confirm the thesis I have developed earlier with *The Da Vinci Code*: the aura of a painting as famous as Vermeer's portrait of a young woman with a blue headband and a shining pearl will be forcibly inserted into a contrived network of clues to personal betrayals, unhealthy passions and religious conspiracies. The almost unbearable epiphanic splendour of the masterpiece is rendered less distant, more tolerable for our rationalistic minds when it is shown to conceal a secret, a riddle which can best be approached by way of a plot – in this case, the plot hinges around Johannes Vermeer's alleged infatuation with a young and beautiful servant. The radiating aura of a celebrated portrait is the point of departure for a series of traces that function as so many clues put together by the novelist who turns into a sleuth.

Here, the plot is based on something that looks like a syllogism, thus confirming Messac's central intuition about detective fiction. If Vermeer is not portraying a society lady but a girl who looks like a peasant, or at any rate a low class servant, and if she wears a pearl earring associated with riches and luxury, then it must be that the painter has given it or lent it to a young girl in his service. He must have asked her to pose for him, perhaps in the process falling in love with her, thus making his wife and older daughter jealous. The intensity of the face's expression is such that we can imagine that Vermeer was attracted to her, or at least, that Greit was in love with him. Both communed in joint ecstasies over colour and the discovery that they were kindred souls sharing a concern for modes of vision and representation. Here is, in a nutshell, the basic premise of Tracy Chevalier's deft novel, a novel in which one may admire the obstinacy with which she manages to make use of *all* the biographical elements known to this day of the life of Jean Vermeer. Her desire to be exhaustive is such that she does not forget to mention that when Vermeer died, his widow had to sell a few paintings to settle a debt with the family's baker. Her narrative is generated in the place where narratives seem most conspicuously absent: still lives, portraits, and the view of a city.

As *The Da Vinci Code* has taught us, today's readers need a religious ingredient. This requirement is met when Griet experiences a religious conflict: she is Protestant, as was the majority of the Delft population, while Vermeer has converted in order to marry his Catholic wife. The confessional factor will be added to the other factors determined by class – an uneducated and poor servant in love with a refined master – and sex, as Griet, living in the household, is the victim of the daughter's machinations and the object of a patron's sexual desire. Yet, despite the temptation of writing a thriller (Vermeer's death at a young age could have attributed to his jealous wife's revenge, after all), Chevalier has refrained from a lurid exploitation of the basic elements of the plot. No one is murdered in the end, Griet avoids being molested by Vermeer's rapacious patron and instead has an affair with a butcher's servant who belongs to her class. The most dramatic scene is when the wife learns about the painting and the use of her pearl earrings, has a jealous fit, almost destroys the paining, then dismisses Griet and gives birth to a baby on the floor of the studio. The novel does not offer a solution for the real riddle, the relative scarcity of paintings, and Vermeer's death at the age of 43 in 1675.

We know that war with France had halted Dutch expansion for a while, reducing economic exchanges, especially when it came to luxury goods like expensive paintings, and that Vermeer sold nothing for a while. His wife said that he died overnight "owing to the great burden of his children . . . he had lapsed in such decay and decadence, which he had so taken to heart that in a day and a half he had gone from being healthy to being dead."[1] In a similar manner, the novel ends when Griet is called upon by Vermeer's widow who tells her that her master had added a codicil to his will by which she was to receive as a gift the famous pearl earrings of the picture. Although she is touched by the gesture (as well as when she learns that Vermeer had requested that the paining be lent back to him to be hung in his studio shortly before he died), she knows that she cannot keep them. She pawns the earrings; effectively freeing herself from the debt she had contracted unfairly when leaving the family. Was it something in Vermeer's paintings that would have precipitated his untimely demise? In this chapter, I would like to address the issue by analyzing the powerful and almost lethal effect of a painter like Vermeer on Proust, who admitted very early on to being fascinated by the art of the Dutch painter, and on one of Proust's characters, the famous writer Bergotte. We may recall that Swann, early in the novel, is always seen working at a study of Vermeer's art. Proust himself cannot avoid the fate of popular writers like Tracy Chevalier: he, too, needs a plot.

I will start from one single passage, the often-quoted pages in which the writer, whom young Marcel had taken as a literary guide and role model,

Bergotte, now an ageing celebrity whose peak has passed, dies in front of the painting. The painting is the well-known *View of Delft*, an urban panorama that, for Proust, was Vermeer's masterpiece. He had discovered it in October 1902 as he was visiting The Hague with a friend, at a time when Vermeer's reputation was just emerging after two centuries of comparative obscurity. He immediately felt that he had seen the most beautiful painting in the world. The *Musée du Jeu de Paume* organized a retrospective on Dutch painters in the spring of 1921, and when Proust visited it, he felt dizzy for a while and almost fainted. He adapted this incident to fit the account of Bergotte's last days.

Reading for the tenth time the page that Proust has devoted to Bergotte's death, I hesitate between two film titles: *The Man Who Knew Too Much*, and *The Colour That Kills.* Did Bergotte and Proust share the same fascination? What did Bergotte know that caused Proust to eliminate him so offhandedly? What clue can this little patch of yellow wall conceal? Is the text playing with the reader so as to offer a submerged thriller in the very heart of the dense mass of *In Search of Lost Time?* What do we need to fill in the gaps? Even if the text does not specify the location, we know that the body was found in the Jeu de Paume museum and that it had fallen on a circular sofa in the middle of the main room, opposite the relatively small *View of Delft*. The official version is that Bergotte died of blood poisoning just as he was watching the famous painting. Let us examine the narrative in *La Prisonnière* more closely in very accurate new translation by Carol Clark:

> This is how he died: after a mild uremic attack he had been ordered to rest. But a critic having written that in Vermeer's *View of Delft* (lent by the museum at the Hague for an exhibition of Dutch painting), a painting he adored and thought he knew perfectly, a little patch (*pan*) of yellow wall (which he could not remember) was so well painted that it was, if one looked at it in isolation, like a precious work of Chinese art, of an entirely self-sufficient beauty, Bergotte ate a few potatoes and went out to the exhibition. As he climbed the first set of steps, his head began to spin. He passed several paintings and had an impression of the sterility and uselessness of such an artificial form, and how inferior it was to the outdoor breezes and sunlight of a palazzo in Venice, or even an ordinary house at the seaside. Finally, he stood in front of the Vermeer, which he remembered as having been more brilliant, more different from anything else he knew, but in which, thanks to the critic's article, he now noticed for the first time little figures in blue, the pinkness of the sand, and finally the precious substance of the tiny area (*pan*) of wall. His head spun faster; he fixed his gaze, as child does on a yellow butterfly he wants to catch; on, the precious little patch (*pan*) of wall. 'That is how I should have written, he said to himself. My last books are too dry, I should have applied several layers of colour, made my sentences precious

in themselves, like that little patch (*pan*) of yellow wall.' He knew how serious his dizziness was. In a heavenly scales he could see, weighing down one of the pans, his own life, while the other contained the little patch (*pan*) of wall so beautifully painted in yellow. He could feel that he had rashly given the first for the second. 'I would really rather opt, he thought, be the human interest item in this exhibition for the evening papers.' He was repeating to himself, 'Little patch (*pan*) of yellow wall with a canopy (*auvent*), little patch (*pan*) of yellow wall.' While saying this he collapsed on to a circular sofa; then suddenly, he stopped thinking that this life was in danger and said to himself, 'It's just an indigestion; those potatoes were under-cooked.' He has a further stroke, rolled off the sofa on to the ground as all the visitors and guards came rushing up. He was dead.[2]

Proust narrates here a strange pact with fate when he accounts for the way in which Bergotte puts his life at stake; he sees it weighing as much as a piece of painting, a blotch of colour, dangerously balancing the two pans of the scale, while slipping to us, in the guise of the dramatic death account, an esthetic programme. His life may not have weighed much more than this patch of yellow colour. The truth that Bergotte discovered too late, for which he pays with his life (and a truth that he bequeaths to his literary executor, Marcel Proust himself) is the promise of a literary craft capable of emulating glazed Dutch tiles produced in Delft. In fact, it is not quite correct to say that he balances his life and the patch of yellow wall, for there are really three terms: his life, bounded as it is by disease and old age; his books, whose flaws he now sees only too well; and the patch of wall. Its very repetition – eight times in the two pages of the original – sounds like a death knell, or a gun discharge (*Pan! Pan! Pan!*) endowed with an obsessive rhythm, as if the incantation of the word left it to echo by itself, depriving it of any signification.

However, as soon as the narrator announces Bergotte's death, he qualifies the statement – is he dead "for ever"? He believes that his books will live on, and meanwhile they keep watch from the lighted bookshop windows like fluttering angels. His resurrection seems assured – as long, that is, as he has readers. Bergotte's fate and that of Vermeer can be equated – both suffered from oblivion but will return if only the public understands their seriousness. This insight is quite true of Vermeer, and even of Anatole France, the model for Bergotte, who has recently regained some popularity. This is because both were martyrs to their art, lived and died for it. In fact, they also toiled in different media because they felt they had to do this, it had become a law of their nature. The narrator explains: "There is nothing in the conditions of our life on this earth to make us feel any obligation to do good, to be scrupulous, even to be polite, not to make the unbelieving

artist feel compelled to paint a single passage twenty times over, when the admiration it will excite will be of little importance to his body when it is eaten by the worms, like the little piece (*pan*) of yellow wall painted with such knowledge and such refinement by the never-to-be known artist whom we have barely identified under the name of Vermeer."[3] Thus Bergotte will not be dead for nothing, his demise is *not* absurd since he has reached an understanding of these unknown laws. Therefore one might say that he has not "died" at all. Vermeer has turned into his tutelary angel, and Bergotte, redeems at the last minute the dryness of his witty intellectual novels.

Proust's "Notes on literature and criticism" insist on a main rule: one should not forget that "the matter of our books" is their literary substance, a substance essential to the creation of a style: "Our sentences and the episodes as well have to be made from the transparent substance of our best minutes, when we are outside reality and the present. From these drops of light will the style and the fable of a book be constituted."[4] Bergotte's death in the museum, a little that of Saunière in *The Da Vinci Code*, contains a crypted message not so hard to read: it is worthwhile to sacrifice one's life for a new esthetic that otherwise would not be taken seriously. Strengthened by this lesson, younger writers will heed the harsh laws of creation, pay more attention to the organic link between their own lives and the luminescent substance created by style, whether in painting or literature. Another critical statement written by Proust for an interview at the time of the publication of *Swan's Way* in 1913, concludes with the concept of style compared to painting: "Style is not a decoration as some believe, it is not even a question of technique, it is like color for painters – a quality of vision . . ."[5]

Bergotte's main function in the economy of the novel has been to embody a new mode of writing, half-way between late symbolism and psychological analysis, a novelty when the narrator was a young man. Later, he discovers that his idol has turned into a repulsive travesty of himself in *Within a Budding Grove.* When the narrator is told that Bergotte will be present at a dinner given by the Swanns, the news has an effect on him similar to being fired at with a pistol: "The name Bergotte made me start, like the sound of a revolver fired at point blank".[6] Only this pistol shot calls up a conjurer's trick more than an attempted murder – and the old polite gentleman with white hair metamorphoses into an ugly little man with a red snail-shell nose and a black goatee. His lovely style has been reduced to self-parody and is now mere "Bergottism", mechanical developments of the "Bergotte manner". Bergotte is now totally out of touch with younger writers who despise him anyhow. He is happy reaping the material benefits

of his literary fame. It becomes obvious at this point that he is a condemned man, the two images of pistol shots announce this clearly, and the repeated "Pan!" made by the yellow wall will contain a faint memory of this. The only surprise is that we have to wait so long to see him die. Nevertheless, it was not anxiety facing a blank page that brought Bergotte close to death. On the contrary, it was more his disconcerting facility, a surprising lack of inhibition that always posed a problem to the narrator. Here is a first reason why Bergotte had to die: he dies not of anxiety caused by literary impotence, although he had stopped writing in the last years, but out of an excess of happiness when confronted by the fullness of Vermeer's yellow patch.

If we agree then that Vermeer's painting is endowed by the whole narrative with the power to kill, we must understand how it can do this. The focus is indeed the yellow colour, but it is not easy to gauge how it can act at a distance; since this colour embodies pure matter, it will resist any such operation, especially if the very substance of the painting is to be allegorized in such a devious plotting. Let us take Proust's hints quite literally and examine Vermeer's painting closely. First of all, where is the incriminating patch of wall? The notes of the Pléiade edition guide our gaze: "The little patch of wall is to be found at the extreme right of the paining," we read in a note.[7] Like Bergotte, I had kept a vague memory of a different location, hardly visualizing a yellow wall in some old castle. In fact, what the note points to is a wall that is above the Schiedam door, to the right of an ancient portcullis, above a tall bascule bridge that still exists today. It is rectangle of pure yellow colour that is often cropped from reproductions. If this is the right "patch", then one has to understand "canopy" as a misnomer for the top of the bascule bridge, a slightly oblique counterweight place above an arch that seems to function as a gate as well. One cannot see the chains used to lift the bottom floor, but they are there. The patch is thus truly at the extreme-right, and it creates the sensation of a curious opening in the frame of the view. The right – left axis is important in what is often described as an urban frieze. Vermeer's visual trick is to let only the right hand side of the city be bathed in sunlight, while the left side remains in a gray light that is accounted for by a number of dark clouds.

The next endnote of the Pléiade adds an explanation that may introduce some confusion: "In reality, at the place where the little yellow wall is, or rather the patches of yellow wall, for there are more than one at the right extremity of the view, one cannot see a canopy but the top part of a bascule bridge with parallel wood pieces jutting out."[8] If we look closer, we perceive clearly three or four flat sections of yellow wall, although the hues vary, some being orangey, others more ochre or sandy yellow. They are comprised between one dark tower, the bascule bridge, and the right hand side of the

canvas. If this is where Bergotte (and Proust, and the first journalist who alerted him) saw the famous patch of yellow wall, one may wonder which of these has been chosen as the more important one. For the unique nature of *one* patch of yellow wall is crucial in general as it is in Bergotte's dying thoughts, even if we suppose that he hallucinates because of his fever and dizziness. The patch plays the role of the significant detail, much as a single sentence can represent the style of the whole novel. Part for the whole, this is the exemplification of the synecdoche – a part powerful enough to be gambled for the whole of Bergotte's life. The synecdoche condenses the idea of life reconciled with art under the shape of an embodied, incarnated light. Its precious materiality provides an allegory of the whole work, in the sense used by Walter Benjamin, less an organic symbol than a detail that will be ripped apart violently from a continuum, a fragment that asserts its own artificiality almost arbitrarily; such allegory is always dangerously over-loaded with meaning to such a point that it explodes, and can injure the observer.

One cannot overstress the fact that such a precious matter, a color that seems to catch the sunlight itself, is a technical consequence of the use a *camera obscura*, a device often used by Vermeer (at least in his views). Even if debate has raged about his use of the *camera obscura* for the portraits, there is an agreement on the fact that the painting of any panorama at that time would entail the use of the optical machine.[9] The exact house and very window from which the painter must have disposed the cubical wooden frame has been found. This technique by which the artist copied directly from reality forced the painter to work as a pointillist *avant la lettre*, and the close-ups on details reveal a surface that is mottled with thousands of tiny dots of white and yellow, like so many fireflies that glue themselves to the darker masses of the brick walls, of the boats at anchor, of the slate roofs and of the trees.[10] This magnification of light that saturates it dot by dot consti-tutes the very essence of Vermeer's art and accounts for his astonishing modernity. The famous red and yellow interlacings that render the reflec-tion of the dress and seat in *Young Woman with a Red Hat* or the little liquid silver half-moon that floats on the side of the pearl worn by *Girl with a Pearl Earring* effectively announce impressionism two centuries before it even started.

Yet it is not on the mottled or granulated light that Proust focuses; on the contrary, he insists on the varnished texture, the glossy smoothness, the glazed polish that the artisans of Delft had managed to reproduce skillfully, vying in craft with their Chinese models to create the sleek luster of the earthenware that is often justly called "Delftware". The glaze is neverthe-less not a static notion, the product of a bygone *vernissage*. What Proust

describes as the consequence of Vermeer's artistic integrity and personal sacrifice is above all the effect of a carefully contrived staging. The yellow patch, wherever it may be, that caught Bergotte's gaze, is remarkable precisely because of the movement that is contained in the picture. What is very unusual in this painting is its dynamism facing a static view, and this is produced because the foreground and the river, marked by a menacing gloom, seem to reflect not only the city, whose towers and spires are visible as inverted shadows in the water, but also appear to duplicate the pattern of the clouds in the sky – this time, of course, not as an inverted shadow image. The first clouds that we see at the front are grey and full of rain, but the sky peeks behind on the left, and behind is strip of blue sky, while further clouds in the distance are whiter and softer as they recede in the background. The result is that we have the impression of seeing the clouds pass, but at different speeds according to where they are respectively to us. The view of the city is divided into three sections as a result. To the left, all the roofs are uniformly red, they are in the shadow of the darker clouds; in the middle, a more distant vista allows us to see four of five buildings whose roofs are orange and a tall church steeple of a light stone colour. To the right, the second half of the right half to be more precise, we have the counterpoint of darker masses with the blue of slate outside the sunlight, and the few walls touched directly by the light – all of which are in a variety of yellows.

Critics like Norbert Schneider have located a political significance in the interplay of light and shadows: "The rays of the sun passing through the dark clouds and lighting the buildings situated in the background on the riverside are very likely to have a political meaning. The Nieuwe Kerk thus lit by the sun had housed since the first half of the century the tomb of William of Orange, and it was invested with great national symbolism."[11] Did Vermeer choose to treat the lit buildings less in a tone of yellow that would call up the sun than in a variety of oranges calling up the House of Orange? This is why it is crucial to decide which patch may have killed Bergotte, may have contained the "Pan!" of the murderous detonation. Can it really be an orangey wall placed in an ungainly manner above a bascule bridge? The result of my first investigation would conclude that we need a real exhibit here, but that what we could have taken naïvely for a single patch of wall has proliferated under our eyes.

We have to conclude that our guide, the Pléiade annotator, simply got it wrong. Moreover, when the picture was cleaned before it was shown at the Vermeer retrospective in the fall of 1996 at the National gallery in Washington, D.C., one could see clearly that the only yellow *punctum*[12] really visible as such is to be found in the single "patch" that includes a

dormer window. Another authority brings us back to our first intuition, Georges Didi-Huberman, who has analyzed the role of details in the art of painting. A superb article first published in 1986 and later republished in *Devant l'Image*,[13] situates Proust's yellow "detail" in the middle of the old castle. Didi-Huberman adds a note that does not lift all the contradictions and ambiguities but states openly the choices. "No-one to my knowledge, except for one painter, Martin Barré, has ever noticed that the famous yellow 'wall' is not a wall but a roof. . . . If they all saw a 'wall' where there is only the inclined pane of a roof, it might be because the yellow color – as patch – tends to create a plane in the picture, that is to say that it obsessively embodies the iconic transparency of the representational inclined 'plane'".[14] With great subtlety, Didi-Huberman criticizes previous idealizing readings by Paul Claudel and Svetlana Alpers who assume the existence of an "absolute yellow" that would be "rinsed off of any matter", whereas Proust insists precisely on the materiality of the yellow patch. The "patch" in question functions as a lure for the gaze of the beholder, hesitating between the status of a minimal detail condensing the procedures of the rest of the painting's rhetorical strategies, and the structural function of any plane that serves to remind us of the basic fact that a painting is a flat surface covered with varied pigments. This is why its "matter" is at the same time wholly its "form", or in Proust's almost Platonician vocabulary, its very soul.

What should we then think of the "canopy" (*auvent*) mentioned by Bergotte just before his second stroke or final seizure? The first English translation was more consistent but less faithful since it had translated by "roof". Here is what Bergotte repeats as he is dying: "Little patch of yellow wall, with a sloping roof, little patch of yellow wall."[15] There is, in fact, a darker orange band under the small dormer window, or *oeil-de-boeuf*, in the middle of the patch. The patch would now be inscribed between a fortified tower to the right, a brown brick chimney to the left, the opening of dormer window, the whole topped by a thin white line, perhaps a rooftop cornice. The surface looks flat even though it must be inclined for a window be just form it, and its shape calls up that of the fatidic butterfly hovering above Bergotte's books after his death. Vermeer has obviously calculated all these effects, thanks to a dramatic staggering of several planes and lines of perspective. The surprise is created by the apparent flatness of the first plane, with the soft ochre sand, seven men and women in two groups close to an open barge at rest, the river, and then the thin band in the middle with the city buildings themselves. The interactions of coloured spots comes to the viewer from behind and is both a frontal gaze black to our glance and a vertical illumination from the hidden sunlight. Vermeer has chosen as his vantage point one of the entrances to the city via the river and

the canals and the real topography of Delft with its main monuments (including the places where Vermeer had been born and was living) is hidden behind the luminous new church. One cannot really know where one is when looking at the view of Delft – Delft is everywhere when death lurks behind the sunlight. Vermeer has indeed found his ideal viewer in the person of Bergotte, a dreamer who became a yellow butterfly dreaming that he is the writer, both soon engulfed by death. Death is the ultimate correlative of the yellow patch since the wall looks back at us from the unnamed window, fixedly staring from a roof that passes as a wall.

Another passage of *The Prisoner* returns to Vermeer, and elaborates on the impression that there is an enigma in the identity of the faces, rooms, dresses that he draws so well. "You say you've been looking at paintings by Vermeer, then you can see that they're all fragments of a single world, that it is always, whatever the genius recreating it, the same table, the same carpet, the same women, the same new and unique beauty, a complete enigma at this period when there is nothing else like it, nothing to explain it, unless one tries to relate him to other painters by his choice of subjects, while recognizing the particular, personal impression made by his colour."[16] Rather unexpectedly, the narrator then compares Vermeer with Dostoevsky, suggesting even that in the interiors of the Delft households, so fastidiously and exhaustively depicted, one could imagine "the house of the killing in *Crime and Punishment*".[17] This is taken from a long discussion between the narrator and Albertine about art and literature, a discussion in which the narrator show himself to be "materialistic" and sure that the only work of art on which he can lay is hands is Albertine. Albertine, on her side, sounds more romantic, and what attracts her and repulses her at the same time in Dostoevsky is the prevalence of crime: "But did he ever murder anyone, Dostoevsky? All of his novels that I've read could be called *The Story of a Crime*."[18] The narrator is more hesitant, accepts the idea that Dostoevsky may have known crime like his heroes, but adds that even if he had been a criminal, there would have been extenuating circumstances.

This debate, interesting as it is in itself,[19] aims at subtly reopening the dangling issue of Bergotte's death. Here, Albertine's insistence on murder is suspicious, especially if we move back in the volume and remember the circumstances following Bergotte's death. Here is how the narrator presents it: "I learned, as I said, that Bergotte had died that day. And I marveled at the inaccuracy of the newspapers who, all copying the same piece of information, said that he had died the day before. For Albertine had met him the day before, she told me about it that evening, and he had even kept her a little late, for he had talked to her for quite a long time. Probably she had been the last person he spoke to."[20] Suddenly, all our certainties about the

previous narrative evaporate. Did Bergotte *really* die on the day he was supposed to? Can one trust the reporters who might have misquoted the date? The narrator finally realizes that he had wrongly accused the news-papers – once more, Albertine had lied. She is what may be called an artist in lies, a compulsive fabulator who will invent anything so as to cover up her other *rendez-vous* and numerous affairs.

In the domain of lies, Albertine surely rivals Bergotte's novels; as an expert cheater, she displays "an aptitude for animate lying, lying with the very colouring of life."[21] Actively fighting against the "decay of lying" deplored by Oscar Wilde, she paints life in better shades and hues, adding a recurrent colour one might define as the pink of shame mixed with excite-ment derived from improvised imaginary encounters, as opposed to the yellow of the wall. However, the pink and the yellow meet in the middle, as it were, in the experience of the beautiful incarnated through flesh, a palpitating flesh that follows the rhythm of everyday life. Just when she is described as a liar, we hear that Albertine had meant to meet Bergotte, insisted to be introduced to him. Then she visits him on her own, unac-companied by the narrator, who had taken some distance facing his "old master" and lets her go for once without being beset by his usual jealousy. This might be a mistake: we learned earlier, in the evocation of Bergotte's fall into the decrepitude of old age, that he squandered his immense fortune on women, or more precisely, girls "who were ashamed to take so much from him in return for so little".[22] They bring him not love but pleasure, the pleasures of the flesh, venal pleasures that he needs in order to continue his work. Albertine is the quintessence of these loose girls, always ready to help creators not die too soon, their tiny monetary reward soon augmented by the aura that rubs off onto them when they frequent great men. If she is the last person to have seen him, could it be that she had insisted to spice up their little games – the old author's exhaustion due less to half-baked pota-toes than to sexual romps carried further than he would wished given his precarious health.

This should make us look more closely at the medical diagnosis so abun-dantly given by the narrator who speaks of an "uremic attack". Uremia is caused by the accumulation of urine in the blood and its toxic byproducts often cause disorders leading to vomiting, convulsions, and at times, comas. However, according to Doctor Mabin, Bergotte's symptoms are not consis-tent with a sudden kidney failure – which had been the cause of the death of Proust's mother – nor with the overdose of hypnotics he would resort to cure his numerous ills. If it is apoplexy, as is said elsewhere, this cannot be accompanied by spells of dizziness as we have seen here. He could not even have been standing to see the picture![23] As Mabin conjectures, the scene

blends Proust's own experience when he had suffered from dizziness brought about by his pneumonia, and the kidney trouble inherited from his mother. What stands out is the diagnosis of uremia, which, with the poisoning of the blood by urine and toxic substances contained in urine, calls up a more sinister yellow colour, a poisonous yellow. The only common point between Vermeer's *View of Delft* and Duchamp's urinal is that they are works of art – although Bergotte manages to reconnect them in a different sense.

In that case, Bergotte would not have been murdered by a painting, nor would he have been sexually exhausted by Albertine; he would have been the unwitting victim of his playing the doctor. The description of his death in the museum is preceded by a long and funny diatribe against doctors. Proust who came from a family of doctors and whose father was a famous MD, unleashes some animus facing the medical corporation as a whole, and his satire is suitably witty. They do not seem to know the exact difference between kidneys and brains (shades of Leopold Bloom!). Furious at changing his medication all the time while being in constant pain, Bergotte decides to invent his own remedies and recipes, thus falling more and more deeply into the habit of drug overuse and a narcotics spree to stop his sufferings. This is how Proust concludes his diatribe, just before the scene of the visit to the museum: "One swallows the new product, with the different chemical composition, in delicious anticipation of the unknown. Where will the newcomer take us, toward what unknown kind of sleep, of dreams? . . . What new system of sensations shall we meet on this journey? Will it lead us to sickness? To blessedness? To death? Bergotte's death had happened the previous day, a day when he had put his trust in one of these too-powerful friends (or enemies)."[24] On this occasion, all the blame would be put on the random consequences of these suspicious medical cocktails. Bergotte's death would have been a suicide in disguise, and his body loaded with potent chemicals, he would have decided to go out and die in front of as many people as possible just to avoid suspicions. This was also Proust's habit to gamble with those substances, coining the term of "the mechanics" to refer to his way of blending cafein with bromides, veronal, chloral and opium. Paul Morand has narrated his surprise facing this practice, telling Proust that this was like accelerating and braking at the same time.[25] Once or twice he made mistakes that were severe, until in October 1921, he suffered an overdose of caffein pills, an incident that made some friends believe that he had wanted to commit suicide. He felt he had been poisoned, had experienced vertigo and spells of fainting.

There are countless parallels between Proust's death and Bergotte's death: I already mentioned the dizziness experienced on visiting the Dutch

exhibition. It was on October 17, 1922 that Proust felt a little better after
the complications of pneumonia. He used this brief reprieve to dictate a few
sentences developing Bergotte's death, which were to be inserted in those
pages. The topic is the series of sudden remissions and reversals that near
death provides to a sick subject: "And then, one day, everything changes,
what was detestable for us, what was forbidden, is suddenly allowed. 'Well,
for example, couldn't I have some champagne? – But of course, if you feel
like it.' One doesn't believe one's ears. One orders brands that one had
always thought prohibited, and this is what gives rise to a suspicion of vile-
ness when we face the unbelievable frivolity of those who are dying".[26] Thus
the repeated *Pan*! of the yellow wall could also be interpreted as so many
champagne corks popping. However, on the following day, Proust became
delirious, hallucinating the very figure of Death under the scary shape of an
old lady dressed in black. He died on October 18 at 4:30 a.m., and the
funerary photograph was taken by Man Ray on the next day, all of this
having been arranged by Jean Cocteau. The burial took place on October
22. This turned out to be Man Ray's second portrait of a famous writer, the
first one being of James Joyce, and the visit to the dead novelist was barely
enough to pull him out of a severe depression, only to feel more dejected
the following day. Proust had extolled the virtue of being a horizontal man,
someone who leaves the vertical state required by social activities and who
takes the time to meditate or write in bed. There is an allegorical signifi-
cance in the curious circumstances surrounding Man Ray's famous deathbed
portrait of Proust, a portrait that was claimed first by another photogra-
pher,[27] nevertheless is the perfect visual equivalent of a funerary monument.

In this meeting between the Dadaist expatriate and an author who
belongs as much to the nineteenth century as to the twentieth century, one
can be tempted to see the return of the pattern in which an older Bergotte
faces a young Marcel. As we have seen, Bergotte has to be killed because he
belongs to another generation. Besides, he may not have attained the
mixture of materiality and spirituality that distinguishes Vermeer and
Dostoevsky. His old paganism, his sensuality, and his Republican spirit
seem things of the past. The repeated signifier of *pan* contained in the patch
no doubt conceals the god of all fauns (at some point, Bergotte becomes a
faun). "The great Pan is dead!" was the cry heard by seamen sailing in the
Aegean sea at the birth of Christ according to Plutarch's *On Oracles* (XVII).
Nietzsche took this as an emblem; it signified the demise of the old pagan
pantheon as soon as Christianity emerged.

Today's equivalent of the "little patch of yellow wall" painted by
Vermeer in the first half of the seventeenth century could be found in Cy
Twombly's collage entitled *Pan*, a collage made in 1975. It is composed of

three sheets of paper glued together. The smaller format sheet, on top, is taken from a botanical encyclopedia and shows two green leaves with strong red nervures crossing one another. The Latin name is visible on the top left corner. The second sheet is lightly painted in yellow with aquarelle paint upon which are trace twice the names PAN and PAN, in clumsy or childish red and black block capitals, with a long loop going from the top N and reaching the edge of the sheet. There are a few smudges, dots and black spots underneath. Are these bullet holes? Is it a parody of a still life stolen from a herbarium, or an elegy to the disappearance of the Greek gods? The most important device is the theme of doubling: there are two green leaves, are there are two names, Pan and PAN interlaced and partly superimposed. This collage belongs to a series devoted to Greek and Latin mythology, and each time one finds the same technique of deliberately clumsy handwriting – Twombly had taught himself to write with the left hand as wanted to trace only childish letters. One hears immediately an echo, a sing-song, a ditty, composed to the glory of a *Pan-PAN!* The artist copies graffiti, artless scrawls with names, leaving a dirty air to his composition.

Like Bergotte, the great Pan had to die so that the little *pan* (patch) of color might survive. It survives today in Cy Twombly's deceptively simple composition, in a colour which is not pure any more but a little dirty, smudged, hence no less material. The capitalized PAN is a writing of the Name as all. Let us remember that, according to the Homeric hymn to Pan, Pan makes *all* the other gods happy: *"Pana de min kaléeskon, 'oti phréna pansin etepsé"* (Then all the immortals were happy in their hearts and Dionysus Bacchus above all. And they called the child "Pan" (from *pantes*, "all") because he had made all their hearts rejoice.)[28] When he was writing *Ulysses* in Zürich, Joyce had found in a lexicon of mythology a post-Homeric legend that stated that Pan was the offspring of the adulterous union of Penelope and *all* the suitors taken together. When Pan strikes his eight beats or shots in the *Jeu de Paume* museum, he reminds us of the need for the artist to sacrifice himself, to be ready to die so that the work remains. In that sense, we are all included in the fateful *pan* and thus as soon as we try to decide who killed Bergotte, we become all accomplices. Besides, did we really kill him? Isn't he literally unkillable?

This might be why, by a curious irony of fate, after Proust had died in 1922, Bergotte was still alive. We need, of course, to assume that Bergotte "was" in reality Anatole France,[29] France, whose real name was Jacques-Anatole-François Thibault, died only in the fall of 1924. This presents us with a rare narratological paradox: it is the author who dies while the character survives. Anatole France had been awarded the Nobel Prize for Literature in 1921, a year in which he was lauded and crowned everywhere.

Anatole France was loved by conservatives and radicals alike, who all praised his style and wit. He had always been courageous in politics, had stood for Dreyfus in the famous affair at a time when this was risky, and Proust had praised him for this. In the post-war years, he had come closer to the French Communists. He had become identified with his pen-name, France, and embodied a certain idea of French intelligence, skepticism and urbane wit that nobody wanted to see disappear after the war. This, however, had made him the butt of the Surrealists, who loathed such a national consensus. As he was at that point very sick and dying, André Breton declared that Anatole France "represented the prototype of everything that we despise".[30] As his regularly-announced death was going to be the opportunity for a huge national celebration, the Surrealists composed a pamphlet which, they hoped, would be published on the very day of his demise, October 12, 1924. In fact, the violent pamphlet, entitled *Un Cadavre* (A Corpse), collectively written by Aragon, Drieu la Rochelle, Breton, Soupault, Eluard and Delteil, was published a few days later – nevertheless, the scandal, upon which they had counted, was enormous. Breton titled his piece "Refusal To Inter" and was scathing: "With France, a bit of human servility leaves the world. . . . Now that he is dead, this man no longer needs to make any more dust."[31] Everyone was outraged in Paris, even the Communists denounced the Surrealists for their petty-bourgeois blinkers, and Breton ended up losing the patronage of the rich collector Jacques Doucet over the France fracas.

It was therefore ironic to see a number of disgruntled ex-Surrealists who had been excluded from the group by André Breton and denounced, as Georges Bataille had been, in the *Second Manifesto of Surrealism*, regroup and pen a vicious attack on the "Pope" Breton. This was also titled *A Corpse* by direct reference to the technique used in the Anatole France pamphlet. This time, twelve writers including Bataille, Leiris, Desnos, Prévert and Baron, pretending to be the twelve anti-apostles of the self-style Pope, derided Breton's covert religiosity and dictatorial tone. They attacked Breton in the most wounding manner. Breton was a "castrated lion", "a stinking ghost", a dignified ox. All this belongs to the history of the French avant-garde, the successive exclusions and denunciations that gave literature an air of politics. What is striking in the context is that it looks as if the spirit of Bergotte had lived on, precisely because the literary murder of which he had been a victim could not find a clearly identifiable culprit. We all have a part to play in that comedy or tragedy – death has taken place, but this is a fictional death that does not occur once and for all. We know, from our readings of de Quincey, that sooner or later the murderous trance will be broken by the fatidic knock at the gate. Is it a signal telling us to wake up from a deep slumber in which shadow crimes are hard to untangle from real-life

murders? The knock at the door of fiction startles us from a trance and makes us feel as if we were alive again, or at least ready to live with all the other guilty parties, our innumerable accomplices.

This is what Proust himself suggested when he answered a rather weird questionnaire just months before he died. In August 1922, Proust was asked to respond to "a little question": "If the world was going to end, what would you do?" His answer begins abruptly: "I think that life would suddenly appear delicious."[32] This sums up the gist of his reply: if we heard that the world was going to end, we would immediately stop wasting our time and work only at the truly important things. We would not keep postponing projects that speak to our wishes and deeper desires, like traveling, studying, or getting married. As incredible as it seems, this condenses the whole plot of *La Recherche*. Of course, what the narrator discovers at the end in *Time Regained* is that he must hurry back to his bedroom and write down the story that we have already been reading. In Proust's response to the questionnaire, among the numerous good resolutions that we keep postponing out of moral laziness, he names as the first of these postponed projects – a visit to the Louvre!

> Ah! If only the cataclysm does not happen this time, we won't forget to visit the new rooms in Le Louvre, to throw ourselves at the feet of Miss X . . . , or visit India. The cataclysm hasn't taken place, we do nothing of all this, since we are back to everyday life, in which negligence blunts desire.
>
> All the same we should not have needed the cataclysm to love life today. It would have sufficed to think that we are human and that this very night, death can come.[33]

Chapter 6

Surrealist Esthetics of Murder
From hysteria to paranoia

Unlike Proust, André Breton deployed the maximum level of violence compatible with a new esthetic to avoid anything that smacked of resignation facing future cataclysms. Hadn't he written, after all, that the "simplest Surrealist act consists in going down, a gun in one's hand, to the street and shoot at random, as much as one can, at the crowd"?[1] In order to make sense of these admittedly outrageous statements, one has to understand the particular circumstances that led him to such an extreme position. Breton's radical stance was immediately condemned by Bataille and his friends. They had no difficulty in denouncing Breton's wish to brutally dominate the field of the avant-garde by suppressing any critical or constructive disagreement. All this suggests, at any rate, that Breton's insistence on the purity of Surrealism as a revolutionary movement did not preclude a fascination for the esthetics of murder. One could observe this by closely reading *Nadja*, in which the eponymous heroine leads a life of petty crime (she has been arrested for passing drugs and engages in occasional prostitution) while being transformed by the magic of Breton's passionate and limpid style into a Surrealist muse. It seems that, from the start, Surrealism has been haunted by *A Corpse*, whether it be that Anatole France, that of its founder, Breton, the *cadavre exquis* of the collective exercises at spontaneous montages of "dictated" lines or drawings, or the seductive but forbidden body of a woman who disappears from sight mysteriously. It has become inevitable to judge Surrealism's impact by its distortions and blind spots. By linking the genealogy of a more "murderous" Surrealism with a reading of Freud, I will attempt to test the validity of the hypotheses about popular culture that I had sketched in the first chapter.

Popular culture adopted Surrealism and Freudianism with identically warping hyperboles in the twentieth century. If the jocular "This is hysterical" can be blamed on Charcot more than on Freud, the phrase "This is Surrealistic" often rings as quasi-equivalent to "This is Freudian." A shocking façade will soon yield a message if we have the code, and that code is easily provided by either by Freudianism (all steeples are phallic symbols)

or Surrealism (the unconscious dictation of desire shows its hand everywhere). Readability is increased by the idea that thematic disorder can be recomposed formally and thus recreate the logic of dream images. Symptomatically, the 1998 exhibition "Freud, Conflict and Culture"[4] which was mounted by the American Library of Congress, after intense controversy, made much of its display of audio-visual documents; beyond illegible manuscripts in Gothic script and disappointing *realia* – such as a few rings or Freud's couch floating in the air – these well chosen film excerpts, mostly from Hollywood classics, made the strong point that Freudianism, although contested, survives thanks to a popular culture which it has literally shaped and permeated. Perhaps the same holds true of Surrealism, whose last public flowering on a large scale was linked to the counter-culture of the 1960s. In France, particularly with the May 1968 revolution, a Surrealist afterimage managed coloured juvenile rebellions in many ways. The hindsight gained once we step more boldly into a new century shows that these cultural phenomena converge without completely meeting, or that they follow a minimally curving parallax.

Breton and Freud were from the start engaged in a waltz of avoidance and a tango of misunderstandings; such missteps nevertheless reveal a deeper harmony. The first missed encounter between Freudianism and Surrealism was linked to the promotion of concepts such as psychic automatism, unconscious dictation, the "over-determination" of dream images (Freud's crucial *Ueberdeterminierung*) and also, more importantly, to hysteria taken as a creative manifestation. The second encounter, promoting the concept of paranoia, was more successful. By narrowing the historical focus on the 1920s and early 1930s, one can observe how the surrealist theory of hysteria was transformed into a Surrealist theory of paranoia. As evinced by the issue of *Le Surréalisme au Service de la Révolution* quoted in Chapter 2 about Duchamp's notes for the big glass that later generated *Etant Donnés*, we can recall that the issue also contains correspondence between Breton and Freud. I will return to this exchange soon to show that the rapport between Breton and Freud was marked by a series of attempts at seduction followed by rejection and absurd bickering; in short, such rapport was caught up in a movement that started as hysterical seduction and ended with paranoid accusations.

Breton began his career as a medical student specializing in psychiatry, and it was in this function that he served during the First World War. We know how closely Breton had read Freud at a time when most French schools of psychiatry totally ignored him. Having begun medical studies in the fall of 1913, Breton was sent to the neuro-psychiatric ward of Saint-Dizier in August 1916, which was supervised by a former assistant of

Charcot. There, Breton voraciously read all the psychiatric literature available, which included an initiation to Freud's ideas found in a compendium of psychiatry authored by Doctor Régis. Breton also read a book entitled *La Psychanalyse*, written by Doctors Régis and Hesnard, and he copied entire pages from these volumes for his friend Fraenkel. In his notes, one finds an accurate synthesis of the Freudian system, along with competent definitions of concepts such as resistance, repression, and sublimation.[3] Even if Freud was not the only writer discovered by Breton at the time, he felt that it was his duty to defend Freudian ideas against his friend's skepticism. There was a moment of glorious illumination when he exclaimed: "I am getting enthusiastic over psychiatry."[4] He also dutifully copied the nonsensical tirades he would hear delirious psychotic patients rattling at night. Thus, even though Breton was transferred to the service of Doctor Babinski in 1917, which forced him to address the sensitive issue of hysteria's reality or fictive nature, one can believe his account when he referred to Freud rather than to Myers or Janet in the first manifesto of Surrealism. This is the conclusion reached by Marguerite Bonnet's study of Breton's manuscripts, a study that contradicts an earlier thesis developed by Starobinski and that had been accepted until recently.

With a wealth of details culled from the psychiatric literature of the times, Starobinski tried to show that the concept of "mental automatism" promoted by Surrealism had little to do with Freud's theories, and was instead derived from Janet and Myers.[5] However, even if Breton's debt to Babinski and his early adherence to Babinski's refutations of the older Charcotian *doxa* regarding the reality of hysteria have been demonstrated, a simple perusal of Breton's notebooks proves that it was Freud's impact that led him to trust the spontaneous production of language as offering a key to the unconscious. Starobinski rightly notes that Freud always limits the "fundamental rule" of psychoanalysis (taking the uninhibited flow of language proffered by the patient to the analyst as material for analysis) to a very preliminary stage and refuses to grant it more than a heuristic value. Nevertheless, it is clear that Breton decided to take this preliminary moment seriously and to endow it with a truth-value; fundamentally, this was a technique that he owed to Freud, recalling the latter's discovery of the unconscious after listening to hysterics and his own dreams. In both cases, it looks as if a major breakthrough had been produced by something akin to beginner's luck.

Thus, even if the terms used by Breton and his friends refer to French classical (that is, pre- or anti-Freudian) psychiatry as represented by Charcot, Janet, or Babinski, a fundamental insight – that these spontaneous utterances disclose material leading to a grasp of actual psychic production

– derives from Freud, and Breton always duly paid his symbolic debt. His narrative in the *First Manifesto of Surrealism* should therefore be trusted: "Quite busy as I was then with Freud at that time, and having been familiarized with his examination methods that I had somehow used with patients during the war, I decided to obtain from myself what one tries seeks to obtain from them, that is a monologue flowing as fast as possible and upon which the critical mind of the subject makes no judgment whatever, letting it be unhampered by any reticence so that it may render as exactly as possible *spoken thought*."[6] Freud dominates the manifesto, written in 1924, which did not preclude Breton's awareness, thanks to his theoretical foundation in psychiatric knowledge, that a whole world separated psychoanalysis understood as a clinical practice from Surrealist experiments aiming at abolishing the borders between sleep and waking life, and ultimately between art and life.

Breton took the initiative of a direct meeting with Freud in October 1921 but he was severely disappointed by it. Under the title of "Interview with Professor Freud" (1922), he published a curt account of the meeting in *Littérature*, later reprinted in *Les Pas Perdus* (1924). Not wishing to attack Freud's reputation, Breton betrays his bitterness by sticking to a purely exterior description: Freud's appearance is that of "an old man without elegance who receives in the poor consulting room one would expect from a local doctor". The French poet is unable to engage this unimpressive Viennese MD in a meaningful dialogue; conversely, Freud, no doubt at a loss with this young enthusiast, hides behind polite generalities. Breton concludes the short article tongue-in-cheek by quoting Freud's tepid endorsement: "Happily, we do count a lot upon the young."[7] The painful sense of a discrepancy between Freud the man and Freudian ideas, or more precisely the distance between the inventor of psychoanalysis, seen in all of his human and social limitations, and the empowering invention of psychoanalysis itself, shapes Breton's attitude in the following years.

The second interaction between the two men turned more critical and started even less happily because of Breton's suspicions about the *Interpretation of Dreams*. According to him, Freud had plagiarized or stolen from previous theoreticians of dreams. In the summer of 1931, as he was preparing a draft of *Communicating Vessels*, Breton re-read the French translation of Freud's *Interpretation of Dreams* very thoroughly, taking twenty pages of dense notes in a schoolboy's exercise book. On the right-hand pages are quotes while the left-hand pages is reserved for personal remarks or associations. On the third of the left-hand pages, Breton jots down a series of references to books dealing with dream symbolism, puts down his own equations and reaches different conclusions from his perusal of Freud's crit-

icism of the literature on dreams. When Freud criticizes Delboeuf in the section devoted to "Theories of Dreaming" (Delboeuf thought that everything in dreams came from thought-material of the previous day), Breton jumps ahead to state a connection between dream activity and paranoia. He writes on the right-hand side page: "Theories of dreams. 1. "The whole psychical activity of the waking state continues in dreams." (Delboeuf) (Very insufficient) Dream = Paranoia." He comments on the left-hand side: "Theories. Delboeuf. Dream-paranoia. Valéry: 'The dream goes on.'" The remark is followed by the names of Robert and Burdach.[8]

These notes are taken from what is now section E of *The Interpretation of Dreams*,[9] in which Freud builds very early a bridge between dreams and paranoia: "If I may venture on a simile from the sphere of psychiatry, the first group of theories construct dreams on the model of paranoia, while the second group makes them resemble mental deficiency or confusional states."[10] This sentence must have struck Breton, for he copies it a second time, then cancels it before rewriting on the left-hand side. The words "Dreams-paranoia" are inserted and then crossed out, having been added by mistake to the theories developed by the second group of writers. Breton does not merely follow Freud's text, but checks various references to the authors, and of course, verifies the bibliography. On the page of the notes equating dreams and paranoia, one finds soon after: "Volkelt's *remarkable* sexual symbolism", and on the left-hand side: "Volkelt, quoted by Freud *without references (?)*."[11]

This paved the way for the personal attack that wounded Freud so deeply. Breton had written that Freud omitted Volkelt's book on symbolism from his bibliography on purpose, implying that he borrowed much more than what transpires form the rapid remarks in the *Traumdeutung*. In Breton's reading, Volkelt could have inspired the whole theory of sexuality in dreams. Breton writes:

> Freud himself, who seems, when it concerns the symbolic interpretation of the dream, just to have taken over for himself Volkelt's ideas – Volkelt, an author about whom the definitive bibliography at the end of the book remains significantly mute – Freud, for whom the whole substance of the dream is nevertheless taken from real life, cannot resist the temptation of declaring that "the intimate nature of the subconscious (the essential psychical reality) is as unknown to us as the reality of the exterior world," giving thereby some support to those whom his method had almost routed.[12]

The attack is double: first Freud stole the idea of sexuality in dreams from an obscure writer who, according to *The Interpretation of Dreams* merely

generalized the insights of Scherner, a good practioner whose defect is a turgid style;[13] then, more damning is the reproach that Freud has forgotten his own monism and fallen into the trap of idealism when he opposes dreams and reality as belonging to radically different realms.

For his philosophical critique, Breton not only relied on Lenin whom he quoted frequently, but also alluded to Schopenhauer, who had assumed that dreams could be prophetic in the gift of "second sight". Such an idealist theory seems to postulate a division between reality and appearances, while for Breton, reality is one with dream in a continuum that allows for prophecy: "Freud is again quite surely mistaken in concluding that the prophetic dream does not exist – I mean the dream involving the imme-diate future – since to hold that the dream is exclusively revelatory of the past is to deny the value of motion."[14] To provide a counter-model, Breton offers his own interpretation of a dream: this is the frank account of the dream of August 26, 1931. No doubt, the dream, in which a tie called "Nosferatu" plays a great role, is mostly about Surrealism, fellow Surrealists and Communists. Against Freud's idea of an "umbilicus" or dark core of unknowability in dreams, Breton attempts to "exhaust" the contents of the dream by a thorough examination of all its images and associations.[15] But even if he rewrites Freud's principles of condensation and "overdetermina-tion" in a materialistic language inflected by Marx and Lenin, he does not comment on the fact that he clutches a loaded gun in his dream.

In real life, Freud immediately replied to defend himself from insinua-tions of plagiarism. He pointed out that the omission of Volkelt's name from his book was a mistake that appeared only in the French translation of 1926 and that the name was in fact given in the original German text. A hastily drafted second letter explained the origin of the mistake: Volkelt's name was dropped for no clear reason after the third original printing; the French version followed one of the subsequent versions.[16] Freud also put to rest Breton's thesis that he had been prudish on matters of sexuality and that Volkelt had been more explicit about the sexual symbolism of dreams. He added that he refrained from mentioning his father, who has just died, but otherwise did not censor himself. The third letter, acknowledging Breton's reply, ended with a barb, since Freud pretended not to understand what Surrealism is about, and above all what it wants: "Although I have received many testimonies of the interest that you and your friend show for my research, I am not able to clarify for myself what Surrealism is and what it wants. Perhaps I am not destined to understand it, I who am so distant from art."[17] Freud reduces here Breton's paranoid critical reading to mere hysteria ("What it wants" means obviously, "What do you want from me?"). He is also echoing his current preoccupation about the riddle of femininity

while simultaneously parading his incomprehension, petty bourgeois philistinism and lack of esthetic sense. Freud returns to Surrealism a feminized version of itself, a sort of Gallic version of *Was will das Weib?* On the other end, Breton wishes to keeps the clash at the level of a male confrontation, of rival theories and conflicting power games. He notes gleefully Freud's obvious agitation, his contradictions in the flurry of successive letters, and finally his desire to pay back in kind by denying any valid aim to Surrealism. Finally, he quotes Fritz Wittels' book on Freud's pugnacious and jealous style in a footnote: "I knocked him to the ground because he knocked me to the ground."[18] Breton may have indeed "touched on a rather sensitive point".[19]

One might say that after the failure of hysterical seduction, *Communicating Vessels* engages Freud and Breton in a paranoid logic revolving around archives, annotations, bibliographies, citations, appropriations, issues of literary ownership and intellectual propriety, and male domination games, not to mention accusations of dissimulation and squeamishness. This time, Breton's strategy worked better: whereas Freud could write that he had succeeded where the paranoiac had failed, Breton proved that the paranoiac succeeded where Freud had failed. After an earlier hysterical seduction attempt failed, Freud found himself caught up in the net, writing apologetically to explain and excuse himself. Indeed, when Salvador Dalí met him in London in 1938, Freud was more receptive to "the young". Dalí had been named in *Communicating Vessels*, a text written in 1932, which, even when it returns to issues of dreams, the unconscious and automatism, does so in manner totally different from the texts published in 1924. We may wonder how Surrealism moved so abruptly from a strategy that promoted hysteria to a strategy that took paranoia as its main weapon and mode of vision.

If one surveys the issues of *La Révolution Surréaliste* from the late 1920s, a clearer picture emerges. In the 1927 issue, Freud's text on lay analysis is published in a translation by Marie Bonaparte. The only text by Freud ever directly published in the review, it plays an crucial role in the Viennese master's attack on the medicalization of psychoanalysis, a drift which the Surrealists could only applaud. Ironically, Freud seems to anticipate the forthcoming debate with Breton when he imagines an opponent who thinks that he has touched a sensitive point, because Freud becomes aggressive: "And if I look aggressive, this is only to defend myself. But when I think of the fuss certain analysts have made about the interpretation of dreams, I could despair and agree with Nestroy's pessimistic outcry: 'Progress is only half as great as it seems.'"[20] It is rather amusing to find this rather conservative extract (in view of the more radical theses on education and medicine

that follow in the complete text on lay analysis) followed on the next page by "Corps à Corps," a prose poem by Benjamin Peret beginning: "To wake up at the bottom of a carafe, haggard like a fly, here's an adventure that will incite you to kill your mother five minutes after you escape from the carafe."[21]

André Breton's and Louis Aragon's manifesto extolling the "Invention of Hysteria" as a revolutionary breakthrough was published in *La Révolution Surréaliste*, no. 11 of March 1928. They celebrate the "fiftieth anniversary of the invention of hysteria", an invention dated from 1878 so as to send us back to Charcot. Hysteria is further called "the greatest poetic discovery of the latter part of the century".[22] In this lyrical homage to hysteria, Breton and Aragon reject Babinski, who we might recall had reduced hysteria to suggestion. They also take a cooler look at Freud insofar as he remains a doctor who claims that one must cure hysterical patients. Charcot is praised less for the fact that the amphitheatre of La Salpêtrière was a theatrical scene in which he exhibited patients in front of a fashionable crowd than for having created the conditions for the vulgarization of hysteria. Freud is not spared: Breton and Aragon oppose his conservatism to what they find truly admirable, the fact that La Salpêtrière's interns would regularly sleep with their beautiful hysterical patients. "Does Freud, who owes so much to Charcot, remember the time when, according to the survivors' account, the interns of La Salpêtrière refused to separate their professional duty and their taste for love, and when night fell, the patients would either visit them outside or they would meet the patients in their beds?"[23] Freud would have been horrified by the insinuation that he belonged to that unruly crowd. The living poetry invented and enacted by the female patients and the young interns who slept together culminates in these "passionate attitudes" photographed by Charcot, in which one sees stunning half-undressed women in curious poses indicative of a convulsive but otherworldly ecstasy.

Breton and Aragon provide their own definition of a state which eludes medical categorization: "Hysteria is a more or less irreducible mental state characterized by a subversion of the relations between the subject and the ethical universe by which the subject feels determined in practice, outside any systematic delirium. This mental state is based on the need for a recip-rocal seduction, which explains the hastily accepted miracles of medical suggestion (or counter-suggestion). Hysteria is not a pathological phenom-enon and can in every respect be considered a supreme vehicle of expression."[24] In 1928, Breton and Aragon insisted upon the quasi-normalcy of a state seen as a limit-experience: for them, hysteria ruled out any "systematic delirium". The phases of the classical hysterical crisis lead to a "superb aura" in a magnificent theatralization before subsiding by a

"simple resolution in everyday life".[25] Announcing Lacan's stress on feminine *jouissance* in the 1970s, hysteria is here identified with a mystical and erotic ecstasy while tapping a fundamental artistic impulse. Adding salt to the humdrum of everyday life, hysteria radically embodies the main Surrealist ambition to merge poetry and life.

Breton and Aragon bid farewell to their former master Babinski without endorsing Charcot's attempts at establishing a neuro-scientific localization in the brain. Babinski saw hysteria as a purely imaginary or mimetic disease, which had to be eradicated by strong counter-suggestion. His harsh treatment of male hysterics, mostly shell-shocked soldiers back from the front during the First World War, led to medical abuse, including gruesome electrical therapy. Yet the idea of simulation looms large in the text written by Breton with Eluard in 1930, *The Immaculate Conception*. In a section entitled "Possessions," the two poets successively attempt to reproduce the discourses of debility, of mania, of general paralysis, of interpretive delirium, and of precocious dementia.[26] The Introduction to this section, written solely by Breton, exploits the amphibology of the term, which alludes to the technical meaning of "simulation" in psychiatry, especially in the psychiatry of war neuroses, and concludes with a critique of traditional poetic forms, which could easily be replaced by imitations of the various types of psychotic speech: "This is to say that we offer the generalization of this device and that in our eyes, the 'attempts at simulation' of diseases that land you in a jail might advantageously replace the ballad, the sonnet, the epic, the nonsense rhyme and other genres now totally obsolete."[27] This passage was written in 1930, just after the first great divide in the Surrealist group that had triggered Breton's *Second Manifesto of Surrealism* dated from December 15, 1929.

In 1929, a new name was added to the list of painters whose works regularly adorned the pages of the review like Max Ernst, de Chirico, Miró, Picasso, Arp, Picabia, Masson, Ray, Tanguy. It was that of a young Catalan painter and poet who would have an important impact on the group, Salvador Dalí. One might say that Dalí replaced de Chirico in 1929; indeed, the *Second Manifesto* was followed by two paintings, one by de Chirico, the other by Dalí. In 1929, however, de Chirico was denounced as a reactionary, anticipating what took place with Dalí a few years later. The *Second Manifesto* still alluded to Freud but rather distantly, the text being peppered with critical asides that reasserted a materialist philosophy. The political references shifted to Trostky, while Freud was suspected of lending arguments to Georges Bataille's non-dialectical materialism. After the publication of the *Second Manifesto of Surrealism*[28] – Breton's frantic call for direct action – Bataille had become Breton's most threatening opponent. Many had left

Breton's camp for Bataille's rather looser group of disgruntled activists who dismissed the orthodoxy imposed on them by Breton. Breton believed Surrealists were witnessing "an obnoxious return to old anti-dialectical materialism, which this time is trying to force its way gratuitously through Freud"[29] and relentlessly denounced Bataille's reduction of materialism to its basest form. According to Breton, Bataille was only interested in *bassesse*, or baseness, the process by which a form is made to decay as evident in his superb essay *Formless*: "*formless* is not only an adjective having a given meaning, but a term that serves to bring things down in the world, generally requiring that each thing have its form . . . affirming that the universe resembles nothing and is only *formless* amounts to saying that the universe is something like a spider or spit."[30] Consequently, for Bataille the real revolutionary was less Marx than Marquis de Sade, and he embraced Sade as one who liberated the hideous and erotic imagination in light of "a corresponding limitation, a narrow enslavement of everything that is opposed to this irruption".[31]

This is where young Dalí seemed to follow in Bataille's steps, especially when he took the systematization of psychic disorder as a new esthetic credo. "Our epoch is dying of moral skepticism and spiritual nothingness. . . . I am thinking of you, youth exuberant with gay generosities, youth of neo-paganism guided by a monstrous utopian idea bloody and sacrilegious. I am thinking of you, companions, comrades of nothingness!"[32] Accordingly, Dalí viewed the Surrealist object as one "absolutely useless from the practical and rational point of view, created wholly for the purpose of materializing in a fetishistic way".[33] Similarly, Bataille's attention to fetishism, as exemplified in "The Big Toe", corresponds with his own views of baseness and formlessness; the big toe is "the most *human* part of the human body".[34] Bataille's toe finds itself in the mud, "subjected to grotesque tortures that deform it and make it rickety."[35] The Surrealists had always condoned violent crime when it seemed to break with bourgeois traditions, but a spate of disruptive murders marked the beginning of the 1930s – the most visible being the murder of the Papin sisters case, in which two maids, Lea and Christine, gouged out the eyes and reduced to bloody pulps the mother and daughter they were employed by. In 1933, the Surrealists even flew in arms to defend the doubtful cause of Violette Nozières, an eighteen-year old parricide.[36]

The year 1933 marks the official recognition by Breton and his friends that it was legitimate for a Surrealist to write a "circumstantial poem" dealing with recent *fait divers*. For instance, Breton exploits the fact that Violette's first name contained in itself the rape (*viol*) programmed in advance by her father.[37] It is no coincidence that this is the same year as the

publication of Duchamp's notes in the Surrealist review I have analyzed in Chapter 2. Pure paranoia was evident in the case of the Papin sisters, who endured scorn and slights for six years while nourishing a deep and perverse hatred of their female employers. As with Violette Nozières, who first accused her father of incest, while admitting to a life of drug-use and sexual orgies with younger men, the gruesome stories exemplify the violent protest staged by madness against family, social oppression, bourgeois decency, propriety and so on. By committing the ultimate paranoiac crime, the Papin sisters seemed to both confirm and radicalize Bataille's theories and Dalí.'s esthetics.[38]

In view of these convergences, Dalí should logically have joined Bataille's camp. Given his insistence on images of corpses in decomposition, his perverse eroticism linked with onanism and rotting animals, his provocative way of flaunting perverse masturbation, he should have logically allied with the authors of *Un Cadavre*. He chose to join Breton's camp instead, most probably because he was in quest of legitimacy within what he perceived to be the only authentic movement. For Bataille had initially taken to Dalí, writing an incandescent essay on the "Lugubrious Game" that created an uproar. Its title quotes a painting done in 1929 for his first Paris exhibition, as Camille Goermans was devoting a show to Dalí's work. In the catalogue essay that he wrote for the exhibition, Breton praised the "hallucinatory" quality of the painting while settling his accounts with the deluded "materialists" who had tried to corner Dalí.[39] Bataille had indeed expressed some interest in Dalí, and the December 1929 issue of *Documents* published Bataille's essay, entitled simply, "The Lugubrious Game." In this brilliant reading, Bataille insisted upon the idea of castration, emasculation being presented according to him as a parody, with the shocking figure of a man with shitty breeches. Dalí, parading his allegiance to Breton, refused to allow Bataille to reproduce the painting and then attacked Bataille directly in "The Rotting Donkey" (July 1930).

Dalí called Bataille's ideas "cretinous" and "senile", stating that their error derived from a wrong interpretation of Freud, or, in his terms, of a "gratuitous use of modern psychology".[40] Thus we see Bataille, Breton and Dalí reproaching one another for having misapplied Freudian ideas. All of this contemporary furore prepared the stage for the emergence of Dali's main concept, his paranoid-critical method. The Freudian source of these ideas stands out more clearly in the first text in which Dalí exposed this discovery, "The Moral Position of Surrealism" (March 22, 1930). Aligning himself with Breton's programme as outlined in the *Second Manifesto*, Dalí explained that next to going into the street with a revolver in hand and shooting people at random, his proselytizing activity should aim at propa-

gating the "violently paranoid will to systematize confusion".[41] Dalí added that Freud's ideas had been watered down; that it was necessary to give them back their "rabid and dazzling clarity." Among the few cases of neurotic behaviour that he provided, he mentioned that he had written under a painting of the Sacré-Coeur, "I spat on my mother." This was not a mere private provocation, but derived from a systematic attempt at demoralization similar to that of Sade. What mattered was to have a method to see reality differently, a method that took its bearings in paranoia:

> Above all, the birth of these new Surrealist images must be considered as the birth of images of demoralization. The particular perspicacity of attention in the paranoiac state must be insisted upon; paranoia being recognized, moreover, by all psychologists as a form of mental illness which consists in organizing reality in such a way as to utilize it to control an imaginative construction. The paranoiac who believes himself to be poisoned discovers in everything that surrounds him, right up to the most imperceptible and subtle details, preparations for his own death. Recently, though a decidedly paranoiac process, I obtained an image of a woman whose position, shadow and morphology, without altering or deforming anything of her real appearance, are also, at the same time, those of a horse.[42]

If we can easily understand why paranoid mechanisms are exemplified by the man who imagines himself poisoned, this looks like a far cry from the practice of guided hallucination, a practice which recalls Rimbaud's famous battle-cry of a "systematic deregulating of all senses." Even if Dalí adds that the process can become more "violent" or "intense" and yield three, four, or even thirty different images, it is revealing that he is talking about the production of images still anchored in reality and not unleashing totally new images freed from conventional systems of representation.

In "The Rotting Donkey," Dalí, no doubt stung by Bataille's admiring but critical account of his work in terms of castration anxiety, pushes his thesis further by radically collapsing conventional systems of representation and paranoid delirium. He goes back to his example of a woman who is at the same time a horse, and possibly a lion's head, to explain: "I challenge materialists to examine the kind of mental crisis that such an image may provoke, I challenge them to examine the even more complex problem of knowing which one of these images has a greater number of possibilities for existence if the intervention of desire is taken into consideration, and also to investigate the more serious and more general problem of knowing whether the series of representations has a limit or whether, as we have every reason to believe, such a limit does not exist, or rather, exists solely as a function of each individual's paranoid capacity.".[43] The reversal of perspective

is obvious: whereas paranoia seemed first to open a door into another kind of visual perception, it now turns into a regulating principle that replaces completely any idea of a "material world". The material world is just one type of simulacrum and Bataille's "base" materialism is debunked. Since reality is de-multiplied in a series of hallucinatory figments, there is no need for a "basis" in a base, obscene or dirty matter.

It is now clearer why Dalí chose Breton over Bataille: both camps criticize Freud's dualism while rewriting his insights in a monist discourse, but Bataille stresses the materiality of the body leading to notions of excess, waste, and excrement, while Breton and Dalí see reality as a series of simulacra underpinned by a universally productive desire. We know how influential and formative this debate was for Lacan, who came into contact with it just as he was completing his doctoral dissertation on paranoia. As Roudinesco has shown in her historical account, it was the impact of Dalí's "Rotting Donkey" that allowed Lacan to break with the classical psychiatric theories of personality and constitution and to revisit Freudian meta-psychology.[44] At that time, Lacan was translating Freud's 1922 article on "Certain Neurotic Mechanisms in Jealousy, Paranoia and Homosexuality" into French, a text in which the thesis that had underlain the analysis of the Schreber case is restated – namely that the root of paranoia is the return of repressed homosexuality. In a case of a jealous delirium observed by Freud in a heterosexual patient, delusional attacks followed successful sexual rapports between the man and his wife: by inventing imaginary male lovers and creating delirious recriminations, the husband facilitated the projection of his own desires facing these men. It is at that time, too, that Lacan contributed to a collective essay on "Inspired Writings" of 1931, in which the authors analyze the psychotic ramblings of a teacher hospitalized at Sainte-Anne; their description of the formal components of a grammar of mad utterance is marked by an awareness of Surrealism, as the authors quote Breton's first *Manifesto of Surrealism* and look for a model of interpretation in Breton's and Eluard's imitations of individual styles of typical delirium in *The Immaculate Conception* published one year earlier, in 1930, which shows how rapid the exchange of ideas could be.[45]

Shortly after, Lacan treated the young woman whom he was to call "Aimée" and who became the focus of the thesis completed in 1932. When "Aimée" was brought to Lacan in April 1931, he immediately diagnosed a paranoid psychosis, with delusions leading to the attempted murder on a famous Parisian actress who had become a dangerous double for her. Lacan's thesis has received some critical attention,[46] but has not yet been translated into English. In fact; the Surrealists were the first to greet Lacan's thesis

with exuberant praise. In his 1933 "Notes Toward a Psycho-Dialectic,"[47] Crevel expresses the hope that Lacan will provide a new foundation for psychoanalysis at a time when Freud is being discredited as reactionary or pusillanimous. It is not only that Lacan dares to treat psychosis directly but also that his work is firmly grounded in the social world, which allows for a Marxist approach. Lacan was then enlisted willy-nilly in the cause of a Surrealist Freudo-Marxism. As Dalí later noted,[48] Crevel's suicide in 1935, partly brought about by his inability to reconcile Surrealism and Communism, was one of the dark omens announcing the untimely demise of the movement. It may not have helped that Dalí was just then developing fantasies about Hitler on the one hand, and high fashion on the other. Conversely, Lacan had already created some distance between himself and the avant-garde's political factions; he only elaborated an original version of Freudo-Marxism in the late 1960s. Even if Lacan's theory of paranoia has little to do with Dalí's concept of serial visual hallucinations, they do partly overlap.[49] Moreover, in 1932, Lacan had not yet elaborated a critical vocabulary that would allow him to go beyond Freud's homosexual thesis of paranoia, even if his inroads into the mirror-stage complex and its attendant release of aggression provided a bridge leading to the construction of the alter-ego as a dangerous rival that one must murder at any cost.

What remains indisputable is that, thanks to the convergence of interests among Bataille, Dalí, Breton, Lacan and Crevel, the second decade of Surrealism was dominated by the concept of violent and murderous paranoia, much as the first had been by verbal automatism and seductive hysteria. This was not a passing fashion: Breton's most comprehensive prose synthesis, his 1937 *Mad Love*, still affirms his belief that desire is the mainspring of all our dreams and actions, while still making an important place for paranoia. Desire, no longer structured by hysteria, follows the lead of paranoia. In the fifth section, Breton reopens Freud's *A Childhood Memory of Leonardo da Vinci* before expounding the principle of paranoiac criticism or critical paranoia. As we have seen in Chapter 1, the vulture hidden in the Virgin's dress may have been Oskar Pfister's hallucination more than the product of Freud's meditations; it nevertheless follows that once an interpretation has generated a new image in a previous one, it will remain there, hovering between objectivity and subjectivity.[50] If Breton refrains from claiming Leonardo as one of the precursors of Surrealism, it is still however true that he had recommended the systematic practice of imagining shapes in old walls, clouds or landscapes. Breton thus muses: "The purely visual exercise of this faculty which has at times been called 'paranoiac' has led to conclude that if a single spot on a wall or elsewhere will almost always be interpreted differently by different individuals acted upon by distinct

desires, this does not imply that one will not manage to make the other see what he has perceived. One does not see *a priori* what would prevent this illusion to go round the earth."[51] If Polonius is merely humouring Hamlet's real or feigned madness when he agrees to see a whale in the clouds, his interested acceptance presupposes a fundamental communicability of hallucinations. Visual hallucinations can be shared whatever one's opinions about the divide between madness and sanity may be. Whereas hysteria counts upon mutual seduction in order to reach the truth of desire, paranoia articulates a system of signs whose pseudo-objectivity soon discloses dangerously flimsy foundations. The force of desire appears as the source of what had been shared, even momentarily. The extravagant gestures enacted by hysterics were pathetic attempts at aesthetic expression; these were staged differently by paranoia in a violently assertive discourse that would be shared not just by an elective master but by a whole confrontational and dialogical community, in a movement that tended more and more to political confrontation.

Breton's failure facing Nadja herself comes from the fact that he read her thought the theoretical filter of hysteria: she was the beautiful soul who wanders in the streets until she finds her poet and "master". Typically, this very master, Breton, misread her deeply pathological state in order to transform her into an *anima inspiratrix*. When the symptoms of psychosis became too worrying, she had to be carted away in a hospital, and he was then free to rail violently against forced institutionalization. Neither Nadja nor Breton could see the psychosis that erupted and engulfed the young woman. In its delirious creations, paranoia flirts radically with psychosis and thus cannot be turned so easily into allegory. If one does, it is better to turn to historical figures such as Hitler, as Elias Canetti does, in the notorious conclusion of *Crowds and Power*, when he forcibly points out the connection between Schreber and Hitler. In that context, Dali's obsession with Adolf Hitler in the late thirties makes ominous sense. Moreover, Canetti's thesis appears reductive and has been disqualified recently by David Trotter's insights (insights reached without any reference to Dalí') in *Paranoid Modernism*.[52]

Accordingly, Breton refuses to allegorize paranoia in *Mad Love*, whereas his narrative provides a good example of the positive use of guided and experimental paranoia. It also re-contextualizes the "esthetics of murder" in a new version of Surrealism. *Mad Love* describes how one summer day of 1936, he and his young wife, Jacqueline, were taking an afternoon walk along the sea in Brittany, not far from Lorient, in the vicinity of Fort-Bloqué. The weather being grey and sultry, the tide at low ebb, they had nothing to do but follow the shore and gaze at the dull debris left by the

sea. Jacqueline and André both started feeling ill at ease, threatened by a sense of separation that seemed to push them apart. Finally, when they saw a little fort, they chose diverging paths and walked far from one another. Breton wished to go back immediately, preferring to leave his wife in order to relieve the tension. Back in Lorient, when he described their excursion to his family, everyone asked whether they had seen the "Villa of the Loch". The place they had passed when they felt most oppressed was a house in which a few years earlier a man had savagely killed his wife for sordid calculations. The garden along which they had walked when they had felt their love wither was the place where the murderer had raised silver foxes. Breton called up paintings that described scenes of murders and concluded that something of the place's negative aura must have influenced their strange behaviour. A few other coincidences are added: he and his wife were precisely reading books with "foxes" in their titles. The worst feeling of despondency occurred when they were closest to the wall where the foxes' cages had been; Breton writes that it felt as if the wall had been transparent! What had been experienced as a "living nightmare" one afternoon could not be due to chance: "Everything happened as if one had been the victim of a most cunning machination from powers that remain until now quite obscure."[53] The formulation remains tantalizingly vague, and Breton seems to despair of convincing a skeptical or rational reader. Apparently, his aim is not to demonstrate the workings of paranoia but to elaborate a new theory of love and its contingencies.

It seems that Breton believed his own theory. Whether one accepts the idea that the scene of a murder can affect innocent tourists who pass by two years after the fact is immaterial. Breton's suggestion that he has been the plaything of occult forces for a few hours follows the structure of paranoia more than that of superstition. In such a pattern, nothing is left to chance: sudden mood swings can be explained by rays, ghosts, emanations, the most archaic contaminations implying dead people and even animals. It is a world full of magical meaning, precisely because, in it, everything has to be meaningful. The main issue is not reality and surreality but rationality and surrationality. Paranoia keeps strong echoes of its association with the *nous*. A more dispassionate approach, such as that of Freud himself – who hated any suggestion of occultism (although he believed in telepathy[54]) – might be limited to observing that the curious incident took place on July 20, 1936, just forty-five days before Jacqueline impulsively left Breton after a violent marital crisis (September 6, 1936). Jacqueline disappeared for a whole month, leaving him to care for their young daughter without sending news of her whereabouts. Breton wrote the account of their walk and the momentary estrangement announcing potential rifts between August 28

and September 1, 1936, which was also the time when he put together various pieces to make up the book he called *Mad Love*.

In a very Freudian manner, the account of the doomed walk because of a past murder somehow surviving as "traces" functioned as a symptom of a deeper "disturbance of love" rather than of Freudian memory. Breton wished to make sense of a strange event which may have functioned as a performative precipitating another crisis. Breton felt that he had been contaminated by the past murder and that his wife had sensed it. The whole book was meant as a way of probing the madness of his love and perhaps the madness of mourning this same love, should Jacqueline have decided not to come back. From the basic facts of life – Breton did not invent these incidents – what emerges is less a totally irrational belief in auras or "bad vibrations" linked to a murder site, than the idea that all of these facts and factors can be organized in a productive paranoia by the act of writing. Nevertheless, paranoia thrives on murder, especially when murder has the power to radiate auras and premonitions.

Surrealist doctrine and practice shifted from a praise of hysteria disclosing sexual desire via seduction to a practice of guided paranoia that forcibly makes sense of the world while altering it, and also making room for violent crime. It thus became one with what David Trotter has called "paranoid modernism". We perceive here one of the most powerful mainsprings of the evolution of modernism as a whole. A good example of the shift from hysteria to paranoia is given by Wyndham Lewis. Trotter devotes a chapter to paranoia in Wyndham Lewis,[55] but he does not stress that this is a theme developed relatively late, and that the early novel *Tarr* (a text that he does not examine, in conformity with his thesis) is above all dedicated to exploiting the subversive forces of hysteria. In revisions between the 1918 and the 1928 versions, the novel systematically takes stock of the modes of hysteria available to various marginal expatriates and *déclassés* who interact curiously and violently in the pre-war Paris recreated by Lewis. The fact that it is a German, Kreissler, who rapes another German, a woman named Bertha, before shooting a Russian Jew in a grotesquely climactic duel, shows how far hysteria can go before leading logically to the chain of exclusion and persecution disclosed in paranoia. *Tarr*'s complex textual evolution announces the profound shift in values that marks the end of the 1920s and confirms that the evolution analyzed in French surrealism had a counterpart in Anglo-Saxon high modernism.

The hysterical style of modernism poses the question of woman, or rather of femininity and masculinity, an thus causes panic for men and women. Hysteria's main question according to Lacan ("Am I a man or a woman?") leads to a troubling and productive doubt – since, indeed, it took two sides,

the seduced interns and the enraptured hysterics, to produce the ecstasies so much admired by the Surrealists. This has had important consequences for what is commonly called "high" modernism, a modernism that allegedly attempts to distinguish itself from commodified mass culture. I am alluding here cursorily to Andreas Huyssen's objections to a modernism that he identifies with literary or artistic experimentation, neo-fascistic a-historicism and male-dominated elitism.[56] On this view, modernism would boil down to male hysteria compulsively rejecting any suspicion of femininity in the name of the new "hardness" and poetic specialization. As Pound and Eliot insisted, the true poet must become a professional and not a feminized dilettante who dabbles in versifying. For Huyssen, the modernist is a "serious artist" only in so far as he chooses as his most threatening enemy a defunct Victorian culture identified with a "bitch", the "botched" civilization that had given birth to the Great War. In fact, such a perspective should be strongly qualified if not completely resisted, and the example of Surrealism confirms my reservations. The role of the Great War is crucial, although the main divide is not before and after 1914 or even 1918, but before and after 1930. Rather, it was the need to assert a discourse about the war as hysteria such as one sees in Ezra Pound's *Hugh Selwyn Mauberley* that delayed the irruption of paranoid readings.

These questions are all contained in the text in which André Breton attempted to mime automatic writing *and* psychotic speech for the first time. Before he worked with Babinski, which forced him to confront hysteria, or rather its hasty refutation and theoretical dismissal, as we have seen, Breton had encountered psychotic delusion. In Saint-Dizier, while he was busy reading Freud and making sense of psychotic discourse, Breton chanced upon a particular type of delirium: it was a soldier who had been traumatized by the battle and who, as a consequence, stopped believing in the reality of war. For this shell-shocked patient, the only way to survive psychically was to believe that the whole battle had been a simulacrum: the bloody fields, ruins and corpses were an illusion manipulated by occult powers. Moreover, it was an esthetic illusion aiming at creating the "sublime." This delirious discourse had such a powerful effect on Breton that he decided to copy it and transform it into a prose poem, his first prose piece in fact.

In this short text, simply entitled "Subject," Breton lets the soldier speak in a sort of dramatic monologue. He begins with a wonderfully well chosen double entendre on becoming a warrior of madness: "How I wish I could harden myself (*m'aguerrir*) one day, with the help of God."[57] The speaking subject announces that he feels that all of humanity watches him and that he is ready to become an experimenter who will sacrifice his reason for the

good of all. He cannot refuse this call: "To what would my refusal serve. – Exploring the so-called murderous zone, it became child's play for me to denounce blatant imposture."[58] The denunciation of such "imposture" takes on epic proportions when he evokes his past experience during a battle:

> Knocked out by gypsies, lost between ramps, a waltzer would fall once in a while, lifting his hand to his vermilion rose. Using the maximum of art, they have maintained me all that time under the empire of the sublime. And the apparatus of death has not been able to awe me as they thought. I have walked over corpses it is true. One can see such as these in any dissecting room. Quite a number could have been made in wax. Most of the 'wounded' looked happy. As to the illusion of spilled blood, you see as well this in any province town when they stage Dumas's plays. . . . What does it cost them to make a whole company disappear little by little?[59]

The mechanism of paranoid interpretation of the world follows the most unassailable logic: how could the spectacle of frenzied massslaughter on such a huge scale be believable? Of course, for Babinski, this "subject" would have been called a simulator, and treated as such, but he is clearly not just a male hysteric. Breton's clever title stresses the ambiguity of a "subject" who will never be objectified by medical knowledge. The subject's refusal of the reality of war is radical, and it goes much further than the logics of persecution displayed by Yossarian in Joseph Heller's *Catch 22*. When the whole world has become a crazy simulacrum, it proves how little "reality" the world contains. Thus "Subject' announces Breton's 1934 "Introduction to the Discourse on the Scarcity of Reality," an essay in which he states his refusal to believe in the tyranny of reality. He writes: "In reality, am I sleeping in a bed made up of elder marrow? Enough! I don't know: this must be true in some way since I am saying it."[60]

"Subject" is a powerful prose poem and in 1918 it immediately caught the attention of Paul Valéry and Jean Paulhan. Both believed that Breton had invented the work and based it upon his interactions with several patients, whereas in actual fact he had transcribed the ravings of one patient, later condensing and rearranging them in one single monologue. The soldier's delusion that the whole world is a simulacrum generates a paranoid interpretation of reality, and it also produces a devastating critique of what is taken as "real" by all those who have blindly accepted it. If Breton started quoting Kraepelin and Freud together at that time,[61] here they do merge. It is as if Freud presented us with a President Schreber who would not stop at transforming homosexual fantasies into a cosmic struggle against an evil God, but went on to show the whole war as a sick joke, an

improbable trick put on for his unique esthetic delectation. As Pascal would say, there are situations when one would be very insane not to become insane – and it is from this awareness that the text derives both its subversive power and its dark beauty.

Hence the "paranoid style" developed by modernism in the 1930s shifts this very same ground by multiplying levels of reality while posing the question of the big Other: whether the Other be situated as the "enemy" that Lewis was so fond of creating for his own endless execration, or becomes an Other that, as with Joyce, forces writing to descend into the deepest recesses of female schizophrenia. *Finnegans Wake* was in great part written for a "hebephrenic" Lucia Joyce, a psychotic daughter in whom one can recognize Joyce's "ideal reader", that is, the main dialogical interlocutor of the book.[62] In fact, Lucia also acted out Joyce's most excessive paranoid delusions of grandeur. Curiously, paranoia might have been the answer to the quandary in which hysterical high modernism had found itself: for, as both Salvador Dalí and Thomas Pynchon have shown, paranoia is one concept that can bridge effortlessly the old gap between high and low culture. Dalí's solution has been to project his archaic phobias, like his fear of grasshoppers and rotting donkeys for instance, into images that would acquire universal validity. They even seduced Freud, who remarked in 1938 that Dalí at least showed an obvious talent, an admission that he never made facing Breton's poetry. Perhaps, he merely registered Dalí's incipient academism. Whatever the motivation, he could finally see that the paranoid style was shaping a world teeming with wild fantasies while interpreting it with a semblance of rational order.

Closer to us, a late modernist such as Pynchon was able to tap the inexhaustible American idea of a "paranoid style" in politics, tracing the movement further back in time, to a Puritan heritage obsessed with ideas of predestination or a new purity to be found in the wilderness. There again, the main danger lies in a feared but desired and necessary encounter with the Other. Oedipa Maas discovers another America through creative paranoia in *The Crying of Lot 49*, while her psychoanalyst is a former Nazi whose job in the death camps was to render Jews catatonic. His name, Doctor Hilarius, shows that we should not take him too seriously, certainly, no more than the pyrotechnics of rockets launched from Nazi Germany still hovering above our heads in *Gravity's Rainbow.*

In this context, it cannot be a coincidence that Aragon should have tried to define modernism in the twelfth issue of the *Surrealist Revolution*, which was the first issue to be illustrated (and abundantly so) by Dalí. Typically, it is a modernism which is still hesitating between hysteria and paranoia. In an essay written in 1929 and devoted to the new decade, "Introduction

to 1930," Aragon writes: "You will not see, behind what constitutes the modernity of a period, the fever it generates, a fever which merits the name of modernism and needs a definition. Modernism is the acceptance of concrete watchwords made up of these modern words, objects and ideas whose evocation implies a number of particular claims, among which those of individuals who first feel their force and launch them first."[63] If the definition is indeed fuzzy, it has the merit of positing a bridge between the avant-garde constituted by Surrealism and the poetologic sense of modernism, which is in fact the meaning institutionalized in current academic discussions. Thus, Aragon concludes his overview with accents that remind one of Shelley's *Defense of Poesy*: "Poets are closer to seismographers than to citizens. . . . [T]o analyze modernism is to analyze the rapport between poetry and its time."[64] Nevertheless, a sweeping avant-gardist discourse reasserts a political urge once more at the end of the section – the "modern" is called the "raw nerve" of an epoch's consciousness, a nerve that will have to be hit hard by "armed people who know where to wound it best." The essay concludes on the notion that the modern is now in the hand of the police, not of poets, as Aragon sees around him the teeming signs of a new violence.[65] This is an impression shared by Walter Benjamin who was writing at the same time (in 1929) about Surrealism. In "Surrealism, The last Snapshot of the European Intelligentsia", Benjamin describes with subdued sarcasm the utopia of Surrealism as "winning the energies of intoxication for the revolution".[66] He also notes that this forceful striving enlists radically violent and anarchistic ideas developed by Dostoievsky and Lautréamont; especially in the latter's paroxysm of violence, as we have seen in Chapter 3, the unbounded cult of evil can hope to become a political device.

In his own essay, Aragon sees the emergence of a new paranoid modernism, but its aggressiveness remains modernist in the sense that it does want to abolish everything or create a *tabula rasa* of values and doctrines. For Aragon, as for Breton, in spite of precise political divergences, Surrealism and modernism go hand in hand; all the "precursors" the Surrealists had claimed for themselves – a practice which, as he admits, was sneered at by the Dadaists and other avant-gardists – evince in one way or another the qualities of a fundamental modernism.[67] This confirms that the Surrealists (some of them at least, Aragon and Cocteau being closer to Anglo-Saxon writers and artists, from Peggy Guggenheim to Pound, than Breton and Eluard) had sensed that their avant-garde movement had already turned into modernism, high or low. Their ambivalence facing this inevitable historicization, doubled by the inevitable enshrining in an "eternal" culture, would be translated into the choice between the provo-

cations of a seductive hysteria and the enjoyment of paranoiac crime, murderously lashing at the Other, always hitting it where it hurts most.

Chapter 7

Murder as Kitsch, Abstraction and Ritual

For a famous art critic like Clement Greenberg, who not only made modernism his own thing in the second half of the last century but also thoroughly Americanized it, the Surrealist fascination with an esthetics of murder and the politics of paranoia should be considered first and foremost as old-fashioned European kitsch. Indeed, for him, it was the whole of Surrealism that had to be treated as kitsch. Surrealism was not just a sign of bad taste in the visual arts, it was above all a cultural symptom betraying the uneasiness and the ambivalence of the avant-garde, a group that pretended to be political while flirting with rich patrons, a group that flaunted purity of design while exploiting popular culture, pandering shamelessly to our greed for shock esthetics while aiming at a canonization on a higher artistic level than they deserved. The hesitations and reversals deployed by André Breton might bring grist to this critical mill. These esthetic ambiguities also had a political counterpart, since these radical artists were often deeply indebted to their patrons. As Greenberg writes in 1944, "The anti-institutional, anti-formal, anti-aesthetic nihilism of the Surrealists – inherited from Dada with all the artificial nonsense entailed – has in the end proved a blessing to the restless rich, the expatriates, and aesthetes-flaneurs (sic) in general who were repelled by the asceticism of modern art."[1] The choice of the epithet *flâneur* may not consciously refer to Benjamin, but aims at the same target. In fact, the real scandal for Greenberg was that kitsch and avant-garde art not only coexist in a market in which all sorts of tastes are accommodated, but that they play off one another: "Where there is an avant-garde, generally we find a rear-guard. True enough – simultaneously with the entrance of the avant-garde; a second new cultural phenomenon appeared in the industrial West: that thing to which the Germans give the wonderful name of *Kitsch*: popular, commercial art and literature with their chromeotypes, magazine covers, illustrations, ads, slick and pulp fiction, comics, Tin Pan Alley music, tap dancing, Hollywood movies, etc., etc."[2] The redoubled "etcetera" points to the danger of a bad infinity, of a tide of debased objects that threatens to engulf the purity and authenticity of real and genuine art. Perhaps because

he had fewer illusions over the role of photography and film, Greenberg could not believe as Benjamin did in the redemptive power of "mass distraction" brought about by systematized reproduction. Whereas Benjamin saw in the hollowing out of bourgeois interiority the weapon against the fetishism of art and the capitalistic appropriation of the aura, Greenberg wanted to redefine the conditions of artistic experience, distinguish between a priori conditions and value judgments, and build secure foundations for a critical appreciation of taste. In this sense, although he would go back to Kant to promote this position, he was uncannily close to a Marxist Hegelian like Adorno.

When Greenberg started his career as an art critic in the late thirties, Surrealism had just invaded New York, and both Dalí and Man Ray had shown how adept they were at tapping rich patrons and making connections with the world of fashion. For a left-wing critic who aimed at introducing distinctions into the muddle created by the incestuous links between money and creativity, this was a situation to examine and criticize. One had to resort to strong opinions, cutting judgments, and at times sheer physical force. Greenberg's career is marked by its consistency. Florence Rubenfeld's excellent biography[3] presents Greenberg as a cultural hero while never hiding his darker or seamier sides. Greenberg often appears as a bully, someone who would not hesitate to knock out an already-aged Max Ernst – Ernst had taken a risk, it is true, in landing on Greenberg's head an ashtray full or cigarette butts that was meant to consecrate him "King of Critics." Greenberg punched him in the face, to Ernst's deep stupor. Greenberg only accepted the titles he could give himself, it seems, and was rather happy playing the role of the bad boy of modernism.

Besides, he had an account to settle with Surrealism, and giving Max Ernst a black eye was probably the most adequate gesture. We know that Breton was not opposed to fisticuffs when they were needed. Besides, Greenberg had already knocked out Surrealism flat in a 1944 article that ruffled many feathers. There, he astutely compares Surrealism with the Pre-Raphaelite movement: in both cases, one sees a return to the Gothic and a revisited academicism, in both cases, the movement becomes visible through its painters, but marks a more serious advance in the field of literature. But when Greenberg invokes photography, as Benjamin did, it is not to praise but to demolish: "The Surrealist represents his more or less fantastic images in sharp and literal detail, as if they had been posed for him. Seldom does he violate any of the canons of academic technique, and he vies with and sometimes imitates color photography, even to the very quality of his paint. Dalí's discontinuous planes and contradictory perspectives approximate photomontage. Ernst's volcanic landscapes look like

exceptionally well manufactured scenic postcards."[4] We can now begin to understand why Ernst crowned him with an ashtray! Greenberg acknowledges that the strategy of Surrealism aimed at making the fantastic appear more shocking: the more vivid the dream images are, the more hallucinatory they will look. On the other hand, he deplores the fact that Surrealist painters should have reproduced reproductions by copying "the calendar reproduction, postal card chromeotype and magazine illustration".[5] What this ends up creating is a literary way of looking at paintings, in which one looks for anecdotes. True, there may be a little Freudian plot hidden behind the collages of insipid postcard images, but this flies in the face of the advances of true painting since the revolutionary progress made by the Impressionists, the Fauvists and the Cubists. History dismisses these regressive attempts as deliberate childishness.

However, an all-too cunning history organized a revenge match and created Willem De Kooning as the embodiment of artistic nemesis when he knocked out Greenberg in a New York bar a few years later. This time the tide was turning – abstract expressionism was on the wane, to be replaced by varieties of pop art, Warholian serigraphs and neo-Dadaist experiments of the Fluxus variety. Duchamp was still alive and back on the art scene, and all types of anti-art were flourishing. Greenberg nevertheless took this in his stride and continued on his own trajectory. With Greenberg, we meet the art critic as boxer, with his broken nose, bald pate, and taunting eye – the tough cookie of modernism, who never lets you off lightly and, if he can, will use you as an unwitting sparring partner to show the audience that he has not lost his punch! What matters, rather than perform some belated form of "Clembashing", is to understand how his promotion of modernism was instrumental in a career devoted to stealing the role of artistic Capital from Paris and giving it to New York, and how much this effort was linked with the American politics of cultural domination after the Second World War.

If hitherto, Marcel Duchamp and Man Ray have been the important characters in my chronicle, now they appear as anti-heroes. Should we really look for a hero? Is Breton fit for the role? The previous chapter explains why he cannot be. And shouldn't we prefer someone closer to us? Would Greenberg fit the bill? He would fit better in the role of the corrupt detective who happens to be proved correct at the end of the story, just because he trusted his gut feelings, like the sleazy cop in *Touch of Evil*, or the bad officer played by Harvey Keitel in Abel Ferrara's *Bad Lieutenant*. Such simplified clichés owe something to the vivid physical description one finds in Saul Bellow's novella, "What Kind of Day Did You Have?"[6] Bellow sets in opposition two figures, Victor Wulpy, alias Clement Greenberg and

Wrangel, alias Harold Rosenberg, arch-rivals in the 1960s for the position of kingmaker among art milieux. Greenberg is presented as a famous art critic who hops from conference to conference. Stopping in Buffalo, he arranges at the same time to meet the divorced woman with whom he has had an affair; she is so smitten with him that she is ready to jeopardize an already compromised personal position to see him for a few hours in a distant city, right in the midst of snow-storm. "In one aspect Victor reminded her comically of the huge bad guy in a silent Chaplin movie, the bully who bent gas lamps in the street to light his cigar and had huge greasepainted eyebrows" (HFM, p. 101). Clement Greenberg's biographer has shown that there had always been a deep antagonism between Bellow, the Nobel Prize-winning novelist from Chicago and Greenberg, the successful New York critic. One day, Saul Bellow, angry at having been conspicuously snubbed by Greenberg during a lunch given in his honour at the Chicago Arts Club, resorted to throwing grapes at the bald head of the critic, until the latter exploded, shouting: "I never did like you"![7]

A similar scene is depicted in Bellow's story, but this time Wulpy confronts a slightly younger man, Wrangel, who claims that he is an old fan of his who nevertheless wishes to discuss some of his ideas. As Wulpy cannot tolerate the slightest dissension, he keeps shifting the conversation topics rudely, in a freewheeling conversation that hinges around definitions of modernism. Wulpy's global approach is Marxist, and the talk that he is about to deliver bears on the applicability of *The Eighteenth Brumaire* to American politics and society. Wulpy believes that "Marx had America's present number . . . When wage earners, the middle class, the professions, lose track of their true material interests, they step outside history, so to speak, and then non class interests take over, and when that happens society itself collapses into neuroses. An ear of playacting begins. Vast revolutionary changes are concealed by the trivialities of the actors. Clowns and ham actors govern, or seem to. Superficially, it looks like farce" (HFM, p. 103). Katrina immediately reacts to the thesis with the naïve remark of "It doesn't sound too American to me" (HFM, p. 98), while Wrangel first agrees with the main drift of the thesis developed by Wulpy. This is how he sums it up for his mentor:

> (Wrangel) had read *The Eighteenth Brumaire*, and he could prove it. Why had the French Revolution been made in the Roman style? All the Revolutionists had read Plutarch . . . 'Ancient tradition lying like a nightmare on the brains of the living' . . . *Le mort saisit le vif*. And you suggest that the modern avant-garde hoped to be free from this death grip of tradition. Art becoming an activity in which life brings raw material to the artists, and the artist using his imagination to bring forth a world of his own,

owing nothing to the old humanism . . . Then you said that the parody of a
revolution in 1851 – history as farce – might be seen as a prelude to today's
politics of deception – government by comedians who use mass-entertain-
ment techniques. (HFM, pp. 111–12)

On the whole, Wulpy agrees with this condensed version of his talk; in it,
one recognizes the gist of many postmodern postmarxist theoreticians
ranging from the Situationnists to Baudrillard. After a few unwelcome
interruptions, prodded by Wulpy, Wrangel explains where precisely he
disagrees: "You argue that class paralysis produces these effects of delusion
– lying, cheating, false appearances. It all seems real, but what's really real
is the unseen convulsion under the apparitions. You're imposing European
conceptions of class on Americans" (HFM, p. 113). Wrangel is not granted
time enough to expose his views on a specifically "artificial mentality" of
Americans who would have no "created souls" but only "artificial souls".
Wulpy breaks off the debate, but later complains to Katrina that Wrangel's
remarks imply that he sides with painters like Tchelitchew even though
they despise him. "He (Tchelichew) said *he* had a vision of the world,
whereas the abstract painting that I advocated was like a crazy lady
expecting a visit from the doctor and smearing herself with excrement to
make her self attractive – like a love potion. Wrangel was trying to stick
me with this insult" (HFM, p. 115). Whereas it is obvious by this time that
paranoia has replaced any sound assessment, the theory of a purely American
"artificial soul" does not sound much clearer or more convincing.

Bellow insists on the idea that Wulpy, alias Greenberg, imposes a
European conception on the American scene while being denounced or
undermined by the very Marxism he embraces. Bellow is attacking not so
much Greenberg's Marxism as his recuperation of a transnational model of
modernism. To follow the idea to its logical end, Greenberg's modernism
would also be caught up in the cycle of returns it denounces. Modernism
would thus return once more, this time not simply as farce, but as the
parody of the Marxist model: the effort to bring international modernism
to bear on a city seen as the new capital of the arts eventually brings it under
the domination of Marxian Capital! The irony implied by this inversion is
that an esthetic neo-Marxism (Greenberg's "Eliotic Trotskyism" according
to the apt phrase coined by Timothy Clark[8]) has worked not only for the
greater glory of cultural capital but with the result of nationalizing an
earlier international modernism that was as European as American in spirit.
At least here is a question that could follow from Bellow's sweeping
critique.

Clement Greenberg always stated that criticism is based on judgments,

a position that places his modernism in the philosophical context of a certain neo-Kantism. Thierry de Duve has more recently questioned certain weaknesses in this Kantianism in *Clement Greenberg Between the Lines*.[9] De Duve usefully distinguishes three different Greenbergs: the first one is a political fighter, a doctrinaire and militant ideologist who finally succeeded in durably modifying the taste of his fellow Americans; he can be shown to evolve slowly from the Trostkyite debut in the little New York magazines to the envied position of the Pope of Abstract Expressionism. The second Greenberg is the critic as journalist who responds to the daily solicitations of the art scene and who displays an extraordinary virtuosity in his reviews, who "discovers" artists such as Pollock and Stills, who attacks violently people like Rouault or the Surrealists, and who changes his opinion about Mondrian, Dubuffet and Monet; he is an "eye" and a privileged witness whose curiosity is always on the alert. The third Greenberg is the theoretician who elaborates a general doctrine with important borrowings from Eliot, Kant and a few others. This last Greenberg could also be described as an "author" in the sense in which Foucault talks about "inventors of discursivity": he can then bequeath his name as a shortcut for a whole set of evaluations, analyses, appreciations, all interconnected by an underlying problematic of modernism, from the crucial and fruitful opposition between Kitsch and avant-garde to the promotion of the New York school of the fifties taken as the embodiment of what his esthetics upholds – apparently justified after it had been canonized as the main American art of the twentieth century.

The reference to Kant in connection with the promotion of Abstract Expressionism appears as the first move in a strategy that opposes both fronts: American cultural jingoism, and a certain type of vague internationalism. What is surprising is that Greenberg never alludes to Kant's well-known theory of the Sublime, with its praise of the "Jewish religion" and its prohibition of representation[10] to promote non-representational painting – which poses a problem that I will try to solve later. His starting point would be the axiom that opens the "Deduction of pure aesthetic judgments": "The Deduction of aesthetic judgments upon objects of nature must not be directed to what we call sublime in nature, but only to the beautiful."[11] Accordingly, Greenberg's two main terms are the beautiful and taste.

In 1946, at the time of the emergence of the New York school, Greenberg uses Kant to fight against a certain American xenophobism when he reviews McMahon's *Preface to an American Philosophy of Art*. Greenberg notes that the philosopher thinks that he can "demolish" the German school of aesthetics because he has seen a contradiction between

Kant's idea that "Nature is beautiful because looks like art" (an idea that McMahon interprets as meaning that art has to imitate nature) and the idea that Beauty has nothing to do with Truth, Greenberg can easily show that Kant does not posit "imitation of nature" as an artistic aim but only that art's finality has to be like that of Nature: its forms must be free of constraints, devoid of arbitrary rules. Kant's "revolutionary insights" are thus trivialized and reduced to a self-canceling plea for mimesis. Such a brief but forcible analysis (CE II, p. 66) shows the serious grounding of Greenberg's meditations on Kant.

The same year, Grenberg also reproaches Claude-Edmonde Magny for not having understood Kant in her book *Les Sandales d'Empédocle.* He quotes Magny when she refuses the "fiction" of a universal point of view and questions the very possibility of proffering general aesthetic judgments. Greenberg accuses her of contradicting herself – hasn't she just made a judgment, even when she talks about the "limits of literature" (CE II, p. 68)? Greenberg implies, therefore, that we are all Kantian, even without knowing it, as soon as we profess to give judgments about art. If neither the Parisian critic nor the American professor can dictate the rules of esthetic judgment, there is an abstract model that lies in the past and that can be applied to a new cultural situation.

Conversely, Cassirer is taken as a model of intelligent Kantianism open both to *Geisteswissenschaften* and to the linguistic analysis of general "symbols" (CE II, p. 27). The foundation of Greenberg's particular brand of modernism could be found somewhere between Kant and Cassirer – it is a rational modernism that begins with the Enlightenment. This is why Greenberg famously begins his famous "Modernist Painting" (1960) with a reference to Kant:

> Modernism includes more than art and literature. By now it covers almost the whole of what is truly alive in our culture. It happens, however, to be very much of a historical novelty. Western civilization is not the first civilization to turn around and question its own foundations, but it is the one that has gone furthest in doing so. I identify Modernism with the intensification, almost the exacerbation, of this self-critical tendency that began with the philosopher Kant. Because he was the first to criticize the means itself of criticism, I conceive of Kant as the first real Modernist.
>
> The essence of Modernism lies, as I see it, in the use of characteristic methods of a discipline to criticize the discipline itself, not in order to subvert it but in order to entrench it more firmly in its area of competence. (CE IV, p. 85)

Modernism inherits from the Enlightenment the wish to found each discipline more securely by criticizing it, however not from the outside but from

the inside: "Modernism used art to call attention to art. The limitations that constitute the medium of painting – the flat surface, the shape of the support, the properties of the pigment – were treated by the Old Masters as negative factors that could be acknowledged only implicitly or indirectly. Under Modernism these same limitations came to be regarded as positive factors, and were acknowledged openly" (CE IV, p. 86). The logical consequence is that modernism will be used to underpin a doctrine of the "purity" of art, a purity based upon "self-definition" and the rigorous exploitation of the formal properties of the medium. Thus, Kant and the Enlightenment provide the conceptual model, while the main examples are Manet, Monet, the Impressionists and Cézanne, along with Flaubert and Baudelaire. All of these are the first Modernists who saw in the exploration of the "limits" of their art the impetus for a technical revolution. Modernism is indeed a mid-nineteenth-century movement that harks back to a distant Kantian heritage.

The reference to Kant, which becomes almost systematic after 1943, and which will never be discarded, is used to give philosophical weight to an insight attributed to Aristotle in the text I examined earlier, "Avant-garde and Kitsch." As we have seen, the essay began by examining the paradox of a culture that can simultaneously produce T. S. Eliot's poems and Tin Pan Alley songs, then investigates how the avant-garde (whose constitution is accounted for in historical terms, at the end of a nineteenth century strongly determined by the industrial revolution) originally appeared as the last ditch defense of absolute values. The artist who invokes the absolute will nevertheless prefer certain values to others: "The very values in the name of which he invokes the absolute are relative values, the values of aesthetics. And so he turns out to be imitating, not God – and here I use 'imitate' in its Aristotelian sense – but the discipline and processes of art and literature themselves. This is the genesis of the 'abstract.' In turning his attention away from subject matter of common experience, the poet or artist turns it upon the medium of his own craft" (CE I, pp. 8–9). An interesting footnote points out the apparent paradox that, according to Aristotle, music is the most "imitative" of all arts – thus confirming a straight line of descent from Aristotle to Kant: both understand how the arts imitate the workings of nature – *e techne mimeitai ten physin* – without having to reproduce the objects contained in nature. As Joyce noted in 1903, what Aristotle says is that the "artistic process is like the natural process".[12] What is "natural" therefore – and this does not follow so obviously – is that the arts should "imitate" their own process of "imitation": "Picasso, Braque, Mondrian, Miro, Kandinsky, Brancusi, even Klee, Matisse and Cézanne derive their chief inspiration from the medium they work in. The excitement of their art

seems to lie most of all in it s pure preoccupation with the invention and arrangement of spaces, surface, shapes, colors, etc., to the exclusion of whatever is not necessarily implicated in these factors" (CE I, p. 9). Greenberg thanks Hans Hofmann for having taught this to him, and an impressive roll call of modern poets (Rimbaud, Mallarmé, Valéry, Eluard, Pound, Crane, Stevens, Rilke, Yeats) is adduced to convey the idea that the same process obtains in literature.

The best example of the application of such an Aristotelian-Kantian esthetic is Monet, who was re-evaluated by Greenberg in the fifties. In a remarkable essay on the "later Monet" (1957), Greenberg shows that he has been wrong to downplay Monet's influence. Indeed, Monet had been mistaken about the aims of art in general, since he thought that what mattered above all was to be faithful to Nature, to reproduce as accurately as possible the coloured world seen out there. His true genius was to radicalize this wish and refuse to take older masters as models the way even Cézanne did. "In the end he found what he was looking for, which was not so much a new principle as a more comprehensive one: and it lay not in Nature, but in the essence of art itself, in its 'abstractness.' That he himself could not consciously recognize or accept 'abstractness' – the qualities of the medium alone – as a principle of consistency makes not difference: it is there, plain to see in the paintings of his old age" (CE IV, p. 8). Because of his fidelity to his own visual sensations, Monet then gives all his attention to problems of equivalences without dominances and creates a superior unity when the coloured surfaces become unmodulated monochromes. Pissaro could observe ironically that Monet was a "decorator without being decorative" – the fact remains that Monet's later paintings anticipate the "wall-paper effect" of most all-over paintings by Pollock and other American abstract expressionists.

Documenting what he calls "the crisis of easel painting", Greenberg nevertheless describes the new painting in musical terms. Pollock, Tobey, Friedman, Ray, Rosenborg, and Sobel all demonstrate the polyphonic quality that had been announced by Klee and Gris more than by Mondrian. While Mondrian talked of "equivalences", Greenberg finds a model with Schoenberg or Gertrude Stein. What matters is equivalence in difference, an equivalence produced by the feeling that each brushstroke is autonomous. Each part of the painting can embody the whole. The new abstract art abolishes the usual hierarchies between high and low, top and bottom, horizontal and vertical, hung or flat, centred or non-centred. In the homogeneous and uniform filling of an "all-over" surface, what counts is less the instant of a glance than the equivalence between each part and the whole – in short, we are witnessing the inverse and simultaneous

transformation of metaphor into metonymy and of metonymy into metaphor.

However, if abstraction is the logical consequence of a process that is both the culmination of a historical progress and a theoretical need, then Greenberg, who often looks towards poetry or music to explain abstract painting, refuses the importation of "literary" ideas into painting. The exploration started at the beginning of the century by Kandinsky, Malevitch and Mondrian finally yields the perfect "autonomy" of the medium of painting in the New York of the fifties with Pollock, Rothko, Stills and a few others. His main critical effort will thus be to avoid any "regression" toward simple representation or its "literary" dimensions (see CE IV, p. 88). One might say that Greenberg's logic is "plokeic", according to the trope that consists of an emphatic repetition. He keeps urging: "Let painting be painting, and only painting, wholly painting! Let it explore what constitutes itself . . . " The same would be true of music and of literature – everything will be fine provided they remain themselves. Therefore, abstract art, having summed up the best in what precedes, becomes both historical and trans-historical. As Greenberg writes in "The Case for Abstract Art": "Abstract art is not a special kind of art; no hard-and-fast line separates it from representational art; it is only the latest phase in the development of Western art as a whole, and almost every 'technical' device of abstract painting is already to be found in the realistic painting that preceded it" (CE IV, p. 82).

However, despite disclaimers stating that the abstract nature of a painting is not a proof of its quality, merely the guarantee of a greater "artistic detachment" required of the viewer, Greenberg repeats that there is a historical evolution leading to the incontrovertible fact that the best painters of the fifties are all abstract painters. This may be true; but on what grounds can he then assert that in 1953 the New York school of abstraction (Gorky, Gottlieb, Hofmann, Kline, de Kooning; Motherwell, Newman, Pollock, Rothko) is better than Parisian abstract painters like Fautrier, Dubuffet, Hartung or Tal Coat (CE III, p. 156)? However, the judgment falls, without equivocation: "Do I mean that the new American abstract painting is superior on the whole to the French? I do" (CE III, p. 156). In the 1953 essay, the first criterion adduced is "plenitude of presence". Finally, historical anteriority delivers the fatal blow: "Our new abstract painting seems to have anticipated the Paris version by two or three years" (CE III, p. 157). Besides, the French painters have neglected Klee and Miro; they have not learnt enough from Matisse; they have little regard for a precursor like Masson – who, moreover, was in New York during the war. Here, fundamentally, Greenberg's history of the avant-garde relies in the last

instance on value judgments and on the vaguer criteria of his own artistic
"experience", of his "competence" and discerning "taste". He thus managed
to achieve what for Remy de Gourmont was the aim of criticism at its best:
to transform one's personal impressions into universal maxims, to let one's
sensations become the laws of esthetics. Greenberg's personal experience
which, as he confesses, was nourished as much by Corot and Velasquez as
by Mondrian and Pollock, tells him that in 1954 the best painters should
go in for abstraction.

In this context, Greenberg's analysis of the diverse reasons that account
for the failure of the first abstract school of New York is instructive. He first
puts forward ideological reasons: "It was this misconception of non-natu-
ralistic art as a vehicle for an esoteric message that encourage Miss O'Keefe,
along with Arthur Dove, Marsden Hartley and others, to proceed to abstract
art so immediately upon her first acquaintance with the 'modern'"(CE II,
p. 86). According to him, it was the innate mysticism of the first New York
avant-garde that prevented these gifted painters from working more
systematically; thus they never deepened their own links to the "tradition
of the new". As a consequence, they all abandoned abstraction to devote
themselves to a pseudo-modernism that soon degenerated into high-end
kitsch. Success, ironically, crowned these efforts, as one can see with O'Keefe
in painting as well as with E. E. Cummings in poetry.

However, one decade later, in 1964, Greenberg could not avoid acknowl-
edging that there had been a rampant "crisis of abstract art " (CE IV, p. 176).
However, at this juncture, the admission was not damaging since he had
won his bet: New York had indeed won against Paris, Greenberg's personal
criteria lay down the law for the art market, the network of galleries relayed
by the modern art museums in the US was solidly entrenched. If this evolu-
tion in the taste of the public is clearly attested, why was it necessary that
Pollock, Rothko and their friends should reinvent an abstract art that had
already taken place some thirty years earlier? Are we not caught up in the
pseudo-paradoxes of the logic of change analyzed by Bourdieu in *The Rules
of Art*? Bourdieu quotes Marcel Duchamp in his chapter on the "Market for
Symbolic Goods" – a Duchamp who was (and this is not a secret) totally
opposed to the spirit of the fifties, and especially to the main spokesman for
Abstract Expressionism, Greenberg. "This explains why, as Marcel
Duchamp noted, the returns to past styles have never been so frequent: 'The
characteristic of the century that is ending is to be like a double-barrelled
gun: Kandinsky and Kupka invented abstraction. Then abstraction died.
One wouldn't talk about it any more. It came back thirty-five years later
with the American abstract expressionists. You could say that Cubism reap-
peared in an impoverished form with the postwar Paris school. Dada has

similarly reappeared. Second shot, second wind. It is a phenomenon partic-
ular to this century.'"[13]

Bourdieu prefaces these remarks by noting that today, "each artistic act
which leaves its mark by introducing a new position in the field 'displaces'
the entire series of previous artistic acts" (RA, p. 160) – a view which seems
strangely congruent with Eliot's ideas in "Tradition and the Individual
Talent." Even if Bourdieu's neo-Marxist language defines this constant
reshuffling of values as a "struggle", the fundamental view is the same:
"Contemporaneity as presence in the same present only exists in practice *in
the struggle* that *synchronizes* discordant times or, rather, agents and institu-
tions separated by time and in relation to time" (RA, p. 158). Greenberg
could not agree more since "Avant-Garde and Kitsch" which mixed up
Marxism and high modernism *à la* Eliot in 1939. This is why one of the
longest, more ambitious and subtle essays of the fifties is Greenberg's review
of Eliot's *Notes Toward the Definition of Culture* (CE III, pp. 122–52). Already
in the "The Plight of Culture," Greenberg pointed out the stylistic failings
of an Eliot whom he took to task for imprecise wording and muddled
thinking. In his last interview, conducted in 1994, the year of his death,
Greenberg confessed that he could not stand Eliot's tone of snug superiority,
while admitting to a deeper agreement with Adorno.[14]

One may say that if he hadn't existed, Greenberg ought to have been
invented – he produced the synthesis that the Zeitgeist needed: an elitist
Eliotian Trotskyism with an American slant. He also manages to answer to
Eliot's main problem when he postulates an "ideal order" of culture that is
modified each time a new masterpiece arrives. Do these strong new artists
coexist peacefully with all the previous ones or do they murder one another?
Greenberg opts for the second solution – one needs to "murder" quite a
number of reputations if one wants one's criteria become the dominant taste.
Which begs the issue of power, money and politics – a game Eliot had
learned to play quite well himself. Thus Greenberg appears both as the least
literary of art critics (he is a very severe critic of the "vacationing literati"
he finds among French intellectuals writing about painting without any
expertise) and the most literary, in the sense that he reconstitutes a
modernist tradition of the new that goes back to T. S. Eliot and Baudelaire.
If he rejects Hopper, whom he describes as a bad painter but a good artiste
whose perception of American everyday life is above all "literary" (CE II, p.
118), he acknowledges that Hopper would not necessarily become a better
painter if he only had a better pictorial technique. On the other hand,
Pollocks's expressive rage and his gothic gifts bring him in close proximity
to Melville and Faulkner (CE II, p. 166). When he examines a painter as
literary and mythologizing as Giorgio de Chirico, this side of his art is not

a sufficient pretext to reject him – on the contrary, Greenberg shows that it was Mondrian who drew the logical consequences of the exaggerated perspectives one finds in de Chirico's metaphysical paintings. In the 1910s, de Chirico already understood that by skewing illusionistic depth and juxtaposing perspectives in an interplay of subtle dehiscences he would end up negating illusionism while highlighting the flat aspect of the planes and even the volumes (CE II, p. 135). Thus de Chirico's real heir is not Dalí, who simply pushes academism to a further peak and overloads it with Surrealist themes, but Mondrian, whose abstraction completes the evolution going from Giotto to Courbet and then Manet.

Finally, it is with Duchamp that Greenberg had to come to terms; here again, he did it flamboyantly. In what is often referred to simply as "Seminar 6," Greenberg tackles the awkward problem posed for him by Duchamp quite squarely. He first notes that prior to 1913, Duchamp was a quasi-Futurist and a pseudo-Cubist, and not a very distinguished practitioner of both schools at that: he relies too much on an illusion of depth and perspective to grasp the inherent logic of Cubism, that is its drift towards flatness. His first paintings suggest that Duchamp "had hardly grasped what real Cubism was about".[15] In a similar fashion, he imitated Picasso's collage construction with his first found objects like the *Bicycle Wheel* and the *Bottle Rack* of 1913, without really understanding what Picasso was looking for. According to Greenberg, it was purely "out of frustration" that Duchamp grew so "revolutionary" after 1912.[16] Duchamp then set out to attack formal and formalized art, although not always in a consistent manner. The point of the urinal and of *Etant Donnés* (curiously regrouped by Greenberg) was to "defy and deny any esthetic judgment; taste, the satisfactions of art as art".[17] In a curious admission that betrays a lack of understanding, Greenberg adds that the background of the peepshow of *Etant Donnés* is "beautiful in a small way"! This mixes damnation with feint praise, since to believe that the photographic chromeotype background aims at something like "the beautiful" is so totally preposterous that this must be a deliberately aggressive misreading. What he later calls the "*'tableau mort'* in the Philadelphia Museum of art"[18] or the "hairless vulva of the effigy of a recumbent young female . . . on view through a peephole in a rather staid museum"[19] is truly "dead" art for Greenberg; it is a weak image devoured by an idea, an illustration that can only reiterate the same point about art and non-art.

A more extended appraisal typically mixes praise and rejection: "Yet Duchamp and his sub-tradition have demonstrated, as nothing did before, how omnipresent art can be, all the things it can be without ceasing to be art. And what an unexceptional, unhonorific status art as such – that is,

esthetic experience – really has. For this demonstration we can be grateful. But that doesn't make the demonstration in itself any the less boring."[20] This reductive reading nevertheless hits a nerve: we may indeed find the concept of the "ready-made" boring, repetitive – a pure demonstration, the theoretical display of an anti-theory of art. Is Duchamp simply demonstrating that two-plus-two-make-four, as Greenberg writes? Quite typically, he flattens the Duchampian anti-art project until it is reduced to a simple statement; as we have seen, the statement, if statement there is, is nothing simple or univocal. True, Greenberg admits that the gesture was not a freak show, an oddity – there was a necessity to this: "Art like Duchamp's has shown, as nothing before has, how wide open the category of even formalized esthetic experience can be. This has been true all along, but it had to be demonstrated in order to be realized as true."[21] Besides, this kind of art escapes from any judgment, since by perverting the whole game of art it can only be judged in its own terms. "That's not the way it is with more substantial art, good or bad: that kind of art you have to experience over and over again in order to keep on *knowing* it."[22]

I had announced that I would try to solve the riddle of Greenberg's avoidance of Kant's concept of the Sublime, and we can find the elements of an answer here. Kant's attack on representation could have been used to promote non-representational painting, and this monochrome formalism is criticized by Hegel in the Preface to *The Phenomenology of Spirit*. Kant's famous analysis of the Sublime in the third *Critique* would come too close to the nothing with which Duchamp already plays. Let us rehearse it: "The sublime may be described in this way: It is an object (of nature) *the representation* (Vorstellung) *of which determines the mind to regard the elevation of nature beyond our reach as equivalent to a presentation* (Darstellung) *of ideas.*"[23] The Sublime, which is first described in terms of absolute magnitude, then encompasses any experience by which we overcome our primal fear facing natural or man-made catastrophes (a shipwreck, armies clashing in a plain) or spectacles (the Alps, a sea storm or a blizzard) and start perceiving them as spectacles, but of a type that baffles and defeats our sensory faculties.

For Greenberg, gazing at an abstract painting is not having the experience of nothing but precisely having the experience of something – of its bi-dimensionality, shape and color, its boundaries on a canvas, and so on. Unlike Kant's theory of a Sublime that is frightening and pleasurable at the same time, since the imagination experiences its own limits, and comprehends somehow that it cannot comprehend the sight, whether natural or artistic, Greenberg's constant return to an esthetic is not one of powerlessness; and unlike Adorno, he shies away from any experience of negativity. One has to remain in control, flex one's intellectual muscles as well as one's

sensitivity so as to go beyond these to the categories of taste and finally pass an informed judgment. Duchamp, on the other hand, insists on letting go, on an interaction between complex sets of calculations in advance and the sudden release or freedom that comes from ataraxia. Interestingly, this is a category that had been posited by Kant as well, when he defines nobility: "But (as seems strange) even *freedom from affection (apatheia, phlegma in significatu bono)* in a mind that strenuously follows its unswerving principles is sublime, and that, too, in a manner vastly superior, because it has at the same time the delight of pure reason on its side."[24]

Duchamp also decided to go beyond the purely Kantian connection between the Sublime and a certain frustration or negativity – but unlike Greenberg, he appears at times almost Hegelian, with his stress on the negation of negation that moves towards a higher type of intellection. Indeed, Duchamp remains on the side of the concept – a concept that is reached at the outcome of a progression which is also an intellection. His conceptual art orients us to a Hegelian *Begriff*: what one can seize in one's mind, often via the negation of the empirical object. Then, and only then, will the imagination follow and examine freely the interplay of forms and ideas. This "murder of the thing" is a directed murder, at the outcome of which private and evanescent sensations move towards the rationality of Spirit. Greenberg forbids this negative step insofar as he wants to start from an experience of matter and sensation: there has to be a sensory impression which is then filtered, discussed, classified, and rationalized. For Greenberg, as a good Kantian, art is the occasion for "reflective judgments"[25] – which, unlike determinant judgments, start from singular objects and my feelings facing them, before "reflectively" going back to categories that give it coherence, finality and a *raison d'être*. In one gesture (indeed, quite often repeated) Duchamp sweeps this aside – what matters now is a process of intellection which will go through various spirals, since the aim is to come as close as possible to an "absolute knowledge" that ushers in pure freedom.

Greenberg sees in Duchamp the wish to combine the "un-esthetic" and the esthetic, thus criticizing the social norms that separate the two. This is clearly one of the aims of *Etant donnés*, as we have seen, but not the only one; Duchamp has more depth and wit to give us to play with. As Thierry de Duve astutely observed, the curiously contorted experience of each having to peer through a peephole abolishes both the concept of a community of viewers (which is generally taken for granted in a museum), and the concept of a collection of objects all visible in the same space and recognizable as signed by one single artist.[26] Should one, for all, that condemn Greenberg for his naïve experiential model underpinned by a simple historical teleology? His indirect reference to Kant's "finality without end"

(*Zweckmässigkeit ohne Zweck*), which defines the essence of art, should at least fend off this accusation.

It is true that it looks as if Greenberg had stopped reading *The Critique of Judgment* half-way; he is defending an elitist modernism exactly as Adorno did, that is with a view of history as determined by progress. Like Adorno, Greenberg believes that there have been "discoveries" in the arts, at least in music, painting and literature, and that one cannot write harmonic music after Schönberg without being in some way reactionary, or paint a realistic genre painting without willy-nilly regressing. After Pollock, Rothko and Kline, one should not paint green pastures with cows or the smiling face of a pipe-smoking neighbour. What neither Adorno nor Greenberg could imagine, is that the cyclical return of genres, techniques and schools could accomplish itself as an empty and parodic "revolution" in an already saturated esthetic field that would be unified in a homogeneous way by the "end of history" deduced by Kojève from a reading of Hegel. A decorative monochrome would be the only wallpaper allowed to the Sunday painter of globalized history, in his or her *"Sunday of Life"* praised by Raymond Queneau in his Hegelian novel.[27] Or perhaps the beautifully saturated blue invented by Yves Klein (and patented YKB) would play off by advance Greenberg and Duchamp, locked up in an eternal duel?

At least one needs to have seen it! Can one explain this blue, describe it to someone who has never seen it? Can one make it come alive to a blind person? Rothko would say yes, since he believed that anyone, even a blind child, could have an experience of the vibrant radiations emitted by his later bi-chromatic paintings. One should be able to intuit their power by approaching them with closed eyes, or even by turning one's back to them. Greenberg always insists on an irreducible experience of the visual, and on his view the mistake of Duchamp and Kossuth is to produce an art that can be described or talked about without being seen. Why should a *ready-made* by Duchamp, say, be seen by a viewer? Obviously, its aim is not to yield artistic pleasure. It has to be seen, indeed, to generate a first shock, and the shock is repeated until it is forgotten or absorbed by the surrounding cultural landscape – most of the time, by being exhibited in a museum. There would thus be no clear difference in the end between a game of chess opposing a solitary player to the whole tradition of canonized and institutionalized art and this brand of purely conceptual creation.

For Greenberg, the abstraction he keeps promoting is not just an idea – it is an historical progression, a sensuous and educational approach to logical time, a teleological time that goes beyond the succession of schools. This evolution implies a whole phenomenology of perception, the sensual appreciation of shapes, colours, textures displayed on a flat canvas. Abstraction

entails a whole logic and therefore needs a critical discourse accompanying it with its retinue of value judgments. It is not idle for Greenberg to wonder aloud who is the best abstract painter of the seventies, Jules Olitski or Ken Noland. These questions troubled the later years of Greenberg's career, just as the discussion of the respective merits of Pollock and de Kooning would split the New York art world in the fifties.

Greenberg's Kantianism is not identical with that of Thierry de Duve, when the latter attempts to rethink Duchamp's logics "after Kant." De Duve has a bold manner of unifying a complex field by keeping a foot in the philosophy of the Enlightenment while remaining in sync with new artistic experiments and contemporary tendencies. In contrast, Greenberg does not struggle with the transcendental or with the transcendent, he refuses the risk of a sublime limit that transforms the presentation of non-representation into a performative engagement with infinity. His recurrent gesture, which asserts that "modernism" and "abstraction" must blend, often boils down to an assertion that a critical judgment needs a retinal object – in Duchamp's sense. Abstraction has to be seen – which entails that it ought to be beautiful – but not sublime.

If an abstract painting is a painting reduced to its critical or reflexive components (Hegel describes Kant as a reflective but not speculative philosopher), yet it nevertheless constitutes an object for a consciousness that perceives it and enjoys it sensuously. Greenberg posits abstraction as a value criterion defined by an esthetic of taste and not as one of the many phenomena marking the end of the consensus about the very idea of art. Those who insist on the collapse of the consensus, like Duchamp or de Duve, have to stick to nominalist esthetics for which the central issue is a nomi-nation simply stating: "This what I do. I call this art." If Greenberg is not necessarily the last critic who could profit by a consensus on minimal issues, he is the last who could reign on a whole world of museum and gallery owners, collectors and patrons, and who will have known how to reconcile the influence of money with the better and better taste of sophisticated connoisseurs. He is the last absolute authority in the world of art, since nobody has been able to replace him.

Nevertheless, the Kantianism, no matter how truncated and deliberately simplified, that Greenberg deployed to militate for modernism, was successful in the promotion of the New York school. It can, ultimately, appear as a pure tool in a struggle for prestige and power. Could it be that formalism was a mask concealing an objective evolution, a geographical reshuffling (from Paris to New York) being subservient to a redistribution of the fluxes of international capital? Greenberg's impact is not reducible to a symptomatic reaction – otherwise he would have been quickly

forgotten whereas it is clear that most of the terms that he left us are used and continue to shape our understanding of modern and contemporary art.

What is more symptomatic on the other hand is the sad spectacle of Greenberg's later years, his strange descent into paranoia marked by perverse power games and the freewheeling "debauchery" that Rubenfeld's biography evokes rather tactfully but with unmistakable severity. Greenberg's dependence upon a guru of non-dependence (Saul Newton) evinces a curious lack of critical insight, unless he merely exploited the fact that the "Newtonians", as they called themselves, by creating the context of an urban sect and the ideals of total sexual freedom, justified his systematic philandering. Success always brings the ability to enjoy the privileges of power to the hilt, and Greenberg did not forfeit these. What makes for painful reading is the suggestion of a perverse enjoyment taken in humiliating disciples, or the evocation of drunken nights systematically spent demolishing one group-member until he or she felt totally annihilated: Michael Fried and Rosalind Krauss were subjected to these ordeals, and suffered from a master they still revered. The term that inevitably recurs in these testimonies is "sadism": Fried remarked that he was a "sadist",[28] and, similarly, Ken Noland called him "a true sadist".[29] It is a sad case when knowledge brought not freedom but power – or rather, the freedom it brought was not absolute but relative, derived from a sense of power exerted upon the other. By constrast, Duchamp's serenity in the last decades of his life is overwhelming. Perhaps because he had never been a formalist, he never had to act out a repressed sadism in his life!

By the seventies, Greenberg's influence started to wane while Duchamp's star has been on the rise ever since. Nevertheless, I would like to conclude with a concrete example of what might be a reconciliation between the opposed theses of Duchamp and Greenberg. Eliot, once more, can show us the way. In spite of his arrogant tone that Greenberg found unbearable at the end of his life, of his high Church attitude, and of his reactionary leanings, Eliot always insisted upon a non-rational connection with the arts – thus, for him, poetry was above all "a savage beating a drum in the jungle". Eliot looked for a direct communication with the nerves, while remaining, as Greenberg did, a model of good taste and cogent problematic: he would always be discriminate in his judgments and pose the relevant questions. But, "like the good artist; the good critic acts on more than he consciously knows",[30] and he trusted the facts of his life, his lived experiences, and the chance combinations of significant details added at the last minute.

The example I would like to take is the artist Hermann Nitsch. He has been active since 1957, when he was associated with the radical Viennese actionists like Otto Mühl, Günther Brus and Rudolf Schwarzkogler. His

consistent practice – since it is hard to speak of a body of work – has moved from provocative "actions" in the late 1950s and 1960s to vast pageants that he organizes in the yard of his princely castle, Prinzendorf, bought in 1981 in the north of Austria, big enough to house the many "actions", rituals, orgies and ceremonies he has since then organized. As an example of an early action, I'll quote the "lamb dismemberment" of 1962, a private happening during which Nitsch locked himself in a basement with two assistants, crucified a lamb, and staged his own crucifixion while they doused him in the animal's blood. The stained cloth became a painting and also a "relic" of the event. This was meant to release the participants' sadistic and sacrificial urges so as to lead to religious ecstasy. It was also intended to bring a deeper understanding of the pagan orgies later transformed by Christian rituals. More pointedly, these "actions" were meant to startle Austrians, and to remind them of the dire reality of the Second Wolrd War, with its attendant slaughters – since the official thesis was that Austria had been seduced by Germany and coerced into participating in unbelievably cruel genocides. The point was well taken by the police and the establishment – Nitsch was jailed repeatedly until he fled and eventually settled in Bavaria.

Today, Nitsch's "orgies" are elaborately staged shows in which willing participants mix with actors and friends, while most people merely watch. From a distance, it looks like a medieval pageant with a baroque stage music composed by the artist; soon, however, it is clear that something shocking is happening. Naked men and woman are carried on crosses, blindfolded, and they drink blood, animal viscera are rolled on their bellies, men and women are coupled, often inserted in carcasses. No-one speaks during the hieratic ritual as the barbaric music swells, a music often performed by more than hundred players at a time in a deafening background accompaniment. Here are notes for the third day of an "orgy and mystery" on the theme of resurrection: "All are invited to drink. A mass intoxication is imperative . . . Slaughter of a pig. GRAPES, FRUIT and TOMATOES; ANIMAL LUNGS, FLESH and INTESTINES are trampled on in ecstasy. People trample in SLAUGHTERED ANIMAL CARCASSES FILLED WITH INTESTINES, in troughs full of blood and wine. Extreme noise from the orchestras. Slaughtering of the bull, slaughtering of the two pigs. Dismemberment." These "mysteries" are followed by sessions of painting, which involve splattering the walls with blood and other paints that look like blood, which reminds one of 1950s action painting, of their drippings and allovers.

Is this very aggressive? The shock value of these shows has waned, as on the one hand the police have grown more tolerant of these "actions", and on the other hand the neighbors, who all live on farms, are not upset by an art that stages the usual practice of slaughtering animals. Nitsch's mysteries

thus integrate the rhythms of country life with the recurrent killings of pigs, bulls and lambs. Some images call up the Bataille of *Story of the Eye*, as when we discover the naked body image of a pregnant woman with crushed eggs on her belly. In one film of the "orgies", one sees for a while a blindfolded man, bound naked to a cross, who gags as he is forced to swill big gulps of animal blood mixed with wine. Was that a fleeting moment of truth that testified to the body's common sense? However, there was no disruption of the choreography – the show must go on, and it went on, a spectacle including eroticism and religion, voyeurism and exhibitionism, displaying human bodies and animal viscera, the whole scene bathed in the light and symbolism of the crucifixion. Indeed, one cannot forget that Austria is a dominantly Catholic country, and as such, better equipped to make sense of apparently blasphemous or perverse representations of the sacred.

At first view, this kind of art seems to follow in the steps of Duchamp, since the exhibition of naked bodies with genitals in full view is something that he had started exploring. He had also made – privately, it is true, and for Maria Martins – a now famous sperm-painting called *Paysage Fautif*.[31] Body art, the parading of male and female frontal nudity does automatically bespeak eroticism, but can be part of a life-affirming ritual. In the same manner, painting with bodily substances, blood, wine, tomatoes, eggs, and fat, calls up the school of Beuys, and Beuys himself was always deferent to Duchamp. These actions are each unique performances, but they are determined by a repetitive structure that leaves room for surprise while minimizing improvisation. Nitsch aims at rivaling Wagner's *Gesamtkunstwerke*, and his "shows" are more in the spirit of Nietzsche's subversive rereading of Greek classicism in *The Birth of Tragedy*, which highlighted the archaic and literally wild elements of Greek tragedies, than of Wagner's Bayreuth operas. A touch of Artaud is discernible, the theatre of cruelty lends a slight sadistic edge and stresses that the body is alive fully in the present, defying representation. All these actions are finally nothing but carefully contrived simulations, with lots of hearty eating, drinking in communal lunches and dinners. The aggressive component seems to have been wholly sublimated.

There is also the Greenberg side of Hermann Nitsch's art, which is most obvious in the stunning beauty of the paintings made in public at these occasions. Nitsch was originally influenced by Pollock's concept of "action painting" as he said in an interview.[32] His large canvases play on the limitations of the medium, while changing the medium as often as possible: he paints on bodies, on canvases, on religious garments, on shirts and linens, etc. Even if he never uses excrement as a pigment, other body fluids and

animal secretions are employed. The aim is fundamentally modernistic in so far as Nitsch blends artistic experimentalism with an archaic quest when he revisits the roots of religions, their underpinnings in ritual sacrifice of humans and animals.

Moreover there is a deep seriousness in these actions that distinguishes them from Dadaist pranks and puns. They are repeatable, since all these procedures are codified, and often written down extensively before being executed. The repetitive procedures in the blood splatters and all-overs generate all the features that Greenberg appreciated in the later Monet: large canvases at times covered in color, at times barely striped, marked by regular zigzagging. Finally, a 2005 exhibition at the Saatchi museum in London (it was the first part of a trilogy entitled "The Triumph of Painting," with a majority of German and Austrian artists) made clear the link between the rediscovery of Nitsch's work and the concept of "return to painting" (which was the theme of three exhibitions). This return is announced as a welcome change after a surfeit of conceptualism. It is clear that these powerful canvases are visual, "retinal" to the utmost; they are made to be seen and could not be describable in terms of ideas. The Saatchi exhibition of a series of splatter paintings amply demonstrated that Nitsch stood out as the most powerful artist to be exhibited there, even if one had no idea of the actions, mysteries and "orgies". Here, it seems that the ritual murder of art has been cleansed by the simulation of murder – the painter becomes therefore less a criminal (although he has been incriminated or criminalized, technically speaking of course, by being often jailed) than a priest, a slaughter-house butcher and a surgeon.

Conclusion
How to Think "Not Abstractly"

There will be time to murder and create,
And time for all the works and days of hands
That lift and drop a question on your plate
Though I have seen my head (grown slightly bald) brought in upon a platter,
I am no prophet — and here's no great matter.
T. S. Eliot, "The Love Song of J. Alfred Prufrock"[1]

It would be glib and facile to suggest that the overarching significance of Nitsch's controversial artwork provides a Hegelian synthesis, a middle term between the conflicting theses of Duchamp and of Greenberg, acting as a dionysiac negation of Duchamp's negation of art, a negation corresponding to a new affirmation of life through the staging of death. However, even the previous statement has to be qualified. Anyone who is familiar with Hegel's *Phenonenology of Spirit* can remember how forcefully Hegel rails against Kant and Fichte, who both tend to reduce knowledge to the mechanical sequence of thesis, antithesis and synthesis. This is what he calls a lifeless formalism, a pure phantom of thought.[2] The main irony is that Hegel's system is often misrepresented as doing precisely that![3] One needs to be more concretely a Hegelian in order to think with him in the domain of contemporary art.

One of my thematic and conceptual leitmotivs has been an analysis of the replacement of the sublime aura of old with a network of clues and traces underpinned by murder, and as we have seen, this movement duplicates the gesture of Hegel when he criticizes Kant for his handling of the Sublime in *The Critique of Judgment*. The argument has been condensed with pithy eloquence by Slavoj Žižek in *The Sublime Object of Ideology*.[4] Negotiating between Hegel's *Esthetic* and the *Phenomenology*, Žižek shows how Hegel differs from Kant when the latter aims at bringing representation to an impassable limit, to a spectacle whose enormous size would always defeat the possibility of recuperation by the imagination, therefore leading a humbled subject to recognize that the failure of representation is compensated by a moral pay-off: in the limit imposed to representation and

imagination, something like awe in front of the moral law appears, triggering a renewed awareness of the infinite in us. Hegel rejects what he sees as an undue collusion between Kant and the ancient Jewish sense of the Sublime facing the Law. He does so because he has decided to base his monistic system on a two-pronged procedure linking the science of phenomena as they appear to consciousness (the phenomenology), with the science of concepts (the logic). What he needs to prove is that nothing can ever exceed the field of representation – what is taken as an experience of the limit, a limit-experience, in other words the old Sublime, is already an experience of negativity itself, hence a seizing or capturing (*Begriff*) the spiraling Idea as it moves through time.

As Žižek comments, Hegel sticks to the same account of an experience of the "unpresentable", but "substracts all its transcendent presuppositions" and limits his analysis "to what is strictly immanent in the experience, to pure negativity, to the negative self-relationship of the representation".[5] For Hegel, there is no need to believe that the Sublime is somehow "out there" exceeding representation, since nothing exceeds consciousness as long as it *is* consciousness, or that the experience of the Sublime turns us away from the imagination, hence from any kind of representation. The Sublime is best approached and expressed as the pure experience of negativity, an experience that is often translated metaphorically as the experience of "death" or of "murder", and which gives access to the Concept, that stepping stone of science which uses negativity for its own ends. This radical experience of a language that both mimes and contains negativity has been embodied imaginatively by a few post-Hegelian poets like Mallarmé (with "Igitur" especially) or Lautréamont (in his games with literary inversion, dialectical negation and the unleashing of black humour's bad taste).

This would be a theoretical context in which Nitsch's theatrical events that somehow abolish yet confirm representation are relevant. With Nitsch, we do not leave the field of representation, however representation soon meets a limit in the flesh, in bodies, in the parody of religion, in the masochistic willingness of spectators to become actors as they participate in bizarre rituals, while some painterly trace of all this is kept by the artist. One could parallel this procedure with the work of the younger Brazilian artist Adriana Varejão. Although different in style and inspiration, since her paintings, sculptures and installations usually refer to Portuguese azulejos,[6] her works evinces the same tendency: it forces representation to exceed itself by calling up the idea of murder. Her walls are crumbing and reveal within their regular planes a mass of grey-red entrails, shiny viscera and bleeding organs full of veins and tendons; punning on the notion of "organic" architecture, she discloses the "meat" contained in the walls. Dotting with

vertical razor slashes a blank squared paper in the manner of Fontana, or cutting through ancient maps of the world dating from the conquistadors, she reveals in her incisions suppurating organic tissue or oozing blood. When she decides to hide for a while the blood and the guts as in her serial representations of swimming pools, saunas and bathrooms, we discover the faintest traces of murder, as with *The Guest* (2004).[7] There, a central white pillar hides what is behind, we just glimpse swirls of drying blood on the tiled floor. The guest must have been a returning host, Agamemnon perhaps, freshly slaughtered in his bath.

A similar tendency is perceptible in the work of Jonathan Santlofer, a painter doubling as an author of popular thrillers and gory murder stories. He has illustrated his last thriller, *The Killing Art*,[8] with a set of his own paintings. The plot revolves around the revenge enacted by the daughter of a former Abstract Expressionist painter who had been excluded from the group in 1950. Santlofer has invented an improbable heroine, Kate McKinnon, a glamorous ex-cop turned art-critic, also a celebrity with a best-selling book on art and a TV programme to her name. Santlofer's first novel, *The Death Artist*,[9] depicts a museum curator who stages replicas of famous paintings with his murdered and often mutilated victims. We witness successively his realization of a portrait by Picasso, David's *Death of Marat*, Titian's *Flaying of Marsyas*, Kienholtz's *Birthday*, a de Kooning painted with the truncated stumps of a collector's arms, Mantegna's *Saint Sebastian* "executed" with arrows during the Venice Biennale. As the "death artist" is finally shot to death by Kate at the end, he has just completed a life-size realistic rendering of Artemisia Gentilleschi's *Judith beheading the Assyrian* and he is contemplating the dramatization of his own suicide next to Kate's body in would have been no doubt, a wonderful *Madonna and Child*.

Santlofer, who knows the art world as intimately as Geary, the author of *Spiral*, and adds to his familiarity with artists, collectors, curators, critics and patrons the distinction of being a painter of some renown, confirms through his suspense novels the notion that contemporary art and detective fiction can converge. It is no accident that the demented and murderous curator of *The Death Artist* has taken Damien Hirst as a model – noting dismissively that Hirst never took risks, since he worked only with dead bodies! Similarly, I have used the popular version of an "esthetics of murder" as a ploy to weave a way between Benjamin and Adorno, Breton and Bataille, Greenberg and Duchamp. I have enlisted de Quincey, Benjamin and Hegel, and the last word should be given to Hegel and his modern commentators. Croce had already said of Hegel that he was a mortician of esthetics; Croce concludes his review of Hegel's esthetic with these

disabused words: "The Aesthetic of Hegel is thus a funeral oration: he passes in review the successive forms of art, shows the progressive steps of internal consumption and lays the whole in its grave, leaving Philosophy to write its epitaph. [10] Hegel would pave the way to conceptual art insofar as the latter also praises the idea over any material realization.

In the hope of showing that this judgment is unfair or one-sided, I will rapidly examine a short essay by Hegel entitled "Who Thinks Abstractly?" This undated text full of verve most likely comes from the years 1807 or 1808,[11] and it starts as a refutation of the common objection against philosophy, which is to say that philosophers speak and write too abstractly. Here is one text that proves that Hegel had not waited for Marx to launch a systematic critique of abstraction in philosophy. Even if Hegel is not resorting to the hard facts of economics and political science, he uses the example of murder in the context of an esthetic apprehension of the world in order to reach the point of view of a saving grace.

Hegel's point of departure is that only uneducated people think and speak abstractly, while truly educated people think concretely. To further his point, Hegel takes a trivial example: there has been a murder, the murderer has been caught and is going to be executed. But in this case, the murderer happens to be a handsome man. "A murderer is led to the place of execution. For the common populace, he is nothing but a murderer. Ladies perhaps remark that he is a strong, handsome, interesting man. The populace finds this remark terrible: What? A murderer, handsome? How can one think so wickedly and call a murderer handsome; no doubt, you yourselves are something not much better! This is the corruption of morals that is prevalent in the upper cases, a priest may add, knowing the bottom of things and human hearts" (p. 285). Hegel's irony does not spare religion, especially when it gives weapons to the prejudices of common people. The scientific discourse elaborated in the name of criminology and sociology are not spared either. "One who knows men traces the development of the criminal's mind: he finds in his history, in his education, a bad family relationship between his father and mother, some tremendous harshness after this human being had done some minor wrong, so he became embittered against the social order – a first reaction to this that in effect expelled him and henceforth did not make it possible for him to preserve himself except through crime" (p. 286). Would such an enlightened approach be the correct one? Hegel asserts that the problem is less that when one tries to understand a murderer's motivations, one seems to be excusing the criminal, than reducing the murderer's intrinsic singularity to that of general categories like the abused child, the misfit, the temperamentally violent man, and son on. He compares this argument with

that of a German a mayor who blamed a wave of suicides on the publication of Goethe's *Sorrows of Werther*. Whether this view was historically true or not, it fails to qualify as concrete or non-abstract thinking: "This is abstract thinking: to see nothing in the murderer except the abstract fact that he is a murderer, and to annul all other human essence in him with this simple quality" (p. 296). If the pathologists or the sociologists may well be closer to truth, they reduce a criminal to a family history, psychiatric or social determinations. They fail to see the murderer's reality because their gaze is still clouded by abstraction.

In fact, the genuine counter-example comes from an old woman who is a nurse in the local hospital. In Hegel's words, she has managed to "kill the abstraction of the murderer and bring him to life for honor. The severed head had been placed on the scaffold, and the sun was shining. How beautifully, she said, the sun of God's grace shines on Binder's head! . . . This woman saw that the murderer's head was struck by the sunshine and thus was still worthy of it. She raised it from the punishment of the scaffold into the sunny grace of God and, instead of accomplishing the reconciliation with violets and sentimental vanity, saw him accepted in the grace of the higher sun" (p. 286). Such a display of naïve piety nevertheless enacts the whole mechanism of Hegelian *Aufhebung*, a "sublation" in which the reconciliation derives from the negation of the negation: the murderer has accomplished the first negation, his beheading is a second negation, and the passage to a third level consists in raising the cut head, seeing it as both touched by the grace of God and glorified esthetically by the sun of this world.

Let us note, however, that the woman in question is neither a society lady nor a member of the populace: her wisdom comes from her age and also from her social function as a lowly healer. She may sound simplistic in her fideism but her innate trust in God's benevolence hits the mark by cutting through a purely sentimental view like that of the esthetes alluded to as the refined circles of Leipzig. Unlike the intellectuals of the Leipzig salons, worldlier aristocrats may engage with what was then a rather fashionable neo-Rosicrucianism; for Hegel, they do not immediately fall into an "opposite abstraction". Here is what he presents as a truer moral example: "The Christians may indeed trifle with Rosicrucianism, or rather cross-rosism, and wreathe roses around the cross. The cross is the gallows and wheel that have long been hallowed. It has lost its one-sided significance of being the instrument of dishonorable punishment, and, on the contrary, suggests the notion of the highest pain and the deepest rejection together with the most joyous rapture and divine honor" (p. 286). Hegel believes that one should be able to appreciate a murderer's physical beauty in spite of his or her

wickedness (perhaps even *because* of the individual's evil nature), while seeing at the same time the punishment as a retribution that confirms to the regulations of life in society, to what he calls *Sittlichkeit* in *The Phenomenology of Spirit*, meaning an objective morality condoned by a given society's dominant values. Only once the severed head appears in the glory of the sun can one start thinking "not abstractly" – for in that case, the image becomes at the same time a concept. This is at least what an old nurse intuitively guesses at and expresses when she sees the murderer's head graced by a worldly halo in a sunshine that allegorizes God's forgiveness.

Hegel is here laying the ground for the often-quoted simile that adorns the ending of the 1820 Preface to *The Philosophy of Right*. He wants to illustrate that his book cannot teach rulers how to build a better state or even conjure up an ideal state; his philosophy can only describe what has been and what is. Then he quotes the classical proverb:

<div style="text-align:center">

Ἰδοὺ ῾Ροδοζ, Ιδου και το πηδημα

Hic Rhodus, *hic* saltus.

</div>

He adds: "To comprehend what is, this is the task of philosophy, because what is, is reason. Whatever happens, every individual is a child of his time: so philosophy too is its own time apprehended in thoughts. It is just as absurd to fancy that a philosophy can transcend its contemporary world as it is to fancy that an individual can overleap his own age, jump over Rhodes. . . . With hardly an alteration, the proverb just quoted would run: 'Here is the rose, dance thou here'".[12] Instead of translating the old saying as usual by "Here is Rhodes, it is here that one must jump," the subtle and deliberate mistranslation of the Greek *rôdos* as "rose" (one of its meanings) and of the Latin *saltus* (jump) as "dance" (also accepted as dance-step) yields here the suggestion of a joyful overcoming symbolized by a dance. While Hegel mocks the pretensions of a jump into the future, he accepts the liberating energy of the jump and sees it as pointing in the right direction. In the present, *salta* becomes an imperative verb ("dance thou here!"), which calls up the freedom and elation brought about by a rational understanding of the world as it is.

A philological sleight of hand has generated the image of the rose combined with a cross. The following paragraph argues that the image holds the key to a new transcendence, an overcoming of "the fetter of some abstraction".[13] Hegel attempts again to show us how to think "not abstractly" something as abstract as "murder"(a term which can send us back to "negativity" or to "death" in a dramatized stage) by refusing to employ the trick de Quincey had played on Kant – that is, when he distinguished the present moment of the murder and the esthetizing sequel, as it

were. For Hegel, one needs to start from the present, but a present always seen from the point of view of a knowledge that is underpinned by an absolute knowing. "To recognize reason as the rose in the cross of the present and thereby to enjoy the present, this is the rational insight which reconciles us to the actual, the reconciliation which philosophy affords to those in whom there has once arisen an inner voice bidding them to comprehend, not only to dwell in that substantive while retaining subjective freedom, but also possess subjective freedom while standing not in anything particular and accidental but in what exists absolutely."[14] This rather uplifting assertion, leading to an awareness of the absolute, contrasts with the more resigned tone of the last page, which is so often quoted, in which Hegel sees philosophy as "painting grey in grey" and no better than the "owl of Minerva" that "spreads its wings only with the falling of the dusk".[15]

The idea that philosophy brings joy because it allows one to think the present absolutely and not abstractly is a concept that Heidegger takes as a main lever in his critical confrontation with Hegel. In a seminar devoted to Hegel's *Phenomenology of Spirit*, Heidegger argues that in striving for "absolute knowledge" Hegel did not really think that he could reach it (this would have been Spinoza's position). Hegel aimed at experiencing thought in a different mode, intimating that it was possible to think differently and more rigorously. By transforming thinking into a process, an experience that presupposes the totality of knowledge, we learn to think *absolutely*.[16] This is the substance of the admonition running through the Preface to *The Phenomenology of Spirit*. I will not engage fully with this notoriously difficult text, and will limit myself to mention Hegel's critique of beauty when it is not coupled with considerations of negativity or death. Here is the passage: "Death, if that is what we want to call this non-actuality, is of all things the most dreadful, and to hold fast what is dead requires the greatest strength. Lacking strength, Beauty hates the Understanding for asking her what it cannot do. But the life of the Spirit is not the life that shrinks from death and keeps itself untouched by devastation, but rather the life that endures and maintains itself in it. It wins its truth only when, in utter dismemberment, it finds itself."[17] The apparently tragic tone of this passage should not conceal its radical optimism; here as always a certain pan-logism underpins a darker pan-tragism. Hegel trusts that he will be strong enough to "look the negative in the face", and thus not close his eyes out of sentimentality to life's unpalatable or horrible sides.

The critique of abstract thinking is identical with the rejection of an empty formalism by which he had disqualified Kant, Fichte and all the Romantics. However, the critique of abstraction under the name of formalism does not mean that Hegel favours imitative or representational

art. In the Introduction to his *Aesthetics*, he quotes with approval the Muslim prohibition of the representation of human beings (or of any living being for that matter). For Hegel the *Zweck*, or aim of art, cannot consist of the mere imitation of life – in this respect, Nature will always prove superior. Such a wish is superfluous, and the Muslim man was right when he reproached the explorer James Bruce who had shown him paintings of a fish. At first astonished that this should be possible, he then told Bruce: "If this fish shall rise up against you on the last day and say: 'You have indeed given me a body but no living soul,' how will you then justify yourself against this accusation?"[18] This is because painting, like all the other arts, must show the Idea as alive; and this will be achieved with Romantic art since it "embodies" the Idea.

This would take to a lengthy discussion of painting as developed in the second part of the *Aesthetic*, a discussion which broaches the issues that I had starting from when quoting the Preface of the *Phenomenology*. In the Preface, Hegel opposes the diverse colours that testify to a truly vital account of the life of Spirit to purely "monochromatic"[19] pictures in which everything is either black (the darkness of a night where all the cows are black) or white (the fake candour of bland wishful thinking). Multi-coloured life contrasts with simple bi-chromic dichotomies. In these limited attempts, only two colours are thus employed, red for historical scenes, and green for bucolic landscapes. In the fanciful parody reducing History to painting by numbers, one recognizes the old clash between the blood of slaughtered people and the temporary pastoral solace afforded by a romanticized nature.[20] At least the "gallery of portraits" into which universal history is transformed by *The Phenomenology of Spirit* requests the most varied tints of the spectrum.

Accordingly, Hegel's *Esthetics* makes of the rendering of flesh or carnation the ultimate test for an artist. Incarnadine, that rosy hue of the skin, was often seen in the eighteenth century as the most difficult test for a painter. Painters would show their skill by blending the colours that evoke the faces of ladies or young girls. Hegel focuses his microscope on the transparent yellows of the skin that let the blue of the veins and the red of the arteries loom underneath. He lists the primary and secondary colours needed to reproduce the human skin: red, violet, blue and yellow have to be compensated with softer ochres, browns and grays in order to produce a satisfactory cumulative effect.[21] Such a palette is not to be reduced to a shimmering effect, but should appear illuminated from inside, like the surface of a lake lit by a sunset: it mirrors objects but lets our gaze penetrate to the depths.

The interiority of such a glow evokes concretely the inner life of the Spirit that Duchamp will later literalize with his lighting gas, but also

suggests the sensuous surging of Life itself. In those feverish pages of the *Esthetic*, which suffice to refute Croce, Hegel quotes at one point Diderot's *Essay on Painting*, as translated by Goethe. For Diderot, the main test is again whether an artist can render the colours of flesh correctly – by this only can one can testify whether someone has mastered the art of painting. He writes: "Indeed flesh is difficult to render; this unctuous white, even without being pale or mat; this mixture of red and blue which imperceptibly perspires; it is blood, thus life, which makes the colorist despair. He who has acquired a feeling for flesh has progressed a lot; the rest is nothing in comparison. Thousands of painters have died without knowing flesh; thousand others will die without feeling it."[22] Diderot's expressive materialism allows Hegel to find life in death and death in life, since it is death's untimely irruption that prevents the artist from feeling, knowing and, what is more important, enjoying flesh.

Is there such a difference between the blood that runs in the veins of a beautiful maiden and the blood that covers the fingers of a murderer? When one dies, does the flesh remain flesh, or is it already meat? Hegel answers by wreathing death with the garlands of all the flowers in the world. Hegel is indeed the precursor of a Jean Genet who prepares his own phantasmagoric *Funeral Rites* as Derrida's most playful philosophical book, *Glas*, asserts. *Glas* lists all the real and metaphorical flowers found in Jean Genet's works, and to these one should add a bunch of dahlias in order to pay a last homage to Black Dahlia. It is in *Glas* that Derrida puns on Hegel, whose name he pronounces in French as "*hègl*", thus transforming him into another bird, not a *nibbio* assuredly, but an eagle, the French *Aigle*. Derrida does not register the fact that part of the critical and creative gesture in *Glas* had been anticipated and duplicated by the Belgian conceptual artist Marcel Broodthaers. Among the many games that he played with artistic institutions, Broodthaers had invented a museum devoted to collecting artifacts evoking or representing eagles. In Derrida's version, Hegel's plaster bust belongs by right to the zany zoology of *la section des aigles*. The monumentalization of the king of birds in an imaginary museum is a perfect framework for the glorious lure of absolute knowledge. In fact, as I have suggested, such a bust should also find a place in a museum devoted to murder.

When Derrida comments on Genet's novel *Our Lady of the Flowers* in *Glas*, he provides the most fitting (and the least abstract) conclusion to this discussion. The novel "opens up with the archive of all the heads that have just fallen, condemned to death", and the first of these is the beautiful face of Weidmann the murderer who appears before us. Here is Genet, who has been seduced by a newspaper photograph and has fallen head over heels in

love with the wounded face which looks like that of an aviator: "His hand-some face, multiplied by the presses, swept down upon Paris . . . " Derrida points out the sexual overtones: "To be decapitated is to appear – banded, erect: like the 'head swathed . . . and like the phallus, the erectile stem the style – of a flower".[23] The phallic flowers that bloom here and there are simply flowers of the field, not flowers of evil, although they are borne out the semen of guillotined murderers. All of this will be even truer if by "field" we allude allegorically to that indefinitely extensible concept, art. Art as a field, a field to be mapped out again by contemporary artists, all the more so if one decides to take into account the booby-traps and para-doxes left by an appropriately named Marcel Du*champ*. Duchamp, the champion of negation in art taken as a field. Let him murder in his field at leisure – whether he beheads weeds, cabbages, dahlias or sunflowers; others will reap. And as Lautréamont might say, because of the holes in the ozone layer, now the sun always falls on decapitated heads.

Notes

Introduction: The Esthetics of Murder: Of sirens, traces and auras

1 Theodor W. Adorno, *Minima Moralia*, trans. E. F. N. Jephcott, London, Verson 1978, p. 111.

2 Two Edinburgh-based bodysnatchers who sold their corpses onto a physician, Robert Knox.

3 Edmund Gosse, *Father and Son, A Study of two temperaments*, London, Penguin, 1989, pp. 108–9.

4 James Ellroy, *My Dark Places*, New York, Knopf, 1996, p. 103.

5 *Father and Son*, p. 170.

6 Thomas de Quincey, "On Murder considered as one of the Fine Arts" in *The English Mail-Coach and other essays*, London, Dent, Everyman's Library, 1923, p. 53.

7 *Father and Son*, p. 106.

8 Jorge Luis Borges, "The Creation and P. H. Gosse," in *Selected Non-Fictions*, trans. Eliot Weinberger, New York, Penguin, 1999, p. 224.

9 Stephen Jay Gould, "Adam's Navel," in *The Flamingo's Smile: Reflections in Natural History*, New York, Norton, pp. 99–113.

10 *Ibid.*, p. 111.

11 Philip H. Gosse, *Omphalos. An Attempt to Untie the Geological knot*, reprint by Woodbridge, Conn., Ox Bow Press, 1998, pp. 353–4, note.

12 Peter Vilhelm Glob, *The Bog People, iron age man preserved*, trans. Rupert Bruce, Ithaca, Cornell University Press, 1969.

13 This is an insight shared by Stephen Kern, though with a different language, in his excellent *A Cultural History of Causality: Science, Murder Novels, and Systems of Thought*, Princeton, Princeton University Press, 2004.

14 Jean Baudrillard, *The Perfect Crime*, trans. Chris Turner, London, Verso,1996, p. 24.

15 "On Murder Considered as One of the Fine Arts", *op. cit.*, p. 47.

16 Jacques Lacan, "The splendor of Antigone," in *The Ethics of Psychoanalysis*, trans. Dennis Porter, New York, Norton, 1992, pp. 243–56.

17 David Ellison, *Ethics and Aesthetics in European Modernist Literature: From the Sublime to the Uncanny*, Cambridge, Cambridge University Press, 2001.

18 See for instance the catalogue *Barnett Newman*, Philadelphia, Philadelphia Museum of Art, 2002, p. 178 and seq. A wonderful discussion of Newman is to be found in Jeremy Gilbert-Rolfe's insightful *Beauty and the Contemporary Sublime*, New York, Allworth Press, 1999.

19 Baudrillard, *The Perfect Crime*, p. 1.

20 *Ethics and Aesthetics in European Modernist Literature: From the Sublime to the Uncanny*, pp. ix and p. 53.

21 *Ethics and Esthetics*, p. 221.

22 Homer, *The Odyssey*, trans. W. H .D. Rouse, London, Nelson, 1952, p. 206.

23 Maurice Blanchot, "The Song of the Sirens" , *The Station Hill Reader*, p. 444.

24 Max Horkheimer and Theodor W. Adorno, *Dialectic of Enlightenment*, trans. Edmund Jephcott, Stanford, Stanford University Press, 2002, p. 46.

25 *Ethics and Esthetics*, p. 263, note 14. Italics mine.

26 *Ethics and Esthetics*, p. 263, note 14.

27 Franz Kafka, *The Silence of the Sirens*, in *The Complete Stories*, edited by Nahum N. Glatzer, New York, Schocken, 1983, p. 430.

28 *The Silence of the Sirens*, p. 431.

29 "The Silence of the Sirens", in *The Station Hill Blanchot Reader*, p. 443.

30 Jorge Luis Borges, "Kafka and his Precursors", *Selected Non Fictions*, pp. 363–5.

31 *The Station Hill Reader*, p. 445.

32 Edgar Allan Poe, *The Complete Tales and Poems*, Harmondsworth, Penguin, 1983, p. 141.

33 Sir Thomas Browne, *Hydriotaphia, Urne-Buriall, or A Discourse of the Sepulchrall Urnes lately found in Norfolk* (1658) in *The Prose of Sir Thomas Browne*, ed. Norman Endicott, New York, New York University Press, 1968, vol. 1, p. 280.

I Freud's Da Vinci Code: Interpretation as crime

1 Typically, in homage to his master Charcot, Freud uses French expressions: *"J'appelle un chat un chat"* (he may be aware of the Libertine connotations of "cat" in French), and then, *"pour faire une omelette, il faut casser des oeufs."* Sigmund Freud, *Dora, An Analysis of a case of Hysteria*, New York, Collier, 1993, pp. 41 and 42.

2 *Psychoanalysis and Faith. The Letters of Sigmund Freud and Oskar Pfister*, ed. H. Meng and Ernst L. Freud, trans. Eric Mosbacher, New York, Basic Books, 1963, p. 38.

3 *Ibid.*, modified. Here is Freud's original sentence: "Ohne ein solches Stück Verbrechertum gibt es keine richtige Leistung." Sigmund Freud, Oskar Pfister, *Briefe 1909–1939*, Frankfort, Fischer Verlag, 1963, p. 36.

4 *Psychoanalysis and Faith*, p. 38.

5 *Psychoanalysis and Faith*, pp. 80–1.

6 *Psychoanalysis and Faith*, p. 77.

7 For more on this subject, see Peter Gay, *Freud: A Life for our Time*, New York, Doubleday, 1988, pp. 314–15.

8 Sigmund Freud, "The Moses of Michelangelo," in *Writings on art and literature*, Stanford, Stanford University Press, 1997, p. 122.

9 *Ibid.*, p. 124.

10 *Ibid.*, p. 134.

11 *Ibid.*, p. 135.

12 *Ibid.*, p. 146.
13 Alain Roger, *Hérésies du Désir. Freud, Dracula, Dali*, Seyssel, Champ Vallon, 1985, pp. 24 and 46.
14 Sigmund Freud, *Three essays on the theory of Sexuality*, trans. James Strachey, New York, HarperCollins, 1975, p. 48.
15 See Sigmund Freud, *Studienausgabe, Band X, Bildende Kunst und Literatur*, Frankfort, Fischer Verlag, 1970, p. 207.
16 "The Moses of Michelangelo", *op. cit.*, p. 148. See also "Der Moses des Michelangelo," in *Bildende Kunst und Literatur*, p. 219.
17 "The Moses of Michelangelo," p. 148.
18 This different meaning of the sublime has been developed by Ginette Verstraete in *Fragments of the Feminine Sublime in Friedrich Schlegel and James Joyce*, Albany, SUNY Press, 1998.
19 This scenario is repeated with variations in many parts of the *Scienza Nuova*. See Giambattista Vico, *The New Science*, trans. T. G. Bergin and M. H. Fisch, Ithaca, Cornell University Press, 1984, pp. 117–19.
20 *The New Science*, p. 150.
21 *The New Science*, p. 343.
22 Walter Benjamin, *The Arcades Project*, translated by Howard Eiland and Kevin McLaughlin, Cambridge, Mass., Harvard University Press, 1999, p. 447.
23 Walter Benjamin, "The Work of Art in the Age of Mechanical Reproduction," in *Illuminations*, trans. Harry Zohn, New York, Schocken, 1969, pp. 232–3.
24 Sigmund Freud, "Leonardo da Vinci and a memory of his childhood," *Standard Edition*, vol. XI, p. 76. Hereafter LV followed by page number.
25 Malcolm Bowie, *Freud, Proust, Lacan. Theory as Fiction*, Cambridge, Cambridge University Press, 1987.
26 Leonardo, *Notebooks*, edited by E. MacCurdy, New York, George Braziller, 1955, p. 1122. Further references to this as *Notebooks* followed by page number.
27 Meyer Schapiro, "Leonardo and Freud: An art-historical study" (1954), in *Renaissance Essays*, ed. P. O. Kristeller and P. P. Wiener, New York, Harper and Row, 1968, pp. 303–36.
28 *Ibid.*, p. 331.
29 K. R. Eissler, *Leonardo da Vinci. Psychoanalytic Notes on The Enigma*, New York, International Universities Press, 1961. Eissler acknowledges Freud's mistake on the *nibbio* and the irrelevance of the allusions to Egyptian mythology while questioning Schapiro's historical assumptions.
30 Meyer Schapiro, "Leonardo and Freud," p. 336.
31 Eissler, *Leonardo da Vinci. Psychoanalytic Notes*, pp. 38–9, and plate 4.
32 *Notebooks*, p. 79.
33 *Notebooks*, p. 1115.
34 *Notebooks*, p. 1105.
35 Dan Brown, *The Da Vinci Code*, New York, Doubleday, 2003, p. 1.
36 Joseph Geary, *Spiral*, New York, Random House, 2003.

2 Duchamp's *fait-divers*: Murder as a "ready-made"

1 I first presented my hypothesis at the international Word and Image conference on *The Avant-gardes* (Nice, June 1997). It was then published under the title of "Étant Donnés: 1° L'art, 2° Le Crime. Duchamp criminel de l'avant-garde", *Interfaces* 14, June 1998, pp. 113–30. More recently, and quite independently, Jonathan Wallis has reached a similar conclusion in "Case Open and/or Unsolved: Marcel Duchamp and the Black Dahlia Murder", *The Rutgers Art Review*, vol. 20, 2003, pp. 7–23.

2 I owe this personal account to Morton Levitt, emeritus professor of English at Temple University.

3 See the facsimile replica, *Manual of Instructions for Marcel Duchamp Etant Donnés: 1° La chute d'eau 2° le gaz d'éclairage*, Philadelphia Museum of Art, 1987.

4 Jean Clair, *Méduse*, Paris, Gallimard, 1989, p. 16.

5 *Philadelphia Inquirer*, July 8, 1969, pp. 1 and 3. Thanks to Jonathan Eburne, who brought these newspapers cuttings to my attention.

6 Dalia Judovitz, "Rendez-vous with Marcel Duchamp: *Given*", in *Marcel Duchamp. Artist of the Century*, edited by R. E. Kuenzli and F. M. Naumann, Cambridge, MA, MIT Press, pp. 184–202.

7 See Calvin Tomkins, *Duchamp. A Biography*, New York, Henry Holt and Co., 1996, p. 356.

8 See *Marcel Duchamp. Work and Life. Ephemerides on and about Marcel Duchamp and Rose Sélavy*, edited by Pontus Hulten, texts by Jennifer Gough-Cooper and Jacques Csumont, Cambridge, MA, MIT Press, 1993. The volume is arranged chronologically and has no page numbers.

9 See Steve Hodel, *Black Dahlia Avenger. A Genius for Murder*, New York, Arcade Publishing, 2003, pp. 418–23.

10 James Ellroy, *The Black Dahlia*, New York: The Mysterious Press, 1987, p. 77. Hereafter, BD. Thanks to Patricia Gherovici who pointed out to me the similarity between the picture of Short's corpse as published for the first time since the press releases of the time in Kenneth Anger's *Hollywood Babylon II*, New York, NAL Penguin, 1984, pp. 127–33, and Duchamp's female figure in the PMA installation.

11 James Ellroy, *My Dark Places*, New York, Knopf, 1996, p. 103.

12 Ibid.

13 *Black Dahlia Avenger*, pp. 458–9.

14 *Black Dahlia Avenger*, p. 86.

15 *Ibid.*, p. 87.

16 *Ibid.*, p. 88.

17 *Ibid.*, pp 211 and 222.

18 *Ibid.*, pp. 240–1.

19 See Neil Baldwin, *Man Ray. American Artist*, New York, Da Capo Press, 2001, pp. 168–9.

20 *Black Dahlia Avenger*, pp. 251–2.

21 Roland Barthes, *Sade, Fourier, Loyola*, trans. Richard Miller, Berkeley, University of California Press, 1989, p. 33.

22 Max Horkheimer and Theodor W. Adorno, *Dialektik der Aufklärung*, Frankfurt, Fischer Verlag, 1969.

23 Maurice Blanchot, "Sade" in Marquis de Sade, *Justine, Philosophy in the Bedroom and other writings*, New York, Grove, Evergreen, 1990, p. 66–7.

24 See *Sade, Fourier, Loyola*, pp. 152–3.

25 Jacques Lacan, *Le Séminaire. Livre X. L'angoisse*, ed. Jacques-Alain Miller, Paris, Seuil, 2004, p. 193. I have developed this analysis in *Jacques Lacan. Psychoanalysis and the subject of literature*, Basingstoke, Palgrave, 2001, pp. 85–114.

26 Samuel Beckett, *Watt*, New York, Grove Press, 1959, p. 72.

27 *Affectionately, Marcel*, p. 292.

28 See the bemused comments of Neil Baldwin, *Man Ray. American Artist*, pp. 276–7.

29 Léon Robin, *Pyrrhon et le scepticisme grec*, Paris, Presses Universitaires de France, 944, p. i. See also Léon Robin, *La Pensée Grecque et les origines de l'esprit scientifique*, Paris, Renaissance du Livre, 1923.

30 Marcel Conche, *Pyrrhon ou l'Apparence*, Paris, Presses Universitaires de France, 1994.

31 *Ibid.*, p. 271.

32 Max Stirner, "Art and Religion" in *The Young Hegelians, An Anthology*, ed. Lawrence S. Stepelevich, Atlantic Highlands, Humanities Paperback Library, 1983, pp. 327–34.

33 Max Stirner, *The Ego and Its Own*, translated by S. T. Byington and revised by David Leopold, Cambridge, Cambridge University Press, 1995, p. 36. Hereafter abbreviated as EO.

34 EO, p. 26.

35 EO, p. 258.

36 EO, p. 258.

37 EO, p. 259.

38 EO, pp. 275–6.

39 EO, p. 324.

40 EO, pp. 323–4.

41 Quoted in Calvin Tomkins, *Duchamp, A Biography*, p. 419

42 *Ibid.*, p. 251.

43 See Marcel Duchamp, *Notes*, Paris, Flammarion, 1999, p. 145 and pp. 147: The first text reads:

> "2 Epitaphe . . . et d'ailleurs c'est toujours les autres qui meurent// dernier" (p. 145).
> *and then becomes:*
> "EPITAPHE:
> . . . ET D'AILLEURS
> C'EST TOUJOURS LES AUTRES QUI MEURENT" (p. 147).

44 Letter to Henri-Pierre Roché from July 17 1950, in *Affectionately, Marcel. The Selected Correspondence of Marcel Duchamp*, ed. Francis M. Naumann and Hector

Obalk Ludion, Ghent-Amsterdam, Ludion Press, 2000, pp. 290 (French text) and 291 (translation).

45 Vladimir Nabokov, *Pale Fire*, New York, Random House, 1977, p. 40. The same poem contains a narrative by John Shade introduced by. And one night I died" (p. 58). And, of course, Shade is about to complete a poem in which he has written: "As I am reasonably sure that I / Shall wake at six tomorrow . . ." (p. 69) when he is shot to death by a lunatic.

46 Lydie Fischer Sarazin-Levassor, *Un échec matrimonial. Le coeur de la mariée mis à nu par son célibataire même*, Dijon, Les Presses du Réel, 2004., p. 41. Thereafter EM, followed by the page number.

47 Sophie Calle, *Douleur Exquise*, Arles, Actes Sud, 2003. Calle chronicles with photographs, interviews, letters and documents the moment when she learned that the man in her life decided to break up their relationship, not meeting her during a trip to Japan and India. She begins her countdown 92 days before the "exquisite pain", then goes on to cover 99 days "after the pain". Similarly, the period of relative felicity between Lydie and Marcel lasted roughly six months. They met in March 1927, got married on June 8 1927 and separated for good in October 1927. The divorce was granted in January 1928.

48 See EM pp. 39, 47, 56, 82, 103, 151 and 183.

49 *Duchamp. A Biography*, p. 283.

50 *Le Surréalisme au Service de la Révolution*, double issue 5–6, may 15 1933, p. 1.

51 *"Mais ce grand artiste, après tout, n'était-il pas qu'un super bricoleur?"* (EM, p. 187). See EM, p. 108 for an account of Marcel's uncanny manual abilities, and of his skill at tedious and repetitive manual exercises.

52 The French title does not keep Duchamp's practice of writing a singular "même" followed by a comma, and has "La Mariée mise à nu par ses célibataires mêmes." (*La Surréalisme au Service . . .* p. 1) The pun on the French homophony between *"même"* (even) and *"m'aime"* (loves me) cannot be rendered anyway.

53 *Le Surréalisme au Service de la Révolution*, 5–6, p. 1. Compare with the translation given in Marcel Duchamp, *The Writings of Marcel Duchamp*, ed. M. Sanouillet and E. Peterson, New York, Da Capo Press, 1973, pp. 27–8.

54 Alfred Jarry, *Oeuvres Complètes*, vol. 1, Paris, Gallimard, Pléiade, 1972, p. 734.

55 *Ibid.*, p. 669.

56 Roland Barthes, "Structure of the *Fait-Divers*", in *Critical Essays*, trans. Richard Howard, Evanston, Northwestern University Press, 1972, p. 185.

57 *Ibid.*, p. 186.

58 *Ibid.*, p. 187.

59 *Ibid.*, p. 194.

60 Guillaume Apollinaire, "Zone", translated by Samuel Beckett in *Collected Poems in English and French*, New York, Grove Press, 1977, p. 107.

61 Stéphane Mallarmé, *Oeuvres Complètes*, ed. Bertrand Marchal, Paris, Gallimard, Pléiade, vol. 2, 2003, p. 82.

62 *Ibid.*, p. 246.

63 Stéphane Mallarmé, *Poems*, translated by C. F. MacIntyre, Berkeley, University of California Press, 1957, p. 91. I thank Arakawa for this useful hint.

64 Stéphane Mallarmé, *Collected Poems*, translated by Henry Weinfield, Berkeley, University of California Press, 1994, p. 72.

65 *Ibid.*, p. 224.

66 Edgar Allan Poe, *The Complete Tales and Poems*, Harmondsworth, Penguin, 1983, p. 478.

67 Thomas de Quincey, "On the Knocking at the gate in Macbeth," in *Confessions of an English Opium-Eater and other writings*, ed. Grevel Lindof, Oxford, Oxford University Press 1985, pp. 84–5.

68 Stéphane Mallarmé, "La Fausse entrée des Sorcières dans Macbeth", in *Oeuvres Complètes*, II, ed. Bertrand Marchal, Paris, Gallimard, Pléiade, 2003, p. 477.

69 *Ibid.*, p. 479.

70 *Ibid.*, p. 480.

71 Thierry de Duve, *Kant after Duchamp*, Cambridge, MA, MIT Press, 1996.

72 Thomas de Quincey, "On Murder considered as one of the Fine Arts", in *Collected Writings*, ed. D. Masson, vol. XIII, Edinburgh, Adam and Charles Black, 1890, p. 35. Hereafter, MFA.

73 See Alina Clej's excellent *A Genealogy of the Modern Self. Thomas de Quincey and the intoxication of writing*, Stanford, Stanford University Press, 1995. See also Joel Black, *The Aesthetics of Murder; A Study in Romantic Literature and Contemporary Culture*, Baltimore, Johns Hopkins University Press, 1991, and Gernot Krämer, *Der Mord als eine schöne Kunst betrachetet. Zur ästhetischen Valenz eines Motivs bei Thomas de Quincey, Oscar Wilde und Marcel Schwob*, Bielefed, Aisthesis Verlag, 1999.

74 Marquis de Sade, *Philosophy in the Bedroom*, trans. R. Seaver and A. Wainhouse, New York, Grove Weidenfel, 1965, p. 332.

75 Jacques Derrida, *Given Time. Counterfeit Money*, trans. Peggy Kamuf, Chicago, The University of Chicago Press, 1992. See also Jacques Derrida, *The Gift of Death*, trans. David Wills, Chicago, The University of Chicago Press, 1995.

76 *Affectionately, Marcel, op. cit.*, p. 109.

77 Roland Barthes, *The Pleasure of the Text*, trans. R. Miller, New York, Noonday Press, 1975, p. 37.

3 Scene of the Crime: Nothing to see!

1 In Walter Benjamin, *Selected Writings, vol. 1, 1913–1926*, edited by M. Bullock and M. W. Jennings, Cambridge, MA, Harvard University Press, 1997, pp. 446–7.

2 Anna Katherine Green, *The Leavenworth Case*, New York, Putnam, (1878) 1934, p. 11.

3 *The Leavenworth Case*, pp. 380–1.

4 "For if, when we love, our existence runs through Nature's fingers like golden coins that she cannot hold and lets fall so that they can thus purchase new birth, she now throws at us, without hoping or expecting anything, in ample

handfuls toward existence." Walter Benjamin, "Hashish in Marseilles," *Selected Writings*, vol. 2, part 2 (1931–1934), ed. M. W. Jennings, H. Eiland and G. Smith, p. 678.

5 *The Leavenworth Case*, p. 8.

6 Anna Katherine Green, *The Woman in the Alcove*, Indianapolis, Bobbs-Merrill, 1906, p. 15. See also Tom Gunning's excellent essay, "The Exterior as *Intérieur*: Benjamin's Optical Detective," *Boundary 2* vol. 30, 1, Spring 2003, pp. 105–29.

7 Régis Messac, *Le "Detective Novel" et l'influence de la pensée scientifique*, Paris, Honoré champion, 1929.

8 *Ibid.*, pp. 31–4.

9 A footnote on p. 34 states that the book's very idea came from the surprise caused by this remark when it was made in front of him by a philosophy teacher in 1913.

10 *The Leavenworth Case*, p. 17.

11 "Theses on the Philosophy of History," in *Illuminations*, trans. Harry Zohn, New York, Shocken, 1969, p. 253.

12 Messac, *Le "Detective Novel"*, p. 350.

13 *Ibid* p. 354.

14 Edgar Allan Poe, "The Purloined Letter," in *Collected Tales and Poems*, Harmondsworth, Penguin, 1983, p. 215. Hereafter, abbreviated as CTP and page number.

15 Vidocq's *Mémoires*, Paris, Garnier, ch. XLVI, vol. II, p. 330, quoted by Messac p. 357.

16 In Conan Doyle's *The Sign of Four*, quoted by Messac, p. 596.

17 Bob Dylan, from *Highway 61*.

18 See the discussion of Ellison's theses in the Introduction.

19 O. P. Monrard's *Life of Kierlegaard* (1909) is quoted by T. W. Adorno in *Kierkegaard. Construction of the Aesthetic*, trans. Robert Hullot-Kentor, Minneapolis, University of Minnesota Press, 1989, p. 41.

20 *Ibid.*, p. 41.

21 *Ibid.*, p. 44.

22 *The Arcades Project*, pp. 219–20.

23 Walter Benjamin, "Theological Criticism", in *Selected Writings*, II, 2, p. 430.

24 Søren Kierkegaard, *Fear and Trembling* and *Repetition, "Supplement,"* Princeton, Princeton University Press, 1983, p. 254.

25 Charles Brockden Brown, *Wieland or the Transformation, together with Memoirs of Carwin the Ventriloquist, A Fragment*, New York, Harcourt Brace Jovanovitch, 1926.

26 Adorno, *Kierkegaard*, p. 54.

27 *Ibid.*, p. 54.

28 Walter Benjamin, *The Arcades Project* p. 461.

29 Walter Benjamin, *Das Passagen-Werk*, Frankfurt, Suhrkamp, 1983, p. 575.

30 *The Arcades Project*, p. 463.

31 Walter Benjamin, *Charles Baudelaire. A Lyric Poet in the Era of High Capitalism*, trans. Harry Zohn, London, Verso, 1997, p. 50.

32 *The Arcades Project*, "First Sketches", p. 834.

33 See Robin Waltz, *Pulp Surrealism. Insolent Popular Culture in Early Twentieth century Paris*, Berkeley, University of California Press, 2000, pp. 13–41.

34 *Ibid.*, p. 839.

35 *Ibid* p. 885.

36 Louis Aragon, *Le Paysan de Paris*, Paris, Gallimard, Folio (1926) 1953, p. 74. Author's translation.

37 Quoted by Messac, *Le "Detective Novel"*, p. 509.

38 See Messac, *Le "Detective Novel"*, p. 425.

39 Messac, *Le "Detective Novel"*, p. 628.

40 Messac, *Le "Detective Novel"*, p. 553.

41 Walter Benjamin, *Charles Baudelaire. A Lyric Poet in the Era of High Capitalism*, p. 48.

42 Poe's *Complete Tales and Poems*, p. 475. Hereafter, abbreviated as CTP and page number.

43 Honoré de Balzac, *Théorie de la démarche et autres textes*, Paris, Albin Michel, 1990.

44 Poe's *Complete Tales and Poems*, p. 144.

45 Quoted by Messac, *Le "Detective Novel"*, p. 511.

46 Quoted by Mesac, *Le "Detective Novel"*, p. 640.

47 Walter Benjamin, *Charles Baudelaire. A Lyric Poet in the Era of High Capitalism*, p. 48.

48 Walter Benjamin, "Little History of Photograph," in *Selected Writings*, II, 2, p. 520.

49 "Benjamin's attitude is marked not so much by ambivalence as by a double-edged response. He welcomes *and* mourns its passing simultaneously; his remarks about aura manifest both a 'liquidationist'and an 'elegiac' undertow, and which is prominent depends on what dimension of aura as a general category of experience is under discussion." Diarmuid Costello, "Aura, Face, Photography: Re-reading Benjamin today," in *Walter Benjamin and Art*, ed. Andrew Benjamin, London, Continuum, 2005, p. 178.

50 "Little History of Photography," p. 515.

51 *Ibid.*, p. 518.

52 *Ibid.*

53 I am alluding to Man Ray's personal photo album of Atget's photographs, a series of 40 photographs bought by Man Ray from his older neighbour in 1926. See Susan Laxton, *Paris as Gameboard. Man Ray's Atgets*, Columbia University, 2002, pictures 16 and 17.

54 *Ibid.*, p. 519.

55 *Ibid.*, p. 527.

56 Ralph Rugoff, ed., *Scene of the Crime*, Cambridge, MA, MIT Press, 1998.

57 I owe this and other details on Abbott to Neil Baldwin's *Man Ray. American Artist*, p. 116.

58 Berenice Abbott, *The World of Atget*, New York, Horizon Press, 1964.

59 Atget told Man Ray: "Don't put my name on it. These are simply documents I make." See Susan Laxton's note in *Paris as Gameboard*, p. 31. The irony is that this remained Man Ray's attitude in later years; and instead of "documents", he spoke of bread and butter fashion portraits, never really "art" in his eyes.

60 See picture 61 in *Eugène Atget*, New York, Aperture, 1980.

61 *Les Mains Libres, dessins de Man Ray illustrés par les poèmes de Paul Eluard*, Paris, Jeanne Bucher, 1937.

62 *Ibid.*, p. 175.

63 Walter Benjamin, *Charles Baudelaire. A Lyric Poet in the Era of High Capitalism*, p. 43.

64 *Ibid.*, p. 43.

65 Poe's *Complete Tales and Poems*, p. 198, and Messac, *Le "Detective Novel"*, p. 349.

66 For all these details, see the excellent historical account and critical review by Amy Gilman Srebnick, *The Mysterious Death of Mary Rogers. Sex and Culture in Nineteenth-Century New York*, Oxford, Oxford University Press, 1995.

67 Amy Gilman Srebnick, *The Mysterious Death of Mary Rogers*, *op. cit.*, pp. 111 and 112.

68 For Benjamin, Lautréamont is one of the three anarchists (the other two are Dostoevsky and Rimbaud) who detonate their literary bombs at the same time by transforming the Romantic praise of evil into a political weapon. See Walter Benjamin, "Surrealism. The Last Snapshot of the European Intelligentsia," in *Reflections*, trans. Edmund Jephcott, New York, Schocken, 1986, p. 187.

69 Comte de Lautréamont (Isidore Ducasse), *Maldoror and Poems*, trans. Paul Knight, London, Penguin, 1978, pp. 129–30.

70 *Ibid.*, p. 130.

71 Hervé Le Corre, *L'Homme aux Lèvres de Saphir*, Paris, Rivages, 2004. See p. 440 for a recitation of the beginning of the passage quoted.

72 *The Arcades Project*, p. 240.

73 Isidore Ducasse, *Poésies*, in *Oeuvres Complètes d'Isidore Ducasse*, Paris, Livre de Poche, 1963, p. 376. According to one legend, this would be the origin of the word "dada" for the Dadaists.

74 See Robin Waltz's *Pulp Surrealism* for a condensed historiography of the arcades, and the context of Aragon's writing of *Paris Peasant* at the time of the demolition of the Passage de l'Opéra, i.e. in 1925, *op. cit.*, pp. 13–41.

75 *The Arcades Project*, p. 847.

76 This is the last sentence of the *Songs of Maldoror*, *op. cit.*, p. 245.

77 *Ibid.*, p. 240. Translation modified, as it has "eighty" instead of "four hundred."

78 *Le "Detective Novel" et l'influence de la pensée scientifique*, p. 493.

79 See for more precisions Robin Walz, *Pulp Surrealism*, p. 53.

4 Scalpel and Brush, Pen and Poison: The ekphrasis of murder

1 See for instance <www.casebook.org/ripper-media> and especially <www.casebook.org/dissertations/dst-artofmurder.html>.

2 Patricia Cornwell, *Portrait of a Killer. Jack the Ripper. Case closed*, New York, Putnam's Sons, 2002. Abbreviated hereafter as PK followed by page number.

3 "He was probably incapable of an erection. He may not have had enough of a penis left for penetration, and it is quite possible that he had to squat like a woman to urinate" (PK, p. 5).

4 "Art of Murder," in *Ripper Notes* no. 39, February 2002, online casebook discussion at <www.casebook.org/dissertations/dst–artofmurder. htlml>.

5 Quoted in *Jack the Ripper. Comprehensive A–Z*, edited by Maxim Jakubowsli and Nathan Braund, Edison, NJ, Castle Books, 2005, pp. 155–6.

6 See the reproductions and commentaries in *Sickert. Paintings*, edited by Wendy Baron and Richard Stone, New Haven, Yale University Press, 1992, pp. 206–15.

7 Quoted in Denys Sutton, *Walter Sickert. A Biography*, London, Michael Joseph, 1976, p. 326.

8 *Ibid.*, p. 100.

9 Quoted by Anna Gruetzner Robins, in her edition of *Walter Sickert. The Complete Writings on Art*, Oxford, Oxford University Press, 2000, p. xxxiii.

10 *Ibid.*, p. 60.

11 See for a thorough exploration of their relationship the superb Tate exhibition catalogue by Anna Gruetzner Robins and Richard Thomson, *Degas, Sickert and Toulouse-Lautrec. London and Paris 1870–1910*, London, Tate Publishing, 2005.

12 *Ibid.*, p. 300.

13 *Ibid.*, p. 669.

14 *Ibid.*, p. 656.

15 *Ibid.* p. 642.

16 Virginia Woolf, "Walter Sickert," in *Collected Essays*, vol. II, London, The Hogarth Press, 1966, p. 236.

17 *Ibid.*, p. 240.

18 *Ibid.*, p. 240.

19 *Ibid.*, p. 247.

20 *Ibid.*, p. 239.

21 *Ibid.*, p. 237.

22 See *Sickert, Paintings*, op. cit., pp. 230–3.

23 "Walter Sickert", p. 237.

24 As Wendy Baron writes in Sickert, *Paintings*, p. 216.

25 Homer, *Iliad*, trans. W. H. D. Rouse, New York, Penguin, 1966, pp. 225–6.

26 Oscar Wilde, *Collected Works*, ed. Robert Ross, London, 1908, XII, p. ix.

27 Richard Ellmann, *Oscar Wilde*, New York, Knopf, 1988, pp. 226–7.

28 "Pen, Pencil, and Poison," in *Intentions, Collected Works*, vol. 10, p. 99.

29 "Pen, Pencil, and Poison", in *Intentions, Collected Works*, vol. 10, p. 98.

30 "Pen, Pencil, and Poison", p. 96.

31 *Ibid.*, p. 100–1.

32 *Ibid.*, p. 90.

33 *Ibid.*, p. 92.

34 *Ibid.*, p. 98.

35 *Ibid.*, p. 74.

36 See the excellent annotations by Carle Bonafous-Murat in his French translation of Oscar Wilde, *Intentions*, Paris, Livre de Poche, 2000, p. 95.

37 See *Oscar Wilde*, pp. 313–14.

38 "Pen, Pencil, and Poison," p. 81.

39 *Ibid.*, p. 85.

40 "Pen, Pencil, and Poison," p. 100.

41 Thomas de Quincey, "The Avenger," *The Collected Writings*, vol. XII, ed. David Masson, Edinburgh, Adam and Charles Black, 1890, AMS Press New York reprint, p. 240. Henceforth, TA and page number.

42 "Pen, Pencil, and Poison," p. 73.

43 Marcel Proust, *Contre Sainte-Beuve*, Paris, Pléiade, p. 273.

44 Felix Vallotton, *La Vie Meurtrière*, Paris, Circé, 1996.

5 Who Killed Bergotte? The patch and the corpse

 1 Quoted by Helen Dudar, "Time stands still in the harmonious world of Vermeer," *Smithsonian*, 26/8, November 1995, p. 118.

 2 Marcel Proust, *The Prisoner*, trans. Carol Clark, London, Penguin, 2002, pp. 169–70.

 3 *Ibid.*, p. 170.

 4 Marcel Proust, *Contre Sainte-Beuve, Pastiches et Mélanges, Essais et Articles*, ed. Pierre Clarac et Yves Sandre Paris, Gallimard, Pléiade, 1971, p. 309.

 5 *Ibid.*, p. 559.

 6 Marcel Proust, *Remembrance of Things Past*, trans. C. K. Scott Moncrieff and Terence Kilmartin, New York, Random House, 1982, vol. 1, p. 589.

 7 Marcel Proust, *A la Recherche du Temps Perdu*, edited by Jean-Yves Tadié, vol. 3, with A. Compagnon and Pierre-Edmond Robert, Paris, Gallimard, Pléiade, 1988, p. 1740.

 8 Ibid., p. 1740.

 9 See, for a more restrictive thesis, A. K. Wheelock Jr., *Perspective, Optics and Delft Artists around 1650*, New York, Garland, 1977, pp. 283–301.

10 One finds this magnified detail in Norbert Schneider's *Jan Vermeer (1632–1675)*, Cologne, Taschen, 1994, p. 11.

11 *Ibid.*, p. 19.

12 I am here borrowing Roland Barthes' concept by which he defines the specific part or detail in a photograph that touches him personally. See *Camera Lucida*, trans. Richard Howard, New York, Hill and Wang, 1981.

13 Georges Didi-Huberman, *Devant l'Image*, Paris, Minuit, 1990. First published in *La part de l'Oeil*, Bruxelles, 1986.

14 *Devant l'Image*, p. 293, n. 37.

15 Marcel Proust, *Remembrance of Things Past, The Captive*, trans. C. K. Scott Moncrieff and Terence Kilmartin, New York, Random House, 1982, vol. 3, p. 185.

16 *The Prisoner*, pp. 348–9.

17 *Ibid.*, p. 349.

18 *Ibid.*, p. 350.

19 A critical fragment from the later years returns to these questions. Proust writes: "All of Dostevsky's novels could be entitled *Crime and Punishment* (as all those by Flaubert, *Madame Bovary* above all, and *The Sentimental Education*)." In *Contre Sainte-Beuve, op. cit.*, p. 644.

20 *Ibid.*, p. 170.

21 *Ibid.*, p. 173.

22 *Ibid.*, p. 165.

23 See the illuminating pages written by Dominique Mabin, Professor of Neurology, in *Le Sommeil de Marcel Proust*, Paris, Presses Universitaires de France, 1992, pp. 152–4.

24 *The Prisoner*, pp. 168–9.

25 See *Le Sommeil de Marcel Proust*, p. 152.

26 Text quoted in *A la Recherche tu Temps Perdu*, vol. 3, p. 1739, note a. Author's translation.

27 See the details given by Herbert R. Lottman in *Man Ray's Montparnasse*, New York, Harry Abrams, 2001, pp. 71–2.

28 Hesiod, *The Homeric Hymns and Homerica*, Loeb, Cambridge, London, 1977, pp. 446–7.

29 The parallels are too numerous to be detailed here. As Bergotte did for the narrator's first literary endeavors, Anatole France was a mentor and a guide who wrote a flattering introduction to Proust's juvenile *Les Plaisirs et les Jours*. He writes that Proust is both "very young" and "as old as the world". He adds that there is something of "a depraved Bernardin de Saint-Pierre and an ingenuous Petronius" about him. Quoted in Marcel Proust, *The Complete Short Stories*, trans. Joachim Neugroschel, New York, Cooper Square Press, 2003, pp. 3–4.

30 For a good account, see Mark Polizzotti, *Revolution of the Mind. The Life of André Breton*, New York, Farrar, Strauss and Giroux, 1995, p. 221.

31 *Ibid.*, p. 221.

32 Marcel Proust, *Contre Sainte-Beuve, op. cit.*, p. 645.

33 *Ibid.*, p. 646.

6 Surrealist Esthetics of Murder: From hysteria to paranoia

1 I translate from the *Second Manifesto of Surrealism*, in André Breton, *Oeuvres Complètes*, vol. 1, edited by Marguerite Bonnet, Philippe Bernier, Etienne-Alain Hubert and José Pierre, Paris, Gallimard, Pléiade, 1988, pp. 782–3.

2 See Michael S. Roth, ed., *Freud, Conflict and Culture. Essays on His Life, Work and Legacy*, Knopf, New York, 1998.

3 Quoted in Marguerite Bonnet, "La Rencontre d'André Breton avec la Folie: Saint Dizier, août-novembre 1916," in *Folie et Psychanalyse dans l'expérience surréaliste*, ed. Fabienne Hulak, Nice, Z'éditions, 1992, pp. 126–7.

4 M. Bonnet, p. 121.

5 I am alluding to Jean Starobinski's essay, "Freud, Breton, Myers", in *L'Arc. Freud*, Aix-en-Provence, Editions L'ARC, 1968, pp. 87–96.

6 André Breton, "Manifeste du Surréalisme," in *Oeuvres Complètes* I, p. 326.

7 André Breton, *Les pas Perdus*, in *Oeuvres Complètes* I, p. 256.

8 Facsimile reproduction of André Breton's notes in *Folie et Psychanalyse dans l'expérience surréaliste*, ed. Fabienne Hulak, Nice, Z'éditions, 1992, p. 155.

9 See Sigmund Freud, *The Interpretation of Dreams*, trans. James Strachey, New York, Science Editions, 1961, pp. 75–8.

10 Sigmund Freud, *Interpretation of Dreams*, p. 76.

11 Facsimile reproduction in *Folie et Psychanalyse dans l'expérience surréaliste*, p 154.

12 André Breton, *Communicating Vessels*, translated by Mary Ann Caws and Geoffrey T. Harris, Lincoln, University of Nebraska Press, 1990, p. 11. See also *Les vases Communicants* I, in André Breton, *Oeuvres Complètes* II, edited M. Bonnet, P. Bernier, E-A Hubert and J. Pierre, Paris, Gallimard, Pléiade, 1992, p. 109.

13 Sigmund Freud, *Interpretation of Dreams*, pp. 83–4.

14 André Breton, *Communicating Vessels*, p. 13.

15 André Breton, *Communicating Vessels*, p. 45.

16 See the Appendix with Freud's letters and Breton's response in *Communicating Vessels*, pp. 149–55.

17 André Breton, *Communicating Vessels*, p. 152.

18 André Breton, *Communicating Vessels*, p. 154, n 7.

19 André Breton, *Communicating Vessels*, p. 155.

20 *La Révolution Surréaliste*, IX–X (Octobre 1927), p. 26.

21 *La Révolution Surréaliste*, p. 33.

22 André Breton, *Oeuvres Complète* I, p. 948. Note that the text is written in small capitals throughout. One finds a good English translation of parts of this manifesto in Elisabeth Roudinesco, *Jacques Lacan & Co. A History of Psychoanalysis in France, 1925–1985*, trans. Jeffrey Mehlman, Chicago, University of Chicago Press, 1990, pp. 6–7.

23 André Breton, *Oeuvres Complètes* I, p. 949.

24 André Breton, *Oeuvres Complètes* I, p. 950. My translation modifies slightly that of Mehlman.

25 André Breton, *Oeuvres Complètes* I, p. 949.

26 See André Breton, *Oeuvres Complètes* I, pp. 848–63.

27 André Breton, *Oeuvres Complètes* I, pp. 849.

28 André Breton, *Manifestoes of Surrealism*, trans. Richard Seaver and Helen R. Lane, Ann Arbor, University of Michigan Press, 1969.

29 *Manifestoes of Surrealism*, p. 183.

30 Georges Bataille, "Formless," in *Vision of Excess. Selected Writings, 1927–1939*,

trans. Allan Stoekl, Minneapolis, University of Minnesota Press, 1985, p. 31.

31 Bataille, "The Use Value of D. A. F. de Sade (An Open Letter to My Current Comrades)", in *Visions of Excess*, p. 93.

32 *Dalí*, p. 303–4.

33 *Ibid.*, p. 312.

34 Georges Bataille, "The Big Toe," in *Vision of Excess*, p. 20.

35 *Ibid.*, p. 21.

36 See André Breton, René Char, Paul Eluard et al., *Violette Nozières. Poèmes, Dessins, Correspondence, Documents*, Bruxelles, Nicolas Flamel, 1933. Man Ray had done the cover photograph. See also Breton's *Oeuvres Complètes*, II, pp. 219–21 for the poem entited "Violette Nozières."

37 *Oeuvres Complètes*, p. 220.

38 For more details, see Jonathan Eburne, "Violette Nozières et la réécriture alchimique du viol", *Pleine Marge*, no. 40, December 2004, pp. 61–77 and Jonathan Eburne "Surrealism Noir," in Raymond Spiteri and Donald Lacross, eds. *Surrealism, Politics and Culture*, Burlington, Ashgate press, 2003, pp. 91–110.

39 Breton, *Oeuvres Complètes* II, pp. 308–9.

40 Salvador Dalí, "The Rotting Donkey,",in *Oui. The Paranoid-Critical Revolution: Writings 1927–1933*, ed. Robert Descharnes, trans. Yvonne Shafir, New York, Exact Change, 1998, p. 117. See the essay by Félix Fanès, "Une toile à destination secrète: *Le Jeu lugubre;*" in *Revue des Sciences Humaines. Lire Dalí*, pp. 163–85.

41 *Oui*, p. 110.

42 *Oui*, p. 112.

43 *Oui*, p. 116.

44 See Elisabeth Roudinesco, *Jacques Lacan & Co. A History of Psychoanalysis in France, 1925–1985*, pp. 110–12, for an account of their meeting, which had been instigated by Lacan, and *Jacques Lacan*, trans. Barbara Bray, Columbia University Press, 1997, pp. 31–2, for a more general assessment.

45 Jacques Lacan with J. Lévy-Valensi and P. Migault, "Ecrits 'Inspirés': Schizographie" in Jacques Lacan, *De la psychose paranoïaque dans ses rapports avec la personnalité* suivi de *Premiers écrits sur la paranoia*, Paris, Seuil, 1975, p. 379–80.

46 See Jean Allouch's thorough examination in *Marguerite ou l'Aimée de Lacan*, Paris, EPEL, 1990.

47 René Crevel, "Notes en vue d'une psycho-dialectique," in *Le Surréalisme au Service de la Révolution* V, May 15, 1933, pp. 48–52. Translated as "Notes Toward a Psycho-Dialectic" by Jonathan Eburne in Mary Ann Caws, ed., *Surrealism*, London, Phaidon, 2004, pp. 265–7.

48 See Dalí's Foreword to René Crevel, *Difficult Death*, trans. David Rattray, North Point Press, 1986, pp. vii–xiv.

49 As shown in Hanjo Berressem's article, "Dalí and Lacan: Painting the Imaginary Landscapes," in *Lacan, Politics, Esthetics*, edited by Willy Apollon

and Richard Feldstein, Albany, State University of New York Press, 1996, pp. 275–90.

50 As noted by Breton in *L'Amour Fou* in *Oeuvres Complètes* II, p. 753.

51 *L'Amour Fou* in *Oeuvres Complètes* II, p. 754.

52 David Trotter, *Paranoid Modernism. Literary Experiment, Psychosis and the Professionalization of English Society*, Oxford, Oxford University Press, 2001.

53 *Oeuvres Complètes* II, pp. 776–7.

54 See John Forrester, "Psychoanalysis: Gossip, Telepathy and/or Science," in *The Seductions of Psychoanalysis*, Cambridge, Cambridge University Press, 1990, pp. 243–59.

55 David Trotter, *Paranoid Modernism*, pp. 284–325.

56 Andreas Huyssen, "Mass Culture as Woman: Modernism's Other," in *After the Great Divide*, Bloomington, Indiana University Press, 1986, p. 45.

57 "Sujet," in *Nord-Sud*, April 1918, *Oeuvres Complètes* I, p. 24.

58 Breton, *Oeuvres Complètes* I, p. 24.

59 Breton, *Oeuvres Complètes* I, p. 25.

60 "Introduction au discours sur le peu de réalité," in André Breton, *Oeuvres Complètes* II, p. 278.

61 In a letter to Tzara from 1919, quoted in Breton, *Oeuvres Complètes* I, p. 1105.

62 I develop this point in *James Joyce and the Politics of Egoism*, Cambridge, Cambridge University Press, 2001, pp. 19–23.

63 Aragon, "Introduction à 1930," in *La Révolution Surréaliste*, no. XII, December 15, 1929, p. 58.

64 Aragon, "Introduction à 1930," p. 58.

65 Aragon, "Introduction à 1930," p. 64.

66 Walter Benjamin, "Surrealism, The Last Snapshot of the European Intelligentsia," in *Reflections*, edited by Peter Demetz, translated by Edmund Jephcott, New York, Schocken, 1986, pp. 189 and 190.

67 Aragon, "Introduction à 1930," p. 62.

7 Murder as Kitsch, Abstraction and ritual

1 Clement Greenberg, "Surrealist Painting," in *The Collected Essays and Criticism*, I, *Perceptions and Judgments, 1939–1944*, ed. John O'Brian, Chicago, University of Chicago Press, 1986, pp. 225–6.

2 Clement Greenberg, "Avant-Garde and Kitsch," in *The Collected Essays and Criticism*, I, *Perceptions and Judgments, 1939–1944*, p. 11.

3 Clement Greenberg, *The Collected Essays and Criticism*, edited by John O'Brian, vol. 1, *Perceptions and Judgments, 1939–1944* (1986), vol. 2, *Arrogant Purpose*, (1986), vol. 3., *Affirmations and refusals, 1950–1956* (1993), vol. 4, *Modernism with a Vengeance, 1957–1969* (1993), University of Chicago Press. Hereafter abbreviated as CE I, CE II, CE III and CE IV followed by the page number.

4 "Surrealist painting", CE I, p. 229.

5 *Ibid.* p. 229.

6 Saul Bellow, *Him with His Foot in His Mouth and Other Stories*, New York,

Penguin, 1984, pp. 63–163. Abbreviated as HFM followed by page number.

7 See Florence Rubenfeld, *Clement Greenberg. A Life*, New York, Scribner, 1997, p. 282.

8 Quoted in Michael Leja, *Reframing Abstract Expressionism*, New Haven, Yale University Press, 1993, p. 223.

9 Thierry de Duve, *Clement Greenberg entre les lignes*, Paris, Editions Dis Voir, 1996.

10 "Perhaps there is no more sublime passage in the Jewish Law than the commandment: Thou shalt not make unto thee any graven image, or any likeness of any thing that is in heaven or on earth, or under the earth, etc. This commandment can alone explain the enthusiasm which the Jewish people, in their moral period, felt for their religion when comparing themselves with others, or the pride inspired by Mohammedanism." Immanuel Kant, *Critique of Judgment*, trans. James Creed Meredith, Oxford, Oxford University Press, 1952, p. 127.

11 *Ibid.*, p. 133.

12 Joyce, "Paris Notebook," in *Critical Writings*, New York, Viking, 1959, p. 145.

13 Pierre Bourdieu, *The Rules of Art: Genesis and Structure of the Literary Field*, translated by Susan Emanuel, Stanford, Stanford University Press, 1995, p. 160. Hereafter, RA and page number.

14 See "The Last Interview," in Clement Greenberg, *Late Writings*, ed. Robert C. Morgan, Minneapolis, University of Minnesota Press, 2003, p. 236.

15 Clement Greenberg, "Convention and Innovation," in *Homemade Esthetic. Observations on art and taste*, Oxford, Oxford University Press, 1999, p. 55. One finds the same essay under the heading of "Seminar 6" in *Late Writings*, pp. 74–85.

16 "Convention and Innovation," in *Homemade Esthetic*, p. 55.

17 *Ibid.*, p. 56.

18 *Ibid.*, p. 58.

19 *Ibid.*, p. 56.

20 *Ibid.*, pp. 56–7.

21 *Ibid.*, p. 58.

22 *Ibid.*, p. 57.

23 *The Critique of Judgment*, p. 119.

24 *The Critique of Judgment*, pp. 124–5.

25 *Ibid.*, p. 26 and seq.

26 Thierry de Duve, *Kant after Duchamp*, Cambridge, MA, MIT Press, 1996, p. 407. I thank Jonathan Eburne for having pointed out this quote to me.

27 Raymond Queneau, *Le Dimanche de l'Histoire*, Paris, Gallimard, 1962. Queneau had been the editor of Kojève's notes on Hegel.

28 *Clement Greenberg. A life*, p. 296.

29 *Ibid.*, p. 298.

30 "T. S. Eliot: The Criticism, The Poetry" (1950), CE III, p. 66.

31 See Calvin Tomkins's *Duchamp*, p. 354.

32 *Nitsch, Eine Retrospektive*, works from the Essl Collection, Vienna, Edition Sammlung Essl, 2003, p. 40.

Conclusion: How to Think "Not Abstractly"

1 T. S. Eliot, *Collected Poems 1909–1962*, London, Faber, 1963, pp. 14–16.
2 See Yirmiyahu Yovel's new translation of Hegel's *Preface to the Phenomenology of Spirit*, Princeton, Princeton University Press, 2005, p. 160.
3 Gustav E. Mueller has traced this distortion to the influence of Heinrich Mortiz Chalybäus, a Kantian philosopher who simplified Hegel in popularized interpretations that were passed to Marx, Stirner and other "left-hegelians", hence spreading the common misreading. See Gustav E. Mueller, "The Hegel Legend of 'Thesis–Antithesis–Synthesis'" in Jon Stewart, editor, *The Hegel Myths and Legends*, Evanston, Northwestern University Press, 1996, pp. 301–5.
4 Slavoj Žižek, *The Sublime Object of Ideology*, London, Verso, 1989.
5 *The Sublime Object of Ideology*, p. 206.
6 Traditional earthenware painted tiles which have decorated houses in Portugal for centuries.
7 See Adriana Varejão, *Chambre d'échos / Echo Chamber*, Paris, Actes Sud, Fondation Cartier pour l'art contemporain, 2005, p. 39.
8 Jonathan Santlofer, *The Killing Art*, New York, HarperCollins, 2005. The cover proudly announces: "Includes artwork by the author."
9 Jonathan Santlofer, *The Death Artist*, New York, HarperCollins, 2002.
10 Benedetto Croce, *Aesthetic*, trans. Douglas Ainslie, New York, Noonday Press, 1969, pp. 302–3.
11 See the editor's note in *Miscellaneous Writings of G. W. Hegel*, edited by Jon Stewart, Evanston, Northwestern University, 2002, pp. 283–4. All subsequent page references in parentheses will be to this translation, pp. 284–7.
12 G. W. Hegel, *The Philosophy of Right*, translated by T. M. Knox, Oxford, Oxford University Press, 1980, p. 11.
13 *The Philosophy of Right*, p. 12.
14 *Ibid.*, p. 12.
15 *Ibid.*, p. 13.
16 Martin Heidegger, *Hegel's Phenomenology of Spirit*, translated by Parvis Emad and Kenneth Mady, Bloomington, Indiana University Press, 1988, p. 110, and Martin Heidegger, "Hegel's Concept of Experience," in *Off the Beaten Track*, trans. Julian Young and Kenneth Haynes, Cambridge, Cambridge University Press, 2002, p. 154.
17 G. W. Hegel, *Phenomenology of Spirit*, translated by A. V. Miller, Oxford, Oxford University Press, 1077, p. 19. See also Yirmiyahu Yovel's rather different translation, *Hegel's Preface to the Phenomenology of Spirit*, already quoted, pp. 128–9.
18 Hegel is here quoting here the explorer James Bruce, who was the author of

Travels to Discover the Source of the Nile (London, 1813) in the Introduction to his *Aesthetic*. I quote the English translation by T. M. Knox, G. W. F. Hegel, *Aesthetics. Lectures on Fine Arts*, Oxford, Clarendon Press, 1975, vol. 1, p. 42. See also G. W. F. Hegel, *Aesthetik*, ed. Friedrich Bassenge, Frankfort, Europaïsche Verlagsanstalt, 1955, vol. I, p. 52.

19 *The Phenomenology of Spirit*, trans. Miller, p. 31.
20 *Ibid.*, pp. 30–1.
21 G. W. F. Hegel, *Aesthetik*, vol. II, p. 220.
22 Denis Diderot, *Oeuvres Esthétiques*, Paris, Garnier, 1959, p. 677. Author's translation.
23 Jacques Derrida, *Glas*, translated by John P. Leavey, Jr., and Richard Rand, Lincoln, University of Nebraska Press, 1986, p. 21. I do not reproduce here the French words between brackets.

Index